Meaningful Places

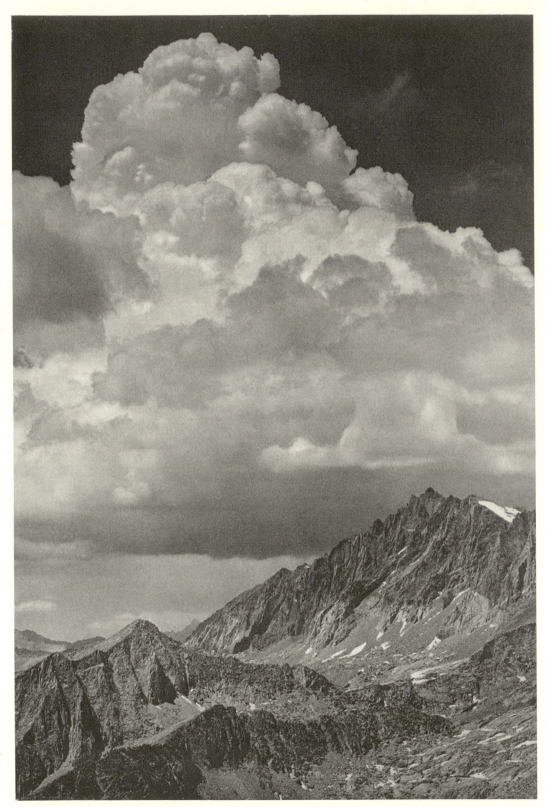

Ansel Adams, *The North Palisade*, *Kings River Sierra*, about 1932. Ansel Adams Archive, Center for Creative Photography, University of Arizona, © The Ansel Adams Publishing Rights Trust.

Meaningful Places

LANDSCAPE PHOTOGRAPHERS
IN THE NINETEENTH-CENTURY AMERICAN WEST

Rachel McLean Sailor

UNIVERSITY OF NEW MEXICO PRESS • ALBUQUERQUE

Library of Congress Cataloging-in-Publication Data

Sailor, Rachel McLean, 1970– author.
Meaningful places : landscape photographers in the nineteenth-century American West /
Rachel McLean Sailor.
pages cm
Includes bibliographical references and index.
ISBN 978-0-8263-5422-8 (hardback) — ISBN 978-0-8263-5423-5 (electronic)
1. Landscape photography—West (U.S.)—History—19th century. 2. Photographers—West
(U.S.)—History—19th century. I. Title.
TR660.S26 2014
770.92—dc23
2013047220

Publication of this book has been aided by a grant from the
Wyeth Foundation for American Art Publication Fund of the College Art Association.

BOOK DESIGN: Catherine Leonardo
Composed in 10.25/13.5 Minion Pro Regular
Display type is Scotch Roman MT Std Regular

To Noah, Dinah, and Aram Miles and to Robert and Mary Sailor

The eye sees not beyond the mind, and will convey to the latter no image or idea which the understanding and the heart are not already prepared to receive.

—EDWARD L. WILSON, "Art Writings for Photographers,"
Philadelphia Photographer, 1871

Contents

Illustrations

Acknowledgments

I HAVE HAD THE PLEASURE of working with many individuals in many capacities over the course of the years that it has taken to research and write this book. In its first incarnation as a dissertation, I had the good help and support from University of Iowa faculty members Joni Kinsey, Craig Adcock, Sara Adams, Kathleen Diffley, and John Raeburn. Those early years were supported as well by a Seashore-Ballard Dissertation Fellowship at the University of Iowa. The Special Collections Department of the University of Iowa Libraries also deserves a word of acknowledgment for their amazing kindness and generosity during my time there as a Robert A. and Ruth Bywater Olson Fellow. Thank you to Sid Huttner, Kathryn Hodson, David Schoonover, David McCartney, Jacque Roethler, and Denise Anderson. For archival assistance, I wish to thank the Center for Creative Photography, Cline Library Special Collections at Northern Arizona University, the Southern Oregon Historical Society, the Minnesota History Center, the Missouri History Museum, and the many other collections both large and small that contributed to my project. Special thanks to Leslie Squyres, Richard Quartaroli, Duane Sneddeker, Pat Harper, and Debbie Miller for their assistance with my research and to Betsy Bress for help with the digital imagery. Student research assistants along the way have proven invaluable. I wish to thank Laura Gilbreath, Noelle Johnson, Kayleigh Lang, Shane Milner, and Harry J. Weil. Likewise, good colleagues and a rich working environment are prized beyond measure. Thank you to the University of Wyoming Art Department, especially Lisa Hunt, for creating a warm and creative atmosphere for working.

Many opportunities have allowed me to travel in my search for photographers. The John Topham and Susan Redd Butler Faculty Research Award from the Charles Redd Center for Western Studies is an amazing source of support for scholars who study the American West. Support from the University of Texas at Tyler's Internal Research Grant and the University of Wyoming College of Arts and Science's Basic Research Grant were crucial to this project. Thanks as well to the University of Wyoming's Office of Research and Economic Development and also to the Wyeth Foundation for American Art for providing a much-needed and generous publication grant. I wish to thank Clark Whitehorn and the University of New Mexico Press for this publishing opportunity and Catherine Chilton for her help in the final stages.

I am most indebted to colleagues, friends, and readers who have helped me along the way with good advice and support. Thank you to Jill Blondin, Tamara Wilde, Stephanie Lopez, and Noah Miles. To the many whom I have failed to mention here and to the anonymous reviewers of my manuscript, you have my heartfelt appreciation. Finally, I express profound gratitude to my parents, who encouraged me to move to the West, and to my husband and children, who have lived here with me.

Introduction

It is a subject that to every American ought to be of surpassing inter-
est; for, whether he beholds the Hudson mingling waters with the
Atlantic—explores the central wilds of this vast continent, or stands
on the margin of the distant Oregon, he is still in the midst of
American scenery—it is his own land; its beauty, its magnificence,
its sublimity—all are his; and how undeserving of such a birthright,
if he can turn towards it an unobserving eye, an unaffected heart.
—THOMAS COLE, "Essay on American Scenery," 1836

Straight portrait jobs; group pictures of lodges, church societies,
and political clubs; and outdoor shots that gratified civic pride.
There were many commissions to photograph shop fronts and, oc-
casionally, interiors. Now and then, too, somebody would order
pictures of his new house or of his big barn, and along with it the
livestock.
—WILLIAM HENRY JACKSON, *Time Exposure*, 1940

MOST WHO VIEW PHOTOGRAPHS FROM the nineteenth-century West intuitively
understand the photographers' presence across the vast and diverse landscapes of
the sixty years when photography existed in that place and time. Scholars and west-
ern enthusiasts, as well, know that photography played an important role in the
development of the Euro-American West. For instance, the documentary aspect of
the nineteenth-century medium was widely touted during that time as instructive
and enlightening concerning the people who lived there, the natural history em-
bedded in geological strata and land formation, resources such as water and timber,
and the pleasing and inhabitable landscapes. Photography's influence on the na-
tional imagination, as well, was profound. People in the eastern United States en-
countered a photographic record in travel and immigration guides, illustrated
books, collectable portfolios, and photographic studios and galleries that inspired
and encouraged thousands. Despite this recognized importance of western

photography to Americans in the nineteenth century and its connection to our understanding of western places today, how photographs of place functioned once settlers arrived in the West has gone unexplored.

Although William Henry Jackson's description of "outdoor shots" in the epigraph above is undoubtedly based on the authority of his experience as a nineteenth-century commercial and survey photographer in the West, it does little to reveal the complexity of imagery created by western settler photographers. Photographs of the land that included a new house or a big barn, for instance, were more typically described in the nineteenth century as "views," a term that does not imply the inspiring experience of nature in a more high-minded type of landscape that the Hudson River artist Thomas Cole had in mind but rather implies a more banal, documentary approach to representation of surroundings. For Jackson, the distinction was important depending on the purpose of a photograph—whether it was scientific or commercial, for instance, or whether he intended it for an exhibition or a single patron.[1] For photographers who lived in the new and growing western settlements and whose clientele did not vary as greatly, a view and a landscape photograph were not so distinct but rather existed closer on a continuum. Despite this blending of the highbrow and lowbrow, western photographers and their clients did not turn to their local western landscapes with "an unobserving eye" and "an unaffected heart." On the contrary, those so-called mundane views held profound significance for those who made the West their home.

Today, Jackson's western photography, which captured the imagination of an eastern audience, and the images produced by countless view photographers all over the American West for local western viewers is an assumed dichotomy that goes unquestioned. Jackson's characterization of local views as images that simply "gratified civic pride," for instance, reinforces the erroneous idea that historical local photographs are uninteresting and uncomplicated, giving us little impetus to investigate them beyond locally felt needs for self-reflective gratification (needs that are still felt today). Modern scholars, as well, have disregarded locally produced outdoor views of the nineteenth-century West as "boring documents" and dismissed them as simply indexical.[2] Jackson's words, fortunately, do not definitively shape our perception of photography's role in local western history. In fact, his sentiment likely speaks more about his retrospective ideals in the 1940s, when he wrote his autobiography, than about his beliefs in the 1870s, when he was most active as a western photographer. Nevertheless, he highlights the differences between those photographers who worked for a national, commercial market and under the auspices of government patronage and those who independently worked for a local clientele.

Photographs by Jackson and other nationally prominent photographers have long been recognized as a fundamental tool for shaping ideologies about western history.[3] Conversely, the phenomenon of local landscape photography is ill defined because many erroneously assume that residential photographers are only interesting or meaningful to the region or locale that they represent. Although not as glamorous as the lavishly illustrated books and album collections produced by the well-known figures in the field, local production for local people was

equally important in the development of Euro-America's visual understanding of the West. In fact, the American idea of the "frontier" developed year by year with the aid of community photographers, significantly augmenting nationalistic rhetoric at the grassroots level. As with textual accounts, photographs by settlers were (and continue to be) used locally to idealize and eulogize the early era of their communities, illustrative on the one hand and saturated with nostalgic esteem on the other.

In this book, I will discuss how photographers actively influenced local notions of the frontier by picturing the land as part of the settlement activities of the Euro-American immigrants throughout the second half of the century, and I will further explain how local communities found site-specific meaning in images of the local and regional places they inhabited. What locally produced images of Minnehaha Falls implied to residents of St. Paul, Minnesota, for instance, was quite different from the meaning of such images to a person living in Connecticut. Likewise, the awe-inspiring photographs of Crater Lake produced by Peter Britt in the 1870s held a specific meaning for those who lived near the site—when the photographs were viewed by those outside the region, however, the perceived meaning was quite different. My point is to demonstrate that photographs of landscape in discrete western places had functional, deeply felt importance for the western settlers of those places and that those local responses to place were manifesting photographically all over the West, from the 1850s through the early years of the twentieth century.

In countless western communities throughout the last half of the nineteenth century, photographers both documented and participated in the acquisition phase of defining place. In response to this history, "regionalism" and "localism" as conceptions of how to understand places in the West have undergone substantial transformations since the 1990s. With a growing recognition that the West is not just one but many distinctive regions full of diverse and complex communities, scholars now consider how geographical and cultural boundaries are based on commonality and by what means these commonalities arose.[4] Photographs as objects of reflection, both visually and mentally, provided the new western inhabitants with a unique means of addressing concerns of difference and commonality, as well as the strange and familiar, in their communities. Altogether, the photographic medium is an excellent barometer of Euro-American perception and the commensurate construction of community, as well as the cultural and geographic site-specific characteristics that came to define regions and locales throughout the West.

The use of landscape photography to augment understanding of place was ever present despite the vastly different kinds of places that photographers found in the West over the course of fifty-plus years. It was a successful strategy for communities trying to define themselves, a strategy periodically revisited and reutilized today in much the same way as it was originally—as a lens for understanding a cultural place. The stories that follow do more than just shed light on how western settlers used the photographic image as a settlement tool; they also illustrate how local and

regional understandings of places have a fundamental impact on those places now, and how, taken as a whole, they have shaped modern concepts of the West.

THE ABUNDANCE AND SIGNIFICANCE
OF LOCAL PHOTOGRAPHERS

All told, settler photographers were present in frontier America in great numbers. In 1850, southern publisher and statistician James Dunwoody Brownson DeBow estimated in the *Statistical View of the United States* that 938 daguerreotypists existed nationally.[5] By 1872, one author in *The Great Industries of the United States* wrote that photography was an industry that had grown to proportions "that surprise," although he admitted that the figures reflecting the number of photographers were understated, saying that "states are returned with an aggregate of particular occupations greatly short of what are known to exist, by local registers and directories."[6] Self-admittedly, the 1872 report was overly concerned with the "great galleries of the metropolis."[7] Photography in general was enjoying unprecedented growth as an industry, and near 1873, "about five thousand two hundred and fifty persons in the United States" existed who followed "photography as a business."[8] Additionally, the number of imported reams of albumenized paper "indicates the amazing number of fifty million and four hundred thousand photographs made every year."[9] Indeed, as the industry grew, it was truly a significant companion to western settlement.

The information recorded in period census reports and industry surveys, however, reliably conveyed neither the number nor the importance of the photographic industry in the West. Photography made by nationally famous photographers, such as William Henry Jackson, John Hillers, Timothy O'Sullivan, Carleton Watkins, and Eadweard Muybridge, dominated and continues to dominate the medium's history, but they are only part of a much larger story of the relationship between the camera and western Euro-American settlement. In fact, the vast majority of photographers in the West were residents and regional itinerants, with a very limited customer base. Carl Mautz's *Biographies of Western Photographers* (1997) and Palmquist and Kailbourne's *Pioneer Photographers of the Far West* (2000) significantly reveal that the number of settler photographers was far greater than previously imagined.[10] Palmquist's diligent work in the state of California, for instance, reveals some seven hundred photographers working between 1840 and 1865.[11] Mostly obtained from historical society archives across the West and nineteenth-century newspaper advertisements, the thorough work of these photographers provides a remarkably accurate picture of their numbers in the West. Mautz's count of California photographers, which was based largely on Palmquist's work and covered an extended period that included very early twentieth-century practitioners, was more than 2,500. California was attractive for westward-bound photographers who were drawn to the booming metropolis of San Francisco, the mining settlements, and the natural beauty of Yosemite and the redwoods, and it

was filled with the not-so-well-known photographers who came to reside there. Other states in the West had similarly high numbers.

These statistics alone suggest a different history of nineteenth-century western photography than is typically represented by those who investigate one photographer outside the context of these numbers. The wealth of regional and local photographs that fills many western state historical society and museum archives makes it strikingly apparent that the camera was a prevalent component of settlement activities and that western photography was more than the documentation of a new home; the medium provided a means for those settlers (and for us today) to interpret those places. Photographic imagery, like western paintings from the same era, enabled Euro-Americans to see the new landscape within their own cultural rubric; selective representation showed the West as "empty" virgin territory, with sublime monuments as proof of and reward for Manifest Destiny, and as filled with huge tracts of fertile land suited for a Euro-American style of agriculture and ranching. It offered a prospect of unlimited natural resources, portraying everything from local inhabitants and their property to the scenery of towns, cities, and the outlying region.

WESTERN VIEWS FOR EASTERN AUDIENCES

Mautz's, Palmquist's, and Kailbourn's efforts confirm that photographers made their way West immediately after the invention of the photographic medium in 1839. Indeed, Jacques Louis Daguerre's photographic invention in 1839 was immediately successful in America, with would-be proprietors clamoring to learn the business. For example, as owner of the first photographic studio in New York City, John Johnson's early experience with the daguerreotype process underscored the excitement when he wrote,

> Having duly arranged the Camera, I sat for five minutes, and the result was a profile miniature, (a miniature in reality,) on a plate not quite three-eighths of an inch square. Thus, with much deliberation and study, passed the first day in Daguerreotypy—little dreaming or knowing into what a labyrinth such a beginning was hastening us.[12]

As the decades progressed, the rate of photographic incursion into the region grew exponentially. In fact, according to their data, Mautz, Palmquist, and Kailbourn demonstrated that photographers were practically ubiquitous by 1900. Despite the rapid rise of portraiture as the single most important genre of photography, consumers demanded a multitude of other subjects. Landscape views, for instance, spurred by the development of the collodion method and the stereoscope in the 1850s, became immensely popular. Along with written accounts, large-scale painting, and printed lithographic accounts, photography provided glimpses of what existed beyond the Mississippi and validation for those already there. Photographs verified the vastness of the plains, the grandeur of the Rocky Mountains, and the unfathomable size of

California's great sequoia trees. Photographs showed eastern viewers not only the majesty and relative oddity of the western landforms through the lens of geological expeditions but also portrayed exotic cultures in these environments. The photographs that depicted opportunity for gold or land or business, whether distributed as photographs, lithographs, or wood-engraved illustrations copied from them, provided proof for eastern eyes of what had before been only speculation and rumor—and they did so in a way that was believable. Unlike travel accounts, monumental paintings, or even small engravings, it was popularly believed that

> The photograph . . . cannot deceive; in nothing can it extenuate; there is no power in this marvelous machine either to add or to take from; we know that what we see must be TRUE. So guided, therefore, we can travel over all countries of the world, without moving a yard from our own firesides.[13]

The apparent veracity of photographs was compelling and made its subjects, especially those enticing and exotic western sites, even more so.

For photographers, as well as for the people who collected and viewed their images, the American frontier offered what seemed like an endless source of subject matter; photographs of Native Americans and landscapes became choice consumer items, spurring a national image trade. Understandably, scholarship concerning this phenomenon has focused primarily on the photographic production of government surveys and a handful of photographers producing images intended for a national audience.[14] The resources of the government survey expeditions and the entrepreneurial spirit of the photographers augmented the proliferation of western photographs. Their photographs not only made their way into the public arena through publication and individual sales but also through expositions, albums, and photographically illustrated books.

Despite the rapidity and eagerness with which photographers took to the western states, photography was a difficult profession. It was so difficult, at times, that it underscores the deeply felt desire for visual representation.

> Fortunately there are those who, from love of wandering, or of Art, or of gain, will incur any amount of fatigue and danger, and bring to us enjoyment and knowledge, without demanding from us either labour or risk; giving in an hour the information that has been gained by years of toil and peril. All honour to the men who are thus our ministers![15]

Based on the stories reported in nineteenth-century photographic journals and later photographers' memoirs, we get a sense of the most common challenges. One of the most tragic tales of the dangers of western image making involved the photographer Ridgeway Glover, a correspondent for the *Philadelphia Photographer*, who set out in 1866 to "illustrate the life and character of the wild men of the prairie."[16] Glover sought subjects in and around Fort Laramie and Fort Kearney in

1866, but his letters stopped coming in the fall of that year. In December, the following notice appeared in the journal: "Knowing no fear and being ardent in the pursuit of his beloved profession, he risked everything, and alas! The result was that he was scalped, killed, and horribly mutilated."[17] In a less violent example, William Henry Jackson, who arguably produced the most cohesive oeuvre of western photographs through his U.S. Geological Survey (USGS) collection, illustrated books, and albums, told a heartbreaking tale of disaster and ruin that occurred on an 1877 expedition to the Southwest. "It still makes me feel sick, in a very real, physical sense, whenever I look back on my return to Washington in the fall and the discovery that not a one of my 400 exposures could be developed into a negative."[18] The source of Jackson's misfortune was technical, as he was using a very early version of dry strip negatives that failed somewhere in the time between exposure in the field and development back at his studio.[19] Similarly, the little-known Thomas Roche described an all too common incident that befell a fellow photographer of the Yosemite Valley in 1871:

> There is a Mr. Garrett, of Wilmington, Del., photographing here. He came out by steamer . . . (and) got his traps and big photo tent in here, but the pack-train mule, in coming up at night, undertook to ford the river, and was carried down the stream, when he rolled over all the photo traps, and was drowned. A man swam out and tied him to a tree until morning, when they went out in the river and cut the boxes off. All his things were soaking wet. His plates were all albumenized. This, of course, used him up for about two weeks; then he commenced, but could not move half a mile, his traps were so heavy. His plates were all fogging. He had a Philadelphia collodion which has a separate sensitizer. This he mixed as he wanted to use it; but the result has been nil.[20]

The threat of death and photographic ruin aside, western traveling photographers faced a substantial set of difficulties. For example, Roche reported that

> It is very difficult to work long with the same bottle of collodion, as it is so hot. I have about one week's more work in the valley, and then, if I can get a good man and packmule, I will make a trip to Lake Genaya and the highest range of the Sierras, fifteen thousand feet above the sea. This will take, out and back, nearly two weeks. I have had not less than six different men to help me. They will not work when it comes to starting at 3 a.m. and tramping all day long.[21]

Likewise, photographers who lived in the West faced many of the same challenges as eastern photographers who were only visiting. Serious obstacles to their work included the obtainment of supplies, difficult topographies and altitudes, and the availability of water; all these were site specific. Some encountered harsh winters and hot summers, mountainous terrain, deep snowfall, lack of navigable roads, and

extreme aridity or high humidity; others had to negotiate the transfer of necessary supplies over land from supply houses in the East or over sea to western ports. Due to the extreme variability in the situations of western photographers, each one, like the western communities and decades they represented, faced different logistical challenges.

WESTERN VIEWS FOR WESTERN AUDIENCES

The very presence of photographers in communities both large and small, despite the deep logistical challenges, attests to a demand for photographs. As well, supplies were precious and photographers were not wasting their material—they produced photographs that were in demand. More often than not, photographs were intended, from their very inception, for an interested, limited market. Images made for reasons other than direct commission were strategic; regional photographers gambled that their landscape photographs, especially, would be popular. Depending on the location and the year, landscape photographs garnered gallery visitors, bolstered profits from a walk-in trade, and prompted commissions, despite the risks and occasional failure of a genre of photography that was not simply "cash for likeness."

Similar to urban views produced in cities across America, landscapes were uplifting to regional viewers. Likewise, photographic galleries provided important services as the hub of visual culture in western locales. Although ostensibly commercial, western photographers provided literal and symbolic sites for cultural expression in both their galleries and the photographs themselves. Photographs brought west helped ease emotional anguish and soften the anxiety of physical distance incurred by western immigration. Letters, journals, and memoirs overwhelmingly point to difficulties—not just concerning long journeys, but once arrived, of the difficult task of turning the unfamiliar territory into a functional and meaningful home.[22] By the 1840s and after, settlers were able to use photographs to their advantage: photographs enabled them to adjust to their new circumstances and aided them in the creation of a meaningful place for themselves. They could see themselves and their neighbors in the landscape, which allowed them to conceptually shape the new spaces according to their own cultural imaginings and to make sense of the new cultural and physical landscapes in which they found themselves. For example, western photographers often portrayed settlers in their new landscapes in a way that confirmed their visual expectations and conformed to their desires for their new home at the same time that it denied the already present cultural landscape of native peoples. What Euro-Americans needed from the landscape, wished for the landscape, and projected onto the landscape was very much rooted in their cultural background, and landscape photographs, especially, expose a point of view mediated via a thoroughly modern and mechanical means.

How settlers and travelers thought of landscapes affected the way in which photographers pictured place and vice versa. Photography was born into a culture that had a very distinct and developed aesthetic sensibility, and the manner in

which photographers framed landscapes, whether in Minnesota or Oregon, Nebraska or the Grand Canyon, were (and are) contingent on a rich, Western European cultural heritage of landscapes in the visual arts. The long and complex history of picturing the land can be traced back to seventeenth-century landscapes of Claude Lorrain, for example, and to the concept of the Renaissance window–like frame before him, as well as to even more ancient concepts of sublime and beautiful presentations.[23] Most prevalent in American imagery generally and western local views particularly is the recurring notion of the "picturesque landscape" as an aesthetic concept; the charming views that may have seemed overly quaint and thoroughly produced in eastern American climes must have seemed especially reassuring to new western communities. In some cases, these appealing landscapes offered a visual link to the rest of America that downplayed physical distance and psychological remoteness. In other cases, it is the very absence of "picturesqueness" that confronts western landscape photographers.[24] At still other times, the quaint and charming picturesque is replaced by the more dramatic and awe-inspiring sublime view that touts western lands as superior to eastern, more European, scenes. All of these, however, were responses to a prescribed cultural aesthetic. Furthermore, in the nineteenth century, viewers unproblematically assumed the verisimilitude of photographs, and this further naturalized Euro-American ways of seeing western places.

 In an interesting contrast to the manner in which the landscapes were understood by the public in the nineteenth century, photographic journals from the era provocatively suggested that photography could be a wholly artificial endeavor. An 1866 article in the *Philadelphia Photographer*, for instance, discussed the elaborate indoor staging of an outdoor hunting scene. The landscape series was lauded for its "truthful account of the sports, pleasures, and perils, of a Cariboo hunt in snowy Canada."[25] In defense of the deception, the author wrote that "each photograph is a picture, and each picture has a meaning. They are not merely specimens of delicate manipulation, artistic posing, and magical arrangement of light and shade. Each one shows the expenditure of time, brains, and talent."[26] Throughout the nineteenth century, photographers were repeatedly encouraged to strive for artfulness. They must be an artist "in the highest sense of the word,—a creative artist,—or else be crushed by the Camera."[27] As early as 1854, Henry Hunt Snelling made the prophetic argument that "although the Art of Photography has made rapid strides during the last ten years, and has assumed quite a position among the arts and sciences, it cannot be said to have attained that sphere of excellence to which it must eventually arrive."[28] By the 1870s, an intense journalistic effort to elevate the photographic arts appeared in the pages of multiple journals. Even in the early years of the daguerrean age, the photographic industry promoted an artful approach to image making. For example, in an 1849 letter from the photographic industrialist Edward Anthony to the writer and editor Henry Hunt Snelling, the former wrote that "a GOOD Daguerreotypist is by no means a mere machine following a certain set of fixed rules. Success in this art requires personal skill and artistic taste to a much greater degree than the unthinking public generally

imagine."[29] As these writers indicate, photographers understood the aesthetic contrivances required to produce a satisfactory image, despite the widely held popular belief that photographs simply documented the truth.

Local landscape photographs in the West were both aesthetically composed and purpose driven. Like the survey photographers and their backers, whose goal was much more than to simply document, local photography created narratives of the past and future that were intended to influence. Local photographers, like their transcontinental counterparts, also explored, assessed, and both consciously and unconsciously celebrated their landscapes. They persuaded viewing audiences to visualize and conceptualize a landscape that augmented their lives—not simply "promoting place" to outsiders but rather presenting views that functioned self-reflexively for the immediate public.

CULTURAL LANDSCAPES

Photographs of western landscapes reveal immense amounts of information about the pictured place, the intents and purposes of the photographer, Euro-American desires for economic prospects, and the history of photographic technology, as well as the history of visual imagery in general. Many people in the nineteenth century and still today assume that photographs of the American West represent an untainted, undefiled vision of what was natural—what was simply there. Strikingly, however, nineteenth-century photographs did not document western spaces as conceived of by native peoples. Scholars have argued convincingly for decades that landscape is a cultural construction, imbued with meaning through the social and moral framework of those who are looking, those who seek meaning.[30] Native Americans had a huge variety of responses to the landscape—tribally constructed responses dictated by their own needs and values. They had a very different conception of landscapes and social spaces than Euro-Americans in that they did not respond to a "scene" in the same way as those whose visual literacy was rooted firmly in Western European culture. Indeed, the native peoples had their own views of the world, equally as culturally dependent but quite different. Furthermore, early Euro-American immigrants to the West consistently misinterpreted the relationships that tribes had with their own local landscapes.

Understanding landscapes as cultural spaces is fundamental to any consideration of western American photography. In the process of constructing their own cultural landscapes, Euro-Americans often ignored, overlooked, or were simply ignorant of existing cultural meanings of those spaces. Despite the "empty" and "virgin" conception of the frontier, for example, we know that Native Americans had been manipulating the western terrain for thousands of years, and their cultural understanding of the spaces they occupied was complex. Although this book will not reconstruct Native American cultural landscapes, my goal is to be persistently mindful that Euro-American photographs of their new places represent a complex situation in which they were actually butting up against, responding to,

embracing, and rejecting the local Native traditions regarding the land. The land-scapes that we can track through photographs do not represent the West "as it was" but rather represent a particular and motivated point of view.

Focusing on local photographers who practiced in towns, counties, or regions and who participated in the creation of community, turning a new and unfamiliar place into their own meaningful landscape, reveals how landscape photography aided in the creation of local culture in nascent western communities—claiming, constructing, reconstructing, and appropriating the landscape they held in com-mon. In each Euro-American settlement, there were boundless political, ethnic, religious, financial, and sociological dynamics that accounted for the local cultural production of landscape. The stories of western images, along with information about who made them, how they were made, who looked at them, and in what man-ner the images were encountered, can add to the ways in which we can understand nineteenth-century landscape photographs in order to take a small step toward a more sophisticated understanding of the American West.

Place making occurred differently in the diverse regions of the West where settlement patterns, customs and demeanor of both immigrant and native peoples, and the physical landscape varied widely. Likewise, the specific date of settlement and local photographic production substantially determined the photographic technology in use. Beside the aesthetic tropes of Euro-American visual culture and the wide range of geographic land formations, photographic technology played a large part in how and where photographs were made, distributed, displayed, and collected. The singular daguerreotype of the 1840s was more precious than, for example, the more ubiquitous *carte de visite* format of the 1870s, which in turn was rendered downright old-fashioned by the rise of the motion-picture industry in the early twentieth century. Each chapter here examines a small sample of a particular photographer's work as representative of important issues relevant to the photog-rapher's place and time, the available technology, the unique features and customs of that region, and the local engagement with Native America.

Each of the following chapters is conceived of and presented as a case study that elucidates the depth and complexity of western photography made in the West for the West, spanning vast geographical territory and encompassing almost one hundred years of changing photographic technology and technique. Each chapter addresses a discrete photographic project in a specific place at a specific time, and together they reveal that, for example, an 1850s daguerreotypist in St. Louis, an 1860s cartes de vis-ite maker in St. Paul, an 1870s photographer in southwestern Oregon, and an 1880s album maker on the central plains of Nebraska performed the same function in their communities. Only toward the end of the century, with the marketing of Eastman Kodak's Brownie camera, did the phenomenon of the local photographer end, only to be replaced with a new kind of practitioner who was forced to reassess his or her audience, subjects, and distribution methods—a turn of events that instantly encour-aged nostalgia for the local professional photographers of the proceeding decades. To address this situation, I turn in the last two chapters to investigations of the Kolb Brothers of the Grand Canyon and the famous Ansel Adams to show how

photographers adapted to new demands in the increasingly modern West. Ultimately, I will demonstrate that the landscape strategies that the masses of nineteenth-century western photographers utilized profoundly affected generations of photographers well into the twentieth century, ultimately creating a legacy for our understanding of western places even today.

What these chapters show is that the photographic profession in general, and in the nineteenth-century West specifically, responded to and in turn helped shape its clientele's strong sense of and need for community. It is interesting that although I discuss a great many landscape images, the vast majority of local landscape production includes human beings. The images in question, it would seem, were not considered so much a distant aesthetic ideal but rather representations of very real places that incited—perhaps demanded—interaction with the community for which the images were being made. The photographs helped settlers see themselves both figuratively and literally as belonging—as occupying and, by extension, as succeeding in their intractability. Pure landscapes were almost never the primary subject matter of settler photographers and were not even exclusively represented in Adams's modernistic oeuvre. Populated landscapes had a strong communal purpose, both in remote locales and in later nationalistic production, as a way to reflect commonly held values of land ownership, aesthetic beauty, and belonging.

The history of photography in the nineteenth-century American West is, indeed, a far greater tale than is represented by an exclusively eastern image market. Photography not only served to spur immigration and offer endless exotic pleasures for eastern audiences but also served a primary function for settlers once they arrived in the West. Understanding their new territory and neighbors was not simply entertaining, it was important. I have included photographers linked by strong commonalities, even though the photographs they produced represent landscapes that invoke myriad cultural and geographical complexities. In all, the photographers and their landscapes herein tell a story of how images of place were important to the individuals of specific frontier towns and counties and how the legacy of that era continued well into the twentieth century and even today. Together, these accounts can achieve something they cannot do alone: they highlight a new way of thinking about the relationship between western landscape photographs and the Euro-American settlers who used them.

Daguerreotypy and the Landscape

Thomas Easterly, St. Louis, and the Big Mound

If not already arrived, the time is not far distant when the reproach
so often flung at this country, that we have no antiquities, will lose
even the appearance of truth, and the world will look with interest
and awe on some of the mightiest monuments of antiquity which
stand above the surface of the earth, as they are opened to view in
the western country.

—WILLIAM PIDGEON, *Traditions of De-Coo-Dah
and Antiquarian Researches*, 1853

THE GATEWAY CITY

ST. LOUIS IS AN URBAN CENTER WHOSE rapid development in the mid-nineteenth
century was largely due to the commercial opportunity afforded by the Mississippi
River. The city is strategically located just south of the confluence of the Mississippi
and Missouri Rivers and at the northern end of the American Bottoms region (the
Mississippi flood plain)—a particularly tactical location, which had been utilized
by Mississippian mound-building cultures and by French and Spanish trappers and
traders long before it became an industrial center. Its position in the developing
West prompted Frederick Goddard to write in his guidebook, *Where to Emigrate
and Why* (1869), that St. Louis

is ordained by the decrees of physical nature to become the great inland
metropolis of this continent. It can not escape the magnificence of its des-
tiny. Greatness is the necessity of its position. New York may be the head,
but St. Louis will be the heart, of America.[1]

St. Louis was a boomtown of commerce and growth in the 1850s, spurred on by
American industrialization, westward expansion, and its tactical setting. Easily

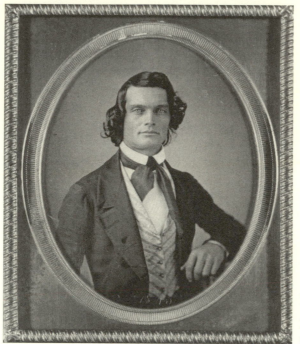

Figure 1. Thomas M. Easterly,
Thomas M. Easterly, 1845.
Missouri History Museum,
St. Louis.

accessed by water and, later, railways, the city was a primary transition point for im-
migrants traveling from the eastern United States to the Far West via overland routes;
its particular history of population growth was partly the result of the flood of over-
landers outfitting for their journey. The city became known as the "Gateway to the
West"—a moniker quite literal, as tens of thousands of travelers passed through.

As the city grew in infrastructure and opportunity, photographers (along with
entrepreneurs of many stripes) streamed into and through it. In fact, due to the
massive influx of travelers embarking on a journey viewed by contemporaries as
both heroic and quintessentially American, St. Louis teemed with photographers.
Some were travelers themselves, who turned to the profession as a way to reap the
benefits of the migration. A few, however, were fixtures, intent on sustaining their
business by accommodating the needs of a growing community.

One example of a regional photographer preoccupied with the St. Louis market
was Thomas Easterly (1809–1882; figure 1). He settled in St. Louis in the mid-1840s,
and although he served transient clients, he produced the majority of his work for
the permanent residents.[2] In the span of his career in St. Louis, which lasted until
at least 1868, Easterly not only created the type of typical "urban booster" imagery
that preoccupied so many photographers in those years; his efforts engaged the
people of St. Louis in a very specific manner, offering them a variety of ways to
contemplate their own community and environment and to see themselves as par-
ticipants in the figurative and literal shaping of their city. His work provides an
illuminating look into an emergent St. Louis and invites a critical understanding
of frontier America and photography's role in the nineteenth-century urban West.

More important, Easterly's work illustrates the importance of landscape photography to an early western settlement.

EASTERLY'S DAGUERREOTYPE SERIES

As in most daguerrean galleries, residents could see in Easterly's shop (at the intersection of Fourth and Olive Streets) portraits of national celebrities and Indian chiefs and views of the city and surrounding landscape. Easterly's image of Keokuk, chief of the Sac and Fox, for instance, was his most well-known image; later it was rephotographed extensively and even became an addition to the official USGS collection in the 1870s. Another reason for residents to visit the local gallery was to track the development of their expanding urban home through images of technology—steamboats and railroad engines, civil engineering projects, and impressive architecture. One of the most intriguing examples in this array was a series of daguerreotypes depicting the so-called Big Mound, a large earthen burial site created by ancient Mississippian cultures (figures 2 and 3). "Indian mounds," as they are still called, were plentiful in the region at the time and were responsible for St. Louis's other nickname, "The Mound City." This latter name was used as early as 1842, when a newsman wrote that "sixteen of these interesting and mysterious remains of antiquity" formerly existed "in the north part of the city."[3] In the 1850s and 1860s, Easterly undertook a project to portray in serial format the destruction of the Big Mound, the largest Native American earthen structure of many that existed within the city limits. Although Easterly probably did not intend the images for outsiders, they did provide opportunities for the self-reflection of an exclusive St. Louis audience. In a broad sense, they represent a significant concern that occupied most nineteenth-century regional photographers of the American West: the activity of physically shaping newly inhabited landscapes and endowing them with new cultural significance. These photographs are rich texts that show not only the physical destruction of a native monument for urban expansion but the implicit notion of cultural advancement through appropriation and eradication of Native American heritage as well. Despite America's great surge of interest in the archaeology of Native American mounds in the 1850s,[4] Easterly's photographs suggest another, more specific subject relating to his St. Louis audience and clientele: the local people in the local landscape. As in pictures of meaningful places all over the developing West, Easterly's portrayals of mounds display an eagerness, by both photographer and his community, to participate in the landscape through photography.

The daguerreotypes that Easterly made over the course of seventeen years were the last visual documents of the mound as it was systematically destroyed. More than simply a narrative of a prolonged but specific event in the history of St. Louis, the images encompass many issues concerning not only the history of ancient America and changes occurring in the region but also a changing city and nation during westward expansion and conflict with native populations, the changing

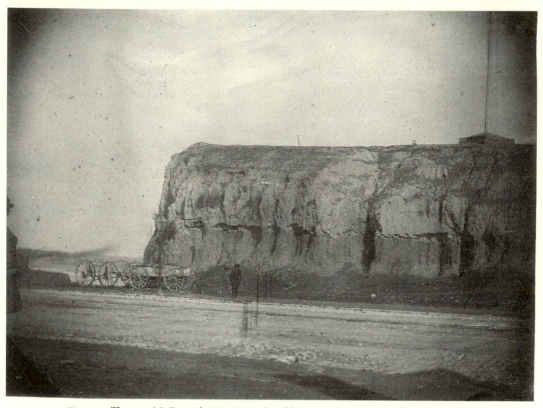

Figure 2. Thomas M. Easterly, *Big Mound, Fifth and Mound Streets*, about 1852. Missouri History Museum, St. Louis.

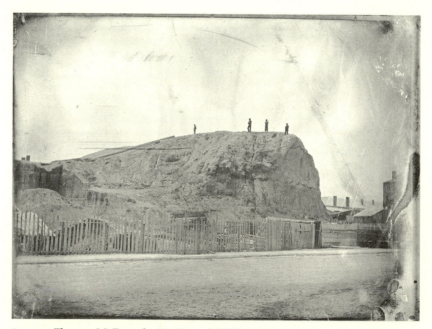

Figure 3. Thomas M. Easterly, *Big Mound, Fifth and Mound Streets*, about 1854. Missouri History Museum, St. Louis.

technology of photography, and the very pragmatic work of a photographer build-ing a business amid all of that change.

Easterly's half plate daguerreotypes, executed between 1852 and 1868, reveal two campaigns of picture making. Ironically, the mound seems to have first come before Easterly's camera through another local event of destruction; in 1850–1851, he was recording the conversion of a local wetland called Chouteau's Pond to a drained tract of land. The conversion was finished in 1854.[5] Chouteau's Pond had been both a pas-toral refuge and a dumping ground in the city's early history. The pond was the long-time property of the powerful Chouteau family, which played a formidable role in early St. Louis, and was named for them. Its swampy nature, however, was recognized by 1850 as a health risk to the growing urban population after a deadly cholera epi-demic in 1849. Once St. Louisans drained and filled the pond with dirt from the Big Mound, it no longer offered the picturesque view that had attracted Easterly and others before, and yet he continued to photograph it, perhaps intrigued by its trans-formation into a new kind of modern landscape. As such, these views comprise an important counterpoint to Easterly's Big Mound Series.

Chouteau's Pond, View South from Clark and Eighth Streets, 1850 (figure 4), for example, starkly contrasts with *Chouteau's Pond After Pond Was Drained* from 1854 (figure 5). In the first, Easterly presented the lake in the foreground with people in boats and a scene of industry in the background, clearly silhouetted against the sky. He framed the view with a clump of trees on the left, a classic compositional device.

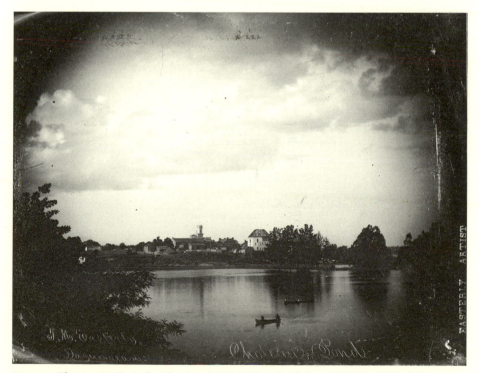

Figure 4. Thomas M. Easterly, *Chouteau's Pond, View South from Eighth and Clark Streets*, 1850. Missouri History Museum, St. Louis.

Figure 5. Thomas M. Easterly, *Chouteau's Pond After Pond Was Drained, H. Chouteau Residence in Background, Herd of Cows in Foreground,* about 1854. Missouri History Museum, St. Louis.

Easterly photographed Chouteau's Pond from above the lake, with a wide view of the area, thereby achieving a commanding, artful scene.[6] His approach to the pond mimicked what was a standard picturesque representation in widely distributed prints of city views. In John Casper Wild's 1840 lithograph (figure 6), for example, the artist depicted visitors rowing, fishing, and sketching in an idyllic environment, with a view of St. Louis in the background.[7] In Easterly's depictions of the pond, however, the peaceful and serene moment of leisure on the lake gives way to a portrayal of wandering cows milling about in a mucky field with the Chouteau mansion and town just beyond. The record of transformation of Chouteau's Pond is typical of Easterly's oeuvre in that it exemplifies his dual appreciation of the idyllic and the march of progress. For instance, the evocative image of the drained pond is artistically composed, even if the point of view is radically different from that of the earlier scene; instead of a commanding view, the viewer is positioned knee deep in the mud.[8] Easterly chose a perspective from within the drained expanse, looking reverentially up toward the city of St. Louis beyond with house, church, and factory apparent against the sky.

To modern eyes, the image is jarring and unattractive compared to the previous landscape. Determining the exact public reception of the images of the transformed site is impossible, however, because of Easterly's own reticence and the dearth of written sources concerning his photographs. Nonetheless, in both

photographs and in the graphic arts, the pond was portrayed as a pleasing location and was afterward recalled with nostalgia: "Those who knew the locality before the shriek of the locomotive or the din of manufactures were heard, agree in praising the natural beauty of the locality."[9] The author of this statement went on to describe Chouteau's Pond in glowing terms by reporting that

> its margin was covered with forest trees, and its grassy slopes were the resort of the surrounding inhabitants in their hours of leisure. Few places could surpass it in loveliness before it was contaminated by the encroachments of civilized man. For many years sportsmen angled in its waters or glided over its smooth surface in their pleasure boats. There are gentlemen still in our midst who belonged to the club that made the place a favorite resort.[10]

This account and others suggest that Easterly not only illustrated local events for the citizens of St. Louis, but he depicted attitudes as well.

Despite an inevitable disconnect between a nineteenth-century viewing experience and a modern one, the daguerreotypes nevertheless reveal a sequence of events. The need to fill the pond initiated the destruction of the mound and prompted recognition of the Big Mound's utility: it was an obvious resource of accessible and expendable soil. The second campaign of removing dirt from the mound was in response to the North Missouri Railroad's requirement for large amounts of dirt for track construction.[11] Beginning in 1868, destruction was rapid and thorough. The chronology of its diminishing stature is revealed in stages, from an 1869 book illustration depicting the mound at its most sizable to the 1869

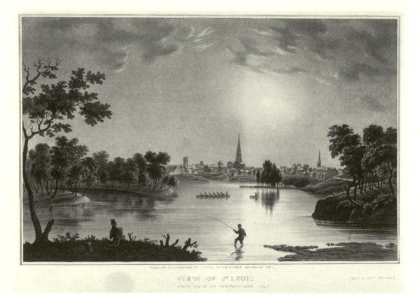

Figure 6. J. C. Wild, *View of St. Louis from South of Chouteau's Lake*, 1840. Missouri History Museum, St. Louis.

Figure 7. Unknown, *The Big Mound at St. Louis,* frontispiece, 1869. Switzler, W. F. *Switzler's Illustrated History of Missouri, from 1541 to 1877.* Edited by C. R. Barns. St. Louis: C. R. Barns, 1879.

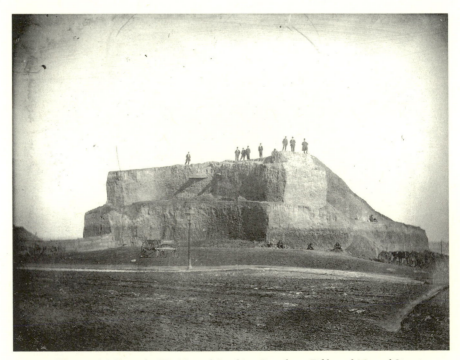

Figure 8. Thomas M. Easterly, *Big Mound, Looking East from Fifth and Mound Streets,* about 1869. Missouri History Museum, St. Louis.

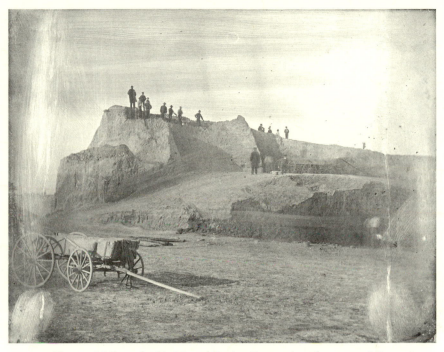

Figure 9. Thomas M. Easterly, *Big Mound During Destruction*, about 1869. Missouri History Museum, St. Louis.

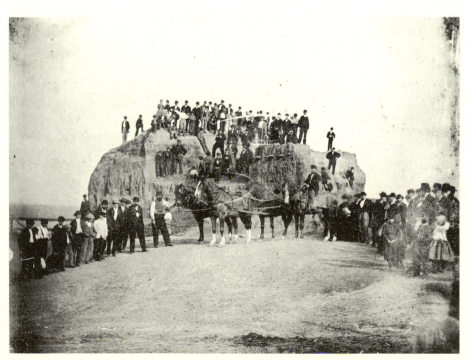

Figure 10. Thomas M. Easterly, *Big Mound Shown Partially Graded*, about 1869. Missouri History Museum, St. Louis.

Figure 11. Thomas M. Easterly, *Big Mound During Destruction*, about 1869. Missouri History Museum, St. Louis.

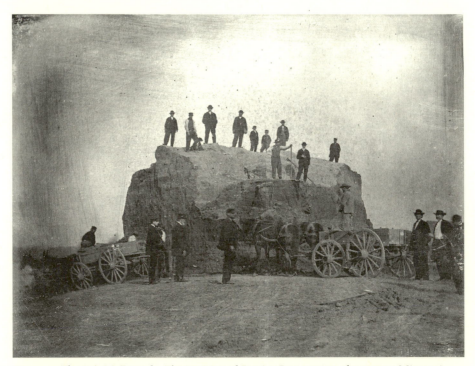

Figure 12. Thomas M. Easterly, *The Big Mound During Destruction*, about 1869. Missouri History Museum, St. Louis.

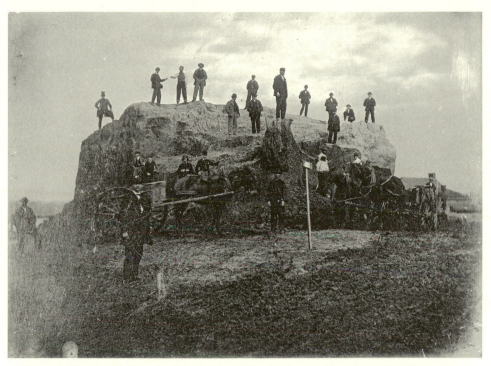

Figure 13. Thomas M. Easterly, *The Big Mound During Destruction*, about 1869. Missouri History Museum, St. Louis.

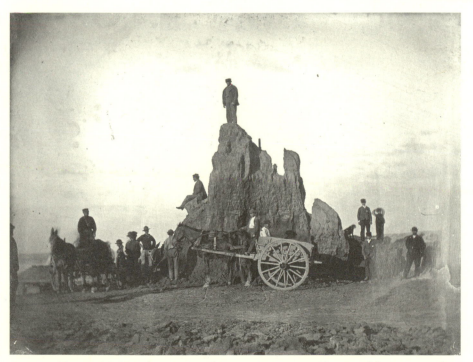

Figure 14. Thomas M. Easterly, *Big Mound During Destruction: The Last of the Big Mound*, about 1869. Missouri History Museum, St. Louis.

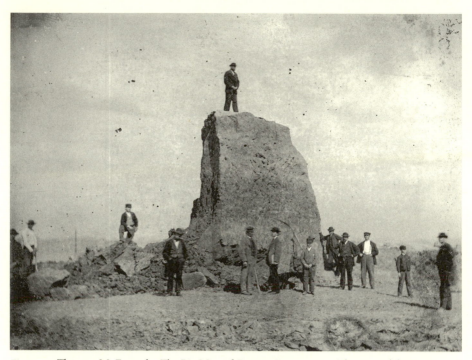

Figure 15. Thomas M. Easterly, *The Big Mound During Destruction: The Last of the Big Mound*, about 1869. Missouri History Museum, St. Louis.

Big Mound, Looking East from 5th and Mound Streets, and other images all titled *Big Mound During Destruction* (figures 7–15).

Although Chouteau's Pond was an ideal subject for a photographer of views, the pictorial appeal of the altered states of the Big Mound was not so simple and did not conform to the compositional conventions utilized in the very few printed views that include the mound in the skyline of St. Louis, such as Wild's *North East View of St. Louis from the Illinois Shore* (figure 16). Also, the mound's designation as landscape seems far afield from "landscape" as defined by the grand tradition in painting. Furthermore, Easterly's daguerreotypes, although they did not approach the elevated concept of the photographic landscapes that occupied other photographers of his era, were fundamentally couched in the traditions of Euro-American visual heritage.[12] Easterly responded to the aesthetic choices that confronted him.

Although subtle, Easterly typically structured his compositions with a strong focal point and emphasis on scale. His clear pictorial representation, although not classically picturesque, appropriately highlighted the subject matter, and his point of view always encapsulated the mound in order to highlight its size and situation. Not the prescribed vista with vague focal points presented in his images of Chouteau's Pond, his views of the mound are more intense images of something specific. Easterly's mound images seem somewhat unusual at first, but they come from the same impulse that drove photographers all over the American West to simultaneously construct and define new settlements and landscapes—culturally

as well as aesthetically. Easterly's photographs of the mounds seem an attempt to understand the past and the future, and not simply as "progress," because the mound represented an aspect of what St. Louis had considered unique about itself. With its monuments of antiquity, the Mound City grappled with the Native American past in a more tangible way than many western settlements did. In fact, the landscape of the Mound City connected the people of St. Louis to a long and complex cultural past. To overlook the cultural and aesthetic landscape characteristics of these photographs would be to deny an important aspect of the way nineteenth-century Americans understood American places.

MISSISSIPPIAN CULTURE AND CAHOKIA

The Big Mound itself was likely the product of the urban expansion of nearby Cahokia, just a short distance to the east, as part of a secondary settlement in the American Bottom region in the mid-eleventh century.[13] Located just off the eastern bank of the Mississippi River, Cahokia was an area rich in ceremonial and burial mounds of many different shapes and sizes. Representing different eras of mound-building cultures from between 800 and 1200 AD, the city was the largest urban center north of the Aztec capital of Tenochtitlan and had a population estimated at sixteen thousand to thirty thousand.[14] The Big Mound, on the west bank of the Mississippi River, was an outlying satellite of this urban center to the east. As a product of Native American labor and as a site for the inhumation of their dead, Cahokia, the Big Mound, and the many other similar structures evoked an

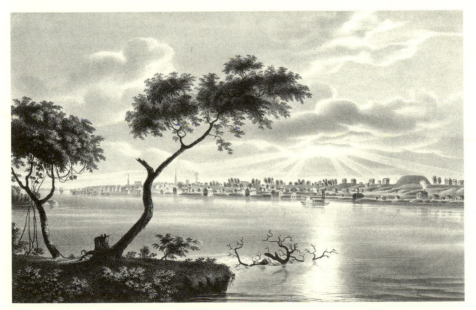

Figure 16. J. C. Wild, *North East View of St. Louis from the Illinois Shore*, about 1840. Missouri History Museum, St. Louis.

unparalleled physical heritage that shaped the topography and skyline of the region in a fundamental way. In fact, the St. Louis landscape with the Big Mound is one of the most profound examples of how the dual influences of environmental forces (such as wind and water) and prolonged cultural forces have shaped the spaces of the American West.

In general, Native American ruins were important for Euro-America's conception of itself as travelers and settlers sought to traverse and explore the North American continent.[15] In the absence of the types of ruins associated with the ancient cultural past of Europe, the ecological and cultural history of the North American continent became primary. Not only were the geology and ecology of North America significant aspects of how Euro-America understood itself, these were also important for how Euro-Americans understood Native Americans. Sorting out the place from the people in the long history of the North American continent was not an easy task, and a paradox seemed to exist at the heart of Euro-America's conception of the "Indian Mound." In his *Notes on the State of Virginia*, for example, Thomas Jefferson declared that he knew "of no such thing existing as an Indian monument," but then he went on to describe his excavation of such a site.[16] Throughout the nineteenth century, as well, Euro-Americans described their encounters with the mounds in and around St. Louis with similarly paradoxical points of view.

In the early nineteenth century, before the combination of modernity and antiquity struck such an intriguing contrast in St. Louis, the mounds drew the interest of all those who encountered them. The formations in the American Bottom region were so plentiful that explorers and settlers alike immediately recognized them as constructions. So numerous and so obvious were the earthen structures that they became *the* notable features of the region, exceeding the interest shown in other aspects of the land.[17] In 1819, the artist and naturalist Titian Ramsey Peale made the earliest official record of the Big Mound as he traveled with the Stephen Long expedition on a survey of the Mississippi region and across the Great Plains to the Rocky Mountains.[18] His measurements indicate that the mound stood 34 feet high, 319 feet long, and 158 feet wide (97.23 × 48.16 meters) as they found it. In his report of the site, he described a lower, tiered section of the mound extending out toward the river, a feature that does indeed link it in form to the Cahokia Mound, where a similar feature was used ceremonially in conjunction with a large woodhenge calendar.[19]

In the excavation that accompanied the Big Mound's destruction, the historian and archaeologist A. J. Conant determined very quickly that the structure was more than just soil; he found an interior room "from eight to twelve feet wide, seventy-five feet long, and from eight to ten feet in height, in which some twenty to thirty burials had taken place" (figure 17).[20] He also discovered that the mound builders constructed the tomb with smooth clay walls that sloped outward from the floor of the chamber, and they capped it with large red cedar beams to withstand the great weight of earth from above.[21] The chamber was not intact, and the tomb and most of its contents, including skeletal remains and a treasury of artifacts, were already destroyed by the time of Conant's discoveries; the cedar beams had slowly rotted over the centuries and moisture from invasive root systems had eventually collapsed it.

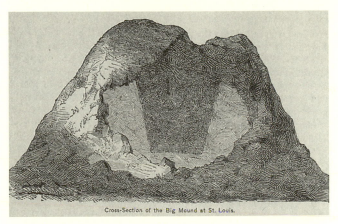

Cross-Section of the Big Mound at St. Louis.

Figure 17. Unknown, *Cross-Section of the Big Mound at St. Louis,*
nd. Switzler, W. F. *Switzler's Illustrated History of Missouri, from
1541 to 1877.* Edited by C. R. Barns. St. Louis: C. R. Barns, 1881.

Along with documenting the extant physical heritage of the Mississippian cul-
ture, Easterly's mound daguerreotypes suggest that Euro-American immigrants
grappled not only with the circumstances of their new region but with the percep-
tion of that place in another tradition. Mounds were landscape forms with immense
cultural meaning for previous Native American cultures along the Mississippi, but
the structures were complex and confusing, according to newspaper accounts, for
nineteenth-century Americans. Archaeologists and St. Louis residents in the nine-
teenth century conceived of the contemporary Native Americans in the region as a
distinctly different group than the original "Mound Builders." The Mississippian
people that had inhabited Cahokia centuries before were part of a sophisticated
culture thought to have been a lost civilization variously described as Greek,
Roman, Phoenician, Welsh, a lost tribe of Israel, or even a vestige of the lost civili-
zation of Atlantis.[22] The explorer Edwin James wrote of his encounters with the
area in 1819:

> The survey of these productions of human industry, these monuments
> without inscription, commemorating the existence of a people once nu-
> merous and powerful, but no longer known or remembered, never fails,
> though often repeated, to produce an impression of sadness. As we stand
> upon these mouldering piles, many of them now nearly obliterated, we
> cannot but compare their aspect of decay with the freshness of the wide
> field of nature, which we see reviving around us; their insignificance, with
> the majestic and imperishable features of the landscape. We feel the insig-
> nificance and the want of permanence in every thing human; we are re-
> minded of what has been so often said of the pyramids of Egypt, and may
> with equal propriety be applied to all other works of men, these monu-
> ments must perish, but the grass that grows between their disjointed frag-
> ments shall be renewed from year to year.[23]

The insistence that Native Americans could not be responsible for mound monuments took on an almost hysterical tone in 1833, when Josiah Priest wrote a book titled *American Antiquities, and Discoveries in the West: Being an Exhibition of the Evidence that an Ancient Population of Partially Civilized Nations, Differing Entirely from Those of the Present Indians, Peopled America, Many Centuries Before Its Discovery by Columbus*, intended to explain that the origin of all North American antiquities were beyond the scope of Native Americans.[24] In St. Louis, the romantic nostalgia that attended the early degradation of the mound relates to the way Euro-American culture bemoaned the "vanishing race" of Native Americans in the nineteenth and early twentieth centuries. Indeed, the almost universally held notion of impending and complete Native extinction was a misconception that produced not only sentimentality but also justification to react to the perceived situation.[25] Even as early as 1820, the archaeologist Caleb Atwater wrote that "the skeletons found in our mounds never belonged to a people like our Indians" in a discussion of the Centerville, Ohio, mound.[26] One local historian believed that there could "be no rational doubt that the Mound-builders were very different in their habits and manners of life from the wild Indians of the present day."[27] Furthermore, even though Conant's archaeological work had revealed multiple contemporary graves at the site, the public was mostly unconcerned with the mound's original function and continuing Native relevance as a burial site, preferring to believe that the ancient mound-building cultures had little to do with the contemporary native population in the region.[28]

The paradoxical beliefs and disbeliefs about the mounds echoed larger sentiments toward Native Americans in the West, especially those that acknowledged their presence while simultaneously denying it. For example, in an essay from *The Home Book of the Picturesque*, one author wrote that "even in those sublime scenes, where no trace of man meets the eye . . . it is the absence of human life which is so highly impressive."[29] Nineteenth-century St. Louisans exhibited the same type of confusion between a desire for an ancient Native history and the compelling notion of a tabula rasa. With blatant ignorance of or disregard for archaeological findings and contemporary scientific scholarship, the public continued to display in local newspapers either ambivalence about the Big Mound or continued support for its destruction. Contradictory notions concerning its origin propagated false and even outlandish information. One of the more ridiculous accounts described a tunnel system connecting the Big Mound with the Cahokia mound.[30] A more commonly held belief in St. Louis was that it was a natural feature of the landscape, despite earlier recognition that it was a man-made structure, the evidence of nearby Cahokia, the tomb chamber Conant found deep within the earthen mass, and the archaeological records that indicated that the mound continued as a site of burial and remembrance for the local Native cultures through the first half of the nineteenth century. Despite such attempts to deny the constructed origin of the mound, the very early maps of St. Louis clearly designate them as "mounds" and "ancient works" (figures 18a and b).

By denying the structure's cultural relevance to nearby tribes, St. Louis

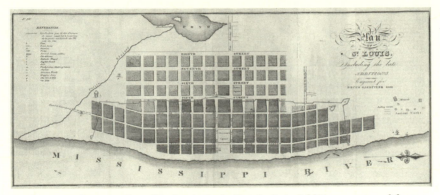

Figure 18a. Unknown, *Plan of St. Louis, Including the Late Additions*, engraved for *Beck's Gazetteer*, 1822. Missouri History Museum, St. Louis.

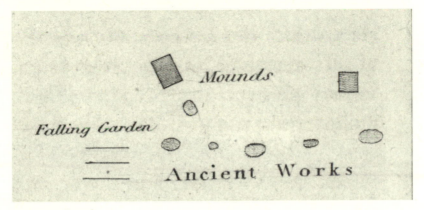

Figure 18b. Detail.

residents could instead fixate on possible contemporary uses for the mound. One man, for instance, suggested using the elevated space for a community park. He indicated that

> the plan was to change the whole mound and its surroundings, which at the time occupied about three or four blocks, into a public garden, with a kind of a pavilion on the elevated ground in the centre, with other locali-ties for public entertainment; to plant it with trees and shrubbery, and surround it by an iron rail-fence.[31]

A restaurant existed at its apex for a time, and there were other schemes as well.[32]

Although the immediate public expressed a remarkable lack of concern for the integrity of the mound, events surrounding its destruction seemed to provide an opportunity for curiosity and exploitation. Concerning Conant's archaeological findings, *The St. Louis Daily Times* reported that "workmen for several weeks have been turning up portions of human bones, Indian coin, beads, and other gewgaws" and that "curiosity hunters flock there daily by the hundreds, armed with all sorts of vessels, hoping to secure and carry off some relic of the past ages."[33] Likewise,

Conant described the pillage of these small bits by local schoolboys: "My work was soon interrupted however by the crowd of eager boys from the neighboring schools, who scrambled for the beads which were thrown out with every handful of earth, with such energy that I was lifted from my feet and borne away."[34] Even though the treasures were small, destruction of the mound drew a crowd of opportunistic souvenir seekers.

Despite the attitudes of the time and the later assertion that Conant and Easterly were "the only ones who followed the destruction of the mound with scientific interest," many expressed sadness and belief in the inevitability of the eventual destruction of mounds in the American Bottom region.[35] Even as early as 1842, concern for the structures was demonstrated:

> The indifference manifested by almost all classes of Americans towards these antiquities of their own country, render it almost certain that in a few years the greater number of them will disappear. Whenever they stand in the way of any "improvement," as it is called, of either tillage or building, they are demolished without scruple, and without regret; and the very expression of a wish that they might be preserved from destruction, is regarded by most persons with a smile at its folly.[36]

Similarly, with a hint of nostalgia, an 1883 history of St. Louis described the lost structure as an important regional landmark.

> The "Big Mound" of St. Louis, once one of the most striking and remarkable features of its landscape, was finally cut down and carted away in 1869, its cubic masses used to make a railroad "fill." Before it disappeared, however, it had come to be recognized . . . as being among the most remarkable archaeological remains in America, and much conjecture and a great deal of controversy have been employed upon it.[37]

Although the wilderness of America was popularly considered as a backdrop to Native American myths and legends, what was buried in mounds such as the one in St. Louis did not strike local settlers quite so powerfully. In the *Panorama of the Monumental Grandeur of the Mississippi Valley* (about 1850), for instance, the painter John J. Egan depicted a similar mound as a cross section that highlights its structured nature (figure 19). Layers are clearly visible, with regularized inhumations and evidence of ceremonial activity in the placement of pottery. This section of the panorama points to the scientific excitement surrounding both the new discipline of archaeology in the American Bottom and the scrutiny and explication of a distant and intriguing people. Egan depicted African Americans digging with pickaxes and shovels as the purveyors of the project stand in the central foreground and an artist sits sketching in the lower left. Easterly's series of photographs is quite different. In fact, compared to this contemporary depiction, Easterly's representational choices show that despite the treasure-hunting activities taking place, he

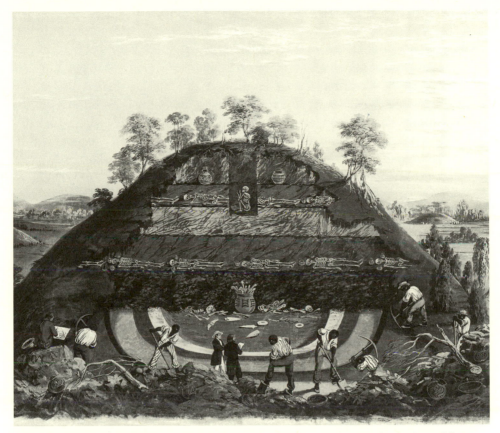

Figure 19. John Egan, *Detail of Scene 20 of the Panorama of the Monumental Grandeur of the Mississippi Valley,* about 1850. St. Louis Art Museum.

took no pains to capture the archaeological process. The idea that Easterly's photographs lack archaeological orientation is also supported by a comparison with the diagrammatic catalogue illustrations that accompanied Conant's report in *Switzler's Illustrated History.* Ironically, Conant was also a visual artist, and ultimately both men display a style that is neither overtly artistic nor purely scientific.

Another strikingly different type of representation is the imaginative frontispiece of William Pidgeon's 1858 *Traditions of De-Coo-Dah and Antiquarian Researches,* which shows a South American Indian mound as the setting for a dramatized battle (figure 20). This "Ancient American Battle-Mound" represents a fictional mound with warriors engaged in warfare on all levels of the multitiered structure. Comparatively, Easterly's daguerreotypes lack the detail and drama of the illustration, but they still evoke a mythic quality as the mound is brought low by the modern era. That quality also suggests that it was an obvious subject for a daguerreotypist interested in capturing local culture. As a permanent resident of St. Louis, Easterly must have been keenly aware that his pictures would have appealed to contemporary public interest in the site, although to outsiders they would have looked odd and carried little meaning.

MOUND DAGUERREOTYPES

Beyond the "beads and gewgaws" that could be found at the site and the activities of local developers, public interest in the Big Mound was surely due to the visual spectacle of the earth-removal efforts and its link to the more impressive feats of railroad technology and urban expansion that signified the growing prosperity of urban St. Louis. In other words, local excitement concerning the mound's destruction was related to how it signaled the growth of contemporary society.[38] In the spirit of the era, Easterly was a type of urban daguerreotypist who responded to civic needs out of economic self-interest.[39] Characteristically, Easterly photographed large and impressive factories and mills; trestles and trains; steamboats lined up along the levee; and, in what are probably the most typically photographed urban views, images taken out of windows and from rooftops throughout the city. His half plate daguerreotype *Fourth Street Looking South from Olive Street*, from 1866 (figure 21), is precisely the type of view that was being made all over America. It reveals details of urban advancement such as local business signs, impressive architecture, streetlight technology, and public transportation.

 In keeping with an interest in technology, the mound photographs show that locals were also intrigued by Easterly's photographic activities at the site. The Big Mound was still a very large and impressive structure in 1868, but the public execution of a photograph was remarkable as well. Despite Conant's work, Easterly focused his camera on the larger event of the mound's demise and not on the specific activity of archaeology and the cultural items it produced. Demolition of the mound most likely appeared significant to the public as subject matter in large part *because* of Easterly's attempts to document it. His images reveal blurred activity, suggesting that not all who were present stopped to pose, but many did, creating a spectacle in the area. People lined up atop the mound and clustered together to be

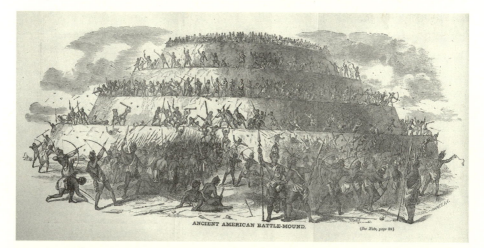

Figure 20. Unknown, *Ancient American Battleground*, nd. Pidgeon, William. *Traditions of De-Coo-Dah and Antiquarian Researches.* New York: H. Thayer, 1852.

Figure 21. Thomas M. Easterly, *Fourth Street Looking South from Olive Street*, about 1866. Missouri History Museum, St. Louis.

included in the pictures: they were workmen, schoolchildren, and other locals who came to investigate. As the mound dwindled, more people came, and men scaled the remaining precipice to perch on the last outcrop of earth.

Many people in St. Louis were aware of the dismantling of the Big Mound, and they could *see* the event in Easterly's daguerreotypes as well as at the site. When people gathered onto the mound for a photograph, he was directly in contact with potential patrons; they learned his name and might have been inspired to visit his studio to see how the views turned out—perhaps to see themselves in the images. The mound images from 1869 were both "views" and group portraits. In each, locals pose as witnesses or participants in the mound's demise. The scene shows a pride of place and the perceived achievement of residents shaping their urban environment and, by extension, their future. Indeed, the mound's destruction linked local pride to the modernity of their city, not explicitly to its indigenous history.

The photographs document more than local history and the rapid growth of various technologies; they record the larger western phenomenon of cultural destruction. The series of mound photographs paradoxically presented the demolition of the Big Mound as a local event of progress as well as a spectacle of devastation for St. Louis. Moreover, the concept of progress through denial and destruction reflected prevailing Euro-American thought about the dynamics of cultural growth during the nineteenth century.[40]

CULTURAL PRESENCE AND ABSENCE

Today, "absence" is a provocative concept in the growing wealth of scholarship concerning nineteenth-century images of Native Americans. The ostensible subject matter in the Big Mound photographs is at first the mound and then a growing void, but more is at stake in these photographs than the apparent subject matter can reveal.[41] In 1983, the Hopi artist and essayist Victor Masayesva wrote that

> photography is a philosophical sketching that makes it possible to define and then to understand our ignorance. Photography reveals to me how it is that life and death can be so indissolubly one; it reveals the falseness of maintaining these opposites as separate. Photography is an affirmation of opposites. The negative contains the positive.[42]

In addition, in her seminal essay "The Occupation of Indigenous Space as Photograph," Iroquois/Tuscarora artist and art historian Jolene Rickard has similarly argued that "the absence, or what is not shown is of equal interest."[43] As negative space became the subject matter in the photographs and the reality in the landscape, the origin of the Big Mound and its place in local history became moot for St. Louis residents. Nevertheless, it continued in the photographs; the Big Mound was literally and symbolically supplanted by Easterly's daguerreotypes as a locus for memory and culture.

The photographs reveal the profound change that was taking place not just in the city of St. Louis but also in the nation in the mid-nineteenth century. The ideological push and pull between the physical heritage of Native cultures and the increasing presence of those of European descent was localized in the very earth of the Big Mound—both groups were concerned with land: who owned it and how it would be used. Ironically, Easterly photographed the ancient structure's demise in service to the very vehicle that facilitated much of the massive Native American displacement of his era. His images acted as a fulcrum between modern urban life and the Native past and perhaps caused Easterly and his audience to ponder issues of cultural identity and the larger implications of building community through destruction.

For the modern viewer, to witness the mound's demise through photography is to recall its creation. In hindsight, these images seem to capture the spirit of Manifest Destiny in a city that was overtly concerned with its future prospects, and they do indeed seem to warn about the fickleness of time and the hubris of expansionism. Today we can understand the images as emblems of memento mori, reminders of the fleeting nature of life—adding a note of caution to accompany the concept of "advancement."[44] Rather than considering the destruction of the mound an epic event of Jacksonian proportions, however, Easterly is more likely to have recognized the occasion's significance as an event of local history.

PIONEER DAGUERREOTYPY

As was typically the case concerning local photographers, the area newspapers kept sporadic track of Easterly's competitions and field activities. By reporting on the success and evolution of local businesses, newspapers offered citizens service information and advertising for entrepreneurs. The *Missouri Republican*, for instance, recorded the comings and goings of gallery operators and reported that during his first visit, Easterly had "very liberal patronage extended to him in his profession during his residence."[45] Information in the newspaper concerning his efforts at the Mechanics Institute exhibition of 1848, as well as his subsequent entries in St. Louis fairs, served as a source of pride for St. Louisans when they could read of his successes.[46]

Along with transportation and local architecture in St. Louis, photography was a quickly transforming technology. Initially, in 1840, the daguerreotype represented one of the most transformative technologies of the modern age. The inventor and photographer Samuel Morse declared in 1839 that "the exquisite minuteness of the delineation cannot be conceived. No painting or engraving ever approached it."[47] Indeed, a daguerreotype has peculiar qualities that later methods could not rival. The technique involved exposing a copper plate coated with silver and light-sensitive chemicals, thereby capturing a scene delicately on the metal's reflective surface. The fragile plate was then housed in glass and typically framed in a small, ornate case for viewing. Because daguerreotypes are made without a negative, the result is a unique image that is a singular representation mirroring the subject. The process ends in a small handheld object that exudes a preciousness not experienced with modern photographs.

Although the daguerrean arts were taken up immediately and enthusiastically in the United States, they were quickly rendered obsolete by new, improved technologies, methods, and products. Typically, photographers working all over the world tried to keep pace with technical advancements—especially with the advent of the collodion or "wet plate" method in the early 1850s, which permitted multiple prints to be made from glass negatives and allowed landscape photography to emerge as a formidable genre. In constant pursuit of improvement, the photographic press highlighted the technique and chemistry of the medium in their publications. The majority of articles in journals such as *The Philadelphia Photographer* and *Anthony's Photographic Bulletin* reported experiments with materials and methods that pushed practitioners ever forward.

Unlike others who embraced new, reproducible methods of photography over the course of the 1850s and 1860s, however, Easterly remained dedicated to daguerreotypy and, by extension, remained reliant on local walk-in trade for patronage. While his contemporaries continually transformed and renewed their techniques, Easterly remained true to the photographic method he came to identify as his art and was renowned locally for his deft handling of the unwieldy and difficult procedure, most notably demonstrated to the public in his daguerreotype of

lightning as it streaked across the sky.[48] In his own defense, Easterly advertised the specifics of his medium:

> In the first place, a perfectly polished surface of pure silver is coated with Iodine and Bromine in the proper proportions, which forms a bromo-iodide of silver, and by the action of light through the Camera and an exposure to hot mercury, as perfect an etching of the object before the instrument is produced, as if done on steel, with acid, though not so intense. In the next place, the picture is subjected to the gilding process, and a coating of pure gold covers the entire surface of the plate, and although Nitric Acid will act on and dissolve silver, it will not act on gold, and a well gilded Daguerreotype is as imperishable as gold itself. The subscriber has often subjected his pictures to the test of Nitric Acid, and knows of what he speaks. Furthermore, he has exposed Daguerreotypes to the weather and hot sun for fifteen years, without their undergoing the slightest change. Try the experiment on a Photograph for as many weeks, and mark the difference. We do not wish to say anything derogatory to the character and nature of the Photograph. It has *its* advantages and we contend only for facts in relation to the perfection and durability of the two pictures.
>
> Be not alarmed then for the safety of a good daguerreotype. It will doubtless out live you, your children, your grand-children, and your great-grand-children.[49]

One writer from the *Philadelphia Photographer* called him "one of the old-style picture-men."[50] "Although not properly a photographer," the article continued, "he has forgot more about pictures than many of them will ever know," and "he will die with the harness on, rather, he will never quit his first love—the Daguerreotype."[51]

Despite this national recognition, Easterly's imagery continued to be locally oriented, as increased competition required him to adapt to changing expectations from an increasingly image-savvy public. Not only was Easterly's obsolete method one reason for his aggressive concentration on a local audience, it may also have been a motivating force behind his production of the Big Mound series. He was trying to promote himself and his business to a local viewing audience for whom his singular images would have resonated. Even though images of "spectacles" were desirable visual commodities at the time, the context of the Big Mound's destruction, more so than his other images, would have been lost in the national market. Certainly, a comparison of his project with the exploits of more typical photographers suggests that daguerreotypes could not compete with the highly marketable and reproducible images that compelled the admiration of the national viewing public.

The only other St. Louis practitioner who seems to have surpassed Easterly in popularity and success was John Fitzgibbon, who worked in St. Louis from 1846 through at least the late 1870s. He also worked in Mississippi and Texas and published the *St. Louis Photographer* in 1877. By all accounts, the production of the two daguerrean galleries was equal in quality in the late 1840s, but as Fitzgibbon

expanded his practice in the subsequent decades in terms of technique and subject matter, Easterly appears to have stagnated.[52] Fitzgibbon was a prolific photographer who traveled widely, wrote numerous articles on technique and artistry, avidly sought new and improved photographic equipment and techniques, and was an accomplished panorama painter. Furthermore, Fitzgibbon's oeuvre did not include imagery of the Big Mound, attesting to the subject's primarily local appeal. Fitzgibbon traveled as far as Guatemala, Panama, and El Salvador; Easterly spent time in the field taking local "views," not only as a way to bolster his gallery with interesting images but also as a way to reach out to his immediate community.[53]

Because the narrative series of the mound's destruction was a uniquely local undertaking, Easterly's daguerreotypes were meaningful to St. Louis residents but less so to outsiders. A sustained relationship between the community and these mound photographs would have offered locals a chance to track their shifting relationship to urban culture and advancing technology, therefore providing an opportunity for them to see themselves in relation to the changing landscape. Easterly recorded the ruins of past eras and the modern ruins of industry, along with the new marvels of an industrialized nation, as gallery novelties for his immediate clientele. He fostered community in St. Louis by showing the events of residents' collective lives, much in the way a family holds its keepsake album dear. Thus, Easterly not only captured local history but also tried to create a local identity by picturing cultural events that engaged the residents of St. Louis and by choosing to depict Euro-Americans' (as well as Native Americans') predilection for shaping their future by shaping their physical environment.

In many regards, Easterly's daguerreotypes of the dwindling mound were part of a last-ditch effort to save his foundering business. He was betting that the local interest in his subject matter, as well as the important position of resident photographers in their communities in general, could save him. But St. Louis was a rapidly transforming city, and like most western communities, it was shaping and reshaping its borders and landscapes through industry and growth. The *Practical Photographer* eulogized Easterly in an 1882 article, noting how "he never would embark in the photographing business, but stuck to Daguerreotyping until the last. In fact, we may say he was starved out of the business, for it left him in poor health and pocket."[54] Easterly's failure to change with the times was his undoing in the modern city.

Although the images of the Big Mound are still useful to the people of St. Louis for a reconstruction of the city's history, their relevance today has transcended their localism. Specifically, the narrative and counternarrative in Easterly's pictures reveals to modern eyes the larger cultural themes of the frontier West, expanding the cultural importance of the images to a greater audience than St. Louis locals. The mound is gone, so the daguerreotypes themselves have become the sites of remembrance, with shifting content and significance—relevant for modern viewers trying to understand the past.

|| 2 ||

Landscape Cartes de Visite

Joel Whitney, Hiawatha, and Minnehaha Falls

From his shoulder Hiawatha
Took the camera of rosewood,
Made of sliding, folding rosewood;
Neatly put it all together.
In its case it lay compactly,
Folded into nearly nothing;
But he opened out the hinges,
Pushed and pulled the joints and hinges,
Till it looked all squares and oblongs,
Like a complicated figure
In the Second Book of Euclid.
This he perched upon a tripod—
Crouched beneath its dusky cover—
Stretched his hand, enforcing silence—
Said "Be motionless, I beg you!"
Mystic, awful was the process.
—LEWIS CARROLL,
Hiawatha's Photographing, 1857

AN EARLY DAGUERREOTYPE OF MINNEHAHA FALLS

ON AUGUST 15, 1852, THE PHOTOGRAPHER JOEL WHITNEY (1822–1886) accompanied Alexander Hesler (1823–1895) on a legendary hike outside the young city of St. Paul. Six years before Minnesota became a state, they hiked into a remote territory near what would eventually become Minneapolis and made daguerreotype views of the landscapes of what was then known as the "Northwest." Hesler was an ambitious photographer from Illinois who traveled widely during his long career (1848–1895), and Whitney was a local photographer from St. Paul. The men reportedly made an

27

astonishing eighty daguerreotypes that day, responding to the prevalent desire in the mid-nineteenth century for landscape views. Traveling from St. Paul, they spent the day taking daguerreotypes of the local scenery, including Hennepin Island, Spirit Island, St. Anthony Falls, and Nicolet Island. They traveled up the Mississippi to a small tributary fed by Lake Minnetonka. A short distance up this waterway, which is now known as Minnehaha Creek, they encountered Minnehaha Falls—a cataract more than fifty feet high. The story of the event was circulated locally until it was inflated and corrupted, and Hesler wrote a letter to Russell Blakeley of St. Paul that was intended to correct the misconceptions. This letter was printed in the local *Pioneer Press* in an article about the photograph's role in the creation of Henry Wadsworth Longfellow's *Song of Hiawatha* (published in 1855). Hesler began the letter by stating that

> in your issue of Oct. 8 in Voices of the Street and of Oct. 16, in reference to An Ancient Artist In which my name is mixed up the Longfellow-Hiawatha-Photographs and my Dear Old Friend & Colaborer Joel E. Whitney. The dates claims etc. etc. are all wrong—and to correct History & set Longfellow & his inspiration to right I will give you the facts from personal knowledge.

He went on to plainly report the details of their adventure, writing that

> arriving there; we prospected for the best view, and selected that from the upper side where the bluff makes a turn south, where, looking west you face the fall, with the gorge in the foreground. The fall in the middle—& the rapid with the country beyond the, distance—here after cutting down two trees we had an unobstructed view and secured 25 or thirty pictures.[1]

An extant daguerreotype shows one approach they took to the scenery (figure 22). The photographers located the falls in the distance, with trees framing the scene in the foreground, augmenting the pleasant view with an oval vignette format.

Despite their team effort that day, the two photographers displayed significantly different approaches to their medium. Hesler's motivation for making the daguerreotypes was expressly to "make the place famous and known over the civilized world," a standard impetus for photographers working in the transnational image trade.[2] He went on to travel widely and made a name for himself throughout the country by photographing such diverse subjects as Abraham Lincoln in 1860 and the effects of the great Chicago fire in 1871. Whitney, on the other hand, was a photographer who spent his career dedicated to the local scene, operating his studio at the corner of Third and Cedar Streets, above Elfelt's dry goods store (figures 23 and 24). In further contrast to Hesler, Whitney's interest in photographing Minnehaha Falls did not end on that August day in 1852 but rather continued to occupy him throughout the 1860s.

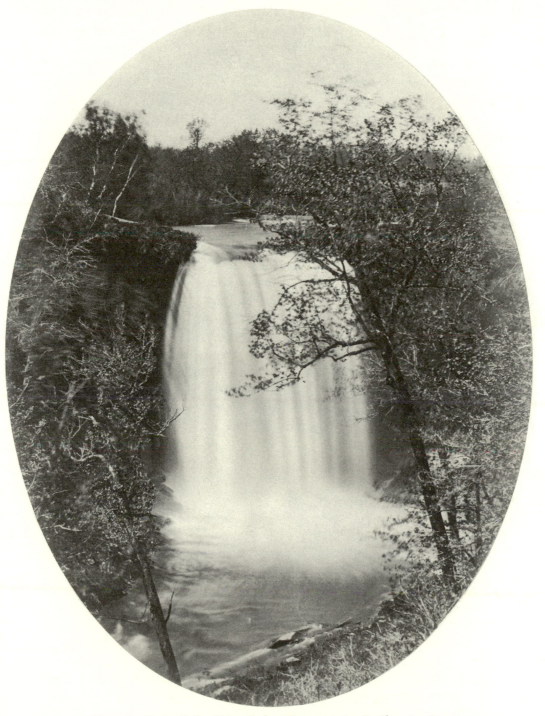

Figure 22. Alexander Hesler, *Falls of Minnehaha, Minnesota*, 1852. Smithsonian American Art Museum. Museum purchase from the Charles Isaacs Collection made possible in part by the Luisita L. and Franz H. Denghausen Endowment.

THE POEM AND THE DAGUERREOTYPE

Although their daguerreotypes of Minnehaha Falls and the surrounding region were and continue to be coveted artifacts, the most famous of Hesler and Whitney's daguerreotypes is the one that made its way into the hands of Henry Wadsworth Longfellow and was reportedly an inspiration for his epic poem *Hiawatha*. In fact, the story of the influence of the Minnehaha Falls daguerreotype on Longfellow's imagination increased in popularity throughout the late nineteenth century. Forty years after Longfellow's 1855 poem, for instance, *Anthony's Photographic Bulletin* reported the story of its relationship to the photograph:

> It has been made the subject of much comment among artists and poets that it was Mr. Hesler who was principally responsible for the inspiration which induced Henry W. Longfellow to write "Hiawatha." The incident became known at a dinner . . . attended by old-time photographers at which anecdotes were discussed, as well as choice morsels and cigars.
>
> It seems that Mr. Hesler, armed with his picture-taking paraphernalia, wandered into the northwest in search of Nature's beautiful retreats. This was in 1851, and in August of that year, he tramped over the present site of Minneapolis. There was no sign of a city at that time. Coming upon the falls of Minnehaha, he took several views of the "natural poem." While arranging his pictures, he was accosted by a man who said his name was George Sumner. The latter purchased two pictures of Minnehaha to take to his home in the East, remarking that he would retain one and give the other to his brother Charles.

Figure 23. Joel Emmons Whitney, *Self-Portrait*, about 1875. Minnesota Historical Society Library and Archives, Minnesota History Center.

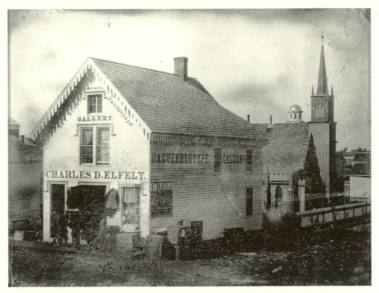

Figure 24. Joel Emmons Whitney, *Charles D. Elfelt's Store and Whitney's Gallery, Third and Cedar, St. Paul,* 1852. Minnesota Historical Society Library and Archives, Minnesota History Center.

The incident had nearly been forgotten by Mr. Hesler when it was revived in a startling manner. He received an elegantly bound volume of a work by Longfellow, and the principal poem was "Hiawatha." On the fly-leaf was the poet's signature and the legend, "with the authors' compliments." Hesler was puzzled to account for the poet's solicitude, and almost a year after the receipt of the book he met George Sumner, who explained that mystery.

It seems that the daguerreotype had got into Longfellow's possession and taking it with him into the woods, he got his inspiration, as he said, from the pretty view, and wrote "Hiawatha." Mr. Sumner said that it was a good thing for the poet that it was the counterfeit of Minnehaha Falls, not the real article, that the poet gazed upon for his inspiration, otherwise there would have been no "Hiawatha" written.[3]

Neither the first nor the last telling of the photographic origins of Longfellow's poem, the story was clearly interesting to photographers. The last part of this account explains why. The author proposed that the daguerreotype of Minnehaha Falls was powerful enough to trump Longfellow's experience of the actual woods where he chose to study the image—it was the photographically mediated experience of the place, not the actual place, that led to such creative and influential poetry.

The Poet Longfellow, in a letter to the Secretary of the Historical Society, writes concerning Whitney's stereoscopic views of Minnehaha as follows:

"I am very much obliged to you for your kindness, and beg you to make my acknowledgments and compliments to Mr. Whitney, the artist.

"To be sure, I have only imaginary associations with the place, never having seen it except in day-dreams. But the views have none the less value on that account, and as I look at them, I begin to think that I have been there, or am there, while I look."

The above settles the question so often asked, "Has Longfellow ever visited Minnehaha?" He has not; but by the aid of his vivid imagination and poetic fancy, he has conveyed to the world a correct picture of tone of the most romantic and beautiful spots in the Northwest.[4]

Thus Longfellow confirmed his secondhand knowledge of Minnehaha Falls and the powerful role of the photograph as an aid to his imaginative verse.

Longfellow's ambition to produce poetry that was overtly "American" in character sustained his interest throughout his long career. The poem can be placed within the context of the era's romantic movement. More specifically, Longfellow's entertaining work both adhered to and departed from traditional poetic style of the time. For example, critics immediately recognized the novelty of the poem. "It will probably disappoint those readers who fail to perceive, not merely its melody, but the adaptation of the melody to the purpose it serves," wrote one columnist.[5] *Hiawatha* also gained immediate renown because it was different from proscribed poetic formulas and appeared to draw on the deep cultural past of the Anishinaabe and the Dakotah peoples. However, the real Hiawatha was the founder of the Iroquois confederacy, and Longfellow's character is more a fictive reference to Manabozho of the Anishinaabe.[6] Combined with a new language style that captured what Euro-Americans thought of as the direct and rhythmic language of a native character, the poem was understood to cut more directly to the heart of that which characteristically defined America and Americans, despite the similarities that the poem shares with the Finnish epic *The Kalevala*.[7] Longfellow's poem received mixed critical reviews, but its popular appeal was substantial throughout the rest of the nineteenth century. Minnehaha Falls, as well, became significantly more renowned with the rise of *The Song of Hiawatha*, and the strong connection between the falls and the poem ensured the region's attractiveness as a tourist destination. By 1883, Mark Twain had visited and commented that "the beautiful falls of Minnehaha are sufficiently celebrated—they do not need a lift from me, in that direction."[8] Such a terse remark from Twain surely attests to the extent of the location's fame.

REGIONAL ATTRACTIONS

The great interest in the Minnesota Territory, exemplified by Hesler and Whitney's early efforts as well its use as the setting for *Hiawatha*, coincided with a similar

growth of interest in the "Father of Waters" itself, not only in terms of entertainment but also for the purposes of exploration and industry. The Mississippi River was, and remains, the principal waterway of not only Minnesota but also North America more generally, and it was the subject of many extremely popular nineteenth-century panoramas, paintings, and broadly disseminated prints that circulated in the eastern states. As *Merry's Museum and Parley's Magazine* reported, Minnehaha Falls commanded popular attention as a side trip from the Mississippi.

> It is becoming fashionable, also, remote as it is; and it will, ere long, be as necessary to the routine of the gay season to dip paddle in its stream, and listen to its laugh, as it now is "to stand in awe" at the roar of Niagara. Put that down in your memorandum book—"Must visit the Falls of Minnehaha next year."[9]

The falls grew in popularity along with the upper Mississippi region throughout the 1850s.

Even before Hesler and Whitney's early photographic interest in Minnehaha Falls, many had regarded the cataract as a natural feature worth visiting. Early acknowledgment of the falls was probably due to the relative proximity of Fort Snelling, located just a couple of miles to the south. One of the earliest published descriptions of the falls was in 1824, by William Keating, a geologist and historian, who wrote:

> The country about the fort contains several waterfalls, which are represented as worthy of being seen. One of them, which is but two miles and a half from the garrison, and on the road to St. Anthony's, is very interesting. It is known by the name of Brown's Falls, and is remarkable for the soft beauties which it presents. Essentially different from St. Anthony's, it appears as if all its native wildness had been removed by the hand of art.[10]

Between 1824 and 1852, when Hesler and Whitney made their first daguerreotypes, the popularity of the site grew enormously. By the mid-1850s, the site had been noted in popular publications, including *Harper's Monthly*, the *National Magazine*, *Merry's Museum and Parley's Magazine*, and others, adding to its popularity as a picturesque locale. According to E. S. Seymour, it was a "very pretty cascade."[11] He described "a small stream, about five yards wide . . . [that] precipitates itself from the verge of a precipice, of about fifty feet in height, into a basin below, forming a curved sheet of water, which presents features, not of grandeur, but of great beauty. The rays of the sun reflected by the spray," he continued, "produced a beautiful rainbow."[12]

Although Longfellow's literary interests, in tune with the 1850s' awareness of America's ecological and cultural history, enabled him to imagine a tale grounded in a specific place, it should not be surprising that Longfellow chose the Northwest as the site of his poem. Considered the "frontier" in the 1840s and 1850s, the

Minnesota Territory was a relatively new region to Euro-Americans, and it inspired ethnographic and historical investigations—most notably in the work of ethnologists Henry Schoolcraft and Mary Eastman.[13] In fact, the geography and its native peoples were the subject of many studies, guidebooks, and images that sought to explore and reveal the region.[14]

Literary and popular accounts of travel in the upper Mississippi region peppered eastern magazines and newspapers in the 1850s. Typically titled "Up the Mississippi" or "The Upper Mississippi," the stories of adventure and travel were clearly compelling to American audiences. In 1856, for example, the tone of romantic adventure was evident in an article written for the *National Magazine*, which, like so many others, chronicled a trip that started at St. Louis and continued north. "We were *en route* for 'the great West,' with an indefinite idea of extent, and of danger, of Indians, wild buffaloes, and prairies. But there must be a first time to an Eastern man going West."[15] The 1850s also saw the publication of D. D. Owen's geological report of the Minnesota region and E. S. Seymour's *Sketches of Minnesota*.[16] These authors offered accounts of the fledgling cities of St. Paul, Minneapolis, and St. Anthony, where "a day may be spent in looking about, in examining the large hotel, now in process of erection, the site of the state university that is to be located here, the islands, the stores, and the churches."[17] In Minneapolis, "just opposite . . . is a water power equal to that of Lowell and already in the hands of an enterprising company."[18] In St. Paul, "The gilt letters of the steamboat agencies catch the eye of the traveler, and the boats are going and coming almost every hour."[19] The city was clearly up and coming.

By the 1860s and 1870s, these small cities in Minnesota were growing dramatically. "What a change has a period of about one generation effected in this great northwestern section of the Union!" wrote the Reverend Holbrook in retrospect.[20]

> I am now in the midst of a city of upwards of 150,000 inhabitants, with another "twin city" of about equal size only ten miles distant (St. Paul). Here I stood about forty years ago, and, looking around, saw not a single dwelling, but only, south, west, and north, unbroken prairie, and to the east the great timber region of Northern Wisconsin. Iowa was a newly constituted Territory just separated from Wisconsin; Minnesota had no existence, nor was there then a single State or Territory organized north or west of Iowa to the British Possessions and the Pacific Ocean. . . . There was not then a railroad west of Chicago.[21]

Holbrook's marveling at the local growth that St. Paul had experienced was matched only by his amazement at the growth of the region.

> As I then stood by the falls [in the 1850s] and thought of the vast extent of country north and west, I questioned whether it would begin to be occupied during the next hundred years; and, lo! In little more than a quarter of that time the whole immense region to Hudson's Bay and the Pacific

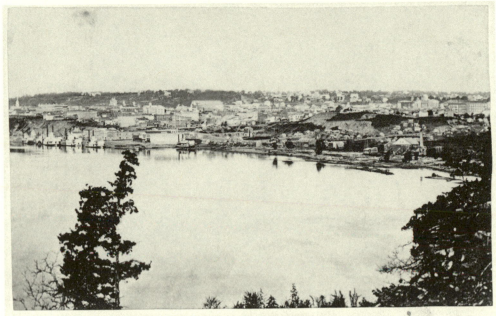

City of Saint Paul, Minnesota.

Figure 25. Whitney's Gallery, *City of St. Paul, Minnesota*, about 1862. Minnesota Historical Society Library and Archives, Minnesota History Center.

Ocean, including Manitoba, has been organized into States and Territories, thousands of farms are under cultivation in it, hundreds of towns and even scores of cities have sprung into existence, two great railroads span the continent, besides innumerable minor ones which radiate in every direction.[22]

Industrial and commercial growth in the second half of the nineteenth century was staggering, and along with the surge in local population came a need for photographic services.

COLLODION AND CARTES DE VISITE

As in all developing cities of the American West, St. Paul received an influx of photographers during the last half of the nineteenth century, and residents revealed an intense interest in photography of the local scene.[23] John Monell, for example, ran a successful daguerreotypy business in the 1850s, as did his competitor, Talmadge Elwell. Later, as the photographic industry grew, more and more businesses were opened by proprietors such as Joel Whitney, Charles Zimmerman, Benjamin Upton, and Elonzo Beal.[24] Along with portrait photography, these men provided local clients with views that included city development and views of the Mississippi region.

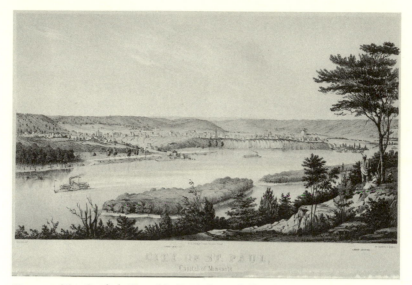

Figure 26. Max Strobel, *City of St. Paul, Capital of Minesota* [*sic*], 1853.
Published by Thompson Ritchie, Philadelphia: Duval & Co., 1853. Minnesota
Historical Society Library and Archives, Minnesota History Center.

In a photograph from the 1860s, Whitney framed St. Paul from across the river,
using a bird's-eye view that was standard for such cityscapes in that era (figure 25).
His representational approach mimicked the contemporary engraved or litho-
graphed landscape and city-view prints used to disseminate information about cit-
ies in an engaging manner and to depict them in a positive light.[25] The 1853
lithograph *City of St. Paul, Capital of Minesota* [*sic*], for instance, shows the small,
budding city in the same "booster mode" of representation, with a vantage point
from across the river that includes a family of Native Americans looking on from
the undeveloped side (figure 26).[26] Based on a drawing by artist Max Strobel, the
lithograph, like Whitney's photograph, presents all the elements of a growing and
prosperous city. Architecture is clearly visible, and the Mississippi bustles with
riverboat activity. The most obvious difference between the lithograph and the pho-
tograph, besides the inclusion or exclusion of Native Americans, is size—the litho-
graph is nearly 13 × 20 inches and the photograph is just over 2 × 3 inches. Because
of the photograph's small scale and the gray tones of the medium, however,
Whitney's image does not represent as effectively the idealistic quality that is the
lithograph's strength. On the other hand, Whitney's photograph was accessible and
collectable in a way that the larger print was not. Despite the print's popular aes-
thetic appeal and its relative inexpensiveness, prints could not be collected as pro-
fusely as photographs.

In an effort to capitalize on the collectability of the photographs, Joel Whitney
(the first photographer to do so) made the falls a recurring subject, producing and
distributing countless views of the site to the public in and around Minneapolis
and St. Paul. His approach to photography and the photographic technology of the
1860s and 1870s was significantly different from the earlier methods that Easterly

had used and that Whitney and Hesler used in the 1840s and early 1850s. Although in their first efforts to depict the falls they produced many similar, but ultimately unique, daguerreotypes, Whitney eventually made use of the wet plate collodion process that enabled the production of reproducible photographic glass negatives. Specifically, he focused his efforts on the fashionable cartes de visite that were cheaper than daguerreotypes, small enough to store easily, and durable enough for extensive handling. All of these attributes made photographs especially popular with the local population, year after year.[27]

Cartes de visite originated in France in 1854. These "calling cards" quickly spread to London and New York, revolutionizing the photography industry. The carte de visite form did not represent new photographic technology—its clear impact was in its commercial application. The card format was simply an offshoot of the stereograph. In fact, double-lens stereo cameras were originally used for cartes de visite, but instead of viewing them in tandem, the binocular view was cut apart and sold as two items instead of one. Soon, multiple-lens cameras were employed to produce as many images per sitting as possible. As reported in *The Farmer and Gardener*, by 1861 Whitney had the capability "to take from *one to sixty four pictures* on a single plate, but designed more particularly for the *cartes de visite*, which are now so fashionable and popular, and in which, as in everything else, he excels."[28] In that same year, cards were so popular in New York City that

in several of the leading galleries it makes the chief business, and in one so great is the demand that the actual work is at least a week behind the orders; the patrons make their applications and appointments a week in advance. Each photograph is multiplied by the dozen, so that it appears that photographs may soon become as common as newspapers, and we trust as useful.[29]

As a marketing ploy, the cards were ingenious. First, they spawned the desire for extensive reproduction—cards were literally passed out freely (especially with the upper-class set), as with today's business card. Beyond distributing and receiving cards in an extensive social network, people bought and sold the cartes de visite of celebrities in huge numbers. Beaumont Newhall reported that at the height of "cardomania," "1000 prints a day were sold of Major Robert Anderson, the popular hero of Fort Sumter," soon after the battle.[30] Second, with the carte de visite revolution came the need to store the flood of images that were gathering in parlors across the nation: thus the photo album was born. Family photo albums began as books with empty pockets for collection and display of these standardized photographs. Not only filled with portraits of family members, these albums housed photographs of friends, business associates, celebrity actors and actresses, politicians, and royalty.

Cartes de visite were known almost exclusively as a format for portraits, so Whitney's cards of Minnehaha Falls were unusual. Even though, as Minnesota historian Bonnie Wilson has pointed out, "less than one percent of cdv's that survive in contemporary collections are views" and "the rest were standard studio

shots commissioned by local citizens who could now afford, at $2.00 a dozen, to have their portraits made," the cards of the falls are significant in that they reflect a subject that, like those of other local photographers all over the American West, Whitney thought he could sell widely.[31] Despite the uncommon subject matter, like all cartes de visite, his images were collectable, tradable, and because of their inexpensiveness—ubiquitous.

MINNEHAHA FALLS AND COMMUNITY PHOTOGRAPHY

Even though Minnehaha Falls' nationally celebrated status likely augmented local interest in Whitney's images, the popularity of his photographs reflects the interests of local residents keen to define and understand the region. On the one hand, the association between Minnehaha Falls and *Hiawatha* (and perhaps even his contribution to their connection) added interest to Whitney's photographs, emphasizing that the site was symbolic of the region's status in the nation. Simultaneously, Whitney's photographic commitment to Minnehaha Falls over the course of the 1860s continually reflected and encouraged a developing sense of local history and repeatedly called attention to the significant aesthetic value of the site.

Despite the obvious desire of Whitney and other commercial photographers to sell their products as widely as possible, his photographs, unlike Hesler's, courted mostly a local audience. Whitney was not an itinerant like Hesler but photographed within the region only as far away as the Wisconsin Dells. More to the point, he was a local businessman. He concentrated his advertisements in local papers, purveying local landscape views that outsiders would not necessarily have recognized (figure 27). An advertising backmark (the verso side of the cartes de visite cardboard mount), for example, lists *Fountain Cave*, *Vermilion Falls*, *Fawns Leap*, and *Pulpit Rock*—places without the national appeal of more famous sites such as Minnehaha or Fort Snelling (figure 28). Regional residents, however, would have known of such places sometimes only because of the circulating photographs.

Besides targeting a local audience in a way that Hesler did not, Whitney created images that are visually dissimilar from his colleague's. In the twenty or so years of the two men's overlapping careers between 1850 and 1870, the falls themselves changed little, but in that time much changed in the Twin Cities region, as it developed from a sparsely populated area of ten thousand to more than four hundred thousand, and Minnesota went from a territory to a state. Accordingly, Hesler's and Whitney's views represented different experiences at the falls. No longer the rugged "wilderness" that so captured Longfellow's imagination, the site became a community space where tourists and residents could spend an afternoon taking in the view. For example, in one Whitney photograph from the 1860s, visitors stand before the falls on a footbridge that spans Minnehaha Creek (figure 29). Construction of the bridge allowed visitors views of the falls from various angles and was part of an effort to make the location more accessible.[32] In

WHITNEY'S GALLERY
OF
DAGUERREOTYPES,
Cor. Third and Cedar sts., St. Paul.

THIS Gallery was built expressly for Daguerreotyping, and is furnished with the VERY BEST of Apparatus. The light is arranged upon the most approved scientific principles. The proprietor uses his best endeavors to please those who favor him with their patronage. All are respectfully invited to call and examine specimens. 49

Pocket Editions of Nature.

DAGUERREOTYPE Views of "Minne-tonka" or St. Anthony Falls, "Minne-ha-ha," or Little Falls, Fort Snelling, and other beautiful Minnesota scenery, for sale at Whitney's Gallery, corner of Third and Cedar streets, saint Paul.

These views have been procured with great labor and expense, and for beauty and perfection of execution cannot be surpassed. All are respectfully invited to call and examine specimens.
August 21, 1852. 49

Figure 27. Whitney's Gallery advertisement, 1853. *St. Paul Weekly Minnesotan,* August 27, 1853. Minnesota Historical Society Library and Archives, Minnesota History Center.

GO TO
WHITNEY'S GALLERY,
AND
ART DEPOT,
174 Third Street, St. Paul, Minn.

FOR THE BEST VIEWS OF

Minne-ha-ha.
Saint Anthony Falls.
Fort Snelling.
Fountain Cave.
City of Saint Paul.
Minne-inne-o-pa.
Vermilion Falls.
The Dalles of the Saint Croix.
Silver Cascade.
Diamond Cascade.
Fawns Leap.
Bridal Veil.
Castle Rock.
Pulpit Rock.
Maiden Rock.
Mississippi Steamboats.
Indians.
Indian Scenes.
And hundreds of other Views of the most interesting Scenery in Minnesota. Being the only Publishing House in the City, purchasers can rely upon always finding

THE BEST,
AT WHITNEY'S,
174 Third Street, St. Paul, Minn.

Figure 28. Whitney's Gallery, *Dalles of the St. Croix* backplate, about 1870. Minnesota Historical Society Library and Archives, Minnesota History Center.

another photograph, visitors pose with the falls as a backdrop (figure 30). Hesler's image had depicted a relatively unknown landscape of the Northwest, but Whitney's images emphasized the falls' location within a local culture. By incorporating visitors positioned on bridges or paths and perched on rocks, Whitney's photographs affirm that the wild aspect of the site that had been so thrilling to the previous generation was being transformed into a highlight of its developing community. In his photographs, women stroll with parasols and couples contemplate the falls from a point of view recommended as the best by multitudes of viewers that had visited before them.

More than just a documentary record, Whitney's photographs helped shape the experience of Minnehaha Falls for others. They provided an edifying escape from the hustle and bustle of the growing city by giving residents an opportunity to ponder the physical spaces of America but also, and perhaps more important to the citizens of the Twin Cities, to consider the tautological relationship between the photograph, the poem, and the place. Whitney made sure to identify explicitly his views of Minnehaha falls with Longfellow's *Hiawatha* by having brief quotations from the poem printed as captions along with such titles as "MINNE-HA-HA" or "MINNE-HA-HA—(Laughing Water.)" Unlike Longfellow, whose relationship to the actual waterfall was abstract, local viewers relied on a direct connection between their photographs and the places they had experienced—an association heightened by the romantic qualities of the epic poem. The photographs provided locals with a figurative ownership and tangible means of identifying with their community and allowed residents the opportunity to contemplate sites in their immediate landscape that held a larger cultural meaning. Whitney, as well, was instrumental in constructing the way locals responded to their region in the 1860s by recognizing the appeal the poem had for residents. Specifically, the poem's long-term effect was to enhance tourists' experience of the falls and to serve as a defining factor in the way locals conceived of the place.

Whitney, like settler photographers across the American West, was a valued member of his community and was considered a notable local artist, documenter, and local historian. By 1861, *The Minnesota Farmer and Gardener* declared of Whitney's picture gallery, "Saint Paul has at least one venerable institution—something that reminds old settlers of other times and 'Days o' auld lang syne.'"[33] Local photographers were often regarded in this way, as embodiments of communities' pioneering spirit, not only because they captured the early history in photographs but also because they evoked its ethos in their work. Whitney recognized this and capitalized on it, advertising his studio as a "pioneer gallery" and thus calling attention to his contribution to the development of the area (figure 31). He also emphasized his identity as an artist, referring to his studio sometimes as "Whitney's Art Depot." Accordingly, the local press referred to him as "our veteran Saint Paul artist" and to his photography as "art."[34] These statements invoking the terms "art" and "artist" were numerous in the popular press and on many of Whitney's carte de visite backplates. The *St. Paul Pioneer Press* reported, for example, that in Whitney's gallery,

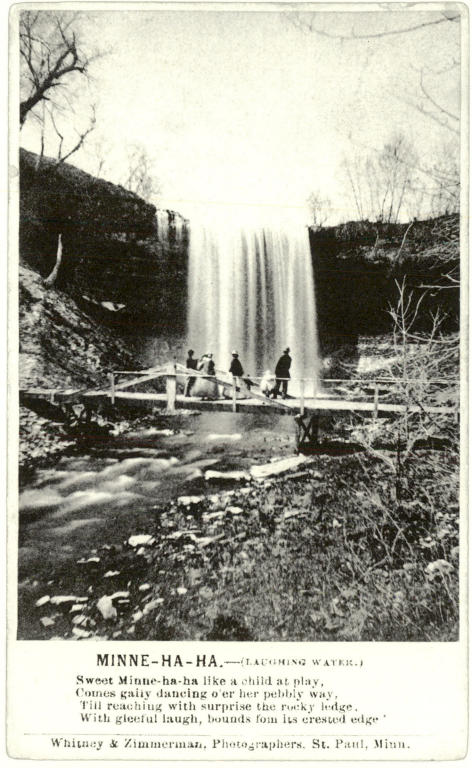

MINNE-HA-HA.—(LAUGHING WATER.)

Sweet Minne-ha-ha like a child at play,
Comes gaily dancing o'er her pebbly way,
Till reaching with surprise the rocky ledge,
With gleeful laugh, bounds fom its crested edge

Whitney & Zimmerman, Photographers, St. Paul, Minn.

Figure 29. Whitney and Zimmerman, *Minne-Ha-Ha.—(Laughing Water.),* about 1865. Minnesota Historical Society Library and Archives, Minnesota History Center.

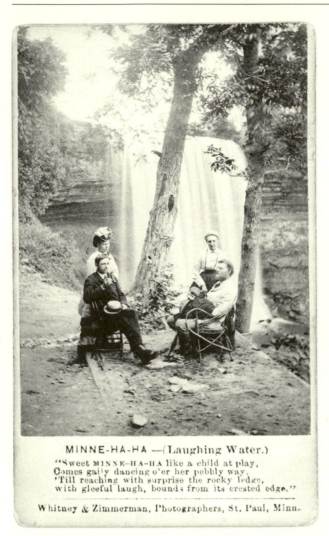

Figure 30. Whitney and Zimmerman, *Minne-Ha-Ha—(Laughing Water.)*, about 1880. Minnesota Historical Society Library and Archives, Minnesota History Center.

The visitor can while away a whole day, almost, examining the really immense lot of paintings, photographs and engravings.

Whitney has on his walls several elegant oil paintings—one or two of them worth $300 each—besides a number of smaller ones. His stock of engravings is also very large, and chromo lithographs equal to an oil painting in effect, [are] found in great variety.

His stereoscopic and card pictures, colored lithographs, &c, are well selected. Statuary and vases for parlor ornaments are also for sale. In short, Whitney can furnish anything in the art line that one wants for their parlor walls, their albums, or portfolio.[35]

The local press also reported with pride Whitney's triumphs at the state fair and other competitions.[36] Whitney was a model citizen who embodied the aspirations of the fledgling community to elevate itself from rough pioneer origins to cultivated society.

Whitney's activities, as well as his products, kept him in the public's eye. When he left the city on a picture-making trip, the newspaper reported it. The *Daily Pioneer and Democrat* reported that on "Tuesday afternoon we accepted the invitation of a friend to visit the farm of B. W. Smith, situated two miles from the city on the St. Anthony road. On arriving at the farm, we found our friend Whitney, of Photograph and Dagerreotype [*sic*] notoriety." Their interest was piqued, and "upon closer inspection," they "found Mr. Whitney had the whole scene transferred to the surface of a piece of glass about eight by ten inches, and was then in the act of getting a stereoscopic view of the same enlivening picture, and we suppose today a Minnesota farm scene will be among the novelties in his photograph gallery."[37] Reports such as these kept the locals apprised of Whitney's activities and served as priceless advertisement as well.

When he encountered something unusual, word got around, and he was admired not only for his role in the Hesler/Longfellow productions but also for his adventurous exploits. One of the more dramatic was in 1869, when his young protégé Charles Zimmerman fell through the ice of Minnehaha Creek.[38] Zimmerman emerged unscathed, but by the 1870s these types of occupational hazards had become, with Whitney as with so many settler photographers across the West, an underlying theme in the photographs themselves (figures 32 and 33). A tale of hardship or accident accompanies most historical accounts of western landscape photographers, whose images become a testament to the adversity they faced as much as to their intention of presenting the West "as it was." Taking and making photographs

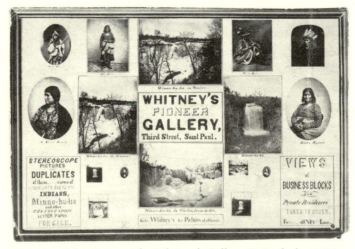

Figure 31. Advertisement for Whitney's Gallery, St. Paul, about 1867. Minnesota Historical Society Library and Archives, Minnesota History Center.

Minne-ha-ha, Laughing Water "Ho! for a revel"
is the Frost Kings cry

Charles A Zimmerman, Photographer St. Paul. Minn

Figure 32. Charles A. Zimmerman, *Minne-ha-ha, Laughing Water,* about 1865. Minnesota Historical Society Library and Archives, Minnesota History Center.

in remote areas with the burden of cumbersome equipment predisposed them to many calamities, so that photographers became local celebrities, early pioneers with a body of work to testify to their travail.

PICTURESQUE REPRESENTATION OF THE FALLS

Besides *Hiawatha,* another aspect of Minnehaha Falls that imbued it with cultural meaning was the aesthetic qualities of the site. Waterfalls had long been icons of natural beauty, based on their picturesque and sublime qualities. "The waterfall may be called the voice of the landscape," wrote Thomas Cole in 1836.[39] By later in the century, waterfalls exemplified an aesthetic in tune with popular taste.[40] In the Twin Cities, as elsewhere, Americans desired picturesque landscapes.

Minne-Ha Ha—Laughing Water

Whitney & Zimmerman, Photographers, St. Paul, Minn.

Figure 33. Whitney and Zimmerman, *Minne-Ha Ha—Laughing Water*, about 1865. Minnesota Historical Society Library and Archives, Minnesota History Center.

Whitney's views were consciously and conspicuously picturesque, even as they highlighted the unique qualities of the site. The picturesque view, marked by rugged textures and irregularity of natural features, including water, trees, and rocks, took root in the mid-seventeenth century landscape paintings of Claude Lorrain and others, embedding it in how western culture perceived nature. Codified in William Gilpin's 1792 *Three Essays: On Picturesque Beauty, on Picturesque Travel, and on Sketching Landscape*, Uvedale Price's 1796 *Essays on the Picturesque: As Compared with the Sublime and the Beautiful; and on the Use of Studying Pictures, for the Purpose of Improving Real Landscape*, and Richard Payne Knight's 1805 *An Analytical Inquiry into the Principles of Taste*, the picturesque, as a desirable aesthetic convention, was enthusiastically adopted by the American landscape school of painting. Closer to home, *The Home Book of the Picturesque, or American Scenery, Art, and Literature*, published in New York in 1851, discussed the unique characteristics of "American Scenery":

The diversified landscapes of our country exert no slight influence in creating our character as individuals, and confirming our destiny as a nation. Oceans, mountains, rivers, cataracts, wild woods, fragrant prairies, and melodious winds, are elements and exemplifications of that general harmony which subsists throughout the universe, and which is most potent over the most valuable minds.[41]

Echoing the sentiment of countless other writers, the author found American landscapes and landscape views important to national and local development.

By the 1850s, the picturesque had become so pervasive that, as one scholar has described it, "it was almost to be breathed in with the air."[42] Public parks and picturesque cemeteries were becoming increasingly popular, picturesque illustrations in magazines and books were ubiquitous, and monumental landscape paintings were reaching the height of their popularity in the United States. Commercial photographers across the country followed the prescribed formula of public taste. Joel Whitney, like many others, created views of the local scene that would appeal to the aesthetic desires of his clientele.

Even though Minnehaha Falls was considerably smaller and less impressive than many nearby cataracts, the site remained significant because of its connection to the cultural and physical past of the Twin Cities. Its celebrated status as a site of cultural importance even outweighed the more impressive industrial might of the nearby Falls of St. Anthony (figure 34). Even though St. Anthony Falls was much bigger and more impressive and seems to have had great importance for the local economy, the focus on Minnehaha reveals the complex construction of local civic identity that is often influenced by outside recognition. The smaller falls seemed

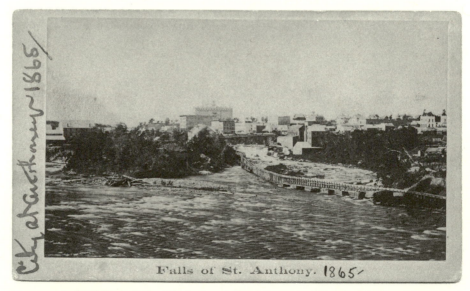

Figure 34. Joel Whitney, *Falls of St. Anthony*, 1865. Minnesota Historical Society Library and Archives, Minnesota History Center.

predestined to become an urban park not only because of its picturesque quality and connection to great American literature but because of its "precious" size and relative uselessness.[43] One visitor commented that

> we visited the celebrated Minnehaha Falls and the Falls of St. Anthony, and saw them in all their original picturesqueness and beauty. This has now all disappeared from the latter, and both banks of the river are lined with flour mills and various manufactories, and the former roar of the great cataract is drowned by the clash of machinery, the rattle of carriages and railroad cars, and the scream of the steam whistle.[44]

Perhaps because St. Anthony Falls was being "drowned by the clash of machinery, the rattle of carriages and the railroad cars, and the scream of the steam whistle," locals felt it necessary to celebrate the "original picturesqueness and beauty" of Minnehaha Falls. Ironically, the site was no less imposed upon than the more industrial St. Anthony's; in different ways, both became caches of created meaning.

A picturesque view of the landscape was attainable in photography by choosing the right scene and by framing it correctly through the viewfinder of the camera. As a device of aesthetic selection, the camera was presciently preceded by the Claude glass—a tinted mirror used by artists and tourists alike to frame and color a scene to reveal its most artful possibilities. Photography has been lauded since its inception as an artistic tool, profoundly able to aid painters in their attempts at visual description. The reverse is true, as well. Successful photographers often had artistic training or were able to educate themselves in rudimentary artistic technique by studying illustrations and paintings.

The picturesque as an aesthetic preference could be found in the actual experience of the landscape—one need only know where (or how) to look. As early as 1856, *Merry's Museum and Parley's Magazine* reported about the region surrounding Fort Snelling that

> the rivers in that section are broken into a multitude of beautiful and picturesque rapids and falls, remarkable for the wild and romantic scenery which surrounds them. Prominent among them all, for its natural beauty, as well as for the classic distinction which poetry has conferred upon it, are the Falls of Minnehaha.[45]

Later in 1872, *Picturesque America* pointedly described the same kind of scene in regard to Minnehaha Falls:

> The chief attraction, of a picturesque nature, in this vicinity, however, is not upon the Mississippi, but on the little Minnehaha River, an outlet of Lake Minnetonka, whose waters are poured into the Minnesota not far from the junction of that river with the Mississippi. The famous falls here are by no means what one would imagine from the poem of Longfellow.

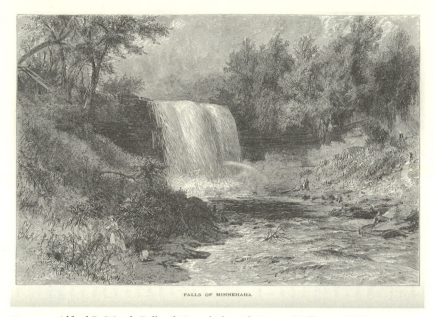

FALLS OF MINNEHAHA.

Figure 35. Alfred R. Waud, *Falls of Minnehaha*, nd. Bryant, William, ed. *Picturesque America,* vol. 2. New York: D. Appleton and Company, 1872–1874.

There is but little water, yet what there is more admirable at its lowest than at its highest volume. For the chief beauty of the fall is in the crossing of the delicate spiral threads of water, producing an effect which reminds one of fine lace. About two hundred feet below there is a bridge, and, as this is only thirty feet long, it will assist the reader in forming a correct idea of the proportions of this somewhat too famous cataract. The gorge is elliptic in form from the centre of the falls to the bridge, and quite narrow everywhere. The depth is about sixty feet. On each side of the top of the falls are numerous birch-trees, and the summits of the gorge crowned with various forest-trees. Below the bridge, the bluffs or banks on each side cease to be precipitous, and come sloping down to the water's edge, with all their trees, the branches of many actually dipping into the brink. The veil of the falling water is so thin that one can see the rock behind it. There is a good path behind, which even ladies can follow, except when the wind blows directly opposite, when the adventurous traveler would get well drenched.[46]

The engraving *Falls of Minnehaha* is in the pages dedicated to the Upper Mississippi and is an illustrative counterpart to the written description (figure 35). The title page in *Picturesque America* (figure 36), as well, shows rivulets of water cascading over a rocky ledge, down through trees and ferns to where an artist sits with palette and easel, and follows on the heels of the illustration of Niagara Falls, which was the first image in the important volumes—testament to the iconic nature of the waterfall as an aesthetically desirable scene (figure 37). The famous

Figure 36. Harry Fenn, *Cascade in Virginia*, nd. Bryant, William, ed. *Picturesque America*, vol. 1. New York: D. Appleton and Company, 1872–1874.

Figure 37. Harry Fenn, *Niagara*, nd. Bryant, William ed. *Picturesque America*. New York: D. Appleton, vol. 1 and Company, 1872–1874.

falls in New York set the tone for the book, guiding readers to consider Niagara Falls as the standard against which other American scenes could be compared and judged.[47]

No exception, Minnehaha Falls was judged by the better-known Niagara Falls. "Those who have visited Niagara, and found a fearful pleasure . . . will find a similar enjoyment, without any sense of danger, in visiting these Falls," wrote one visitor in 1856, perceptively contrasting its picturesqueness with Niagara's sublimity.[48] By 1894, one writer for *Our Own Country: A Weekly Magazine of Fine Art* compared the two cataracts by writing that

> at Niagara the visitor can walk beneath a rush of raging water which inspires him with awe, and, unless his nerves are strong, is apt to fill him with alarm. At Minnehaha, on the other hand, he can walk behind a film of water so transparent that he appears to be gazing on the surrounding scenery through a curtain of the most exquisite lace.[49]

The differences between the picturesque and sublime experiences offered by the two sites was clearly one of Minnehaha Falls' attractions. Despite the difference in scale, the innumerable circulating photographs, prints, and illustrations informed the public of what to expect in representations of such scenes, as well as at the actual waterfalls. Likewise, most Americans in the mid-1800s would have recognized in Whitney's images a common style of representation, which they could file away into a mental library of pleasing water scenes. From a point of view on the bridge, or near a tree higher up on the rocks, Whitney's photographs match myriad written descriptions of Minnehaha Falls and display his talent for framing a picturesque scene. Despite a multitude of variations, the photographs are similar. Whitney's formulaic approach to the landscape ensured that it would be instantly recognized, and slight variations in his position in relationship to the falls and the more extreme seasonal changes kept his views fresh and desirable to a collecting public.

Regardless of their broad and somewhat generic appeal, picturesque landscapes had extra importance for locals trying to adapt to a new life. Views of local scenery connected new "frontier" places to the more domesticated, eastern places from where settlers had emigrated. The conformity to aesthetic standards put the experience of the frontier landscape on a visual continuum with European heritage, representing the new places as extensions of this cultural tradition rather than as dislocated settlements. In the Northwest, Whitney's conformity to the waterfall as a "type" of picturesque scene linking local sights to East Coast and even European precedents was advantageous because the implication was that the natural beauty of the Twin Cities region was a powerful justification for settlement.

Whitney's customers sought views that reflected civic desires and values and that highlighted their position in the nation. For instance, the physical landscape— rocks, trees, arches, and even waterfalls—were not only viewed through the rhetoric of the picturesque aesthetic system but also represented a uniquely American

subject matter to Americans. The nation considered itself a newborn in terms of cultural development but saw in its natural wonders, both East and West, a "green old age." Clarence King coined the term, but although he was specifically referring to the very old sequoia trees he happened upon in the Sierra Nevada, the term is a useful illustration of America's notion of the ancient ecological history of the landscape. He wrote that

> no imperishableness of mountain-peak or of fragment of human work, broken pillar or sand-worn image half lifted over pathetic desert,—none of these link the past and to-day with anything like the power of these monuments of living antiquity, trees that began to grow before the Christian era, and, full of hale vitality and green old age, still bid fair to grow broad and high for centuries to come.[50]

Although other landscapes signaled possibility and the desire for material gain, locals and visitors valued Minnehaha Falls for its continuing reference to the physical past of Minnesota that linked it to the deepest history of America.

MINNEHAHA FALLS AND NATIVE HISTORY

Longfellow's fictionalized tale certainly augmented a relatively young nation's perception of its history. In a sense, *Hiawatha* helped construct a social landscape for the new territory on the northwest fringe of America by linking the legend concretely to the place of Minnehaha Falls.[51] On a local level, however, by conflating the waterfall's geological and hydrological history with that of the area's Anishinaabe and Dakotah cultural past, Twin Cities residents created a legacy that they could consider as formidable as Europe's cultural history. Through photographic representations, as well, the site of Minnehaha Falls has come to represent what residents of that area can identify as a cultural past, rooted in local (albeit fictionalized) Native American legend. Photographs of this place aid in our understanding of the complicated relationship between western and eastern states, past and present, and Euro-American and Native American histories.

Tellingly, Minnehaha's current moniker has less to do with a Native American place name than is generally suspected. The place name that was more or less taken from the Dakotah language was reestablished after earlier attempts to name the falls after Euro-Americans. Besides "Little Falls," the site was also known as "Brown's Falls," named for army general Jacob Brown as early as 1823.[52] Then, in *Hiawatha*, Longfellow wrote, "From the Waterfall he named her, Minnehaha, Laughing Water," but the source was Mary Eastman's 1846 ethnographic study *Dakotah, or Life and Legends of the Sioux around Fort Snelling*, which explains, "Between the fort (Snelling) and these falls (St. Anthony) are the 'Little Falls,' 40 feet in height, on a stream that empties into the Mississippi. The Indians call them Mine-hah-hah, or 'laughing waters.'"[53] However, local Native Americans may never have called the falls

"Minnehaha," and "laughing water" is likely an absurd transliteration. As George Stewart pointed out in his dictionary of American place names, "The whole jumble is a good example of the way in which romantically inaccurate interpretations have confused the situation with Indian names." "Minne" means water, "haha" means a waterfall, and so Minnehaha Falls "is thus tautological, i.e. water-waterfalls-falls."[54] This confusion parallels the larger phenomenon of mistranslating Native American legends and the more complex cultural understanding of place, calling attention to Euro-Americans' frequent practice of co-opting landscape meanings by renaming and misnaming. Similarly, landscape photographs neither captured a Native American landscape in aesthetic terms, nor did Whitney's photographs imply a true or accurate history of the Native relationship with the landscape. Instead, the images are about the relationship between the *new* inhabitants in the area and their developing connection to the land, their own cultural past, and the way they imagined the cultural past of the indigenous occupants.

The awareness of a Native American prehistory in and around Minneapolis and St. Paul was fundamental not only to Longfellow's poem but to early Euro-American conceptions of the region—and, by extension, to Whitney's photographs. As with Longfellow's poem, paintings, prints, and sculpture played a great part in constructing the way Americans responded to the "Northwest."[55] Many paintings and illustrations, for instance, denied human presence at the falls and instead focused on them as an untrammeled, pristine area. Representations of the site are numerous, and the picturesque quality of the falls made them obvious subject matter for landscape painters in the nineteenth century who chose not to focus on a poetic narrative but rather on the subject matter of the American wilderness in representations that capture the smallness and the intimate quality of the quaint location. Another pictorial approach was to depict an Indian at the site. Rather than Native Americans, however, loitering picnickers were more likely to be seen at the falls from the 1860s onward.

Photography was distinguished by its connection to reality and its perceived ability to confirm experience. Consequently, very few Anishinaabe or Dakotah pose before the falls in photographs from the era, even though Whitney did photograph many Native Americans in his studio, taking part in the era's ubiquitous trade in "Indian pictures." Contemporary Native Americans at Minnehaha Falls would not have evoked the same kind of romantic associations as they did in paintings and would even have threatened the perceived safety of the urban park, discouraging Euro-Americans from visiting, especially in the years following the notorious 1862 Dakotah uprising, when tensions between Native Americans and Euro-Americans were particularly high.[56] As was the case with St. Louis and the Big Mound, the distant past, indigenous legends, and romantic ideals of noble savages in the region were quite distinct from contemporary relationships between local tribes and Minnesota residents.

Similar to *Hiawatha*, an epic fictional poem full of conflated history and imaginative depictions of Native American myth, Whitney's photographs conjure a historic narrative that was equally constructed. The views make cultural references,

memorializing an American past that could be glimpsed in the nation's physical environment—in its lakes and waterfalls, trees, and canyons, for example. Instead of simple representations, Whitney's photographs were cultural constructions as complex as the cultural synthesis needed for Longfellow to produce *Hiawatha*.

THE PARK

The photographs of the falls and the poem continued to have a long relationship throughout the nineteenth and early twentieth century. It is only in recent times, when *Hiawatha* has fallen from popular imagination, that the falls and the photographs seem discrete sources of cultural meaning. Why did this happen? Minnehaha Falls had gained fame through the literary work of an eastern American cultural authority, but it was the falls themselves, the physical characteristics of the Minnesota Territory, that inspired Longfellow. No matter how extensively the photographs drew on the poem for meaning, their indexical visual qualities were primary, and for the regional population, the photographs would always be linked to the place over the poem, highlighting the falls' popularity as the source of *Hiawatha*, not the result. Even though the poem remains obscured by popular taste, the actual falls continue to embody the poet's legend and, more important, the nineteenth-century cultural connection between picturesque landscapes and western settlement—a connection propagated locally by photography.

Although the area surrounding Minnehaha Falls did not officially become a park until 1889, when the city bought it from private owners, the site was accessible to day-trippers from St. Paul. In 1875, attendance at the site increased with the installation of Minnehaha Depot as a stop on the Milwaukee Road railroad, which served Minneapolis and St. Paul. With as many as thirty-nine train stops per day, the local population had ample opportunity to visit the site.

Besides the replica of Longfellow's Connecticut home built in 1906, a bronze statue of Minnehaha and Hiawatha graces Minnehaha Park today (figure 38). Created by Norwegian immigrant Jakob Fjelde (1859–1896) in 1893 and placed in the park in 1912, the sculpture is a typical figurative response to the site that draws on the imagined past of local natives via Longfellow's imagination rather than an effort to be historically accurate.[57] Near the Fjelde sculpture, which perpetually enacts Longfellow's lines, "Over wide and rushing rivers / In his arms he bore the maiden," a bronze mask of the Dakotah Chief Little Crow also sits in proximity to the falls. Carved from red cedar by Ed Archie Noisecat and cast by the Anurag Art Foundry in 1995, the mask is the only reference to an actual Native American. The connection between Little Crow, famous for his role in the 1862 Minnesota uprising, and the falls remains unclear.[58] Despite the disjunction, the sculpture acts as a balance to the strongly represented fictional history by referencing an actual historic figure at the site.

Modern response to the falls indicates a desire to preserve them as a historically picturesque site. Encouraged by the stewardship concerns at the park, modern

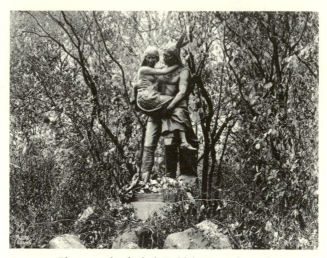

Figure 38. Photograph of Jakob Fjelde's Hiawatha and Minne-haha statue, Minneapolis, 1916. Minnesota Historical Society Library and Archives, Minnesota History Center.

landscape engineers have helped the falls fight the natural processes of erosion and transformation. Such efforts, like Whitney's integration of Longfellow's poem into his photographs, acknowledge a deeply felt need to retain that early invented cultural meaning by preserving the appearance of the place. More so than ever, the complexity of the falls as a cultural landscape has become clear. Through the photographic medium that can "capture" the falls or through modern methods of preservation that maintain them, the value of Minnehaha Falls still lies in what the place can communicate about local heritage. Today, that preserved heritage is not the cultural history of the local natives (either real or imagined) but rather nineteenth-century Euro-American efforts to create a meaningful landscape through photography and poetry.

Wet Plate Collodion
and Western Monuments

Peter Britt and Crater Lake

There is a singular fascination about the Pacific coast. Ever since the human family set forth from the banks of the Euphrates to claim its heritage, the cry has been, "Westward, ho!" But here on the sunset sea the East and West have found each other. Here the East becomes West and the West becomes East. Here the world-tide stops and turns back upon itself.

—W. D. LYMAN, "The Switzerland of the Northwest," 1883

OVERLAND TO OREGON

THE LURE OF THE OREGON TRAIL spurred many Americans to make the arduous overland journey in the late 1840s and early 1850s to where "the world-tide stops." Some of these travelers were itinerant photographers who hoped to profit from the seemingly limitless supply of visual wonders the frontier could provide. By the 1880s, for instance, photographers had traversed the West to such a degree that Yosemite, Yellowstone, the Grand Canyon, and the Mountain of the Holy Cross (to name only a few) were landscapes etched into the minds of easterners through image and written account. Still other photographers, however, intended to settle in the West. Along with immigrants in search of gold or land, photographers traveled the Overland Trails, drawn by the promise of new subject matter and new communities desirous of their services.

One photographer to settle in Oregon was Peter Britt (1818–1905), who had begun an artistic career as a portrait painter in Switzerland and immigrated to the United States in 1845 (figure 39). Pessimistic about his future as a painter in America, he learned the art of daguerreotypy in St. Louis from Thomas Easterly's formidable competitor John Fitzgibbon and moved to Portland in 1852.[1] A short

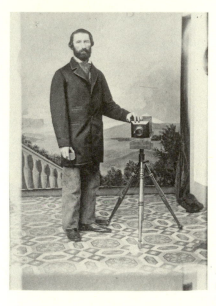

Figure 39. Peter Britt, *Self-Portrait*, nd. Southern Oregon Historical Society, #704.

time later, he settled in the small mining community of Jacksonville in southwestern Oregon. Jacksonville is in the Klamath-Siskiyou mountain region, approximately two hundred miles south of the Columbia River and three hundred miles north of San Francisco, and in the mid-1850s it was home to between 1,500 and 2,000 people (figure 40).[2] Within a year of arriving, Britt had set up a gallery and a small mining operation. Despite the waning of gold fever in the following decades and the fruitlessness of Britt's own mining efforts, the settlement of Jacksonville survived, and Britt rapidly gained status and affluence as a photographer as the community transitioned from a rough camp full of single men to an agriculturally based town full of families. Britt eventually became one of Jacksonville's most esteemed residents, exerting influence through his efforts as a winemaker and horticulturist and because of the pack route that he blazed to the nearby port of Crescent City, California. Photography, however, is his most enduring legacy.

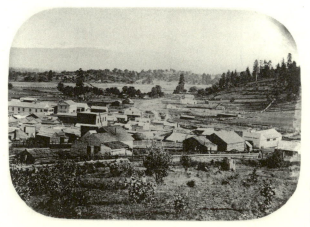

Figure 40. Peter Britt, *Jacksonville*, 1860s. Southern Oregon Historical Society, #738.

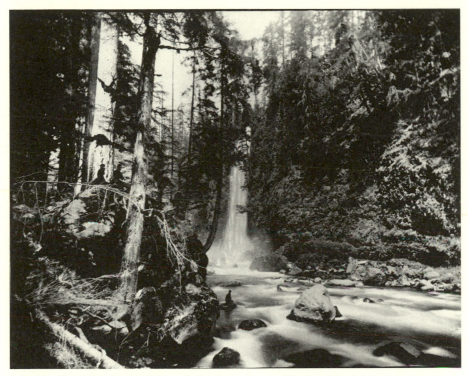

Figure 41. Peter Britt, *Rogue River*, nd. Southern Oregon Historical Society, #742.

Britt produced a large body of work over a period of fifty years and developed a successful commercial operation that focused mainly on portrait photography. He was highly skilled and adaptable and kept up with the latest technological advancements in the field, and like many photographers of his era, he ventured into the landscape to capture "views."[3] While not a true itinerant, Britt spent most summers traveling to various sites along the Rogue River and even as far south as Northern California's Mt. Shasta (figure 41). Much in the same way that Joel Whitney scoured the Twin Cities region for pleasing views, Britt sought out new and interesting regional scenery for his Jacksonville clients.

Although the largest percentage of Britt's work is portraiture, his landscape photographs, especially his images of Crater Lake, are the ones that have endured as representations of Oregon's early history (figure 42). Especially valued today for their influence on the formation and development of Crater Lake National Park in 1902, the photographs, taken almost thirty years earlier in 1874, were the first images of the remote site and were fundamentally important to the early community. Although they are recognized as significant primary documents of the far western territory, these pictures have never received the same kind of scrutiny as other early views of national park landscapes have. Neither has Britt received the attention afforded to other photographers, such as the more well-known Carleton Watkins, for his photographs of Yosemite in the 1860s, or William Henry Jackson, for photographs taken at Yellowstone in the 1870s. Perhaps this is because Britt produced his images primarily for a local clientele.

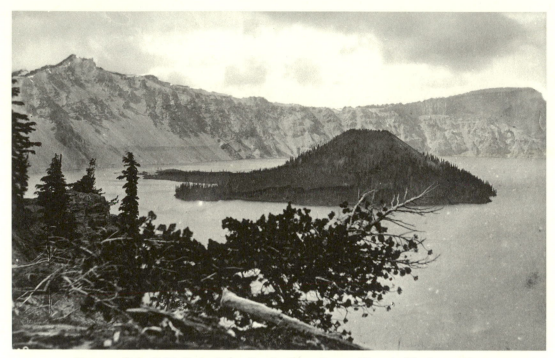

Figure 42. Peter Britt, *Crater Lake*, 1874. Southern Oregon Historical Society, #10891.

Crater Lake, in the Cascade Range, is among the grandest of western attractions, but even today it is far less well known than many others and remains relatively remote. In his 1869 guide, *Where to Emigrate and Why*, Frederick Goddard wrote enthusiastically about the state of Oregon but admitted, "Until late years, owing to its remoteness from the great channels of intercourse, the popular impression of Oregon has been that it was a vast and sparsely settled region, almost 'out of the world.'"[4] Although Portland and the Willamette Valley were "beating fulltime to the quickstep of progress," Crater Lake and the nearby county seat of Jacksonville remained comparatively secluded.[5] "It is thinly populated," Goddard wrote of Jacksonville, adding that it "would furnish homes for an indefinite number of immigrants."[6] Indeed, the Klamath-Siskiyou region that sits to the west of the volcanic Cascade Range is vast, with millions of acres of mountainous terrain covered with forests.

EURO-AMERICANS DISCOVER CRATER LAKE

Euro-Americans discovered the lake in much the same way as they did other western places, gradually imbuing it with cultural meaning. Crater Lake was first encountered by non-natives early in 1853. The wandering miners voted among themselves to dub their discovery "Deep Blue Lake."[7] Word of mouth that an enormous lake had been found high up in the volcanic peak region of the Siskiyou

Mountains did not spread the news far, because nearly a decade later, in late 1862, another group of miners came upon the lake and thought they had "discovered" it. They proceeded to call it "Blue Lake" and published their account in the *Oregon Sentinel* of Jacksonville.[8] In 1865, Crater Lake was "discovered" yet again, this time by a military party from nearby Fort Klamath. They called it "Lake Majesty." Despite the enthusiasm of these early explorers, Crater Lake did not achieve the national standing of other notable western sites until much later; for decades, it was known almost exclusively by Southern Oregon residents.

As Alan Trachtenberg has argued in his essay discussing the mapping efforts of the Clarence King Geological Survey, "The name lays claim to the view."[9] At Crater Lake, as at many other sites, the multiple acts of naming were a series of efforts to claim the landscape. A long relationship, however, had already existed between the lake and the Klamath tribes, the Southern Molalla, the Takelma, the Upper Umpqua, and the Rogue River tribes. Native beliefs as recorded and disseminated by non-Native sources suggest that these people considered the lake a powerfully spiritual place and that they approached it with fear and reverence. The Klamath, especially, as one of the few tribes not to have had their population severely decimated or moved far from their homelands, describe the lake as a powerful place for shamanistic activities and vision quests.[10] Attempts to understand the Native Americans' traditions and relationships to the lake, however, should be undertaken cautiously. As one prominent anthropologist has noted, the Euro-Americans who authored the records "remodeled, edited, cheapened, censored" and "Europeanized" native legend.[11] As with *Hiawatha*, nineteenth-century accounts of Native lore tend to be very romantic and stereotypical in their presentation. For example, in an 1873 article about Crater Lake, one author wrote:

> This wonderful lake furnishes a vast amount of mystery for Indian tradition. Here their medicine men still come, as they always came in the olden time, to study spiritual wisdom and learn the secrets of life from the Great Spirit. In the solitude of these wilds they fasted and did penance; to the shores of the weird lake they ventured with great danger, to listen to the winds that came from no one knew where—borne there to roam the pent-up waters and bear the mysterious whispers of unseen beings, whose presence they doubted not, and whose words they longed to understand. They watched the shifting shadows of night and day; the hues of sun-light, moon-light, and star-light; saw white sails glisten on the moon-lit waters; caught the sheen of noiseless paddles, as they lifted voiceless spray, and having become inspired with the supernal, they bore back to their tribes charmed lives and souls fenced in with mystery. It is by such inspiration that the Indian medicine-men become infused with superstitious belief that they are more wise than they are mortal.[12]

Another author wrote in 1891:

The Indians in this section of the country have several traditions concern-
ing the lake. One that it is the abode of evil spirits; that whoever looks into
its silent depths will soon die, and solemn warning has been given to the
whites to keep far away, lest harm befall them. Others say it is holy ground,
made sacred by the immediate presence of the Great Spirit; that in the past
none ever visited it save the medicine men or their pupils.[13]

These passages exemplify a common perception among nineteenth-century immi-
grants that the lake was a place steeped in superstition. As Euro-Americans re-
shaped and recounted tribal heritage to highlight its enigmatic value, they conferred
upon the site their own sense of delight. The romantic tone of the above quotation
suggests, for example, that a spiritual experience was waiting for the visitor at
Crater Lake. Such literary musings, along with images like Britt's, served to bolster
the mystique of this strange crater according to the immigrants' own system of
beliefs about the western landscape, including perceptions about place and identity
on the frontier.[14]

Along with the notion that regional inhabitants were somehow heirs to the rich
native and geological legacy of the Southern Oregon region, the site was approached
and described with the same type of spiritual rhetoric that attended other "wonders"
of the West. Nineteenth-century viewers thought of Crater Lake, like Yosemite, as
sacred:

We all exclaimed, as people do under such circumstances; but I could not
help feeling that silence was a more fitting expression of the emotions the
view inspired. I have heard of persons weeping over the first sight of
Yosemite. I think that at Crater Lake the feeling that rises most strongly
within us is awe and gladness mingled in that proportion that inspires us
to say, "Let us pray!"

To say that we saw the water would hardly be true. We saw a mirror of
the cloudless summer sky, intensifying its azure—reflecting heaven as a
deep well does the stars. . . . It lay there in the top of the mountains, smil-
ing back to the bending empyrean as if God himself had consecrated it to
the presence of cherubim and seraphim.[15]

Another description reflects a similar tone: "Its grandeur is almost monotonous, its
solitude is supremely desolate, and the mystery of its authorship is most sublime."[16]
Even the scientist Clarence Dutton waxed romantic in his description of the site:
"The Beauty and majesty of the scene are indescribable. . . . It was touching to see the
worthy but untutored people, who had ridden a hundred miles in freight-wagons to
behold it, vainly striving to keep back tears as they poured forth their exclamations
of wonder and joy akin to pain."[17] Many have described the experience of their first
view of the lake as one of incomprehension, followed closely by a dawning realiza-
tion of what they were seeing. "The first sight was disappointing," said a writer in
1873, "for it was not what I conceived it to be, and, indeed, I could not conceive it to

be what it was."[18] Another anecdote from 1891 echoes the sentiment. "We found ourselves almost on the edge of an immense precipice, looking across a wide stretch of water lying almost two thousand feet beneath us. As we stood in silence contemplating the scene . . . the stillness and solitude became almost oppressive, and yet it was not at once we could realize just how wonderful it all was."[19] Attempts to understand the scene and articulate the experience clearly proved difficult.

Similar to other sites of cultural significance, the lake eventually achieved an iconic status for the nation through both religious associations and scientific inquiry. Encouraged by the scientific and military expeditions that investigated and mapped the West, the country's interest in the environmental past of the American landscape grew. In this regard, the ancient volcanic history of Crater Lake was quite compelling. Geologist and survey leader Clarence Dutton's efforts to study the lake's depths during expeditions in 1885 and 1886 led to a better understanding of its creation. For example, he described the origins of Crater Lake much as how we understand it today, writing that it was

> formed in much the same way as the great calderas of the Hawaiian Islands, by the melting of the foundations of the original mountains, the blowing out of the molten material in the form of light pumice and fine tufa. It cannot have been formed by an explosion like Krakatoa and Tomboro, for there is no trace of the fragments anywhere in the country round about. But the pumice and tufa which surely emanated from this crater are seen in vast quantities anywhere within a radius of twenty to sixty miles, and in quantities ample to fill the whole vast crater twice over.[20]

Crater Lake is a relatively recent volcano in geological time; it erupted about 7,900 years ago, spewing molten rock and ash in all directions and hollowing out the cone. It eventually collapsed in upon itself, leaving a crater to fill with water from massive snow runoffs each spring for thousands of years. Dutton's theory of the origin of the formation expanded the notion that the citizens of the American Republic were the inheritors of a very ancient and dynamic past.

PHOTOGRAPHY AND CRATER LAKE

Well before Britt photographed Crater Lake, Euro-American responses to the site followed the standard western cultural traditions of describing scenery in literary tropes, making it clear that the need for visual representation was great. In 1873, the lake was described in writing, with a nod to its visual appeal: "So far as I know, there has never been a record made of this expanse of water, and I mistrust my pen when I attempt to describe this greatest wonder of Klamath Land. . . . It is a scene that some master hand might be immortalized by transferring to canvas."[21] Even in 1883, the lake was described in the same way: "And such a view! I cried out for an artist who could paint it, but doubt if there be one."[22] But as one writer from the

Philadelphia Photographer noted, "The pen is weak, and the camera is great," and in Britt's photographs of Crater Lake, the characteristics of the place were crystallized for the inhabitants of Jacksonville.[23]

Britt seems to have understood that he was depicting a scene for many in Jacksonville who would never see the lake otherwise, and he utilized pictorial methods that would visually explain the lake much in the same way that writers attempted to convey the scene with words. Because the lake covers an area of about twenty square miles, it is impossible to photograph it in its entirety from the ground without panoramic cameras, and even excellent photographs failed to capture the sublime firsthand experience. Instead, Britt photographed sections, being sure to frame the scene with rocky ledges or impeding tree branches for picturesque effect. To best respond to the public's interest and demand for images of local natural wonders, Britt consulted his dog-eared and chemical-stained copy of R. M. Linn's *Landscape Photography*:

> Go to work with coolness, deliberation, and confidence. Throw off all care, constraint, and nervousness. Woo Dame Nature in her mildest and happiest mood. Let your soul be inspired and your senses charmed by her matchless beauties. Take your time to it. Strive lovingly, perseveringly, intelligently, and that measure of success which crowns the true artist will gladden your heart at last. Let every weary, careworn operator take a new lease on life by making a campaign to the woods and mountains. Emancipate yourself from the routine of the gallery, and the baneful odors of the chemical-room, for communion with Nature and the health-giving breezes of heaven.[24]

The prospect of communing with nature may have inspired other practitioners who sold views to "emancipate" themselves "from the routine of the gallery," but Britt's particular challenge was to adequately represent the unique qualities of Crater Lake and communicate them to the public.

Just as "the name lays claim to the view," Trachtenberg noted that "by the same token, a photographic view attaches a possessable image to a place name. A named view is one that has been seen, known, and thereby already possessed."[25] The people in and around Jacksonville who already knew of the lake were, in fact, poised to take possession in this fashion as early as 1868, but they would have to wait until Britt successfully secured the first photographs in 1874. By then, local parties had been visiting the lake for years, and the interest in this site both locally and in the larger region of Oregon and Northern California was such that a profitable reception for Britt's images was assured.

Britt had tried multiple times to photograph the site before 1874, but the journey was difficult, especially when transporting photographic equipment to the remote area.[26] From Jacksonville, Britt had to traverse approximately seventy-five miles of dense forest, mountainous terrain, and extensive lava beds, carrying approximately two hundred pounds of material on his pack mule, including chemicals, glass plates,

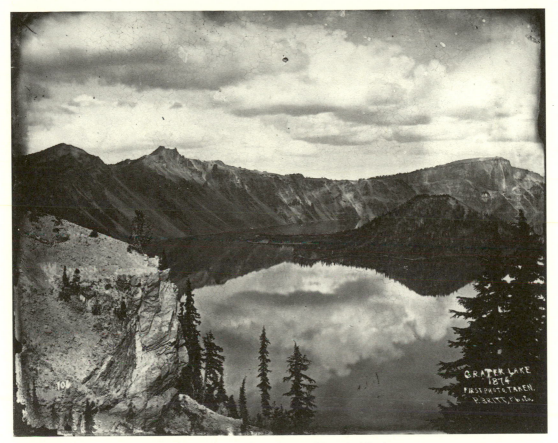

Figure 43. Peter Britt, *Crater Lake*, 1874. Southern Oregon Historical Society, #740.

and a "dark tent" for developing. He also took his children. The journey to Crater Lake was at least a ten-day round-trip affair, and weather was often a trial. Winter typically brings ten to fifteen feet of snow to the lake, with an average accumulation of 533 inches from October to June. Even summer weather is unpredictable.

Britt's first successful photographs were taken August 13, 1874, after he had waited for days in inclement weather.[27] Britt stepped from his tent at the rim of the lake and fixed an 8 × 10 negative (figure 43). Although not the only images he would make of the lake that day, this photograph represents an extraordinary moment in his career and prompted him to label the negative as the "first photograph" of Crater Lake. The image reveals Britt's ability to describe a landscape with a sound technical skill. Not only was he able to achieve excellent tonal quality through a correct exposure time, he was also able to develop the negative in an adequate manner—not an easy task, given his circumstances. Later, he was able to print images with a marvelously clouded sky, a technique that involved negative manipulation.[28] He was able to capture the reflective quality of the surface of the lake by the same technique.

The images he made that day also expose his aesthetic talents. In large-format painting and print material, the picturesque and sublime presentation of the West allowed audiences to understand little-known regions through traditional and

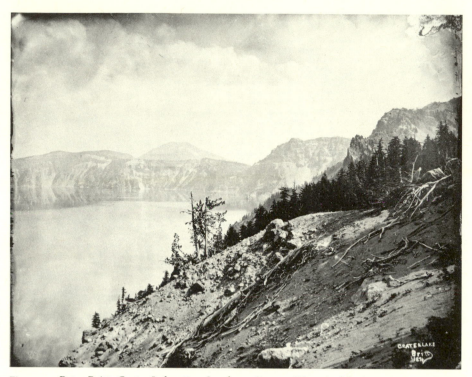

Figure 44. Peter Britt, *Crater Lake*, 1874. Southern Oregon Historical Society, #741.

widely understood artistic tropes. Britt's artistic background suited him well for the task of framing and composing such scenes. Partially due to his training as a painter and to his long career as a photographer, Britt was aware of the type of view that would appeal to his audience. Britt's image of Crater Lake that depicts the steep embankment (figure 44) and the one with his son Emil seated at the rim, for example, demonstrate his aesthetic abilities (figure 45). In his photograph of Emil, he framed the view of the lake in a standard and familiar way, couched between trees, with a mediating figure in the foreground that appears to be an attempt to capture the sublimity of the place. The boy, like all visitors, sits serenely contemplating the view. More than simply to provide a sense of scale, Emil demonstrates the type of experience advocated by contemporary writers. Unlike Easterly and Whitney, who effortlessly included locals in their views, Britt had few opportunities to encounter people at the remote lake. In contrast to the sublime aspects of the scene, his image of Mt. Shasta includes Emil. With a fenced pasture in the foreground and a boy fishing peacefully on a lazy creek, Britt presents the fierce sublimity of the ragged peak in the background as somehow tamed, perhaps even domesticated, through the figure's presence (figure 46). Emil does not focus on the mountain but rather enacts a pastoral scene.

In the year following his successful photographic journey to the Crater Lake, Britt immortalized the site in oil paint, and this painting is now in the Jacksonville museum (figure 47). This painting shows the site almost completely within its

frame, a view impossible to see through the viewfinder of his camera. Britt artfully framed the scene with trees and composed the landscape elements to draw viewers' attention to the deer in the middle ground, which in turn emphasize the expanse of water in the distance. Probably painted from a composite of his earlier photographs, this representation demonstrates his creative approach to the lake in general and suggests in turn that his photographs drew heavily on the representational techniques he learned as a painter.

Through photography as well as painting, image makers could render the unknown West as exhilarating, yet not fearsome. Britt's image of Rogue River Falls, for instance, presents the dense Oregon forests as inhabited by Euro-Americans who easily seem to occupy the dramatic landscape. These images also employ the technique of picturesque representation despite the sublime quality of their locations. Britt pictured roughness, variation, irregularity, intricacy, movement, and charm by using framing devices and special vantage points. Perhaps he was reluctant to represent both the cataract and the snowy peak in a sublime manner, but nonetheless, his choice of the picturesque exemplifies a

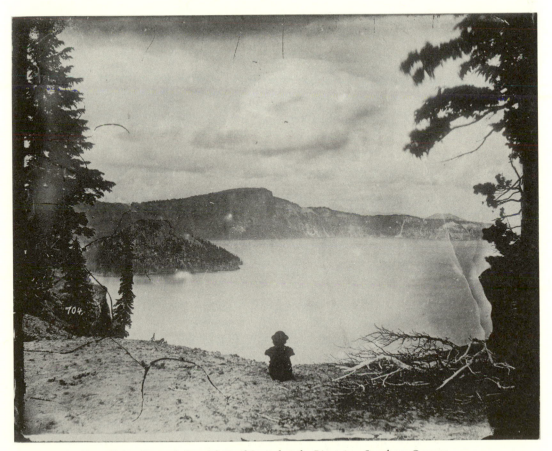

Figure 45. Peter Britt, *Crater Lake with Emil Seated at the Rim*, 1874. Southern Oregon Historical Society, #724.

cultural eagerness to see the western landscape as controllable. The exciting ter-
rain of the frontier fascinated the nation, but by framing views in familiar ways,
artists made the West more recognizable and comprehensible. Because Britt dis-
tributed the images locally, Jacksonville inhabitants were given the opportunity
to contemplate their own existence as active participants in the pictured land-
scape. They were the tamers of the new landscape that in turn was rendered fa-
miliar through photography.

As one of a vast number of regional photographers who settled in the frontier
West, Britt consciously created a visual context for his adopted region. He did not
distribute the images nationally for marketing purposes or to boost the region's
popularity; nor did he have a corporate or government sponsorship, as so many
western photographers did. Instead, Britt circulated the first images of the lake to
Euro-American settlers in the southern Oregon region, focusing specifically on the
small town of Jacksonville. He photographed the people and environment of
Southern Oregon for the new pioneering generations who lived there, and despite
his work's role in the eventual formation of Crater Lake National Park, his inten-
tions had very little to do with the discourse on national identity that compelled so
many artists, writers, and photographers of the era. Instead, he used his photo-
graphs to enhance his business; they strengthened a local sense of ownership and
engagement with the land.

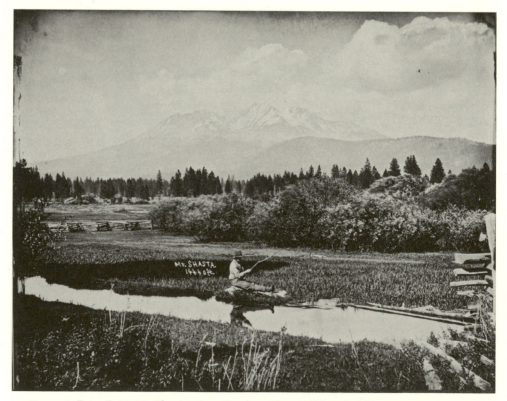

Figure 46. Peter Britt, *Mt. Shasta*, 1870s. Southern Oregon Historical Society, #749.

Figure 47. Peter Britt, *Crater Lake*, 1875. Oil on canvas. Southern Oregon Historical Society, #717.

STEREOGRAPH AND DRY PLATE TECHNOLOGY

Britt began his photographic career as a daguerreotypist, but unlike Easterly, he was quick to acquire new skills as photographic technology developed. With the advent of the "wet plate" or collodion method in the early 1850s, reproducibility encouraged the popular activity of collecting photographs.[29] The collecting craze centered mainly on portraiture, but it also increased the market for landscape views. Although cartes de visite, cabinet cards, and albums were the industry's primary response to consumer demand, the most important technological advancement for landscape photography was arguably the stereoscope—a binocular viewing device that transformed photographs into a three-dimensional viewing experience. Beginning around 1858, stereoscopic views became enormously popular throughout America due to relatively cheap photographic paper and the novelty of the uncanny three-dimensional views. In a manner consistent with other western view makers, Britt made both large-format prints and stereo views for his clientele and for gallery display (figure 48). According to Peter Palmquist, Britt's house and studio were like a museum dedicated to the history of photography, with examples of many different cameras and printing technologies that he had used over the course of his career.[30] Unfortunately, the Britt house burned down in 1960.

Despite the immediate and intimate experience of peering through a stereoscope, the activity was, like the photo album, an essentially social activity. Its popularity was demonstrated in 1883, when Dr. Hermann Vogel wrote in *Photographic Times*, "I think there is no parlor in America where there is not a stereoscope."[31] Placed in a communal area, stereoscopes became an object for the entertainment of family and guests. Furthermore, like the album that displayed family portraits alongside a wide variety of images, stereographs represented a huge range of subjects that included landscapes domestic and foreign, urban and rural. Oliver

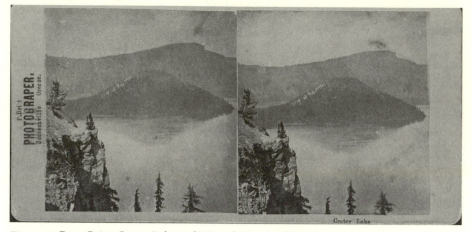

Figure 48. Peter Britt, *Crater Lake and Wizard Island*, nd. Southern Oregon Historical Society, #19123.

Wendell Holmes, one of the first proponents of the stereograph (and coiner of the term), described the experience in glowing terms:

> The first effect of looking at a good photograph through the stereoscope is a surprise such as no painting ever produced. The mind feels its way into the very depths of the picture. The scraggy branches of a tree in the foreground run out at us as if they would scratch our eyes out. The elbow of a figure stands forth so as to make us almost uncomfortable. Then there is such a frightful amount of detail, that we have the same sense of infinite complexity which Nature gives us. A painter shows us masses; the stereoscopic figure spares us nothing,—all must be there, every stick, straw, scratch, as faithfully as the dome of St. Peter's, or the summit of Mont Blanc, or the ever-moving stillness of Niagara. The sun is no respecter of persons or of things.[32]

Accordingly, the viewer was able to have a visceral experience of distant landscapes; the odd, almost holographic images enabled an intimacy with the site.[33]

Another more technical and less-examined advancement for landscape photographers in the West was the dry plate collodion method for developing glass plate negatives, which became commercially available in 1880. This method allowed an exposed plate to be stored for a short time before it had to be developed. Negatives of the older wet plate process needed to be fixed and washed immediately after exposure—a laborious and inconvenient task if the photographer was bivouacking far from the studio. The *St. Louis Practical Photographer* reported in 1879 on the new method: "Less assistance is required in taking pictures. Many more can be taken in the day; they save the time previously occupied in filtering baths, washing out, etc., and the waste in wear and tear of apparatus. All this means money; but, besides this pictures cost less on dry plates than on wet collodion."[34] "This can be done in two-thirds of the time required for wet plates, and with one-eighth of

the exposure."[35] Although Britt's 1874 Crater Lake photographs were obtained with wet plate technology, his experiments allowed him to develop his own dry plate techniques by 1877, facilitating his travel between Jacksonville and other destinations in Southern Oregon and Northern California.[36]

Like other photographic entrepreneurs, Britt provided other image-based services for the people of Jacksonville. He painted pictures of local scenes and sold photographs of engravings and lithographs (themselves often modeled on original paintings), disseminating a huge variety of visual works locally. He sold cartes de visite and cabinet cards of illustrations and reproduced works of art that he photographed. He also sold cartes de visite of his own paintings. His photographic business was not simply the portrait trade; it had a wide-ranging impact on Jacksonville's early visual culture.

A REGIONAL VERSUS NATIONAL LANDSCAPE

In 1886, Clarence Dutton claimed of Crater Lake that "it is difficult to compare this scene with any other in the world. . . . In a general way, it may be said that it is of the same order of impressiveness and beauty as the Yosemite Valley."[37] Despite general similarities, when Jacksonville settlers confronted the stunning and remote landscape of Southern Oregon, whether in actuality or through photography, their awe must have been different from those confronting a more nationally recognized tourist site such as Yosemite. A multitude of images prepared tourists for an experience of that valley, but for settlers with only a dawning awareness of the incredible grandeur of their region, Britt's images revealed an exciting discovery—perhaps heightened by the rest of the country's ignorance of the place.

Compared to Carleton Watkins's images of Yosemite, for instance, Britt's photographs of Crater Lake are strikingly different. Although there are many aesthetic and technical differences, their respective compositional strategies suggest specific cultural implications at each site. Both Watkins and Britt benefited from the generally understood notion of veracity in photographic representation. For example, images of Yosemite that infiltrated the eastern United States at the same time Britt was distributing his Crater Lake images locally were perceived as having captured the scene "as it was" without artful interference. But technical skill aside, both photographers displayed a fair amount of artfulness in the way they chose to frame a scene and in their choice of vantage point. In Carleton Watkins's stereograph *The Yosemite Valley, from the Mariposa Trail*, for example, Yosemite Valley is depicted from a high point of view, providing the audience with a vast overview (figure 49). Through either a stereoscopic or mammoth plate display, the viewer could engage in a visual journey down through the valley and on to the horizon. The way Watkins framed the view suggests a visual and physical passage—a spiritual voyage to the place and through the place that offered a transformative experience.

Traveling to Yosemite offered the pilgrim and tourist an experience not unlike the process of western migration. The frontier, under the aegis of destiny, was like

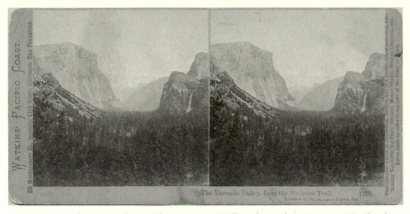

Figure 49. Carleton Watkins, *The Yosemite Valley, from the Mariposa Trail*, nd.
1980 045:09, courtesy of the Bancroft Library, University of California, Berkeley.

the glorious scenery at Yosemite in Watkin's photographs—a view that suggested limitless possibility in that both were understood as divinely inspired. John Szarkowski's assertion that Watkin's images "were intended for customers who believed that there was something close to religious meaning in wilderness—especially spectacularly beautiful wilderness—and spiritual value in its contemplation," explains the national sentiment right after the Civil War.[38] Although Yosemite's protected status, created by Abraham Lincoln in 1864, set the physical space apart in the state of California, the immense growth of that site's popularity made it a landscape of national repute. Crater Lake, on the other hand, was distinctly less touted and known.

Watkins was responsible for some of the most well-known photographs of Yosemite in the nineteenth century, along with other notable photographers such as Eadweard Muybridge, George Fiske, Charles Weed, and, eventually, Ansel Adams. Besides exhibitions, photographic competitions in the United States and Europe, and extensive distribution of his photographs, Watkins illustrated a number of books about the region. Specifically, he was called upon to provide the photographic illustrations for *The Yosemite Book*, "published by the authority of the legislature" only a few years after Yosemite's congressional designation.[39] The self-proclaimed purpose of the book was "to call the attention of the public to the scenery of California, and to furnish a reliable guide to some of its most interesting features, namely: the Yosemite Valley."[40] Despite both photographers' penchant for artful presentations, *The Yosemite Book* is a distinct example of how Watkins's audience and his resources differed from those of Peter Britt, who found no such prestigious sponsors or outlets for his Crater Lake imagery.

Many of Watkins's photographs use standard landscape framing devices. Watkins's photographs are now widely understood as constructed views, sophisticated scenes that responded to the expectations of the viewing audience, often predetermining the viewer's relationship to the actual site. Similar to his other images,

a preexisting national understanding of Yosemite sets these views apart from Britt's of Crater Lake. Because the popularity of western landscape imagery was the result of a national anticipation of prospects in the West, which in turn boosted interest in western landscape imagery, Watkins's photographs acted as tantalizing offers to come and stand on the brink of the future.[41] At all levels of culture, from congressional reports to corporate boosterism and national fetes of pride to western immigration brochures and travel guides, the photography of the western landscape was indelibly linked to opportunity and national identity—Watkins was picturing the West for the consideration of the nation.

Britt's Crater Lake images, as well, provided a viewing point from which to experience the landscape. Britt's vantage point is high above the surface of Crater Lake, but unlike other such grand vistas, there is no implied journey, either visually or metaphorically. The California valley was thought of as limitless and the arrival at Yosemite only the beginning of the journey, but Crater Lake was a finite place (albeit a very large finite place), bound by the rim of the ancient volcano. When seen as a whole, the lake implies completion and culmination—a rewarding end, not a metaphorical beginning. Created for Jacksonville, Britt's views nevertheless evoked ideals of destiny, identity, and landscape aesthetics. For instance, as did Watkins in his photographs of Yosemite, Britt consistently gave viewers a point of view: in Crater Lake, it was from the rim of the caldera. Instead of a view of a much-publicized destination, Britt's images must have seemed to reveal a more rarified location, even to the regional residents. Side by side, however, a Britt and a Watkins photograph do not ostensibly reveal the significant differences in who received them and how they were perceived. Much like the universal appeal of Minnehaha Falls, the appeal of Crater Lake could be appreciated by all Americans, but it held special meaning for those that lived near it and could claim it as their own. Ultimately, the images of both were attempts to define the relationship between Americans and American places.

A western identity was inextricably linked to place, and this became a subject that preoccupied writers and artists. For example, in 1883, one columnist wrote that

the true Westerner is the boldest, the most humorous, most extravagant, and least conventional of men. The East seems insipid, timid, colorless to him. This is largely due to the extremes of natural scenery and production of this region. To the inhabitant of the Pacific coast, any other skies than his own seem dull and muddy; any other mountains half-grown; any other trees dwarfed; and any other people singularly deficient in feeling and native passion. This is indeed a country of extremes. The skies are brighter and the storm-clouds blacker, the deserts more desolate and the valleys more rich, the mountains more abrupt and the plains more level, the rivers both swifter and slower, clearer and more turbid, than elsewhere on the continent. Corresponding extremes among the people make them very interesting.[42]

Besides such examples in the popular press that defined westerners so precisely, celebrated photographers and painters also gave the East a clear understanding of the western character. Again, Carleton Watkins's views of Yosemite depicted not only the prospect of California for eastern viewers but also the future of America, solidifying ideals about those people living amid such natural grandeur. The notions of Yosemite that proliferated—as a cosmic, infinite, and therefore highly spiritual realm—reinforced the collective ideas about the perceived grandeur of American destiny. Because the landscape of Yosemite was almost immediately marketed as a tourist destination, the population of the whole nation, not just westerners, saw themselves as heirs and benefactors.

The singularity of the phenomenon of Crater Lake, combined with its relatively close proximity to Jacksonville, made the site and, hence, Britt's photographs particularly meaningful to residents, ultimately bringing to fruition idealistic notions of local culture. Just as the Yosemite Valley offered the nation a visual parallel for the infinite prospect of western futures, for the residents of Jacksonville, Britt's Crater Lake pictures provided a monumental counterpart to their experience as immigrants. Instead of inspiring a journey through the spiritual landscape, the lake was like a reward for an arduous journey completed; it signified arrival and achievement. These concepts would have been particularly important for regional inhabitants as a parallel to the experience of frontier settlement and the reality that immigration was often not what people "conceived it to be." For the pioneers, the western landscape was not just about future prospects; it also represented what had already been accomplished.

TOURISM AND CRATER LAKE NATIONAL PARK

Especially after Britt's photographs became available, locals assumed an increased pride of place and a willingness to identify with their region's scenery. In an article titled "Ramblings in Oregon," one writer stated:

> I found the citizens of Jacksonville obliging and hospitable and willing to do all in their power to make one acquainted with the fertility and beauty of the land of their adoption. They seemed to be anxious to give every information about it; and their statements I found on investigation to be true. One thing attracted my attention, even among the rural population, where the study of aesthetics is popularly supposed to be overlooked, and that is the keen interest they manifested in any striking scenery. This attribute they receive from the beauties surrounding them, for intellect must be dull indeed that would not be impressed with the charms which Nature displays so generously in Southern Oregon.[43]

Here the author suggests that the landscape itself is responsible for the regional population's quickened intellect and heightened aesthetic interests.

After Britt began creating stereoscopic views of Crater Lake in the mid-1870s, selling them directly out of his studio instead of utilizing large distribution houses, locals began to visit the site in increasing numbers. "It was a Mecca to many families of Jacksonville in summer," reported an 1875 article in *Forest and Stream*.[44] The trip was arduous and often eventful for many of the locals, who were by and large cut off from society beyond their region. Luckily, Britt was connected to the rest of the country more significantly than most of the residents of Jacksonville. Records indicate that he frequently ordered the latest photographic equipment, trade journals, and catalogs.[45] For a period, Britt even maintained a pack route to Crescent City, California, putting him into direct contact with the San Francisco trade.[46] Even though Crater Lake eventually stood among the ranks of national landscapes as a symbol of the value of America's ancient and sacred natural history, for a time this conception of the site existed primarily for southern Oregonians, despite the opportunities Britt encountered for promoting it elsewhere.

By the late 1880s, despite its remote location (even for the people of Jacksonville), visitors from outside the region began journeying to the lake in small expedition parties. In 1888, for example, an article appearing in *Frank Leslie's Popular Monthly* reported that "since its marvelous and majestic features have been made known to the world, a good many tourists have visited its rugged shores."[47] But in a later 1891 article in the *Overland Monthly*, titled "Off the Beaten Paths," the author wrote that "The secluded situation, away from the usual routes traveled by tourists, keeps the lake still comparatively unknown, but as it is described from one to another the number of its visitors is increasing yearly."[48] Finally, an 1896 article in *Scientific American* summed up the site's relative national obscurity, claiming that "although its existence has been vaguely known for more than forty years, its remoteness and difficulty of access have prevented any considerable numbers from visiting it, beyond those living in its near vicinity."[49] This article was written by the secretary of the Mazama Club and is an obvious "booster" piece. The author went on to write that "the weirdness and grandeur of the lake itself have so focused attention that it had been forgotten that the mountain on which it is situated, although over 8,000 feet high, had never had a name. It has now been formally christened Mount Mazama, in honor of the vanishing genus of mountain goat, from which the society . . . takes its name."[50] By contrast, tourists could visit Yosemite with relative ease.[51] Only in the late 1890s did tourism to Crater Lake increase considerably, when a Portland mountaineering group organized a trip for more than five hundred of its members.

Throughout the 1880s, Britt's photographs continued to influence the flow of local tourists to the site, and they were even used to encourage the United States government to establish Crater Lake as a national park. In 1886, William Steel wrote to Britt asking for photographs of Crater Lake to take with him to Washington.[52]

> Dear Sir: During the past summer I enjoyed a trip to Crater Lake and since my return have started a movement to have the surrounding county withdrawn from the market and made a national park. With that end in view I am having a petition to the president signed.[53]

Steel circulated a petition intended to add support to the bill, and despite the early importance of Britt's Crater Lake photographs, scores of photographers visited the site in the late 1880s and early 1890s, providing plenty of advertisements for Steel's endeavor. In addition to contacting the press, he set up a display of Crater Lake photographs in a Portland photographic materials store. Steel's efforts were eventually successful, and the site became known as Crater Lake National Park in 1902, when President Theodore Roosevelt signed the authorizing bill into law.[54]

Earl Morse Wilbur correctly predicted in an 1896 article for *Scientific American* that "the place is sure before long to be known as one of the greatest scenic attractions of the country."[55] By the last decade of the nineteenth century, Crater Lake had gained considerable exposure in the popular press and had been described and pictured multiple times for a national audience, capitalizing on the site's popularity and relative inaccessibility. Railroad access to nearby Ashland likely accounted for the growing number of visitors, and the lake eventually became a significant destination for people outside the region. In 1903, tourists could take an autobus to the lake for eighteen dollars when travel by motorcar was still a challenge. By the turn of the century, the trip from Ashland took four days by automobile, but by the 1910s, Wilbur's prediction appears to have come true with help from the Southern Pacific Railroad.

Today, Oregon continues to capitalize on Crater Lake as a tourist attraction and site of state pride, popularizing it in a host of materials, from postcards and postage stamps to license plates and mugs. The image of Crater Lake has entered the public consciousness as a jewel of the West, part of the extensive lexicon of natural wonders that have come to define America. Because the lake is one of the "greatest scenic attractions of the country," the original importance and complexity of Britt's images for the regional settlers in Jacksonville and the surrounding area are easy to overlook. But throughout the West, communities arose through shared experience, and in many cases the landscape was a primary point of commonality—a readily available and visible icon upon which residents could coalesce. Britt's community looked to its immediate environment (and to photographs of that environment) for signifiers of identity, finding in the forested mountains, the lava fields, and, ultimately, in Crater Lake a grandeur equal to the settlers' extraordinary efforts. His images of Crater Lake presented Southern Oregonians with a chance to contemplate the wonders of their region and to consider themselves as inhabitants of and participants in the unfolding saga of the western frontier. His pictures were images of arrival and the perceived achievement of destiny.

The giant caldera of Crater Lake was undoubtedly dramatic, but the Rogue River and its waterfalls, dense old-growth forests, and extensive lava fields provided ample material for viewers seeking to own small tokens of the incredible grandeur of their region. A glimpse of majesty, however, was not the only reason for popular interest in landscape imagery. As with photographic representation all over the developing West, artistic construction and presentation of the western landscape were complicit partners in the manifestation of America's perceived destiny.

Photographers like Britt left a visible record of the early settlers, the landscape as they sought it, and imprints of their own activities. Perhaps the prominence of

Figure 50. Peter Britt, Pioneer Portrait and Landscape advertising card, nd. Southern Oregon Historical Society, #21205.

photographers in their own communities kept them conscious of their role in the history of their locale, of the West, and in America. More than his packing business to Crescent City, more than his horticulture and winemaking endeavors, Britt is known and celebrated for the lasting legacy of his photographs. As a settler photographer, Britt helped change the landscape from something elusive and remote to something familiar and accessible to its Euro-American inhabitants. From his first visits to the edge of Crater Lake to its national park status, Britt, like all settler photographers, had the means and the desire to record and interpret immigrant experiences through photography. The first generations of photographers in the nineteenth-century West became recognized and lauded, even during their own time, not only as recorders of their transformative era but as participants in it. Photography was a contributor—shaping and forming conceptions of the landscape as sure as the farmer or the miner shaped and formed the actual land.

Jacksonville has continually celebrated Britt as one of its earliest and most significant residents. While Britt was still active in his profession, for instance, the backplates on his cartes de visite and cabinet cards evolved from "Portrait and Landscape Photographic Studios" to "*Pioneer* Portrait and Landscape Photographic Studios" (figure 50). Furthermore, in 1883, Emil Britt's photographic enterprise became "Britt and Son," and the self-conscious addition of "established 1852" to the backplate suggests that the Britts were aware of Peter's renown. As a historical town, Jacksonville still strives to maintain the pioneer past of Britt's era. He is still central to the town's identity, as well as to nearby Medford's, as they celebrate the "Britt Festival" every summer. He is perhaps the quintessential pioneer photographer, central to the development of his community, having provided enduring images that evoked the ethos of the West during a formative era.

The Photographic Album

Solomon Butcher in Custer County, Nebraska

> We praise, thee, fair Custer county,
> Whose fame is often sung,
> Whose story of dearth and bounty
> Is told in every tongue.
> —C. H. CARLOS, *Ode to Custer County*, nd

> Some people call their scenery flat, their only picture framed by
> what they know.
> —WILLIAM STAFFORD, *In Response to a Question*, 1962

HOMESTEAD PHOTOGRAPHS

ONE OF SOLOMON BUTCHER'S FIRST PHOTOGRAPHS WAS a self-portrait from about 1882 in which he poses proudly at the door of his sod brick dugout in Nebraska, his eyes at the same level as the horizon, which is at the same level as the roof of the dwelling (figure 51). The photograph foreshadowed hundreds of such images that he would execute over the course of the 1880s and 1890s portraying the intense integration between the landscape and the everyday experience of plains homesteaders. Sod houses were made from the "stuff" of the land in the form of sod bricks and thus were visually and materially embedded in their surroundings, blurring the line between landscape and structure. Butcher's photographs have continually inspired curiosity—about the uniqueness of sod brick construction, about the overwhelming aesthetic quality of the central Nebraska plains, and about him. In 1882, Butcher, like so many others, went to the Nebraskan prairie as a homesteader and hopeful Custer County settler.[1] As a notoriously unmotivated farmer, when told to buckle down and get to work on his homestead, he said, "It seemed to suggest that they thought I was afraid (of) work. On the contrary I could lie down and go to sleep along side of it at any time."[2] In addition to agriculture as the standard means of support for him and

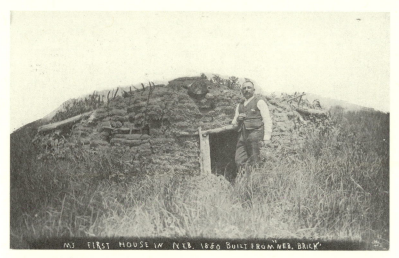

Figure 51. Solomon Butcher, *My First House in Neb.* (Solomon Butcher in front
of his dugout), about 1880. Nebraska State Historical Society, RG2608 PH
05169.

his wife, Butcher opened a portrait studio in 1883 and began a career in photography.
His restlessness with homesteading brought him to many additional vocations in
his life, including medical student, schoolteacher, postmaster, and real estate agent,
and later he created and marketed a "miracle elixir."

Because of the sparse settlement in central Nebraska in the 1880s and the
requirement that homesteaders live on their land instead of in the developing
towns, only a few photographers took up residence in Custer County. These in-
cluded, besides Butcher, Harry Bangs (1893–1895), the Sunbeam Studio (ca. 1890),
and Peirson & Mayer (1888–1889) from Broken Bow.[3] Similar to the short-lived
businesses of these photographers, Butcher's endeavor failed to attract enough
patronage to sustain his enterprise in the area. Unlike the studio and gallery that
regional photographers such as Whitney, Easterly, and Britt relied on as a locus
for their community's culture, Butcher operated out of a tent and was unable to
draw more than a few curious visitors; these would have been the mainstay of
more urban outfits. Like many other photographers in the West, Butcher was
committed to the idea that photography was an important (if not lucrative) en-
deavor. Instead of investing more time in a gallery operation that was clearly not
suited to the cultural patterns of Nebraska homesteaders, however, he decided to
take his business directly to his target clientele, and he developed an imaginative
scheme that would take him into the far corners of the large and daunting prai-
ries of his own Custer County.

Like Easterly, Britt, and Whitney, Butcher's subject matter was his local com-
munity, the people and places of the region. Also like his contemporaries, the story
of his life and photographic business in Custer County and the spirit of the place are
entwined, both physically and conceptually. Butcher's photographs from the 1880s
show a region of the United States during what is popularly thought of as the last
great phase of Euro-American expansion. According to Frederick Jackson Turner,

As the frontier had leaped over the Alleghanies, so now it skipped the Great Plains and the Rocky Mountains; and in the same way that the advance of the frontiersmen beyond the Alleghenies had caused the rise of important questions of transportation and internal improvement, so now the settlers beyond the Rocky Mountains needed means of communication with the East; and in the furnishing of these, arose the settlement of the Great Plains and the development of still another kind of frontier life.[4]

Until the 1880s, immigrants considered central Nebraska an area to be passed through on their way to the famously productive mines and fertile lands of Oregon, California, and other areas in the West. In 1862, however, the Homestead Act opened the central plains for farmers and cattle ranchers, who were drawn to the inexpensive land and transformative responsibilities that came with it. Through photographs such as that of the Ira Watson house—sod house homesteaders in the landscapes they inhabited—Butcher communicated personal and cultural ideas about that place in history, telling a story of development, success, and community (figure 52). His photographs spoke to his clientele about their shared experiences and were not only intimately tied to the nature of the photographic process he utilized and the way he conceived of collecting and displaying the images but to the way he interacted with the immigrants when he took photographs. His images also communicate something about the way he and other homesteaders conceptualized the space of the Great Plains region in terms of human habitation.

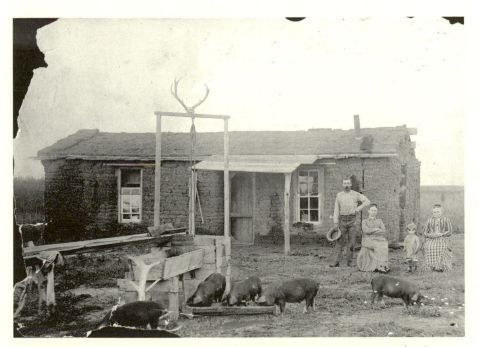

Figure 52. Solomon Butcher, *Ira Watson Family, near Sargent, Custer County, Nebraska,* about 1886. Nebraska State Historical Society, RG2608 PH o 1003.

A PICTURE ALBUM OF CUSTER COUNTY

Perhaps because of the difficulty of operating a photographic studio in a sparsely populated county more than twice the size of Rhode Island (Custer County is approximately 2,576 square miles), Butcher decided to change his tactics and took his business to his clients instead of waiting for them to come to him (figure 53). More than just a way to drum up some business and sell photographs, the project that was Butcher's ultimate goal was the production of a photographic album that would chronicle the homesteading era of Custer County. Butcher spent many years on this endeavor, recording about 1,500 "farmviews" comprising about one-third of the county's population.[5] Like the work of settler photographers all over the West, Butcher's project has become the stuff of legend in his particular region, partly due to the sheer bulk of his material and partly due to the unique nature of the work. Butcher described the excitement with which he conceived of the scheme:

> From the time I thought of the plan, for seven days and seven nights it drove the sleep from my eyes. I laid out plans and covered sheet after sheet of paper, only to tear them up and consign then to the wastebasket. I was so elated that I had lost all desire for rest and had to take morphine to make me sleep.[6]

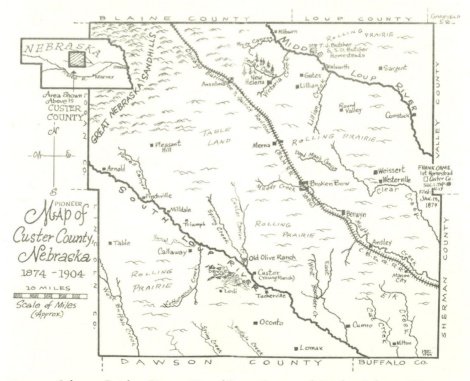

Figure 53. Solomon Butcher, *Pioneer Map of Custer County*, nd. Butcher, Solomon, *Pioneer History of Custer County Nebraska, 1874–1904*. 2nd ed. Denver, CO: Sage Books, 1965. Nebraska State Historical Society, 978.231 B97.

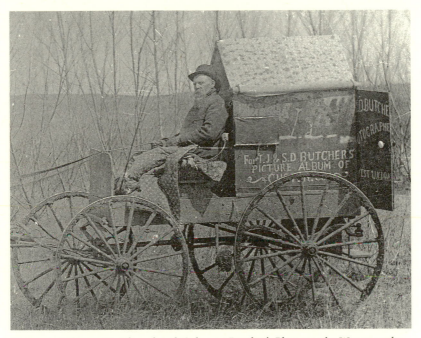

Figure 54. Solomon Butcher, detail, *Solomon Butcher's Photography Wagon at the I. N. Butler Sod House near Jefferson, Custer Country, Nebraska*, about 1886. Nebraska State Historical Society, RG2608, PH 0 1181.

Although he did not elaborate on the details of his plan, an 1886 self-portrait evinces his original intent. The image shows him seated in his horse-drawn buggy and portable darkroom, which sported the words "Picture Album of Custer Co." (figure 54). Butcher sought to create a comprehensive album portraying his home region for the county's residents. To this end, he photographed individual families all over Custer County, spending days and weeks traveling to the different sites. While at a location, Butcher took the opportunity to photograph other details of the homestead, including livestock and crops, with the intent of selling prints to the family. The partial records of one of Butcher's notebooks from the Custer County project indicate that he was selling prints of the chicken coop or hog pen as well as the more formal portraits of the family, sometimes by the dozen, at fifty cents for a 5 × 7 print.[7] He would also take subscriptions for his album and record a brief history of the family. He included information about where they came from, when and where they married, who their parents were, how many children they had, and, finally, details about the homestead itself—how many sections they owned and how much of their land was used for crops and grazing. The details of the homestead that interested Butcher, and that he thought would interest his clients, betray a consciousness of the passing nature of their era and the unique challenges of their location.

Butcher's plan in the 1880s was consistent with the popular demand for pictorial albums. The nineteenth-century album was a centerpiece of many living rooms and parlor spaces, and its display and viewing were essentially communal activities. In general, the album encouraged photographic collection and trade, which in turn

supported the growth of the photographic profession. Although Butcher's eventual book seems to represent the success of his endeavor, the term "album" suggests that he originally intended to produce books with tipped-in images accompanied by a caption, or short inscription, similar to modern photo albums and scrapbooks. However, Butcher published a genuine book, *Pioneer History of Custer County, and Short Sketches of Early Days in Nebraska*, in 1901, and the photographic archive and the book are strikingly discrete entities. The discrepancy indicates that *Pioneer History of Custer County* is far different from the album he originally intended. By the time he finally completed his project around the turn of the century, it was no longer in album format but rather printed with the half-tone process that allowed photographs and text to be printed alongside one another, and it ultimately contained only a fraction of the original views.

The album format seems to have originated as a way to contain and display the rapidly growing number of cartes de visite in use around 1861, which naturally segued into albums as family keepsakes. Later, thematic picture books cropped up. An early example is *Gardner's Photographic Sketch Book of the War* from 1868, a compilation of Timothy O'Sullivan photographs depicting scenes from the Civil War. In Gardner's album, photographs became sites for "sacred memories."[8] This sentiment indicates, as well, what Butcher probably had in mind for the picture album of his original project. The images of sod house homesteaders were indeed "sacred memories" and the sod homes "monuments" to Custer County residents who desired representations of the heroic frontier families living in the harshest of conditions and overcoming monumental odds.

Butcher's many images of Custer County homesteads provide a marvelous glimpse of the mundane facts of life on the Nebraskan prairie. Even as the homogeneity of their sod dwellings visually links the residents of Custer County in his photographs, they also quite astonishingly reveal grand and sometimes nuanced differences. The houses, like the people, vary greatly, and it is fitting to consider the images as portraits of place as well as portraits of people. The consistent pairing of family groups with their sod houses in the landscape furthermore reveals Butcher's own understanding of the intimate connections between the structures, the land, and the identity of the people who resided there, as well as the pervasive understanding that sod houses were transitional, temporary dwellings.

The significance of the architecture as a symbol of the passing phase in the settlement of the Great Plains reveals a consciousness of history as a driving force in Butcher's project. He wrote of this history in his book to his "friends and patrons":

> It will be doubly interesting to many of you, because you have helped supply the material from which it is made, while new arrivals will read with interest these anecdotes and reminiscences and short, thrilling stories of the founders of this county, their many trials and hardships endured while braving the elements in the howling blizzards of winter, the scorching suns of the drought period and devastation by grasshoppers. All tend to make it a most

remarkable book, and every one will have the satisfaction of knowing he is reading truth and not following the wild imagination of the novelist.[9]

Furthermore, Butcher's photographs provide visual evidence of the homesteaders' understanding of the transient nature of their time and place. Very few sod houses appear as places of display in his photographs—indeed, the homes are often depicted in a dilapidated state, as a stepping stone to something much better. In a state of decay or as a work in progress, the sod houses were symbols of the settlers' essential activity of improvement.

LANDSCAPES

Like the images of Easterly, Britt, Whitney, and other local photographers in the West, Butcher's photographs reveal not only the intimate connection between the settlers and the cultural spaces they were attempting to settle but also the regional residents' unique response to the physical aspects of the landscape. Indeed, a kind of "seeing around" the ostensible subject matter necessary to the deeply unique characteristics of the place strengthens the viewer's understanding of the deeper tensions inherent in the Custer County photographs.[10] That is, the physically harsh landscape significantly shaped the homesteaders' understanding of the aesthetics of Custer County as a place.

Butcher, similar to other photographers, attempted to utilize the standard visual rhetoric of landscape imagery. However, although this usage was true to some degree for all settler photographers who strove to shape a community with their photographs, Butcher was less artistically inclined than most of the established regional photographers in the West because of lack of formal artistic training. Butcher was neither an artist before his career as a photographer, nor did he benefit from a photographic apprenticeship that would have taught him, for example, composition and framing techniques. Because of his relative artlessness, his ability to produce picturesque views is truly a testimony to how thoroughly pervasive that particular aesthetic trope was. Unlike the extreme mastery that Easterly had over the technical aspects of his medium and the eye for aesthetics so clearly displayed in Whitney's and Britt's work, Butcher's efforts were at times awkward and at other times sloppy. Lengthy exposure times blurred active children or animals, and his technical inconsistency produced many damaged negatives. A revealing example is the photograph of Mr. Homan and his family that depicts the very large form of a turkey on the roof of a sod house. A blank spot on the negative was cleverly scratched into the shape of a creature (figure 55). Like the homesteaders he photographed, Butcher was able to make do in less than ideal conditions.

In response to a perceived aesthetic lack in the plains that surrounded them, the homesteaders defined the way Butcher took his pictures by framing their families with items they considered important. In many pictures, Butcher captured a distant view but also would include in the foreground a horse, cattle, a wood-frame

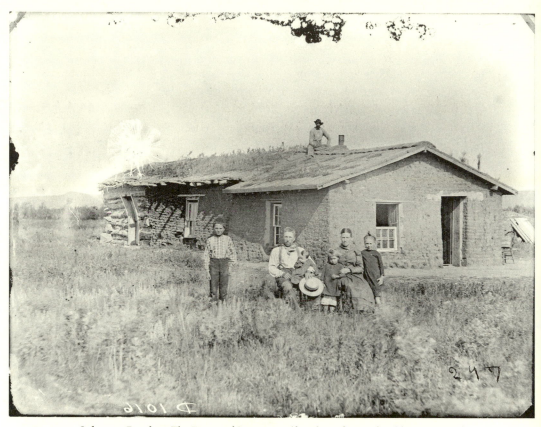

Figure 55. Solomon Butcher, *The Power of Suggestion* (family in front of sod house, Woods Park, Custer County), about 1886. Nebraska State Historical Society, RG 2608 PH 0 1016.

addition to the soddy (as sod houses were called), dogs, chickens, and various tools. The famous plow that broke the prairie sits in a prominent position in the middle ground in an unidentified photograph, with the occupants placed between home and field (figure 56). The camera's position in the field allows Butcher to present the scene against the rise of earth behind the house. Although many homesteaders were not able to tuck their sod houses or dugouts up against such a sheltering rise, its inclusion in Butcher's photograph suggests the desirability of such a geographic feature. Variety in the land was important for the homesteaders' comfort, both physically and emotionally.[11] Along with elements that demonstrated a family's "proving up," such as crops, trees, and animals, natural features such as a hill or a pond were significant, and their presence influenced how Butcher framed the view. *Mr. and Mrs. Davis on Clear Creek near the Mitchell Ranch, Custer County, Nebraska*, and *James Pierce Home near Somerford, Custer County, Nebraska* (figures 57 and 58), for example, seem to be veritable views of paradise, with their thriving growth of trees and watering holes. The scenes verge on picturesque.

Despite his persistent use of figures, Butcher was also very much concerned with the landscape. His visual approach, for example, was to depict a "nested" landscape—where the immediate subject matter seems to be the homestead, its residents, and the activities of a farm seen at close range, while the larger plains loom

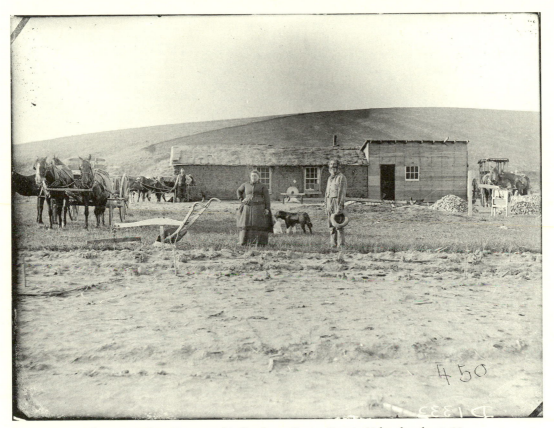

Figure 56. Solomon Butcher, *Homestead in Southeast Custer County, Nebraska*, about 1887. Nebraska State Historical Society, RG 2608 PH 0 1333.

undeniably, encompassing the smaller built environment.[12] Even though Butcher often highlighted the individual settlers, he sometimes chose to present them subsumed by their land. In some photographs, the distant horizon seems to lurk hazily on the edges of the picture, but in others, the clearly defined horizon slices the picture dramatically into sections of land and sky (figure 59).

The visual emptiness of Great Plains landscapes historically produced a conundrum for Euro-Americans attempting to represent, describe, or even understand them.[13] Because Custer County does not fit into the "sacred places" paradigm that dominated nineteenth- and even most twentieth-century attempts to understand the West, landscape meaning and settler identity there emerged more from settlers' construction of place, both ideologically and literally, than from any kind of aesthetic value in the appearance of the terrain that they could recognize.

The fundamental misunderstanding of the landscape of the plains occurred in response not only to its perceived aesthetic vacancy but also to its perceived agricultural value. Until the 1860s, most Euro-American immigrants mistook the region for a vast, infertile, and worthless tract of land. Popular understanding of the region was based almost exclusively on early accounts of travelers and government expeditions. For example, in Edwin James's 1823 *Account of an Expedition from Pittsburgh to the Rocky Mountains*, James declared that "in regard to this extensive

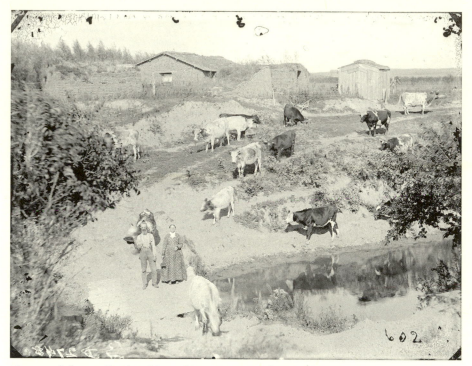

Figure 57. Solomon Butcher, *Mr. and Mrs. Davis on Clear Creek near the Mitchell Ranch, Custer County, Nebraska*, about 1886. Nebraska State Historical Society, RG 2608 PH 02748.

section of country, we do not hesitate in giving the opinion, that it is almost wholly unfit for cultivation, and of course uninhabitable by a people depending upon agriculture for their subsistence."[14] The influence of accounts such as James's on popular media is evident. For instance, in a brief 1824 account of the Long Expedition, the *Christian Register* reported that

> there is an extensive desert in the territory of the United States west of the Mississippi. . . . It extends from the base of the Rocky Mountains 400 miles to the east and is 500 from north to south. There are deep ravines in which the brooks and rivers meander, skirted by a few stunted trees, but all the elevated surface is a barren desert, covered with sand gravel, pebbles, etc. There are a few plants, but nothing like a tree to be seen on these desolate plains, and seldom is a living creature met with. The Platte, the Arkansas and other rivers flow through this dreary waste.[15]

Although only hinting at the complexity of the plains environment, the above passage discusses the "dreary waste" as valueless. This conception not only delayed settlement but also caused problems when Euro-Americans eventually did come to stay—with the accompanying extreme variation in rainfall, the locust plagues, prairie fires, and unceasing wind that fueled them representing only part of the problem.

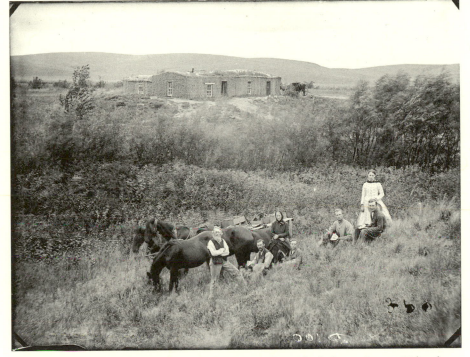

Figure 58. Solomon Butcher, *James Pierce Home near Somerford, Custer County, Nebraska,* about 1886. Nebraska State Historical Society, RG 2608 PH 0 1001.

A 1902 Union Pacific Railroad publication demonstrates that Americans were still grappling with the plains landscape:

> Surely no one, least of all those who have occasion to work in virgin-prairie soil in a practical way, can fail to discover that it is exceedingly hard digging and tremendously hard plowing for the first time. Who for a moment could expect it to be otherwise?
>
> Here is a State rich in marls and loess, subject to the beating action of countless storms and to the never ending tramp, tramp of millions of herds of buffalo, elk, deer, and antelope that once sought the luxuriant grasses of Nebraska above all other regions. If domesticated animals tramp down and pack to brick-like hardness the clays in the farmyard, so unnumbered wild herds, at large for generations, must pack the prairie.
>
> These unbroken prairies are so hard, firm and smooth that a bicycle can often proceed across them, and carriages can drive over them with ease and comfort. They are packed as hard as a well-traveled road.
>
> What is the effect of all this rainfall and moisture?
>
> Simply this, the soil beneath is covered with a hard, impermeable crust. The rain falls upon it, but does not enter it.
>
> Instead, it flows rapidly off to the nearest rivulet, thence it hurries to the nearest brooks and creeks, which swollen, rush like torrents to the

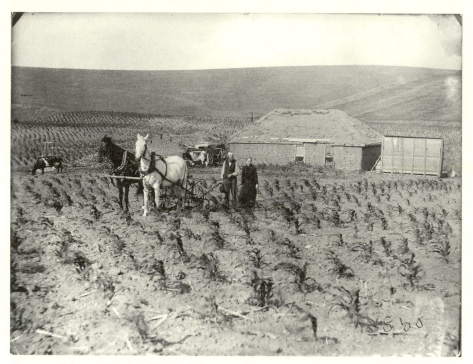

Figure 59. Solomon Butcher, *Using All the Farm for Crops*, Custer County, Nebraska, about 1888. Nebraska State Historical Society, RG 2608 PH 0 2023.

> tributaries of the great rivers, and soon the rain which might have entered the soil has left the confines of the State and is poured into the sea.
>
> Throw a pail of water on this hardened prairie and it flows freely in every direction as on a floor, but try the simple experiment of the cultivated ground and the water is absorbed on the very spot where it fell.[16]

The soil did indeed seem like an "impermeable crust," and breaking the prairie was no easy task. The John Deere polished steel plow, invented in the 1830s, made sod-busting a reasonable task: the endeavor to cultivate the region was now merely extremely laborious and no longer nearly impossible.

The early Euro-American misunderstanding of the region's environment determined the formal choices made by artists and illustrators. *Picturesque America*, for example, did not represent Nebraska at all in its pages. Although partly due to its relatively late settlement by Euro-Americans, the principal reason for excluding plains imagery was likely because it lacked the fundamental elements of a picturesque landscape (figure 60). Nevertheless, some representations show a struggle to capture the space of the plains. Photographers and artists were not trained to represent such a place—they were, after all, used to pointing their cameras at *something*, not at the seeming *nothingness* of the Nebraska grasslands.[17] Although Butcher displayed an occasional ability to render a picturesque scene from the landscape, he consistently downplayed the potential sublimity of the land. In

contrast, for example, to the ominous *The Prairie, on the Banks of the Red River, Looking South* by H. L. Hime (figure 61), Butcher tempered the overwhelming physical and aesthetic qualities of the plains because he intended his photographs to bolster community, not negate it. Hime's photograph is an atypical view of the plains as pure landscape that does not highlight human presence and dominance.

Hime's photographs of the Great Plains from the nineteenth century are exceedingly sublime. They uniquely depict the starkness of the plains landscape and the severity of the horizon line along the Red River as it ran from northern North Dakota up through Manitoba. Despite his obvious attempt to picture the "empty" plains as the primary subject matter, Hime did not produce images without content; they reinforce an already defined stereotype of the Euro-American conception of plains topography as featureless and without interest aesthetically, culturally, or environmentally. Hime's *The Prairie Looking West* goes beyond emptiness by including a bleached skull and randomly strewn human bones—dramatically turning a visually empty landscape into a threatening one with dire overtones (figure 62).

Hime's photographs, taken on Henry Youle Hind's expedition to explore Saskatchewan and Manitoba in 1858, stand in great contrast to Butcher's, whose work was expressly for the local clientele in and around Custer County. Butcher had very little interest in communicating austerity and emptiness and no desire to indicate a foreboding future. On the contrary, Butcher photographed the life and vitality of the settlers in the landscape almost exclusively. Their differing representations reveal not only the transformation of the prairie but the transformation of attitude.

Figure 60. Solomon Butcher, *Sandhills Farm Scene*, about 1908. Nebraska State Historical Society, RG 2608 PH 0 5223.

Figure 61. Humphrey Lloyd Hime, *The Prairie, on the Banks of the Red River, Looking South*, 1858. Library and Archives Canada, C-018694.

Figure 62. Humphrey Lloyd Hime, *The Prairie Looking West*, 1859. Library and Archives Canada, C-017443.

PORTRAITURE

In the absence of what the aesthetic tradition identified as meaningful in the visible landscape, Butcher focused his camera more intently on the people and the possibilities they represented. The landscape/portraits that Butcher produced represent more of a concerted effort to reflect local culture and history than the attempts of settler photographers in other, more visually replete landscapes where content could easily be identified in the scenery. Easterly, Whitney, and Britt, for instance,

all recognized content in their landscape subjects, even if that meaning was not fully developed or correct.

Butcher's approach was to strive to foster a sense of community not only by taking portraits but by identifying the individuals in a more significant manner. Take, for example, the image of the four Chrisman sisters, the first Custer County residents that Butcher photographed (figure 63).[18] As offspring of a major landholder in central Nebraska and substantial landholders themselves, the four young women represent the closest Nebraska had to an upper class.[19] The women—Harriet, Elizabeth, Lucie, and Ruth—are lined up in front of a sod house, well dressed, with hats in hand. The scene is atypically symmetrical and tightly framed for a Butcher photograph: the two flanking women wear dresses of the same material, and the horses on either side act as bookends. The photograph presents a typical sod house, but the house is not framed by the sweeping prairie landscape or the myriad animals typically found in a sod house's yard. No pitchforks or antlers litter the scene, and none of the typical details of a homestead, such as small potted plants or bird cages, hang in the doorway. In fact, the prairie grass seems to grow right up to the house's front door, revealing its lack of habitation.[20] The four women do not stand in front of their home; they stand in front of their property. According to the caption in Butcher's *Sod Houses or the Development of the Great American Plains: A Pictorial History of the Men and Means that Have Conquered this Wonderful Country*, this particular homestead and sod house belonged to Lizzie Chrisman, second from the left.[21] The four girls and

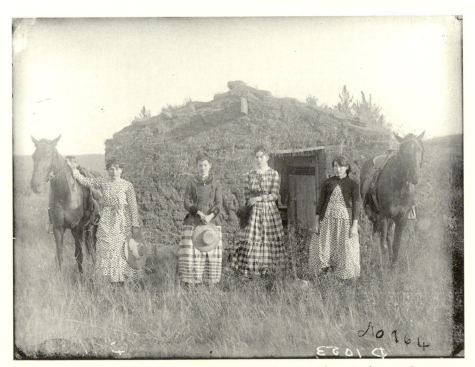

Figure 63. Solomon Butcher, *Chrisman Sisters, on a Claim in Goheen Settlement, Custer County, Nebraska*, about 1886. Nebraska State Historical Society, RG 2608 PH 0 1053.

three of their brothers took homesteads adjoining their father's, creating a ranch encompassing an area of more than one thousand acres. Family members often erected token homes on different (but often adjoining) homesteads, staying only long enough in each to comply with the occupancy laws stipulated by the government in the terms of their homesteading contract. The landscape surrounding the sod house was not likely to have been altered significantly by the women's brief residency and was probably considered an undesirable component of the photograph by all involved. As ostensible signs of habitation and progress surrounding the sod house were unavailable, Butcher focused more on the attractive young women than on their relationship to their homestead.

The photograph depicting George Barnes and his children (figure 64) presents a striking contrast to that of the Chrisman sisters. The widower George Barnes stands with his three children in front of a caved-in sod house. The misfortune of their recently collapsed roof is made more heartbreaking by the knowledge that Mrs. Barnes had died the year before.[22] Butcher has captured, along with the details of the trampled yard, barefoot children, and hitched team of horses, a scene of wrenching pathos that, although similar in form to many of his other photographs, yields a starkly different and individual content. Again, the landscape does not figure into this photograph and Butcher's intuitive sense of how to frame it.

Butcher's insistence on emphasizing the individuals over the homesteads and their surrounding landscape is also apparent in his photograph of the Shores family

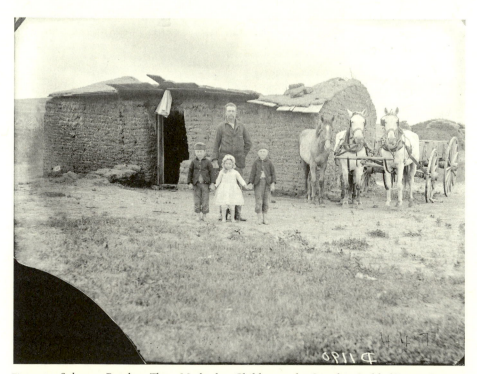

Figure 64. Solomon Butcher, *Three Motherless Children and a Caved-in Soddy* (George Barnes family, Custer County), about 1887. Nebraska State Historical Society, RG 2608 PH 0 1190.

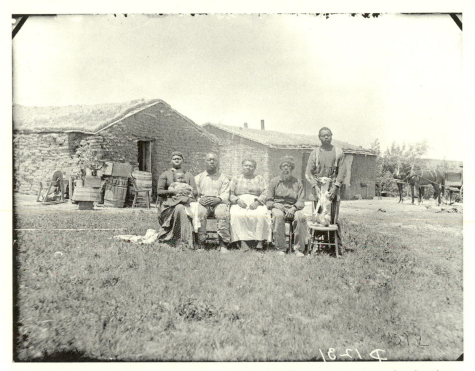

Figure 65. Solomon Butcher, *Shores family, near Westerville, Custer County, Nebraska*, about 1887. Nebraska State Historical Society, RG 2608 PH 0 1231.

(figure 65). For a family of African Americans, victims of the heinous American institution of slavery a few decades earlier, their photograph is a depiction of success, albeit a different kind of success than that of the Chrisman family.[23] The Shores family consisted of three generations, some born into slavery and some born free, but all sitting serenely in the front yard of their home on their homestead. The success and perhaps triumph of this family is evoked by the details that bind many of Butcher's photographs together—a team of horses standing hitched in the background, potted plants, various barrels and chairs, a grindstone, and a pet. It is easy to imagine the gaping expanse between the Shores's experience of Nebraska and that of the Barneses. Both images show homestead families on their land in front of sod houses, but one evokes loss and the other a new, promising life. The biographical information about the Chrisman, Barnes, and Shores families creates a meaningful context for the photographs and exemplifies the wide variety of stories that would have been represented in Butcher's intended album.

The individual photographs of Custer County residents provide glimpses into the lives of a specific group of people. Unlike portraits produced in a studio, however, the sod house photographs represent them at home, on their own land. These images are intimate compared to more formal photographs, revealing the conditions of life that a studio view could not capture. In fact, the lack of studio portraits in the bulk of Butcher's oeuvre makes him a unique nineteenth-century settler photographer.

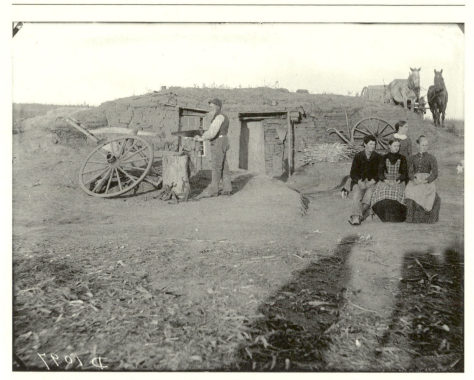

Figure 66. Solomon Butcher, *Rev. William McCaslin Home in Rose Valley, Custer County, Nebraska*, about 1886. Nebraska State Historical Society, RG 2608 PH 0 1097.

The images also reveal details about the choices and challenges Butcher faced as a photographer. As he drove the dirt ruts of Custer County with his photographic equipment, his intent was to focus on the individuals of a particular family and their homestead's physical situation. Thus, Butcher was continually assessing the conditions that might affect his image, such as weather, time of day, and cooperation of the family, as well as the quality of the view surrounding the home. Indeed, individual photographs record Butcher's general concerns as a photographer as well as document the specific challenges that each homestead presented. Take, for example, the 1886 photograph of Reverend William McCaslin and family in front of their dugout sod house in Rose Valley, Custer County (figure 66). In this photograph, the family is arranged in front of their sod house—a typical composition for Butcher. Interestingly, the sun was low in the sky, shining directly into the eyes of the McCaslin family. To compensate, Butcher had the family members gazing off at oblique angles instead of directly into the camera. Unfortunately, the early morning or evening sun was often Butcher's light source. Although he seemed to have been more interested in framing the sod house behind the sitters than in attending to details of lighting and time of day, perhaps it was not Butcher at all but rather the busy schedule of the family that determined when the image was taken. An interesting result of this unfortunate timing is the eerie shadow of

Butcher and his equipment that falls in the immediate foreground at the feet of the seated family.

Besides time of day, the details of the family's sod house and yard speak of Butcher's choices. Images such as *The George Ball Homestead at Woods Park, Custer County, Nebraska* (1886), or *The Sylvester Rawding Family, North of Sargent, Custer County, Nebraska* (1886), indicate that a muddy, sloppy yard or a wandering animal were often included (figures 67 and 68).[24] Although he took the photographs when he had the opportunity, the serendipitous details certainly embodied the local flavor that Butcher sought to capture. Butcher likely needed more time to capture the "right" conditions for a photograph than the people of the Nebraskan prairie had to be interrupted. The images suggest that the struggles of homesteaders were at once highly individualistic and common, and, fittingly, the photographs are both similar and diverse. Like the views of the Chrisman sisters, the Barnes and Shores families, and countless others, most of Butcher's scenes find a family posed in front of a dwelling. In some, there is a sense that the occasion of a photograph was an extraordinary one, and special clothes, shoes, and white shirts or dresses were brought out. Likewise, objects of pride are displayed: family photographs, plants, beloved pets, and musical instruments.[25] Other times Butcher seems to have interrupted the very busy lives of his subjects, and animals and children fidget restlessly, captured by Butcher's camera as a blur of activity.

Figure 67. Solomon Butcher, *The George Ball Homestead at Woods Park, Custer County, Nebraska*, about 1886. Nebraska State Historical Society, RG 2608 PH 0 1069.

Figure 68. Solomon Butcher, *The Sylvester Rawding Family, North of Sargent, Custer County, Nebraska*, about 1886. Nebraska State Historical Society, RG 2608 PH o 1784.

THE NATIVE AMERICAN LANDSCAPE

In addition to its perceived paucity of desirable aesthetic characteristics, plains settlers were not skilled at seeing the land as a discernible record of Native American history. As in other western landscapes, however, place had already been culturally and physically shaped by Native American residents long before Euro-American immigrants appeared. In the Great Plains region, especially, an indifference to how the Apache and Pawnee and others understood the place characterizes modern conceptions. These regional Native Americans would have perceived this plains landscape as full of historically and culturally significant places.[26] Western historian Richard White further illustrates the discrete cultural vision of landscape of the Pawnee and of Euro-Americans when he recounts an interaction between Pawnee Chief Peta-la-sharo and government agent Samuel Janney in 1871:

> Worlds encompassed more than the physical world their senses revealed to them. They both saw Americans, Pawnees, and Sioux; grass, cornfields, cottonwoods, and willows; rivers and streams; horses and buffalo. Culturally, however, each man ordered these elements in distinctive ways and gave them different meanings. Out of the same environment, they constructed different landscapes. As accurately as Samuel Janney saw the components of the Pawnee landscape, its order and meaning escaped him.[27]

The Central Nebraskan region of the Great Plains is perhaps the most dramatic example of how different cultures can perceive the natural environment in strikingly diverse ways and construct landscapes accordingly.

As we have seen at Minnehaha Falls and Crater Lake, aesthetically pleasing landscapes encouraged Euro-Americans to imagine Native American relationships to the environment in a romantic and mythical manner. Very little imagination was dedicated, however, to the importance of the plains for Native American inhabitants. In the absence of any obvious indications of a preexisting culture, such as St. Louis had in its many earthen structures, homesteaders did not confront the local Native American history, despite the thousands of years of Native American impact on the land. The lack of concern given for the region's cultural past is most likely because a sacred and romantic Native American legacy on the plains was not useful for homesteaders, who instead chose to focus on the notion of a tabula rasa.

The absence of Native Americans and visual signifiers of their cultural past, like the absence of the picturesque, define Butcher's photographs. As in other western communities, however, ambivalence seems to have been at the heart of residents' attempts to understand the history of their location before their arrival. Although countless sources from the period reveal a deep awareness of the Plains Indians, they simply do not figure in Butcher's landscapes as other tribes did in their respective regions. His images neither reveal Native American earthworks, nor are they rich in native lore. Unlike the landscape images of Easterly, Whitney, Britt, and others, Butcher's images do not co-opt the local indigenous past as a narrative counterpart to the promising Euro-American future. In Butcher's photographs, as in the plains themselves, settlers saw possibility and open space for future development. The conscious shaping or "proving up" of the blank slate into a landscape with value encouraged the early residents of Custer County to see themselves as the original stewards of the land, and this was the initial impetus for Butcher's album scheme.

THE BOOK AND HALF-TONE TECHNOLOGY

Butcher's *Pioneer History of Custer County* was romantic, practical, and based on a plan both altruistic and cunning. In general, Butcher's photographs and biographies chronicled central Nebraska's Euro-American community's unique experience and desire for documentation. Although he was mindful of his role as recorder of pioneer life, Butcher's overarching purpose, as with so many other settler photographers, was to make money by selling photographs and, in this case, specifically by selling his book. To this end, the promise of a family's inclusion in his book must have been alluring. As Butcher wrote down biographical details, the immortality of print may have seemed an enticing notion to the homesteaders. For many, especially those who had recently emigrated from foreign countries, a formidable record of their efforts in such an album would have celebrated their achievements, eased their displacement, and somehow softened the severe break with the past that

was an unfortunate aspect of moving west to occupy land. Displacement and isolation were particularly harrowing problems for European immigrants, because their homeland farming practices had, typically, located families together in a village instead of separating them so that each family inhabited the field they tilled.[28] If Butcher had succeeded in his endeavor, that album could have been successful (depending on how many subscriptions he sold), with hundreds of entries that had the potential of being well received among the homesteaders.

Ironically, very few of the sod house images made it into the final product. In fact, only eighteen such photographs are included. Very few scholars question his shift in focus, suggesting instead that the sod house photographs were too "commonplace" to draw the interest of Butcher's prospective readers.[29] The number of sod house photographs and family histories suggests otherwise. Likewise, local newspaper accounts reporting Butcher's arrival in towns and describing his project also suggest community interest. Waning interest may rather have been due to the inordinately long time it took him to complete the project.[30] Moreover, Butcher did not change the format of the book as a response to consumer demand but primarily because a chimney fire on March 12, 1899, destroyed his house and all of his recorded histories:

> On the morning of March 12, 1899, we saw our home and its contents go up in smoke, with no insurance and all our seven years' work of compiling biographies. But I still had the negatives of farm views and determined to make another effort. How well I have succeeded I will leave the reader to judge after he has read this book to the last page and looked at the last picture, and hope you will always hold in kindly remembrance, your humble servant, S. D. Butcher.[31]

This passage indicates that he was aware of the disappointment and vexation many people may have felt about the exclusion of their images and historical accounts because of the necessary reformatting of his book and vision. After the fire, Butcher was left with many prints and negatives but practically no biographical information to go with them. That fateful day when the histories burned not only changed the content of the book but also altered the fate of the photographs. Left with hundreds of unidentifiable portraits, Butcher believed that the images had been rendered significantly less meaningful, especially as individual histories. Because *Pioneer History of Custer County* lacks most of the photographs from the sod house era, it represents a mere shadow of its original conception.

After the fire, Butcher would have had to make some very important decisions. It had taken him years to collect the biographies the first time around, so it is unlikely that he considered collecting them again. The land area of Custer County is huge, and inevitable isolation on the prairie prevented extensive social relationships. The families of the county were not people he knew, nor would he have remembered their stories or even been able to recognize them from his own prints and negatives—and they were not only Butcher's intended subject matter, they were also his audience. He seems to have addressed them in the preface of his book:

As you turn the pages of this book and see the familiar landmarks of former years, you will begin to appreciate the endeavors of the man who, for fifteen years, has labored against many difficulties, and is at last able to place in your hands a truthful history of pioneer life in Custer County.[32]

Instead of the "truthful history of pioneer life" in album format, *Pioneer History of Custer County* was published as a compilation of tales and local legends gathered from a variety of sources. In this final version, others wrote many of the chapters. Apparently, Butcher put out a call for locals to add their own memories and histories.[33] He recognizes them in his preface: "We thank those gentlemen who have kindly furnished us articles over their own signatures, besides the many pioneers who have furnished us manuscript to be boiled down and which is made the foundation on which our history rests."[34] Butcher also admonishes the locals who did not come forward with their own manuscripts and versions of events:

If, in looking over the pages of this book, you find a fuller description of some other portion of the county than of your own, pause before criticising the historian and ask if it is not your own fault that you are not more fully represented. If you have done any great deeds in Custer county which are worthy to go down in history, was it not your duty to have them recorded?[35]

And indeed, one portion of the county was emphasized more fully than others— Butcher's own central location. Many of the family histories and local legends originated from Butcher's hometown of Broken Bow, and this section contains town views and ranch images that postdate the 1899 fire. It appears that Butcher did some fairly intense catch-up work in order to publish his book by 1901.

Luckily, one of his subscription notebooks from the early years of the project escaped the fire that burned the rest of his precious biographies. It contains some original information that can be compared to Butcher's final product and illuminates some of the changes that took place between 1886 and 1901. For example, both the book and the original subscription notebook contain information about a fellow named E. S. Finch. The entry concerning this man in the final publication is remarkably similar to the other short pioneer biographies in the surviving notebook.[36] Butcher notes that Ephraim Swain Finch was born on March 25, 1836, in Richland County, Ohio, and that his father's name was John. It also says that E. S. Finch married Sarah Moore in Iowa City, Iowa, on August 20, 1863. She was originally from Zanesville, Ohio, and her father's name was George. They arrived in Custer County in the spring of 1875 and claimed a homestead. Butcher goes on to remark that Finch and his brother, D. H. Finch, had been cattlemen in Custer County for twenty-five years. They had three and a half sections of land, with 320 acres under cultivation and two thousand acres fenced. They also had frame buildings and seven "spring brooks" on their property that fed into two fishponds capable of producing twenty-five pounds of carp.[37] Mr. and Mrs. Finch ordered six

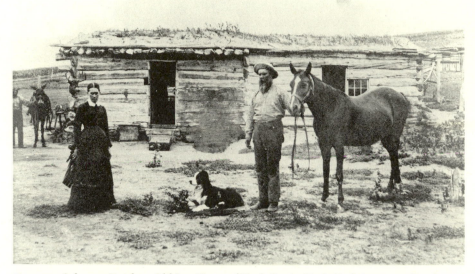

Figure 69. Solomon Butcher, *Old Log House of Uncle Swain Finch, Built in 1875 on South Loup River in Nebraska*, about 1880. Nebraska State Historical Society, RG 2608 PH 0 2156 a.

prints of a photograph of the fish pond and six prints of the photograph of their house, totaling six dollars.[38]

Although this notebook entry is typical in some ways, E. S. Finch was represented in the final book in a way that the other pioneer families were not. Uncle Swain (as he was known) was integral to Butcher's post-fire project and was given prominence in the introduction:

> And last, but not least, we wish to thank the man who has come to our aid financially, when the clouds seemed to be the blackest and most gloomy, and our book had again almost come to a standstill for want of means to push it to success. How glad it made our heart when Uncle Swain Finch said, "Butch, you have worked faithfully and deserve success, and if the people of Custer County want a history, by George, they shall have it."[39]

Although Butcher originally seems to have recorded his biographical information with no special favor or prevalence attached, Uncle Swain (E. S. Finch) was a local man of repute, and his financial assistance after the fateful 1899 fire seems to have garnered him a privileged entry in the final publication. Finch figured prominently in the Buffalo and Dawson County histories as well. In newspaper articles from the *Custer County Chief, The Custer County Beacon*, and the *Custer Co. Republican*, he is named as a supporter and financial backer of Butcher's projects. The articles also suggest that this association would help the Buffalo and Dawson County histories turn out better than *Pioneer History of Custer County*.[40]

The history of Finch in Custer County, which is in a chapter titled "Old Settler's Story," illustrates the necessary changes Butcher made to his publication. The book

describes John Swain's initial journey to Custer County, as well as Finch's own exploits and success in the region—including a log cabin and a pond (figure 69, pond not shown). The other image to accompany the chapter was a more recent photograph, concocted in 1900 to illustrate Finch's tale of grasshopper infestation (figure 70). Besides Finch appearing older and heavier in this image, the obvious addition of scratched-in grasshoppers exemplifies Butcher's attempt to recreate past events to augment his book.

Despite the setbacks that delayed publication, such as a chimney fire and considerable drought, Butcher sold two thousand copies. Rightfully proud, and considering it a great success, he began planning other projects in Dawson and Buffalo Counties, as well as another book, titled *The Cowboy Shorn of His Hoofs and Horns, or Fifty Years Hustling on the Western Plains*. These later endeavors, although never brought to fruition, can be a useful source of information about his initial Custer County project. Specifically, even though the *Pioneer History of Custer County* was not the picture album he intended, it is clear that Butcher continued to believe an album compilation a worthy ambition, because he took up the same technique and returned to that format in his preparations for the Dawson and Buffalo County histories. In fact, the recording of personal histories became a more streamlined operation. Preprinted subscription booklets replaced the blank notebook pages that served as his earlier log. These subscription pages illustrate Butcher's original vision for his earlier book and more clearly state the nature of his endeavor (figure 71). Here, Butcher explicitly sold space in the book for the inclusion or mention of a family portrait and history. Also, in an effort to represent and resell an expanded and enlarged version of the Custer County book, Butcher again used a preprinted subscription form (figure 72).

For this expanded version, conceived in 1916, Butcher's subscription notebook indicates that he was reselling the space in written and half-tone engraving form. Because the photographs had been taken decades before, Butcher was offering the same people another chance to be included in the book. But instead of buying

Figure 70. Solomon Butcher, *Ephraim Swain Finch Demonstrating How He Killed Grasshoppers in 1876*, 1880s. Nebraska State Historical Society, RG 2608 PH o 2156 h.

prints, subscribers were entitled to a "one-fourth page space for reading matter (or pictures furnished by me at my expense)."[41] This particular line from the subscription booklet indicates an underlying problem with the enlarged version of the Custer County histories. Without the original family histories for the old photographs, he could not identify the people. Butcher was hoping that the families of Custer County could come up with the image he created years before, give him another account of their family history, and buy a subscription for his new book, even if they already owned the first one.

Butcher also went to great lengths to re-identify the original homesteader portraits for his new book. He advertised in the newspaper for old-timers who had photographs and could match up names to negative numbers.[42] He also retraced his original routes around Custer County, talking to people and trying to secure the information. In a letter to Addison Sheldon of the Nebraska State Historical Society, dated May 10, 1916, Butcher describes his interest in re-identifying the old photographs:

> I have made a scrap book of the proofs and pictures 4/6 that I made for myself and that has taken lots of time and I have trimed [sic] all the large

Figure 71. Solomon Butcher, order form, nd. Nebraska State Historical Society, RG 2608 AM, 45048.

Figure 72. Solomon Butcher, order form, 1903. Nebraska State Historical Society, RG 2608 AM, 45047.

ones and put the numbers on the backs of all of them that any one could recognize and so far as I have been able to do. My object now is to take the numbers from the backs of these picts. as they are, and put them on my proofs, then carry the book of proofs this summer and get the names of those I havent allready [*sic*] got.[43]

In September 1916, when Sheldon suggested sending prints to the Custer County Fair as a means of securing identities, Butcher responded:

I am advertising for the old settlers to send me the numbers on my old pictures so that when I get back we can Identify a lot more of my negatives, when I come down to help catalog them and make prints from the negatives, we may be able to make enough extra pictures from these negatives, at 50cts apiect [*sic*] to help pay for the printing. Yours Truly S. D. Butcher[44]

These two excerpts show Butcher's knowledge of the extraordinary nature of his original photographs and their value for pioneer history. Likewise, his effort to revisit the aims of his initial project shows his inclination to make good on his earlier promises. After so many years spent in service to the Custer County project, he seems to have needed to produce a book more closely matching his original vision.

Butcher, like other western photographers, banked on his participation in the early days to garner social status and continued business in his later career. By the turn of the twentieth century, however, much had changed around Broken Bow and in Custer County. Instead of the ubiquitous sod dugout, stick-frame houses were being erected, and the early settlers had fulfilled the terms of their initial home-stead claim. After fifteen years of working on his project, Butcher was confronted with a different audience than the one he originally identified in 1886. Indeed, the way of life that he had tried to capture had mostly passed during the time it took him to complete his book.

Three years after *Pioneer History of Custer County* was published, and in the midst of many ongoing projects, Butcher did produce another book, titled *Sod Houses or the Development of the Great American Plains: A Pictorial History of the Men and Means that Have Conquered this Wonderful Country.*[45] One of the most interesting aspects of this booklet is its format. It offers the reader a photo-essay of the changes on the Nebraska frontier, pairing the original views of sod house homesteaders with more current photographs of the same families in front of their new wood-frame houses. *Sod Houses* is further proof of Butcher's interest in the architecture of homesteaders as a defining characteristic of their experience. More important, the publication reveals Butcher's desire to document the fulfillment of the homesteaders' earlier belief in the limitless possibilities that the plains seemed to offer.

Sod Houses reveals, as well, Butcher's urge to create a picture album that would, through the inclusion of multiple images, create a narrative of community.[46] Also, his focus on the written biographies before the 1899 fire and then again in his later Dawson and Buffalo project suggests his interest in the word-and-image

combination in an album format. Finally, his attempt to redo the Custer County
project and the 1904 *Sod Houses* booklet suggests that the first publication did not
fulfill his expectations for the project.

Butcher eventually turned to the Nebraska State Historical Society, where his
sod house photographs were unified as an archival resource. In 1911, with the help
of Sheldon, Butcher began the process of selling to that institution his collection of
glass plate negatives for six hundred dollars.[47] At present, Butcher's photographs of
Custer County settlers are often used individually to illustrate homestead life. They
represent discrete moments on the prairie, but to see one photograph out of the
context of the whole project is to miss one of the crucial reasons Butcher made the
images. His main interest was to focus on the details of particular lives in order to
create a larger document of shared experience. Even though this goal was never
fully achieved in the way he intended, Butcher realized his most fundamental as-
piration—to portray a remarkable era for the benefit of his community.

Even without the documentary history, the Solomon D. Butcher Archive of
photographic prints and glass plate negatives is a unique and important entity in
its own right. Today, our image-sophisticated culture recognizes (or should rec-
ognize) Butcher's photographs as more than mere illustrations of bygone days:
they comprise an extremely large and complex visual narrative that speaks vol-
umes about the people and places of the homestead era on the Great Plains.
Photograph after photograph in the archive reveals hardship, pride, determina-
tion, success, and disappointment. Although details such as marriage dates, num-
ber of children and cattle, and the amount of fenced acres are mostly lost, a
devastating circumstance that derailed Butcher's project, the archive continues to
have a strong narrative voice. In fact, the recent digitization of the Butcher collec-
tion and its inclusion in the massive Library of Congress "American Memory
Project" website underscores its importance.

Butcher's intended album would have bound the people of Custer County to-
gether as something of a family, a visual and textual relationship among widely scat-
tered and disparate people. The final product would have unified the people of Custer
County visually by binding their likenesses together, but even as anonymous views,
Butcher's images tantalize with their striving toward community; they offer a new
way to understand the western plains, and one culture's narrative of the achievement
of individuals at home—creating roots—in their own sweeping locale.

‖ 5 ‖

Performing the Pioneer

*The Kolbs, the Grand Canyon,
Photographic Self-Representation, and Moving Pictures*

In the long run, the memory of the men, their character, and their
exploits may well outshine their photographs.
—Bruce Babbitt, *The Kolbs and Their Photographs*, 1978

VIEW HUNTERS

IN 1904, THE GRAND CANYON photographers Emery and Ellsworth Kolb pro-
duced an image titled *The View Hunters at Work in the Canyon*. It shows Emery
dangling in a rope harness with a cumbersome-looking camera while Ellsworth
stands astride a narrow gap, supporting him from above (figures 73 and 74). The
vertical framing device of the narrow space between the two precipices provides a
stunning counterpart to the equally dramatic view across the canyon. The Grand
Canyon is the effectively utilized backdrop, with a horizon line that splits the image
in half, highlighting each brother against a void of canyon and sky. They success-
fully used the photograph over the course of several decades to promote themselves
and their work, capitalizing on the hazardous-looking situation—one that was
carefully constructed to show their dedication and mettle as "view hunters."

Hoping that these photographs would make their way across the country in the
form of postcards, as part of their Grand Canyon souvenir sets, and eventually in
their publications, the Kolbs were gambling that travelers to the region would re-
member them as the daring duo that would go to great lengths to capture sensational
views (figure 75). In the photographs, the brothers were essentially displaying *them-
selves* as a tourist attraction. In establishing their studio at the Grand Canyon rim in
the first years of the twentieth century, they used a savvy promotional tactic that, for
decades, would comprise their core strategy for garnering customers. A handful of
images like *View Hunters* testify to not only the brothers' self-promotional tendencies

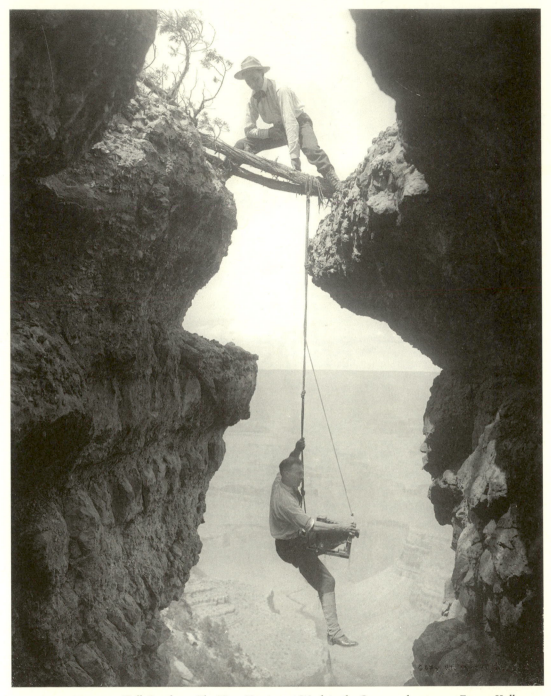

Figure 73. Kolb Brothers, *The View Hunters at Work in the Canyon*, about 1904. Emery Kolb Collection, Cline Library, Northern Arizona University.

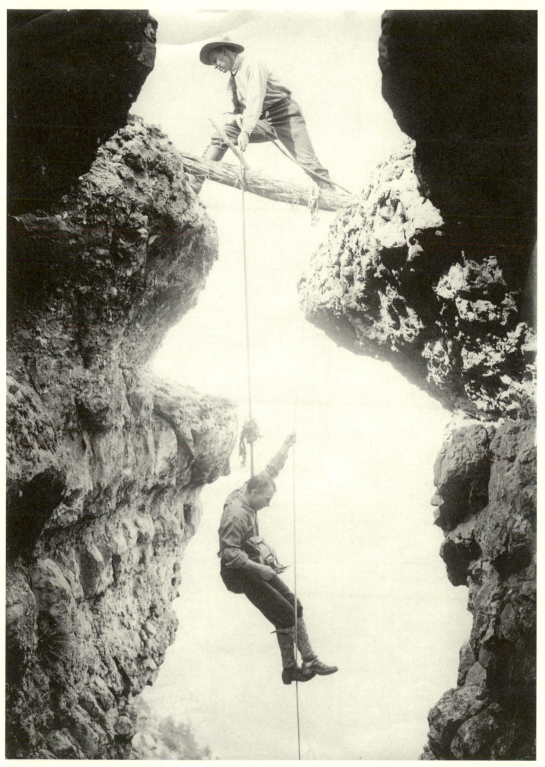

Figure 74. Emery Kolb, *How a Difficult Photograph Is Secured*, 1902–1913. Emery Kolb Collection, Cline Library, Northern Arizona University.

Figure 75. Kolb Brothers, *The Grand Canyon of Arizona*, Grand Canyon souvenir album, 1913. Yale Collection of Western America, Beinecke Rare Book and Manuscript Library, Yale University.

but to their desire to create a narrative about their lives in the canyon. One view, for example, shows Emery with a tripod perched precariously on the almost vertical slope of the canyon wall (figure 76). He poses as if in the process of taking a picture, while Ellsworth (presumably) photographs him from below. In yet another scene, Emery dangles from a rope as he passes from a tree in pursuit of a view of Cheyava Falls (figure 77). Although depicted without a camera, Emery is emphasized as a vital and daring character. Still other photographs highlight the adventures of the Kolbs and the risks of photographing such a place (figures 78–80).

More than just a representation of their audacity, *View Hunters* is a fascinating image for other reasons. First, although the photograph shrewdly communicates a compelling narrative of bravery and industry, the image is an odd conflation of subject and object. Because the picture is of the photographers themselves at work in the canyon, it is unclear who is taking their picture. Are the brothers really working, or are they just posing? Second, although the tremendous tourist market in the Southwest drove the Kolbs' enormous photographic output, their particular style of self-representation connected them to the lineage of western photographers that preceded them and highlights the impact that the previous generation of settler photographers had on the West. The Kolbs' canyon-centered photography had the site specificity that characterized typical nineteenth-century photographers such as Easterly, Whitney, Britt, and Butcher—as they lived in and identified with the particular place they photographed. Instead of catering to a local clientele and symbiotically building community and their business the way others did in the earlier West, however, the Kolbs were essentially *enacting* an earlier form of the western photographer for tourists by highlighting new experiences in a terrain that until the early

twentieth century was beyond the reach of most travelers. Furthermore, the Kolbs' emphasis on their own audacity was a response to the development of the American West and their own evolving medium. They were moving beyond the thrill of the landscape for its own sake and adopting new strategies of promotion that took the "pioneer photographer" as their dominant narrative.

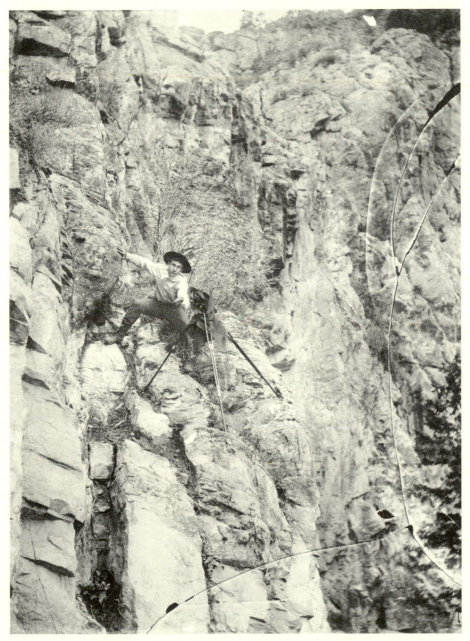

Figure 76. Emery Kolb, *Emery Kolb with Camera, Cape Royal Rim, Grand Canyon*, 1906. Emery Kolb Collection, Cline Library, Northern Arizona University.

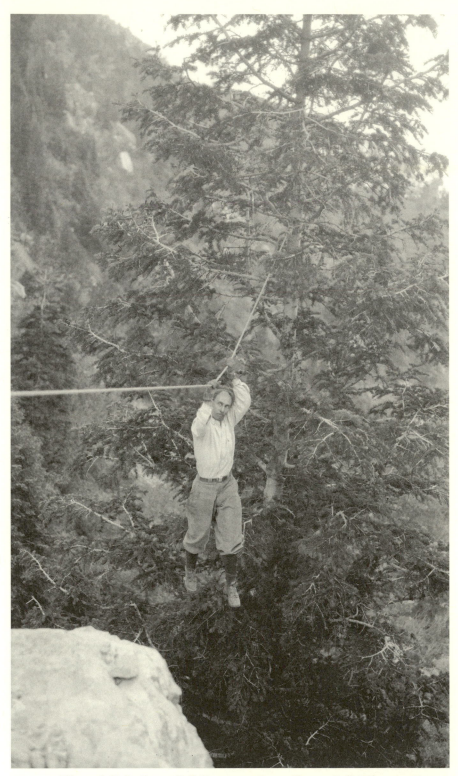

Figure 77. Ellsworth Kolb, *Emery Kolb Hanging on Rope, Cheyava Falls Hike*, 1930. Emery Kolb Collection, Cline Library, Northern Arizona University.

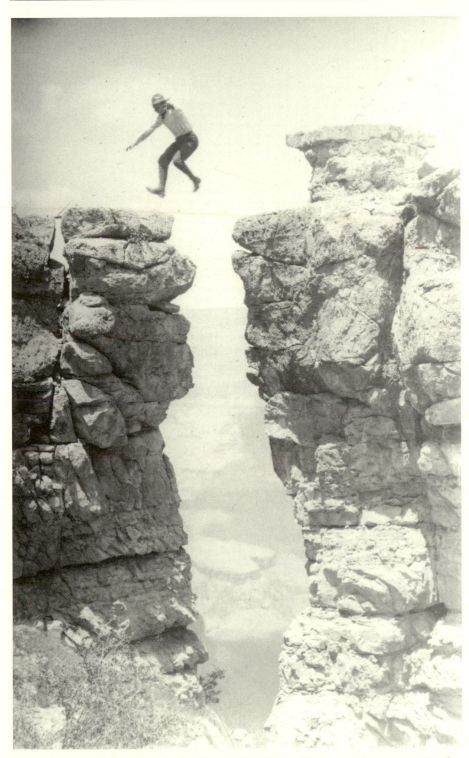

Figure 78. Emery Kolb, *A Leap in the Interest of Art: Not as Dangerous, However, as It Looks,* 1902–1913. Emery Kolb Collection, Cline Library, Northern Arizona University.

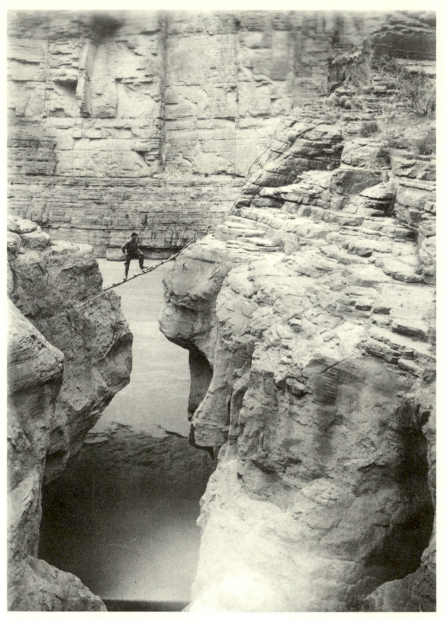

Figure 79. Emery Kolb, *Looking Across the Colorado River from the Mouth of Havasu Canyon: Cataract Creek*, 1913. Emery Kolb Collection, Cline Library, Northern Arizona University.

KOLB BROTHERS PHOTOGRAPHY

Even though the Kolbs focused on dangerous escapades that highlighted the western landscape as untamed and wild, as it had been popularly perceived a generation before, they did so by fully utilizing the modernity offered by the early decades of the twentieth century. Their own activity at the canyon became the underlying subject matter not only for countless still images but for what would become their most important photographic feat—a 1911 film of their trip down the Colorado

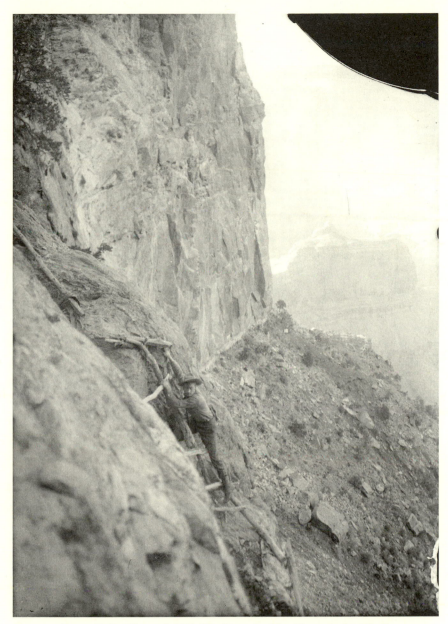

Figure 80. Emery Kolb, *Ellsworth Kolb Climbing a Ladder, Hummingbird Trail,* 1902–1976. Emery Kolb Collection, Cline Library, Northern Arizona University.

River. Their achievement was a response not only to rapidly changing technology (in photography and otherwise) but to the desires of their clients and the cultural ideas about the place they photographed.

Ellsworth Kolb's arrival at the rim of the Grand Canyon in 1901, along with that of the Santa Fe Railway, was auspicious. There he met Ralph Cameron—entrepreneur, hotel owner, and tour guide—who convinced him of the lucrative and impending opportunities in the area (figure 81). Cameron originally had mining claims along the rim of the Grand Canyon and at Indian Garden. Before the arrival of the railroad, he

had built a hotel on the rim and begun to develop Bright Angel Trail, turning the hazardous old path into something passable for tourists.[1] Soon after, Emery joined his brother, bringing with him the burgeoning skills of a photographer, and they began a business taking pictures of tourists. From 1903 to Emery's death in 1976, their business remained a working studio, situated on the south rim of the canyon, strategically located at the head of Bright Angel Trail (figure 82). Their bread and butter were the trail photographs that they began taking in 1903 (figure 83). As burro-riding trains of tourists descended to the Colorado River, Emery would take their portraits, run down to the water supply at Indian Garden (three and a half miles below the rim), develop the negatives, and then run back up to the rim to make prints to sell by the time the group returned—a common approach to tourist photography that went back to the early days of the daguerreotype.

The story of the Kolbs at the Grand Canyon is most often told with a focus on their romantic struggle to photograph the awesome canyon; the overriding theme is the rugged individualism of western character, with the traits of fortitude, doggedness, and bravery.[2] Theirs is an easy story to tell, because the Kolbs were extraordinarily adventurous individuals, just as they imagined the photographers in the nineteenth-century West who preceded them. The tale of their life at the canyon, however, was crafted by the brothers themselves as they sought to draw in touring customers by holding up their own life and work as a bona fide western experience. In other words, even as they struggled to commercialize the canyon, they did so by invoking what had become a tradition of western photographic adventure as a counterpoint to the increasingly modernized world.[3] Most ironically, their nostalgic identification with the legacy of previous river trips rested largely on their ability to tell their story via moving pictures, the most modern of photographic technologies.

They likely began toying with the idea of a river trip soon after their arrival at the canyon, and they solicited local river runner Charles Russell's advice.[4] Among other things, Russell was an Arizona miner who had already run the Colorado River purely for sport and adventure. In a May 17, 1908, letter, he wrote:

> I should be greatly interested in such a trip as you contemplate, and should you succeed you would be the first parties to secure a continuous series of good photographs of the canyon. I should like very much to talk the matter over with you as I think I could give you some valuable pointers that would be worth your while.[5]

Russell's postscript asked: "Say why don't you try to work up a scheme among some of the tourists this summer to take the trip down the canyon many would like to do it, and you might get some wealthy fellow to put up the expenses for a party. If it was arranged right I might be induced to go through again."[6] The Kolbs, however, chose not to take Russell, nor did they choose to make their trip available to tourists. Instead, along with their decision to film the adventure, they decided to make themselves the principal protagonists and focus on a product that could be resold indefinitely through repeated screenings.

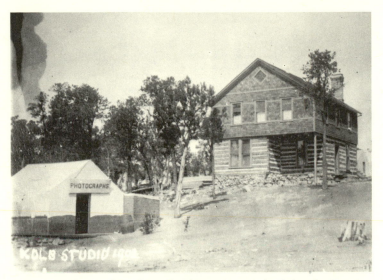

Figure 81. Emery Kolb, *Kolb Brothers' First Tent Studio, below the Cameron Hotel, Grand Canyon,* 1903. Emery Kolb Collection, Cline Library, Northern Arizona University.

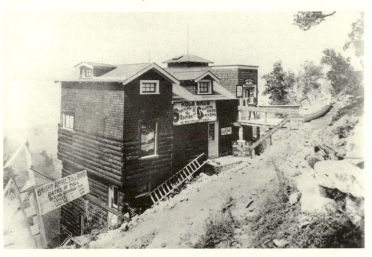

Figure 82. Emery Kolb, *Kolb Studio,* 1914. Emery Kolb Collection, Cline Library, Northern Arizona University.

The early 35 mm film that the Kolbs took of their river trip was more than a simple novelty of the modern age in the early years of motion-picture technology. More than their other products, the film was their most successful tourist commodity. Not only did it allow the American public to experience the Grand Canyon as never before, it also allowed them to experience the adventure of true westerners. The brothers were packaging the adventure as they were having it, creating the ultimate memento—one that people would pay to see but could not physically take with them. More than a simple souvenir, the greatest Kolb product was the vicarious experience that others could have through the brothers' genuine experiences in the depths of the vast and awesome Grand Canyon. To be sure, their experience

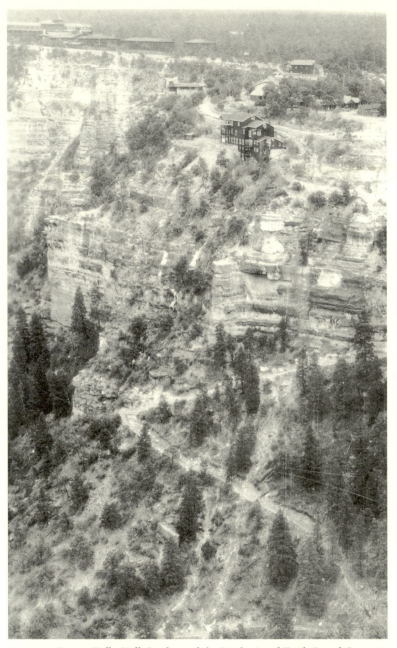

Figure 83. Emery Kolb, *Kolb Studio and the Bright Angel Trail*, Grand Canyon, 1925. Emery Kolb Collection, Cline Library, Northern Arizona University.

as canyon residents, as portrayed in photograph and film, inspired their audience to consider them as daring, exhilarating, and pioneering. The Kolbs tactically utilized the underlying self-promotional narrative of localism exemplified in *View Hunters* for the historic journey, and because the trip was as much about their own fearlessness as adventuring western photographers as it was about the canyon, it has become the Kolbs' most enduring story.

MOVING PICTURES AND THE ILLUSTRATED LECTURE

On September 8, 1911, Emery and Ellsworth Kolb pushed off from a riverbank on the Green River in Wyoming to begin their historic journey.[7] Producing their film took them, intermittently over the course of two years, down the Green River to the Colorado, through the Grand Canyon, and eventually on to the Gulf of California (figure 84). With meticulously designed boats, they faced the notoriously difficult rapids of Ladore Canyon and the numerous other canyons that make up the Green and Colorado Rivers. Through low and high waters, sickness and injury, temperatures fluctuating from scorching to below zero, and inconsistent assistantship, they toiled, determined to complete their self-assigned task. Besides these difficulties, Ellsworth recalled the acutely encumbering motion-picture equipment, in which he echoed the complaints of similar troubles that plagued so many earlier western photographers.

> In addition to three film cameras we had 8X10 and 5X7 plate cameras; a
> plentiful supply of plates and films; a large cloth dark-room; and whatever

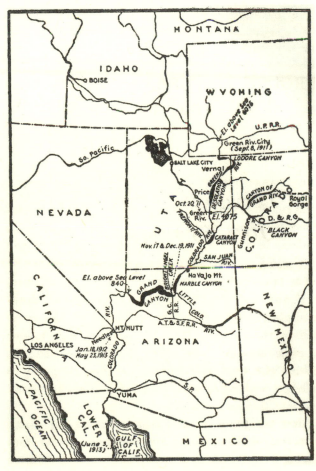

Figure 84. Map of the Kolbs' route through the Grand Canyon, 1914. Kolb, E. L. *Through the Grand Canyon from Wyoming to Mexico.* New York: The Macmillan Company, 1914. Emery Kolb Collection, Cline Library, Northern Arizona University.

chemicals we should need for tests. Most important of all, we had brought a
motion-picture camera. We had no real assurance that so delicate an appa-
ratus, always difficult to use and regulate, could even survive the journey—
much less, in such inexperienced hands as ours, reproduce its wonders. But
this, nevertheless, was our secret hope, hardly admitted to our most inti-
mate friends—that we could bring out a record of the Colorado as it is, a live
thing, armed as it were with teeth, ready to crush and devour.[8]

More than once, the brothers' filming and photographic efforts *were* crushed and
devoured as they struggled to keep their camera and film free of sand and water.
Like the generation of photographers before them, they sometimes lost their work
due to mishaps or glitches with their equipment. The sequences of the river that did
survive were pieced together in order to provide a visual narrative of their trip. The
first sequence was shot from the boat as the Kolbs' journey began: "Something of a
crowd had gathered on the bridge to wish us *bon voyage*. Shouting up to them our
thanks for their hospitality, and telling them to 'look pleasant,' we focused the mo-
tion-picture camera on them, Emery turning the crank, as the boat swung out into
the current" (figure 85).[9]

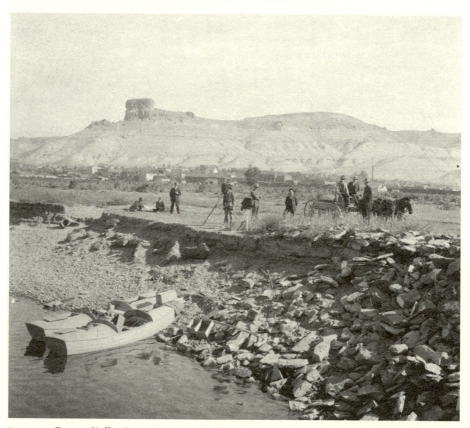

Figure 85. Emery Kolb, *Green River Send Off,* September 9, 1911. Emery Kolb Collection,
Cline Library, Northern Arizona University.

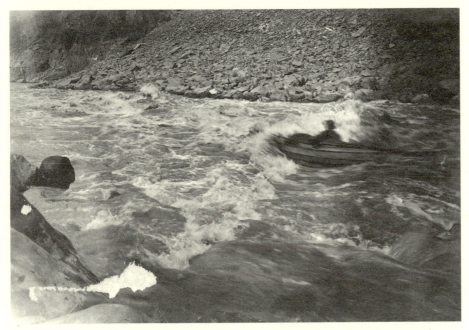

Figure 86. Emery Kolb, *Rough Water in Hermit Creek Rapid, Height of Distant Wave About Fifteen Feet, in the Granite Gorge*, 1911. Emery Kolb Collection, Cline Library, Northern Arizona University.

Their film clips and still photographs oscillate between footage from their own points of view and sequences of one or both brothers battling fierce rapids—taken from the riverbanks when the canyons allowed (figure 86).

> We were convinced that a third man was needed; if not for the duties of camp making, helping with the cooking and portaging; at least, for turning the crank of the motion-picture camera. Emery and I could not very well be running rapids, and photographing ourselves in the rapids at the same time. Without a capable assistant, therefore, much of the real purpose would be defeated.[10]

The "real purpose," this passage makes clear, was not a motion-picture experience of the river or the canyon, but rather the Kolbs' experience as western photographers and their adventures in making the film.

Part of their preparation for this undertaking included designing their own boats. The Kolbs relished their inventions, saying that

> They were beauties—these two boats of ours—graceful, yet strong in line, floating easily, well up in the water, in spite of their five hundred pounds' weight. . . . We had placed no limit on their cost, only insisting that they should be of materials and workmanship of the very best, and strictly in accordance with our specifications. In every respect they pleased us. Imagine our consternation when we discovered that the hatch covers were

anything but water-tight, though we had insisted more upon this, perhaps, than upon any other detail.[11]

They also had to acquire the equipment and skills required to make the film. In those early years of film technology, however, the Kolbs had difficulty obtaining a moving-picture camera. Letters to the Edison Manufacturing Company, the main purveyor of film in 1910, were rebuffed. The company offered to sell them film projectors but not a camera, claiming that it was illegal, and subsequently referred them to the Motion Picture Patents Company in New York City.[12] The Edison Company also refused to divulge any information concerning the development of the film.[13] The brothers finally tracked down two used cameras for sale by Frederick I. Monsen, famous photographer of Indians, Chautauqua lecturer, and member of the Salmagundi Club in New York.[14] Of the two, the Kolbs bought the larger Pathé camera, an unwieldy machine that came with a magazine capable of housing three hundred feet of strip negative. Monsen sold the $400 camera to the brothers for $250 and suggested they contact Mr. Cline of the Eastman Kodak Co., who was that company's expert on motion photography.[15]

By 1910, the major cinemagraphic medium was the nickelodeon—a very small theater that played short variety films for the price of a nickel. By 1907, for instance, one newspaper reported that "to-day there are between four and five thousand running and solvent, and the number is still increasing rapidly," and that "incredible as it may seem, over two million people on the average attend the nickelodeons every day of the year, and a third of these are children."[16] Large theater houses that showed silent films with more complex narratives were on the rise, however, and by 1915, *Vanity Fair* reported the growing size of the industry:

> Most of us accept the movies. We never stop to consider that ten years ago such a thing as a theatre devoted to moving pictures exclusively was unknown to us in America. It makes little enough impression upon us when we are told that the manufacture and exhibition of motion pictures has so grown in scope and magnitude that it is now said to be sixth in importance of all of our industries.[17]

Although the Kolbs' film seems to resemble the earlier genre generally referred to as the *actualité*, which highlighted real action instead of staged drama, their self-conscious attitude about capturing certain scenes gives the film a produced quality. For example, the Kolbs chose rapids that were dramatic but not dangerous, and they filmed "each other, alternately, as the boats made the plunge over the steep descent."[18] They also tried their hand at staging some "movie-drama" about a horse thief, a sheriff, and a prospector. In the end, a mishap with the film consigned these performances to "kindling."[19] Ultimately, the end result was a series of film clips and still photographs pieced together to create their story.

At the heart of this division between the actualité and a more narrative-driven format was the issue of verisimilitude, and this was key to the success of the Kolbs'

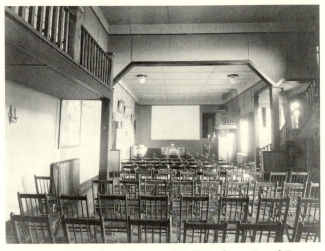

Figure 87. Kolb Brothers, *Interior of Kolb Studio at Grand Canyon*, about 1940. Emery Kolb Collection, Cline Library, Northern Arizona University.

movie. Their film was "true to life" in the sense that they actually did experience the adventures they were depicting. However, like *View Hunters*, much of what their audience saw was in fact staged. Nonetheless, verisimilitude was continually cited as the film's most valuable trait. The early film stars Douglas Fairbanks and Mary Pickford, for instance, visited the canyon and saw the Kolb lecture/film, and according to Emery, Fairbanks noted that it was "the greatest show in the world because it's real."[20] Veracity in film was a concept that was still very much unquestioned in 1911, despite the rapidly growing preference for theatrical narrative.[21] As one who would know, perhaps Fairbanks's comment about the film as "so real" was intended to note the difference between the dramatizations of the burgeoning film industry and the quasidocumentary nature of the Kolb film. However, it is also likely that Fairbanks was referring to the increasingly cloudy reputation of still photography as an accurate purveyor of truth and reality in the 1910s. Compared to the overtly fictional style of motion picture, the actualité served the Kolbs' purposes well, and its "realism" still impresses audiences today.[22]

From the very beginning, the brothers seemed to have intended their cobbled film to accompany lectures describing their adventure. The illustrated lecture was Emery's domain, beginning in 1912, when he did presentations in Flagstaff and Los Angeles and more notably at the Carnegie Music Hall in Pittsburgh, where the event was attended by a record-breaking 1,700 people the first night.[23] He also spoke at the National Geographic Society in Washington, D.C., and the Geographic Society of Philadelphia.[24] Because many illustrated travel lectures were presented by individuals who had not experienced the places about which they were lecturing, Emery's offering must have seemed especially compelling. He was the journey's hero and appeared in the slides and film clips he showed. The true commercial return on the film, however, came from its twice-daily showings at the Kolb Brothers Studio in an auditorium built specifically for that purpose (figure 87).

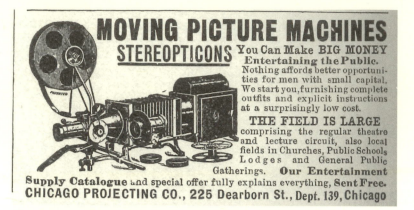

Figure 88. Moving-picture machine advertisement, 1901. *The Cosmopolitan,*
April 1901, 714.

Illustrated slide lectures grew increasingly typical in the decades after the Civil
War, so that by the 1910s they were a common, if slightly old-fashioned, presentation
technique.[25] Advertisements for lectures and equipment indicate that the use of mo-
tion pictures in an illustrated lecture was also not a new feature by the 1910s and had
been first introduced to wide acclaim at least a decade earlier. By 1901, "moving pic-
ture machines" were marketed as an opportunity to "make BIG MONEY entertain-
ing the public" (figure 88).[26] In fact, the "travel lecture" was a particularly popular
form that appealed to upper-class audiences because of its educational and enriching
qualities; audiences could better themselves and be entertained at the same time.
Many traveling lecturers featured foreign and exotic countries; others were con-
cerned with Native American cultures and the West. Although most illustrated
travel lectures "promulgated an ethnocentric belief in Western cultural superiority,"
in the words of X. Theodore Barber, they also promoted and confirmed popular
notions about western America—emphasizing that it was empty or wild and that the
Indians were vanishing, assimilating, or docile and thus an appropriate tourist com-
modity.[27] Emery Kolb's lecture, as well, encouraged his audience to revere the west-
ern man, to find in his accomplishments ideal American characteristics through his
enactment of the popular sentiment that "America is a continent of Pioneers" and
his demonstration of that dramatic lifestyle.[28]

THE BOOK

Along with the positive response to Emery's illustrated lecture, Ellsworth also re-
ceived acclamation for his published travelogue. *Through the Grand Canyon from
Wyoming to Mexico*, with a foreword by noted novelist Owen Wister, was first pub-
lished by Macmillan in 1914 (figure 89). The book gave a lengthier version of the
river trip than did Emery's lecture and was a popular accompanying souvenir,
which the brothers offered for sale along with their photographs and albums. Book

reviews in the *Dial* reported that Ellsworth and Emery had a "long and intimate familiarity with the region" and that "an abundant stock of health and strength and courage, and an unsinkable boat . . . seem to have constituted the adventurers' most important equipment."[29] A review in the *Bookman* suggests similar interest in the Kolbs as the protagonists. "Simple and truthful, they say they have tried to make the story of the long tussle. Even if its veracity were not of that spontaneous and engaging sort which seems the natural voice of the modern explorer there are the photographs to convince you." The ultimate recommendation, however, was that the reviewer saw the Kolbs' story as "full of the joy of fight . . . a hand-to-hand grapple in the turmoil of waters."[30] The Kolbs' adventure, not the canyon, took precedence in the public imagination.

Like the reviewers who wrote in the florid language of the times, Wister chose a romantic approach in his introduction to the book, a "spontaneous and engaging sort" of writing instead of the tangible and pragmatic tone that Ellsworth utilized. He did so, however, in response to the locale, not the adventure.

This place exerts a magnetic spell. The sky is there above it, but not of it. Its being is apart; its climate; its light; its own. The beams of the sun come

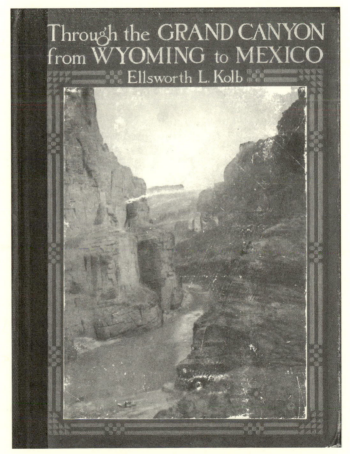

Figure 89. Through the Grand Canyon from Wyoming to Mexico, cover, 1914. Kolb, E. L. *Through the Grand Canyon from Wyoming to Mexico.* New York: The Macmillan Company, 1914.

into it like visitors. Its own winds blow through it, not those of outside, where we live. The River streams down its mysterious reaches, hurrying ceaselessly; sometimes a smooth sliding lap, sometimes a falling, broken wilderness of billows and whirlpools. Above stand its walls, rising through space upon space of silence. They glow, they gloom, they shine. Bend after bend they reveal themselves, endlessly new in endlessly changing veils of colour. A swimming and jewelled blue predominates, as of sapphires being melted and spun into skeins of shifting cobweb. Bend after bend this trance of beauty and awe goes on, terrible as the Day of Judgment, sublime as the Psalms of David. Five thousand feet below the opens and barrens of Arizona, this canyon seems like an avenue conducting to the secret of the universe and the presence of the gods.[31]

Wister's use of descriptive language recalls descriptions of Crater Lake. It was typical of his era, and its wide popularity with authors who wrote about western landscapes linked the "sublime" experience of the river and the canyon to the cultural and religious heritage of Euro-Americans. Likewise, his description of the Kolbs conjured a heroism and pluckiness consistent with the prototypical western man of the frontier era.

Whether it deal with the climbing of dangerous peaks, or the descent (as here) of some fourteen hundred miles of water both mysterious and ferocious, the well-told tale of a perilous journey, planned with head and carried through with dauntless persistence, always holds the attention of its readers and gives them many a thrill. This tale is very well told. Though it is the third of its kind, it differs from its predecessors more than enough to hold its own: no previous explorers have attempted to take moving pictures of the Colorado River with themselves weltering in its foam.[32]

Instead of attempting "to take moving pictures of the Colorado River with themselves weltering in its foam," Wister might well have commented, "No previous explorers have attempted to take moving pictures of the Colorado River *and of* themselves weltering in its foam" (figures 90 and 91). The Kolbs' self-promotional tendencies, however, went discreetly without comment.

Wister's contribution to Ellsworth's book was significant because he was a literary authority on the West. He was well known for his highly successful 1902 novel *The Virginian*, and he brought an aura of romance to the Kolbs' production.[33] His close friendship with Theodore Roosevelt and Frederic Remington also put the Kolbs in good company.[34] Roosevelt knew the brothers from his own trips to the Grand Canyon, and his "strenuous life" motto was perfectly suited to the brothers' own feelings about a life of vigorous existence in the West and supported their attempts to evoke a bold and audacious adventure in their photographs (figure 92). For Wister and Roosevelt, the Kolbs were living examples of the western characters about which they wrote. In fact, Wister's interest in art and his association with

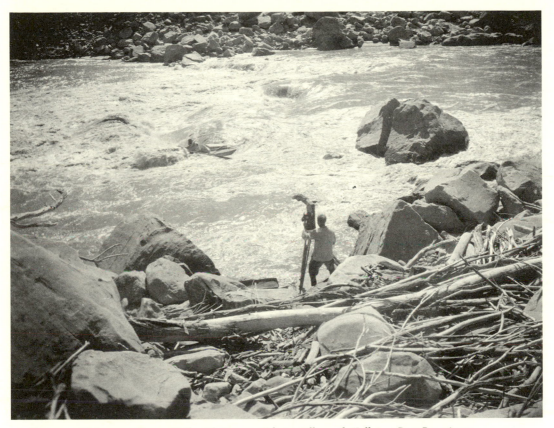

Figure 90. Unknown, *Emery Kolb with Camera Filming Ellsworth Kolb in a Boat Running a Rapid in Cataract Canyon, Utah,* about 1922. Emery Kolb Collection, Cline Library, Northern Arizona University.

Frederic Remington likely inspired him to introduce the brothers' book. Even though *Scribner's* reported in 1892 that "Eastern people have formed their conceptions of what the Far-Western life is like more from what they have seen in Mr. Remington's pictures than from any other source," by the 1910s, easterners contended with a veritable deluge of western imagery.[35] By obtaining Wister's voice and his approval of their undertaking, the Kolbs stood to gain not only his support, but also that of a field of men such as Roosevelt and Remington; it identified them squarely in the public's eye as the same type of men, or, as Remington famously phrased it, as "men with the bark on."[36]

Contrary to Wister's floridness, the very first line of Ellsworth's preface presaged his more straightforward style: "This is a simple narrative of our recent photographic trip down the Green and Colorado rivers in rowboats. . . . We were there as scenic photographers in love with their work."[37] Ellsworth's plain-spoken characterization emphasized that the film's value lay in its honest depiction of the Colorado River, contrasting dramatically with Wister's comments that valorized the brothers. "Is much wonder to be felt that its beckoning enchantment should have drawn two young men to dwell beside it for many years," Wister wrote, "to

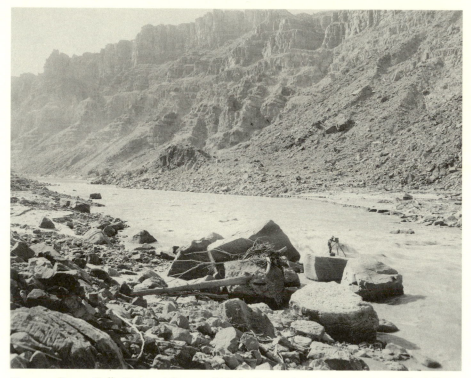

Figure 91. Emery Kolb, *Cataract Canyon, Kolb Setting up Camera*, 1911. Emery Kolb Collection, Cline Library, Northern Arizona University.

give themselves wholly to it; to descend and ascend among its buttressed pinnacles; to discover caves and waterfalls hidden in its labyrinths; to climb, to creep, to hang in mid-air, in order to learn more and more of it, and at last to gratify wholly their passion in the great adventure of this journey through it from end to end?"[38] His admiration for the brothers and their exploits was clear. In fact, reviews of Ellsworth's book discuss the difference between the two writing styles. In contrast to Wister's introductory "word pictures," the literary critic Algernon Tassin wrote that "the brothers Kolb were too much occupied to rhapsodise over the scenery, although it is evident that they appreciate it."[39] Another noted that Wister provided "commendation, both of the book and of the hardihood it so unassumingly portrays."[40] In all, Wister and the Kolbs seemed a good combination.

Wister endeavored to provide some context by noting that the Kolbs' trip was not the first descent of the Colorado River.[41] John Wesley Powell's first trip in 1869 lacked pictorial documentation, but subsequent efforts remedied that deficiency. Although the use of the motion-picture camera was unique to the Kolbs at the time, chronicled river journeys were hardly a new concept. The brothers were intent on drawing a distinction between their photographic journey and the previous narratives of Colorado River trips, including that in Frederick Dellenbaugh's 1908 book, *A Canyon Voyage*, which provided an account of the second Powell expedition down the river and which the Kolbs took with them as a guide.[42] Ellsworth's book directly

addresses the relationship between their trip and previous ones. "It is not intended to replace in any way the books published by others covering a similar journey."[43] Reviewers were also aware of the lineage. For example, one author from the *Dial* wrote: "Major Powell's report of the first exploration of the stupendous gorge was the pioneer account, in elaborate form, of its wonders; and Mr. F. S. Dellenbaugh afterward described its majesty and romance."[44] Instead, the Kolbs were "the first to

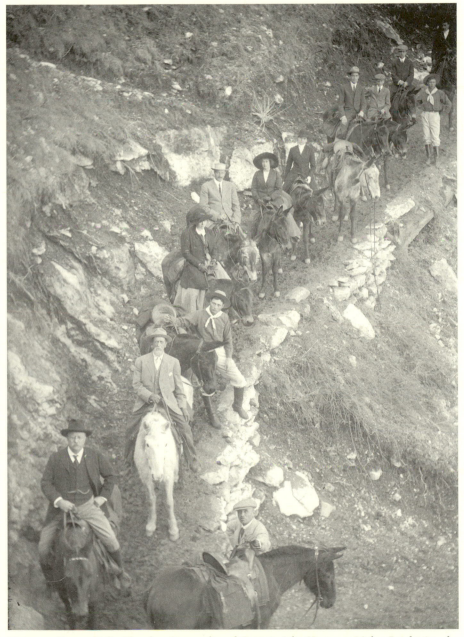

Figure 92. Emery Kolb, *Theodore Roosevelt and Captain John Hance on Mules, Bright Angel Trail*, 1903–1919. Emery Kolb Collection, Cline Library, Northern Arizona University.

chronicle a daring attempt to capture by camera and in moving-picture form the myriad marvels of the Grand Cañon."[45] Rather than competing with these other adventurers, they were instead joining their ranks, capitalizing on a new tourist market and the early twentieth century's nostalgia for an earlier era of exploration.

In addition to Ellsworth Kolb's book of the same year, the Kolbs published an impressively lengthy article about their photographic achievements in the August 1914 issue of *National Geographic Magazine*.[46] Although the introduction claims that "their primary object" for the piece and for their work in general "has been to obtain a complete photographic record of the unequaled scenic wonders of the Southwest for the enjoyment and instruction of the millions of Americans who are unable to visit them," the article is a self-reflective recounting of their own experiences. The first sentence, although modestly downplaying their own heroics, calls attention to their personal story as the narrative thrust of their work:

> Ours was no triumphal entry as we toiled our weary way through the little village of Havasupai Indians, in the bottom of Havasu, or Cataract Canyon, 50 miles west of the Bright Angel trail, in the Grand Canyon, one of us astride a mule as weary as ourselves, the other walking, while one of our two pack-burros, with his precious load of cameras and dry plates, stampeded down the road, trying to shake off some yelping curs that were following at his heels.[47]

True to the pioneer photographer model, the passage highlighted the difficulty of their effort.

Not only did the Kolbs' book, lecture, and photographic activity in the canyon fill a commercial niche, their athletic camera work similarly satisfied a growing national interest in physical activity as a pursuit of leisure. The notion of photographing a boat trip down the Colorado River had been on their minds for years, encouraged by public attitudes and desires concerning the "sporting life" that emerged in the late nineteenth century. By the 1910s, the growth of sports and other healthful leisure activities was deeply embedded in the cultural life of America. By mid-1915, for example, *Vanity Fair*, a popular magazine devoted to fashion, art, and theater, began to run a regular series of essays about recreational activities such as tennis, automobile touring, and baseball in a section titled, "Sports Au Plein Air."

By making the trip, the Kolbs could join the short list of adventurous men who had already accomplished the harrowing task. They provided proof that those brave enough could still have true western experiences—a shrewd approach that distinguished them as reliable interpreters of the canyon by linking place and character. Their adventure took advantage of sport and leisure tourism as a growth industry by staging an extreme adventure in which their customers could vicariously participate, and at the same time the Kolbs "lived the frontier" by retracing the Powell trip. Theirs was a new approach to the pioneering spirit archetype exemplified by previous generations of river runners and photographers.

TOURISM AND PHOTOGRAPHIC TECHNOLOGY

Although Congress did not officially confer national park status on the Grand Canyon until 1919, visitors to the chasm were already common by then, and a new era of touring the West was well underway. In fact, the many western sites that drew tourists at an ever-increasing rate through the nineteenth century have led scholars to argue that tourism has fundamentally shaped modern American culture.[48]

The Grand Canyon quickly became one of the top western attractions, along with Yosemite and Yellowstone, and with its popularity, the Kolbs found themselves in serious rivalry with one of the greatest success stories in the history of western tourism. Fred Harvey's company, with its El Tovar hotel and aggressive monopolizing practices, forced the brothers to adapt creatively to an environment of fierce competition in selling canyon photographs.[49] The expansion of the railroad was originally conceived of as a much-needed transportation system for miners, loggers, and ranchers. The Atlantic and Pacific Railroad reached the plateau lands south of the canyon in the mid-1880s. By 1901, via the Atchison, Topeka and Santa Fe Railway, the south rim was accessible within a day of the station in Flagstaff, an established college town that was built originally as a logging center and then grew with the ranching empire of the Babbitt family. This easy access, in tandem with the savvy business practices of Fred Harvey and the natural spectacle of the chasm itself, ensured the canyon's status as a tourist destination.

Together, Harvey and the Atchison, Topeka and Santa Fe Railway are widely regarded as two of the driving forces behind the commercialization of the Southwest. But although the Harvey/Santa Fe team largely monopolized the tourist dollars at the canyon's rim, they also provided the Kolbs with a business model. Because they were unable to dominate the image market with their sublime views of the canyon and were unable to outdo sales at Harvey's Hopi House Indian Market, the Kolbs turned to the sale of a product they could control—imagery of themselves. Eventually, the fight between the powerful Harvey Company and the small Kolb outfit became legendary in itself, feeding the brothers' individualistic image.

The Kolbs' particular approach also represents the changing profession of the western landscape photographer, transformed not only by the rapid advancement of tourism but also by the development of a huge variety of technologies. Advancements of all kinds marked the turn of the century West—in transportation, communication, and industry. By 1911, for example, the "western experience" was tempered by easier access via automobiles and trains. Likewise, the comforts of life in the West largely included secure borders and electricity, and telephones and the wide circulation of regional newspapers and magazines assuaged feelings of remoteness. Although these advances are all significant to the development of Grand Canyon tourism, the growth of photographic technology was also important.

By the twentieth century, photographic processes were vastly different from those utilized by earlier settler photographers. Instead of daguerreotypy or wet collodion (or even the dry collodion of earlier decades), the Kolbs were skilled in

the use of the most modern dry products for their still pictures. By 1891, it was re-
ported that

> the invention of the dry-plate process revolutionized the entire science of
> photography, and at once brought into existence an army of amateurs
> whose advent at first threatened to ruin the photographers of the old
> school though it has really been rather a pecuniary advantage rather than
> a detriment to most of them. New subdivisions of labor have been devised
> and now instead of carrying on the business in all its branches, the
> old-fashioned photographer now devotes himself to a portion of a single
> branch—with better pecuniary results to himself.[50]

In recalling the older method, Ellsworth called the wet collodion products "won-
derful photographs, which for beauty, softness, and detail are not excelled, and are
scarcely equaled by more modern plates and photographic results."[51] "The only
great advantage of the dry plates," he wrote of the more modern method they used,
"was the fact that they could catch the action of the water with an instantaneous
exposure, where the wet plates had to have a long exposure and lost that action."[52]
As did photographers across the West, the Kolbs welcomed technological and
methodological advancements that could augment their business even if it meant
a loss in the quality obtained by the earlier process.

New roll film also put the camera into the hands of the masses. Identified as
"Kodakers," the throngs of people with cameras seriously compromised the profes-
sional photographer's trade. By the 1890s, Americans were purchasing cameras al-
ready loaded with film, encouraged by extensive advertising campaigns that
promised, "You press the button, we do the rest." George Eastman had made the
camera a do-it-yourself novelty with the introduction of the "Brownie," a camera
simple enough to market to children.[53] For the tourist and traveler, "Take a Kodak
with you" became the slogan, a phrase with many ramifications for local western
photographic outfits (figure 93). By the 1910s, however, the success of Eastman
Kodak in the popular market caused the Kolbs to suffer from the plummeting pro-
fessional market. In response to the sharp decline in demand, Eastman Kodak
developed a campaign to reassert the value of professional photographers by their
"There's a photographer in your town" campaign. One ad, for example, reads:

> In our grandparents' time, picture-taking meant long sittings in uncom-
> fortable, strained attitudes—with success always more or less in doubt.
> There was excuse in the old days for not having pictures taken at frequent
> intervals. But to-day, clever photographers, in comfortable studios, with
> fast plates and fast lenses at their command, make the experience a plea-
> sure. And you owe this satisfaction to yourself and to your friends.[54]

Photographers were put out of business at an alarming rate, and those who survived
did so by focusing on increasingly specialized products. In the Kolbs' case, these

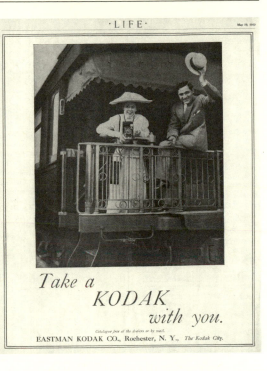

·LIFE· May 19, 1910

Take a
KODAK
with you.

Catalogue free at the dealers or by mail.
EASTMAN KODAK CO., Rochester, N. Y., *The Kodak City.*

Figure 93. "Take a Kodak with you,"
1912. *Life Magazine*, October 31, 1912,
2117.

included their bound souvenir photo sets and their daredevil views, which were be-
yond the amateur's ability to make. Their choice of motion-picture technology was
also a response to the Kodak phenomenon. "In love with their work" or not, many of
the brothers' photographic choices were contingent on the threat of declining sales.

NATIVE AMERICAN LANDSCAPES

Besides landscapes, Native Americans continued to be considered popular subject
matter in the early twentieth century. As popular ethnography, Indian imagery
from all over the West made its way across America. The extensive displays at the
Centennial Exhibition in 1876 revealed the great surge in Euro-American interest
in Southwestern Native Americans of the late nineteenth century, when William
Henry Jackson's "Photographs of the United States Geological Survey" collection
of Indian photographs and Mancos Canyon reconstructions "drew almost as many
visitors as Dr. Alexander Graham Bell's improbable telephone."[55] Representations
of Native Americans gained popularity from the late nineteenth century through
the first two decades of the twentieth century. Differing from the documentary
style that characterized the work of William Henry Jackson, John Hillers, and oth-
ers, many early twentieth-century depictions of Indians displayed the unmistak-
able soft focus and romantic compositions of "art" photography. By the early
twentieth century, "pictorialism" was the preferred amateur and professional aes-
thetic in art photography, apart from the development and growth of "straight"

photography, encouraged by Alfred Stieglitz beginning in 1907. Roland Reed, Joseph Kosuth Dixon, Carl Moon, and Edward Curtis, probably the most famous of such Indian photographers, all went to great lengths to reconstruct and refashion the manner in which Native Americans were pictured. Moreover, they did so with the financial backing of men such as John Pierpont Morgan and Rodman Wanamaker, desiring to capture aspects of native culture because of a fear that the passing of time would prevent further opportunity. The Kolbs were well situated to join the hordes of photographers, both professional and amateur, to make an ethnographic record of southwestern Native Americans, because they believed, like so many others, that "the Indian, as an Indian" was "rapidly disappearing."[56]

Besides photographs, motion pictures represented Native Americans extensively in the eastern United States. The Kolbs bought their motion-picture camera from Frederick Monson, the famed "Indian photographer," who was experienced in the medium. Burton Holmes and Oscar Bennet Depue filmed the Hopi Snake Dance in 1898 and 1899, and Theodore Roosevelt commissioned another film of the event in 1913. Such availability of motion pictures of Native Americans probably deterred the Kolbs from concentrating on that subject matter even though they had attended Hopi ceremonies.[57]

Native American imagery, in either format, was only a small fraction of the Kolbs' immense body of work. A significantly dissuading factor may have been, again, the Fred Harvey Company, which had a large impact on the western tourist's conception of a southwest Indian and which certainly tried to corner the market at the canyon. The company's use of photographs was particularly geared toward displaying the Native American as a "spectacle" for tourists.[58] The Hopi House, for example, was a reconstruction of Hopi architecture built by Hopi men in 1904, with an interior designed by Mary Colter. Fashioned as an on-site pueblo for educational purposes, it functioned mainly as a gift shop and photo opportunity for guests at El Tovar.

The innumerable photographs of Native Americans and their landscapes were attempts to mediate the tourist's experience of the region. The Colorado River and the Kaibab and Coconino Plateaus, however, similar to other western places, had a much richer cultural history than Euro-Americans' modes of representation could accurately depict. In fact, the cultural history of the region goes back thousands of years, as evidenced by twig figures that have been found in the canyon and radiocarbon dated to between 5,000 and 3,200 years old. That history has culminated in the cultures that still exist in the Great Basin area today, including the Hopi, Zuni, Navajo, Paiute, Yavapai, Hualapai, Havasupai, and others. The Grand Canyon itself, 277 miles long, 10 miles across, and 4,000 feet deep, in what is today Northern Arizona and Southern Utah, is a place that is most closely associated with the Havasupai, whose traditional summer residency included the adjacent Havasupai (Cataract) Canyon.

The Kolbs were not as keen as other photographers to embrace the growth of popular interest in Southwest ethnography, as photographing too broadly would have thwarted their attempt to develop a commercial niche. Several factors

influenced the brothers' relative inattentiveness to such an overwhelmingly popular subject. First, the Kolbs' strategy of placing themselves before the camera was an effort to tie their names to the Grand Canyon experience. The Kolbs focused their photographic relationship to the Grand Canyon on the theme of "nostalgic frontier landscape," not "the dying race." The local Havasupai, as well, may have influenced the Kolbs' choice to forego an aggressive ethnographic endeavor. The tribe was in flux—shaped by the intervention of governmental policies that substantially reduced Native land to a fraction of its original almost two billion acres.[59] Furthermore, the railroad's expansion into the Kaibab and Coconino Plateaus caused a great deal of consternation among the Hualapai and the Havasupai already living there because of the railroad's dominion over all odd-numbered forty-mile sections of land on either side of the tracks.[60] The Kolbs probably did not consider the local Havasupai population a subject likely to bring them profits. Also, because the brothers were residents, they probably did not want to join the hordes of itinerant photographers that spent time in the pueblos to the south.

Although Native Americans were only a very small part of the Kolbs' photography, they were completely absent in Owen Wister's romantic introduction to Ellsworth's book, in which he claimed that the Colorado river "passed through regions of emptiness still as wild as they were before Columbus came; where not only no man lives now nor any mark is found of those forgotten men of the cliffs, but the very surface of the earth looks monstrous and extinct."[61] Railroad engineer and river explorer Robert B. Stanton called Wister to task for his negligence in these matters, suggesting that the Kolbs rectify Wister's mistake. No one thought to rectify the Kolbs' representations.[62]

Euro-Americans at the Grand Canyon, as Stephen Pyne reminds us, have "actively shaped the Canyon's meaning, without which it could hardly exist as a cultural spectacle."[63] Unparalleled in the early twentieth century in terms of its vicariousness, the Kolbs' depiction of the Grand Canyon was a profoundly important addition to the "cultural spectacle" of the location. During the long tenure of the Kolb Studio, where Emery worked until he died in 1976, tourists continued to revel in the twice-daily reminders of an earlier time at the canyon. Two years after Emery's death, Arizona Governor Bruce Babbitt wrote that during his lifetime,

> The Kolb brothers and their photography studio were a splendid anachronism. The Kolb home and studio, a tidy frame house pinned incongruously under the canyon lip, resembled a scene from an old wet plate negative. The lure of the Kolb Studio was not as a museum of ancient photography. What beckoned was the spirit of the inhabitants, two ancient mariners who had ventured into the face of danger, won the contest, and returned to serve as inspiration to others. Tourists came to see not their photos, but to hear of their personal exploits, to measure not the photography but the men.[64]

By repeatedly conjuring the legacy of the adventuring photographer in the West and modeling themselves after the profession's archetypal practitioners, the Kolbs showed that the profession was a formidable historical phenomenon in the region. Their self-promotional tactics ultimately succeeded, as their longtime home and studio still stands as a monument to the brothers and their work—continually perpetuating the idea, expressed by Babbitt, that "no other river runners were so uniquely American: average mid-western youths with no special education, no wealthy sponsors, just endowed with a big idea, plenty of persistence, naiveté and courage."[65]

Despite his focus on the brothers as "uniquely American," Governor Babbitt exuded the type of pride that nineteenth-century photographers still inspire in their communities all over the West. The Kolbs' repeated representations of themselves and their trials as western pioneers honed their image as residents of the nation, to be sure, but also as residents of Arizona and, most important, as inhabitants of the Grand Canyon. Their attempts to evoke the earlier days of western photography and their ability to adapt to the demands of the modern age demonstrate an attitude keenly aware of the transitional nature of their era. Moreover, the Kolbs' combination of modern technologies and commercial strategies with an anachronistic approach to the creation of western identity illuminates photography's legacy in the region and the supreme changes that the new century wrought, and, ultimately, the Kolbs bring to a close the history of the settler photographer in the American West. Today the studio still sits at the head of Bright Angel Trail as a testament to the brothers' contribution as well as to the importance of a bygone era of western photography.

6

Frontier Photography and Early Modernism

Ansel Adams's Sierra Nevada: The John Muir Trail

I have photographed mostly in the creative euphoria of the natural
environment in the West as a matter of choice and circumstance.
— ANSEL ADAMS, introduction to *Picture America*

Study the pictures of Hill, Atget, and others of earlier years, then
turn to the Photography of the last decade that meets, more or less,
the purest definition of the medium. The essential relationship of
the two periods cannot be ignored.
— ANSEL ADAMS, "The New Photography,"
in *Modern Photography 1934–1935*

THE KOLB BROTHERS EXEMPLIFIED THE KIND OF scrappy adaptability that
early twentieth-century photographers had to perform if they wanted to stay rele-
vant in the early days of amateur photography. As the century progressed, however,
photography was increasingly considered as a valid medium alongside high art
forms such as painting. This changed the conversation concerning western photog-
raphers from one about the difference between amateur and professional to one
about the difference between amateur and artist. No photographer embodied that
transition more than Ansel Adams. In the 1920s and 1930s, the era of the profes-
sional western "settler/pioneer/frontier" photographer seemed to breathe a dying
gasp as it was replaced by throngs of do-it-yourself "Kodakers." Despite its severely
waning significance, the nineteenth-century tradition was almost single-handedly
revived by Adams, but with a written rhetoric that linked him to the contemporary
avant-garde of photography over his obvious connections to the frontier past. With
deep connections to the strategies of his western forebears, Adams manipulated the
discourse on western landscape photography by aligning himself with the eastern
fine art tradition introduced by the influential photographer Alfred Stieglitz a cou-
ple of decades earlier. The consequence of Adams's savvy embrace of a modern

aesthetic and fine art rhetoric, however, was his disconnection from the earlier western traditions of landscape photography in popular consciousness.

Adams was born in the West, unlike every other photographer represented in this book and the vast majority of western practitioners in the previous century. As a young teenager in San Francisco, Adams began playing with landscape photography and, as we shall see, approached his region with the ideals about the great West to which he was heir. Specifically, his 1938 publication *Sierra Nevada: The John Muir Trail* reveals his transformation from a young practitioner who seems to have fallen effortlessly into the old traditions to someone whose self-determining efforts changed the conversation about western landscape photography in the twentieth century.[1] Indeed, a comparison between his early and later work demonstrates the shift that took place in his art and life that allowed him to build his reputation as America's preeminent western photographer. An even more fruitful comparison, however, is between his early work and the tradition of western landscape photography developed in the nineteenth century.

Sierra Nevada: The John Muir Trail (1938) was Adams's first fully funded commission. As a limited edition of five hundred copies with tipped-in photographs, the book precluded widespread distribution. It did, however, fulfill its function for the artist and for Walter Starr Sr., the patron; for Adams, it was a demonstration and promotion of his fine art photographic style; for Starr, it acted as a quiet but deeply meaningful memorial to his son, who had died four years earlier in the Sierra Nevada on a solo mountain climbing trip. Despite the book's importance to Adams professionally and its poignant connection to the young Pete Starr, this very special work was and continues to be eclipsed by his later more seminal works. The wider importance of this book in the history of photography has also been overlooked, as it represents an important transition point in the photographer's career—one that straddles the gap between Adams's early practice of previous nineteenth-century strategies and his adoption of the conscious modernism of a new era in the photographic arts.

Although most approaches to Adams's early work focus on its role in the development of what would become his most fully realized, mature style of the 1940s and beyond, a style defined by the sharp focus and "straight" photography effect created by the greatest depth-of-field aperture setting, an exploration of Adams's conscious link to the earlier western photographers and an investigation of how that manifested itself visually in his work is clearly lacking.[2] The literature on Adams is great, as scholars have assiduously sought to contextualize Adams through the veil of art photography via his relationship to contemporary moderns such as Alfred Stieglitz and Georgia O'Keeffe and to fellow members of Group f/64. Historians and art historians have also exhaustively investigated Adams's sociopolitical relationship to the development of Yosemite National Park, the formation of the Sierra Club, and the legacy of John Muir conservationism. Recontextualizing Adams's 1930s work, exemplified by *Sierra Nevada*, as a culmination of an early paradigm in western photography *as well as* the beginning of an emerging modernist aesthetic provides a new, more complex way to think about Adams's photographic career and sheds lights on the enduring legacy of nineteenth-century western photography well into the twentieth century.

NINETEENTH-CENTURY LEGACY

An image of Carleton Watkins being helped out of his studio during the San Francisco earthquake of 1906 evocatively illustrates the temporal and geographical overlapping of the two generations of important photographers of the West (figure 94). Adams was four years old at the time and clearly remembered the catastrophe.[3] This intersection of experience of the two great names in American photography is also fascinatingly manifest in their images of many of the same western places and monuments (figures 95 and 96). A comparison of the images of Yosemite Valley by these two photographers encompasses their clear aesthetic similarities as well as their differences. Both photographs show the valley in a clear manner, without an overt artful manipulation of focus or a consciously crafty cropping. Instead, they relied on the well-trodden picturesque tropes that framed the spectacular valley according to expectations. Both men also sought wide audiences for their work, and both relied on their spectacular subject matter to ensure commercial success for the scene.

Despite the slight differences of framing presented by this comparison, a distinguishing factor relates to the technology available during their respective eras that allowed Adams to capture the details of clouds even though Watkins's sky remained uniformly overexposed. Watkins used the nineteenth-century wet plate technology that was equipment intensive and technologically cumbersome. Adams produced crystal-clear images with a modern photographic technology that allowed him to

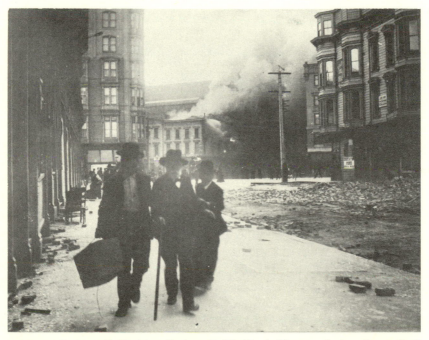

Figure 94. Carleton E. Watkins, *Carleton E. Watkins* (with cane, during aftermath of earthquake), April 18, 1906. Watkins, Carleton E.—POR 1, courtesy of The Bancroft Library, University of California, Berkeley.

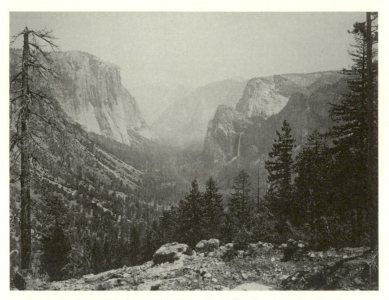

Figure 95. Carleton Watkins, *The Yosemite Valley from Inspiration Pt., Mariposa Trail*, 1845–1866, albumen silver print. The J. Paul Getty Museum, Los Angeles.

use a variety of film and camera sizes. He used smaller, 35 mm cameras to streamline his field-exposure work, as well as large-format view cameras. Technology not only transformed the field of professional photography, but it allowed photographs of unprecedented clarity and tonal value. Unlike the photographers discussed earlier in this book, Adams spent less time on the mechanics of exposure (with the help of his famed "zone" technique) and more on development—perhaps allowing him a greater freedom in his choices of subject matter and an ability to photograph at will.

Although these two photographers diverged technically, the more profound differences between their productions lie in their respective eras' conceptions about photography and the West. Watkins, unlike Adams, was far more committed to the pictorial tropes of the picturesque and chose scenes that conformed to the highly cultivated nineteenth-century taste for landscape. Watkins consistently sought what Adams would later dub "gargantuan curio," a term he used to designate the iconic images of grandeur that came to define the West as a region, scenes that were "appreciated for size, unusuality, and scarcity."[4] In contrast, Adams intentionally channeled high art, not visual culture, in his rendition. He consciously emphasized form as a signifier of emotional content rather than the model of didactic documentation that concerned Watkins, whose work articulated a selective cultural content that highlighted nationalistic ideals. Adams's passion for emotional content through formal composition firmly roots him in modernist America and makes an investigation of his link to earlier western photography one that goes beyond aesthetics. His awareness of his link to the nineteenth century was demonstrated when he wrote that

there is a perfection in many of these old photographs—a perfection of technique and aesthetic objectivity—that surpasses most of the camera work of today. I do not imply that we should entertain an "old-master" complex about such men as O'Sullivan and Watkins, but I am convinced that a careful study of their work would have a constructive effect on contemporary photography.[5]

Although Adams promoted the relationship between the earlier model and the modern, the connection runs deeper than perhaps even he knew.

Although a staunch champion for the modern, Adams unquestionably felt connected to and nostalgic for the previous century. He anecdotally discussed the anachronisms of his childhood in San Francisco's Bay Area in the early part of his autobiography, expressing a fondness for the artifacts and traditions that represented the earlier era:

There was always the distant bustle of the city, a deep and throbbing space-filling rumble of ironclad wagon wheels on cobbled streets and the grind of streetcars. This was a resonance we cannot experience today;

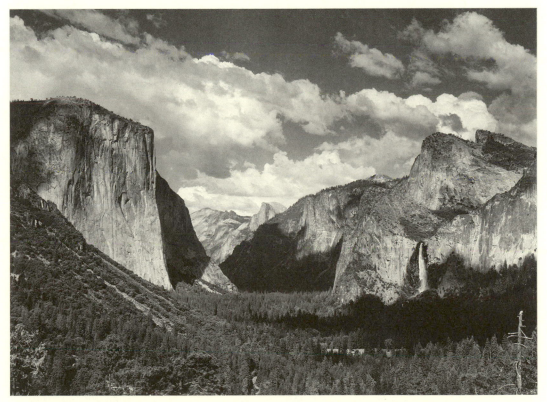

Figure 96. Ansel Adams, *Yosemite Valley from Wawona Tunnel Esplanade*, about 1933. Ansel Adams Archive, Center for Creative Photography, University of Arizona, © The Ansel Adams Publishing Rights Trust.

rubber tires on smooth paved streets have muted the old, rough sounds of iron and stone and the clopping of thousands of horses' hooves, timing the slow progression of ponderous wagons and more sprightly buggies. It was a sound not to be forgotten; a pulse of life in vigorous physical contact with earth.[6]

This nostalgia for the older "pulse of life" underscored Adams's interest in the "vigorous physical contact with the earth" that he spent his life pursuing in the spaces of the American West.

Although most children grow up with the heritage of their parents' generation surrounding them in the form of antique artifacts and wistful stories, Adams spent his life visually exploring the physical places of that heritage. Like many boyhood experiences that spur interest in the West, Adams recalled his (by now legendary) 1916 encounter with the 1888 publication *In the Heart of the Sierras* by J. M. Hutchings,[7] recalling that he had "become hopelessly enthralled with the descriptions and illustrations of Yosemite and the romance and adventure of the cowboys and Indians (figure 97)."[8] Besides the descriptive text of Hutchings's book, it was also full of engravings of photographs taken by early California photographers such as George Fiske, Charles L. Weed, Carleton Watkins, and others. Later in his life, Adams came to greatly respect Fiske, especially, even more than the more widely regarded Carleton Watkins and Eadweard Muybridge.[9] Adams was very familiar with these images and wrote of Fiske: "I firmly believe [that Fiske was] a top photographer, a top interpretive photographer. I really can't get excited at Watkins and Muybridge—I do get excited at Fiske. I think he had the better eye" (figures 98 and 99).[10] The two photographers certainly had a significant amount in common, but Fiske, unlike others who worked in Yosemite (especially Watkins and Muybridge), did not achieve stellar fame and an enduring popular legacy.

The romance of the old West infiltrated Adams's life in numerous other ways, as well. A particularly formative experience was his boyhood adventures at the 1915 Panama Pacific-American Exposition, at which he encountered the heavy-handed ideological position favored in the United States regarding western lands and Native Americans.[11] He would have seen *The Westward March of Civilization*, in two panels, by Frank V. DuMond (in the Western Arch of the Court of the Universe); Western landscape paintings by Albert Bierstadt, Thomas Hill, and Thomas Moran; and the sculptural works *End of the Trail* by James Earl Fraser, *The Pioneer* by Solon Borglum, and *The Pioneer Mother* by Charles Grafly. Although it is impossible to say to what degree these works influenced Adams, they do suggest a general ethos in the West during his childhood. All told, the remnants, both photographic and otherwise, of the previous generations in northern California seem to have made a deep impression on Adams.

Professionally, Adams was in the right place at the right time to bridge the divide from the aesthetic and topical paradigms of that earlier era to the later concerns of a burgeoning modern America. Although the subject matter that could be found in Yosemite and the Sierra Nevada stayed the same, popular conception of these western

Figure 97. Cover of *In the Heart of the
Sierras*, 1888. Hutchings, J. M. *In the Heart
of the Sierras.* Oakland, CA: Pacific Press
Publishing House, 1888.

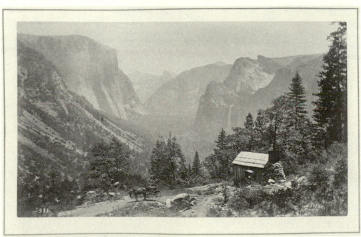

Figure 98. George Fiske, *Yosemite Valley* (Horse and buggy near shack),
nd. 19xx.066:23—ALB, courtesy of The Bancroft Library, University of
California, Berkeley.

places changed dramatically. The nineteenth-century photographic approach to
western sites was precipitated by a general ignorance of the West and a desire to in-
terpret and construct meaning via a familiar visual format. Practitioners like the ones
previously discussed in this book were active instigators of meaning, creating the
sense of place that ultimately determined how people saw themselves in their com-
munities. Their goals were to reflect the community and, in doing so, to anticipate
the nostalgia that would surely come their way in a generation or two's time. Unlike

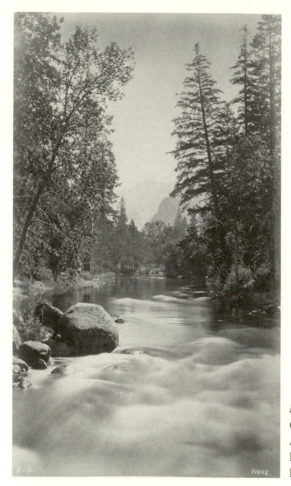

Figure 99. George Fiske, *From El Capitan Bridge*, nd. 19xx.066:28—ALB, courtesy of The Bancroft Library, University of California, Berkeley.

the photographers discussed in earlier chapters, Adams had a very real sense of historical precedent—he didn't believe, as did the earlier photographers, that he was inventing or creating place identity; rather, he promoted the idea that he had a fundamentally different photographic understanding of place, an understanding rooted in deep emotion and artistic sensibility. Ultimately, his desire to change the rules of western photography demonstrates how acutely he understood his connection to the photographic legacy of the nineteenth century.

Adams, who came of age in the first quarter of the twentieth century, would have understood the West (like others of his generation) as a wonderland for exploration in a leisure-time capacity—a camping, hiking, and mountaineering experience within which photographs revealed a spiritual connection that he and, through his work, others felt to America's western wilderness. Like all of the photographers represented in this book, Adams spent significant time in the field, tramping through wilderness to hunt views. Most notably, Adams often participated in the annual mountaineering outings of the Sierra Club.[12] His photography and approach to the medium, like that of the Kolbs, occurred after the nostalgia for pioneering adventurers had set in.

Photographers such as Britt and Butcher, Watkins and Fiske, and others revealed and created a new visual context for those western spaces, building a relationship between Euro-Americans and the West; Adams refined that relationship by using earlier photography as a precedent upon which to solidify the mythic quality of the West through form and content. In other words, Adams's conscious use of "art photography" was a way to express his own experiences, which had been heavily shaped by the previous century and the earlier photographers, but it also ultimately served to entrench America's emotional connection to iconic western places.

EAST VERSUS WEST

The divide between the old and new conception of photography was paralleled by the cultural difference between the eastern United States and the West, a difference determined by their relative historical and aesthetic traditions. Adams embodied the western tradition in his conception of western spaces, his interest in nature and exploration, and his efforts at conservation. Adams considered himself a westerner—through and through—even while he aspired to the ranks of an aesthetic tradition whose roots were firmly planted in the urban centers of the upper East Coast. Adams's self-awareness about being a westerner was demonstrated early in his career. In 1932, he emphasized the positive qualities of the West to an eastern audience when he wrote, for a show at San Francisco's De Young Museum, that western art was "a bright light eating into the old darkness," presumably of the more eastern American and European aesthetic traditions. His assertion verged on insulting to eastern visitors when he continued, saying that "our painters, sculptors, poets, and photographers reflect the qualities of a joyous relation with a young and vigorous civilization and rely more on the dynamic actualities of the present than the somber relics of past cultures."[13] Adams also snidely wrote that very little wilderness remained in the East, "as any visitor from the west acutely realizes." Furthermore, he thought that Easterners were lacking in wilderness experience and that "urban and rural people of the east and Middle West often think of western wilderness as a complex of 'curiosities', related to the background of television 'westerns,' Currier and Ives lithographs, and the reason for being of myriads of postcards, folders, Indian Head pillow-cases and plastic bears which are thrust upon them in most National Park and tourist centers."[14]

Adams asserted the dominance of the West in art and vitality often in his early career. However, when he wrote that "here the land is so beautiful it cannot be denied" and that "photography finds an admirable environment in the West. It is a new art in a new land," he was not being original.[15] In fact, his statements reflect the still pervasive awareness that the West had to be touted. The rhetoric demonstrated by tourists, boosters, and photographers with wares to sell consistently emphasized the special nature of their locale in contrast with the stolid, more familiar spaces in the East. That western spaces were distinctive was a belief held by all of

the photographers discussed so far in this book, as well as by visitors and locals who engaged the actual landscapes directly or did so only through the images these men produced. Not only does Adams's apology for the West tie him firmly to his photographic forebears, but it demonstrates the reach of the West's relative insularity deep into the twentieth century, a remoteness described by its vast physical space and distance from the East as well as by perceived cultural differences.

By the 1930s, the West was considered both the ideal of American hopes and values and a distant cultural backwater. Adams sought to rectify the latter perception of the West through his ambitious insistence on meeting the great New York photographer Alfred Steiglitz and becoming part of his milieu. Despite Adams's entrenched westernism, or maybe because of it, he sought out Stieglitz, whose early-century approach to straight photography greatly influenced Adams's sense of his work as "art." Born on the very western edge of the continent, Adams was disconnected from the trends in eastern artistic circles. Instead of traveling West to find a more purely American place, as so many artists of that era did (including Stieglitz's own wife, Georgia O'Keeffe), Adams traveled to visit Stieglitz in New York so that he could hoist himself beyond his western heritage into the more rarified field of art photography.[16]

Adams visited the aging Stieglitz at An American Place Gallery in 1933 to introduce himself and promote his photographs. In the letters that transpired afterward, Adams clearly expressed a reverence for the legendary photographer, as a devotee to a master. "I trust you will believe me when I say that my meetings with you touched and clarified many deep elements within me," he wrote in a 1933 letter. "It has been a great experience to know you."[17] Adams even unabashedly wrote that "in a sense, the history of Stieglitz is the history of modern photography—he is undoubtedly the Giotto of the photographic Renaissance."[18] On the news of Stieglitz's death in 1946, Adams struggled to sum up his relationship to the old photographer, but ultimately admitted Stieglitz's power over him by writing that "it will be very hard when the time comes to make a decision and know that he will not be there to approve or disapprove."[19]

Adams's visit to New York was both inspiring and a bit confusing. Instead of his more famous landscape photographs on which he built his career, Adams's 1936 exhibition at Stieglitz's An American Place oddly focused on portraits, cultural objects, architecture, and other such subjects.[20] The exhibition recalled an earlier eastern presentation of his photographs shown at the Delphic Studios in New York in 1933–1934, where he also displayed a mix of landscapes and images of the built environment.[21] Despite his dabbling in a variety of subject matter, the more immediate and inspirational outcome of his first visit to Stieglitz's gallery in 1933 was the subsequent opening of a like-minded gallery in San Francisco. It was called Ansel Adams Gallery, and it fused his own commercial photographic enterprise that dealt in "portrait, landscape, architectural, and advertising" with a high-minded center for "photography, painting, and graphic arts" (figure 100).[22] His 166 Geary Street gallery did not last long, breaking under the pressures of the Great Depression, the

Figure 100. Invitation to gallery opening, September 1933. Ansel Adams Archive, Center for Creative Photography, University of Arizona, © The Ansel Adams Publishing Rights Trust.

fine arts climate in San Francisco, and the increasing financial demands of Adams's domestic life.

Modernist photography was new to the West when Adams opened his gallery. On the other hand, straight photography had existed for decades before it was understood as an aesthetic strategy. So when Adams attempted to spur interest in fine art photography in San Francisco, he unwittingly revived a version of the professional photography studios and all-around visual arts studios that had existed in frontier towns across the nineteenth-century West.[23] Adams's gallery had as much in common with, for instance, Joel Whitney's "Art Depot" as it did with Stieglitz's An American Place. The fine arts business was a tough sell in the 1930s and the pioneer gallery model a moot endeavor. Although Adams was trying to enact modernism, he was doing it by default in the manner of his western American forebears. Adams was well aware of the western gallery's relationship to mercantilism, a fact he bemoaned when he wrote to Stieglitz that the

> high priest of commercialism bellows from the tower of necessity the call to prayer, and the faithful bend and sprawl and grovel at the ghost of the Almighty $—rents have to be paid, food bills have to be paid, shoe-shines and clean shirts have to be bought,—so that the smirk of ideals compensating with existence is given a proper setting.[24]

Although his gallery didn't last long, and Adams claimed that he could "not operate both my photography and an art gallery and do them both well,"[25] a sense of entrepreneurial spirit characterized his photographic exploits throughout his long career.[26]

FROM PICTORIALISM TO GROUP F/64

Adams's decision to pursue a so-called "straight aesthetic" was complicated and meaningful in an era when photography was marked by deep philosophical and practical complexities. The documentary style of photography that was in full swing in the 1930s and 1940s demonstrated, in the work of such photographers as Walker Evans and Margaret Bourke-White, who claimed a "straight" approach, that the medium was focused on social justice and not interpretive content. For purposes of reporting and Farm Security Administration motives, a clearly focused image lent itself to the notion of truth. Although few denied its artfulness, documentary photography had defined an intent that was quite different from the work of those who employed the straight technique. The western photographic tradition also manifested a de facto "straight" aesthetic and is still considered to be connected to the documentary tradition. Although Adams flat-out rejected any connection to the documentary style save the straight technique, he neither blatantly rejected nor vociferously embraced the nineteenth-century photographic heritage of western landscape imagery except to benignly comment on it now and again when it suited his purposes.

The more overt battle that Adams waged in his early career was against the widely popular pictorialist style that persisted in America (especially in California) in the 1930s. Pictorialism was an approach to photography that emphasized aesthetic manipulation with soft focus, filters, and other methods for manipulating both negative and print. The earliest forms of pictorialism in late nineteenth-century Europe demonstrated the possibility of photography as a serious art form but were quickly considered, especially in the United States, to be derivative of painting, with no hope of equivalency.

Adams participated in a few pictorialist exhibitions, including the well-attended 1931 "Pictorial Photographs of the Sierra Nevada Mountains" in Washington, D.C.[27] *Parmelian Prints of the High Sierras* however, is the most enduring example of this early work. The portfolio demonstrates Adams's experimentation with the pictorialist aesthetic and preceded his *Sierra Nevada* publication by nine years. Like the 1938 publication, this earlier portfolio of prints, sold by subscription, represents various views from the Sierra Nevada. *Parmelian Prints*, however, was not as tightly conceived and was made while Adams still pursued music as his primary form of expression. The clearest example of Adams's lack of a defined style in the portfolio is the title that it bears. *Parmelian Prints* was a made-up name meant as a marketing tool to give the portfolio an air of distinction.[28] It was an ineffective ploy to which Adams never returned. Images in the portfolio, such as *El Capitan* (ca. 1923), *Mt. Brewer* (ca. 1925), and especially *Lodgepole Pines* (ca. 1921, figure 101), are overtly romantic in form, transferring concrete places to softly lit, dreamlike spaces. Adams also demonstrated his understanding of the Japanese influence on European and American art in the second half of the nineteenth century in two of the prints (*From Glacier Point, Yosemite Valley*, and *On the Heights, Yosemite Valley*, figures 102 and 103). The prints that comprise this group show

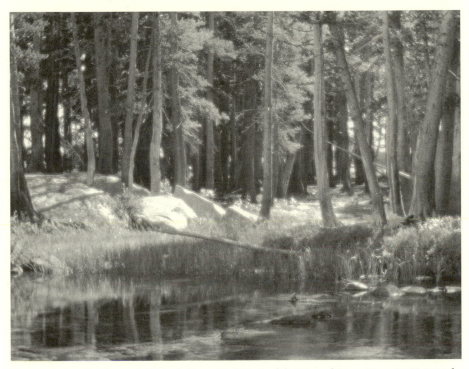

Figure 101. Ansel Adams, *Lodgepole Pines, Lyell Fork of the Merced River, Yosemite National Park, California,* 1921. Ansel Adams Archive, Center for Creative Photography, University of Arizona, © The Ansel Adams Publishing Rights Trust.

Adams's early struggle to define his style, his oscillation between the pictorial and straight aesthetic, and the standards of composition that attend each.

Adams's beloved Stieglitz had been at the forefront of the pictorialist "secession" movement in the United States at the turn of the century but quickly dropped the style between 1907 and 1910 when he moved toward the clear, focused view that would characterize modernism in the medium. Adams's transformation to a straight-shooting modernism seems to have occurred in 1930, during a summer visit to Taos, where he met Paul and Rebecca Strand, John Marin, Georgia O'Keeffe, and Mabel Dodge Luhan. Adams very quickly changed not only his style but also his rhetoric concerning his photographs. Adams joined the elite of "straight" art photographers on both the East and West Coasts in promoting a new style that would ultimately gain the medium acceptance into the art world at large and into the galleries of major museums. In the years after photography's stylistic sea change into modern art, pictorialism continued to flourish despite its passé reputation among the fine art elite of photography. Through the 1930s, pictorialism even gained adherents, as amateur camera clubs remained active and strong across America.

Adams admitted in 1932 that his "first work was definitely 'pictorial.'" He described the situation (in third person) for a De Young exhibition, claiming that

while he never manipulated his negatives or prints, his compositions were reminiscent of conservative schools of printing. . . . It was not until 1931 that the veil of these relative inessentials was torn away and the emergence of a pure photographic expression and technic [*sic*] was revealed. Almost overnight, as it were, the fussy accoutrements of the Pictorialist were discarded for the simple dignity of the glossy print.[29]

Later, he again acknowledged the early change in his work by stating that although his "first selection of photographs was . . . made with care and devotion, it was more representational in approach than my later productions and reflected a style of work less realized in character and emphasis than my photography after 1930."[30] More than simply an example of an immature style, the *Parmelian Prints* demonstrate Adams's conscious aesthetic choices and ultimately his decision to leave pictorialism behind.

To his credit, Adams recognized that pictorialism did little to express the western sense of place that defined his landscape interests, especially given his knowledge of and connection to the aesthetic and ethos of the pioneer era. Straight photography seemed a much more natural fit, and his introduction to modernism in New York, Taos, and Santa Fe allowed him, in effect, to maintain a connection to the preceding generations of western photographers and to break from the perception of that earlier style as "documentary." Adams created art photography and worked in connection

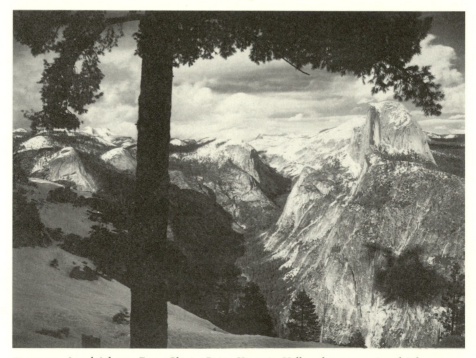

Figure 102. Ansel Adams, *From Glacier Point, Yosemite Valley,* about 1923. Ansel Adams Archive, Center for Creative Photography, University of Arizona, © The Ansel Adams Publishing Rights Trust.

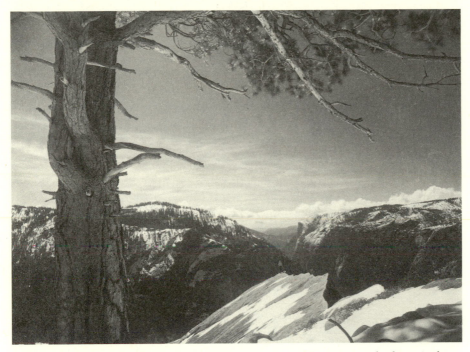

Figure 103. Ansel Adams, *On the Heights, Yosemite Valley*, about 1926. Ansel Adams Archive, Center for Creative Photography, University of Arizona, © The Ansel Adams Publishing Rights Trust.

to the lineage of the nineteenth-century practitioners as a way to have his cake and eat it too. His photography was steeped in the rhetoric of high art but retained the veracity of experience that defined the approach of his forebears.

Adams sought renown in his photographic career by embracing a modern style and disdaining pictorialism, which had a more popular appeal to amateurs. Like Stieglitz, Adams wanted to rarify his photography—to create pictures in an elite, "high art" style. Rejecting pictorialism eventually led Adams to the formation of Group f/64 in 1932—a group whose very existence attested to the staying power and popularity of pictorialism. The group was quickly championed by the upper echelons of the high art world—by those who would see photography take its place alongside other more traditional fine art media. Founders included Adams, Imogen Cunningham, Edward Weston, Willard Van Dyck, and others who agreed with the straight aesthetic as achieved by the f/64 aperture setting, which ensured crystalline clarity and the greatest depth of field.

Despite Adams's early pictorialist dabbling and his indelible link to the Group f/64 philosophy, he recognized his own need to develop a unique approach to landscape, a subject from which he rarely strayed. Adams broke with the pictorialist aesthetic very early in his career, and his photographs continued to undergo significant stylistic change as he struggled to understand his place in the new modernist world of photography. Notably, his move toward modernism began to manifest in his work for *Sierra Nevada*. Adams himself characterized the period in which he

produced *Sierra Nevada* as transitional. As early as 1948, he wrote that "Since 1938–39, all my work has been based on an exposure-development rationale in which visualization of the final print is the prime consideration."[31] Just as he transitioned from pictorialism to the straight modernist aesthetic, he continued to hone his work until he found his niche. Despite the stylistic battles during the era and his conscious shift to the fine art straight aesthetic model, *Sierra Nevada* demonstrates his instincts to return to many of the principles of the more traditional nineteenth-century version of western landscape photography, notwithstanding the belief stated in Group f/64's manifesto that "photography, as an art form, must develop along lines defined by the actualities and limitations of the photographic medium, and must always remain independent of ideological conventions of art and aesthetics that are reminiscent of a period and culture antedating the growth of the medium itself."[32] Adams's work sat at the crossroad of a number of converging traditions in the 1930s, a complex situation that he largely worked out in the pages of *Sierra Nevada*.

SIERRA NEVADA: THE JOHN MUIR TRAIL

In 2006, a facsimile of *Sierra Nevada* was published and, with it, an explanation of the origins of the book, something the first edition did not include. The book was funded by Walter Starr Sr. as a memorial of sorts, for his son who died in the Sierra Nevada on a solo mountaineering trip.[33] The original withholds the explanation and presents a simple "To the Memory of Walter A. Starr Jr.: He sought and found the high adventure great mountains offer to mankind" in the front of the book.

At its heart, this book was a memorial that highlighted the sometimes harsh beauty of the remote and dangerous mountain range. The pictures, taken along the John Muir Trail from north to south, simulate an expedition: some of the grand sights that one would see on the way and some of the aesthetic details of the natural world. Indeed, the book begins with *Climbing on the Minarets*, an image of two mountaineers lashed together (figure 104). They are silhouetted against the sky and denied an identity that would make the *Sierra Nevada* publication less than metaphorical. Ironically, Starr was on a solo climbing trip, without the security of a tethered companion.[34] Despite one critic's point that "you do not arrange aesthetic experiences in geographical order,"[35] the images in *Sierra Nevada* are sequential, progressing from the Yosemite Sierra through the San Joaquin Sierra, the Kings River Sierra, the Kern River Sierra, and culminating in the Kaweah River Sierra with one picture from the Kaweah Gap. As a visual journey for anyone who would look at the book and as a figurative last journey of the young Starr, the photographic content carries a poignancy of individual life and loss that is unusual in western landscape production. For those who knew that the book was a memorial, the pictures would have encouraged open-ended thinking about how and where he spent his last days. Adams's photograph of *Michael Minaret*, where Starr fell and died, is especially moving (figure 105).[36]

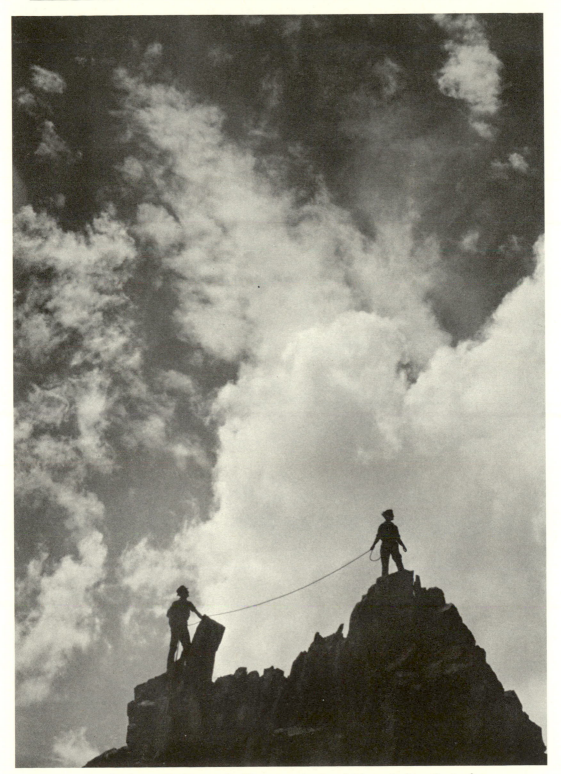

Figure 104. Ansel Adams, *Climbing on the Minarets*, 1930s. Ansel Adams Archive, Center for Creative Photography, University of Arizona, © The Ansel Adams Publishing Rights Trust.

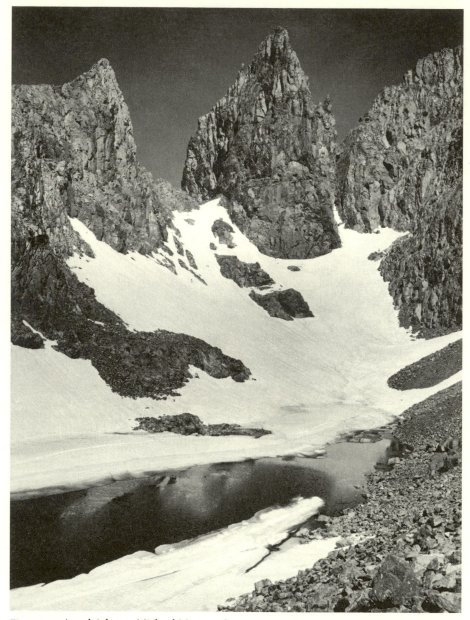

Figure 105. Ansel Adams, *Michael Minaret, San Joaquin Sierra*, 1930s. Ansel Adams Archive, Center for Creative Photography, University of Arizona, © The Ansel Adams Publishing Rights Trust.

While Adams certainly fulfilled the requests of his patron, he was also able to fully explore and integrate his new ideals about photographic style. Despite the book's roughly sequential format, he wrote in the foreword that "no attempt" had been "made to portray the Range in the manner of a catalogue" but rather that "informative qualities" had been "submerged in favor of purely emotional interpretative elements." Adams sought to capture the emotional experiences he had had and

likely assumed all mountaineering explorers would have in the Sierra Nevada, and he strove to avoid emphasis on "gargantuan curio."[37] In keeping with these ideals, the book displays fifty full-page photographs of the Sierra Nevada mountain range, alternating between grand vistas and closely cropped photographs of natural details that show Adams's early affinity for modernism.

Just as with the earlier photographers discussed in this book, not every image was a grand statement for the outsider. Although Adams happily marketed to the armchair tourists and visitors to the Yosemite region, the book functioned in another way as well. In the tradition of earlier photographers, the collection of images was also for the initiated westerner. Specifically, the subjects and arrangement of photographs were an attempt to speak the language of the mountaineer's experience in the landscape. This approach would change later when Adams's style became more fully formed and his landscapes became more iconic.

Throughout this book, I have argued for the profound effect that the multitudes of settler photographers had on modern conceptions of western places and the idea that western photographers of the 1910s consciously drew on their vocational forerunners to lend credibility and an air of history to their work. Despite the romantic landscape work produced during the twentieth century in the pictorialist aesthetic, the more significant shift from nineteenth-century western landscape precedents took place when the modernist aesthetic was embraced and advocated by Adams and others in Group f/64. Even then, however, Adams's landscape photographs largely embraced tropes established in the nineteenth century.

As he shed the pictorialist approach in the early 1930s, Adams began to explore aesthetic issues of composition and subject matter, and the merits of the traditional landscape versus the often abstracted modernist close-up began to occupy him. The simultaneity of the ever-present historical and the modern approaches can be seen in *Sierra Nevada*, for example, in *Grouse Valley* (figure 106). Adams retained an expansive and dramatic scene of mountain and sky that emphasizes a sublime view of America's wilderness, as he began to explore expressive, closely cropped photographs that emphasized the formal elements of line, texture, light, and shadow. Both styles adhere to Adams's proclamation that although his images showed specific places, they equally represented emotional response. Many of the *Sierra Nevada* photographs are anchored firmly in the modernist paradigm, with its clear emphasis on formal qualities, but the more traditional landscapes are inescapably tied to the nineteenth-century model. Adams wrote in 1941 that "'mountain photography' does not mean only pictures of great peaks, distant ranges, awe-inspiring gorges. It relates to everything large and small that concerns mountains, physically, emotionally, socially."[38] He thought that if he were to "overlook the exquisite details of the natural scene" in favor of broad vistas, he would miss "that essential quality of direct experience, of contact with the intimate and immediate aspects of the world."[39] He wrote that "almost everything, from a huge expanse of mountains to a delicate lichen can be photographed and photographed well. The intense realism of the camera makes possible an equality of a great mountain and a small stone."[40] Finally, in one of his most articulate moments, he wrote that "a significant detail,

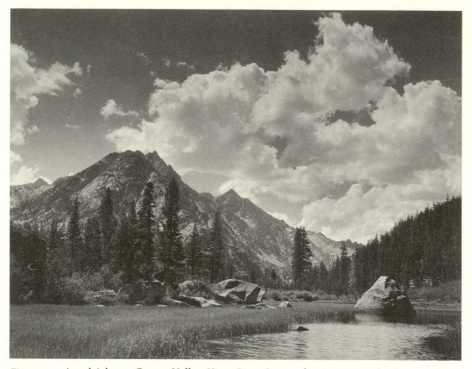

Figure 106. Ansel Adams, *Grouse Valley, Kings River Sierra*, about 1932. Ansel Adams Archive, Center for Creative Photography, University of Arizona, © The Ansel Adams Publishing Rights Trust.

an exquisite balance of a few planes of light, an interesting combination of textures, a moment of time when a few objects or conditions relate intensely to one-another; these things are of greater importance than extensive and crowded 'views.'"[41] Adams's ability to speak and write so eloquently about his work helped him control public understanding of it and shaped the manner in which we still interpret him.

A reviewer of *Sierra Nevada*, interested in understanding the new modernist impulse, wrote in the 1939 *Sierra Bulletin* that Adams "became interested in making his own interpretations of the things around him."[42] This, finally, is the distinguishing factor that separates the earlier settler photographers who interpreted place under the guise of veracity—a truthfulness that at least their clients bought into—and the later "art" photographer who understood the persuasive, interpretive possibilities of a photographic image. "The early photographers had a job to do," wrote Adams. "They were *factualists* (which is one of the basic requirements of good photography). What is essentially important to us—they saw things in terms of things themselves. . . . Only the greatest artist is justified in seeing things in terms of himself—and these camera men had no illusions."[43] This overt conceptual variance is the single most important difference between nineteenth-century photographic practice and Adams's. Adams understood that "photography can tell the truth gloriously, or lie enormously" and that the "*content* of a fine photograph can be aesthetically supurb [*sic*] and materially false at the same time."[44] *Sierra Nevada:*

The John Muir Trail demonstrated his interest in adapting a more nuanced, more complex way to understand a photograph—an approach that merged the old and the new, the historic and the modern into his own unique photographic vision.

Despite his demonstration of acumen in both modern formalism and traditional views, many of the photographs seem unusual for either category. For instance, *Grouse Valley* shows jagged peaks but not the traditional landscape tropes that emphasize a visual journey from foreground through a middle ground to the far distant background (figure 106). In this example, Adams seems to have favored texture, shape, and tonality as opposed to the photograph's ability to create a sense of location. Still other photographs rebuff the landscape tropes but still encompass expansive space. *Devils Crags, from Palisade Creek Canyon*, for example, offers an expansive view and at the same time emphasizes formal compositional elements (figure 107). Extreme depth and solid physicality created via mountains, for example, offer contrast to the ethereal and infinite sky beyond. Others, such as *The North Palisade, Kings River Sierra* emphasize the textural vastness of the sky, an approach that demonstrates formal and aesthetic qualities at the expense of landscape and place (figure 108). Stieglitz himself had embarked, in the late 1920s and early 1930s, on a series of cloud formation photographs, called *Equivalents*, which may have inspired Adams.

Of the many photographs that reveal a connection to the western photographic past, one image in particular stands out as a clear example of Adams's connection

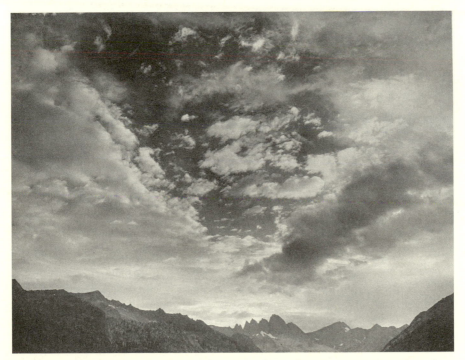

Figure 107. Ansel Adams, *Devils Crags, from Palisade Creek Canyon, Kings River Sierra,* 1930s. Ansel Adams Archive, Center for Creative Photography, University of Arizona, © The Ansel Adams Publishing Rights Trust.

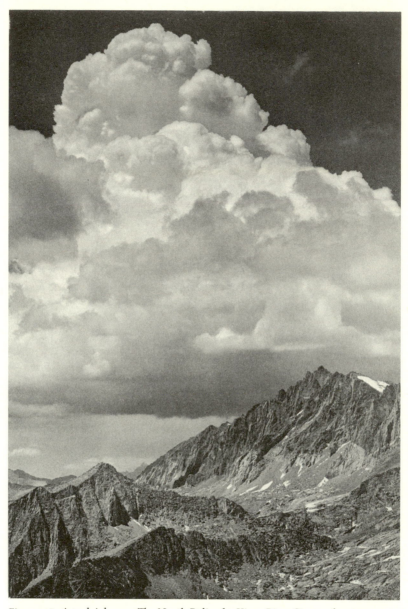

Figure 108. Ansel Adams, *The North Palisade, Kings River Sierra*, about 1932.
Ansel Adams Archive, Center for Creative Photography, University of Arizona,
© The Ansel Adams Publishing Rights Trust.

to nineteenth-century precedents in both composition and subject matter. *Kaweah Peaks from Little Five Lakes* is a picturesque scene of a lake with a looming mountain range in the background (figure 109). The traditional *repoussoir* technique of framing the scene on either side with trees in the foreground leads the viewer's eye inward to the edge of the lake and associates the experience at the site with the lengthy history of such western scenes. Similar to his nineteenth-century forebears, Adams has depicted this place not as a distant ideal of grandeur and glory but as a

site that encompasses actual people. Like the peopled landscapes represented by all of the photographers highlighted in this book, Adams's image reveals inhabitation; on close inspection, this landscape is populated with campers, picnickers, and sunbathers, once more recalling the earlier precedents in which locals found their way into landscape photographs more often than not. *Kaweah Peaks from Little Five Lakes* is one of four photographs in *Sierra Nevada* that include people in the landscape; *Mount Kaweah*, *Moraine Lake*, and *Red and White Mountain* are the others.

ADAMS'S INHERITANCE

Adams voiced his attitudes toward western photography in the previous century on a number of occasions. In an unpublished article, he wrote about the "many stabilizing sources" in the efforts to understand photography as an art form. "Not the least of these sources," he wrote, "[is] found in the achievements of early landscape and mountain photographers." "There is a certain serinity [*sic*] and simplicity in their work (Watkins, O'Sullivan, Muybridge and Fiske) which is rarely to be found in contemporary photography."[45] In a more official capacity, he wrote about nineteenth-century photography in 1940, when he participated as a director of photography in the "Pageant of Photography" exhibition in the Palace of Fine Arts on

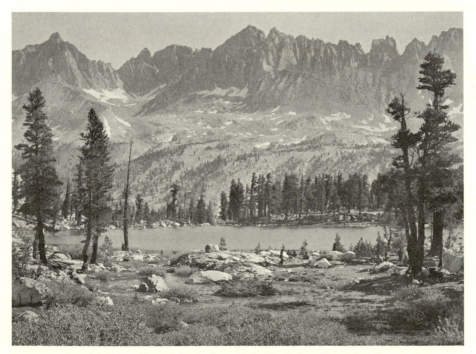

Figure 109. Ansel Adams, *Kaweah Peaks from Little Five Lakes, Kern River Sierra*, 1930s. Ansel Adams Archive, Center for Creative Photography, University of Arizona, © The Ansel Adams Publishing Rights Trust.

Treasure Island at the Golden Gate International Exposition in San Francisco.[46] In his introduction, Adams wrote eloquently about the previous generations, explicitly connecting them to his fellow moderns:

> Today, with due consideration for the startling technical advances, the best modern work suggests the basic qualities of the great photography of a century ago, plus the enlarged vision and increased social awareness of our time. The moving spirit of the Hills and the Camerons and the fine daguerreotypes lives again in the magnificent work of Stieglitz, Strand, Weston, and others who have assumed the responsibility of continuing a simple, incisive statement by means of the camera.[47]

He continued:

> We cannot fail to be impressed by the magnificent daguerreotypes of Southworth and Hawes, and the historic photographs of Brady, Gardner and others of the 1850's and 60's in the Eastern United States, and the exciting work of the great Western photographers, such as Jackson, O'Sullivan, and Watkins. . . . Above all, the work of these hardy and direct artists indicates the beauty and effectiveness of the straight photographic approach.[48]

Here Adams demonstrates his understanding of the history of nineteenth-century American photography as two distinctly geographic traditions, even though he suggests they both represented the origins of the "straight photographic approach."

In 1942, Adams was involved in an exhibition titled "Photographs of the Civil War and American Frontier," an event that he described as his "most important contribution" to the Museum of Modern Art in New York as the acting vice chair of the Department of Photography Exhibition Committee.[49] Adams would have been a natural fit to assist with exhibitions relating to the American West, and he did work on a number of exhibitions for MoMA, including the "Sixty Print Exhibit" and "The Negative and Print Show." His link to the nineteenth-century subject matter of the Civil War and the American frontier demonstrates his active interest in those photographic precedents. Instead of simply recalling the older photographic traditions as purely didactic, however, Adams chose images by Mathew Brady, William Henry Jackson, Timothy O'Sullivan, and others for purely aesthetic reasons. Most viewers of frontier photography, then and now, assumed documentary content for the photographs included in the exhibition, but Adams attempted to recast the American public's perception of the earlier era by focusing on the emotions those photographs inspired. In a letter to Alfred Barr, then director of the museum, Adams stressed that his purpose was "to concentrate on the asthetic [sic] aspects" of American photography "rather than on the historical aspects," despite early criticism that the show demonstrated a "historical paucity."[50] Adams

reprinted the most visually appealing images he could find, and Beaumont Newhall hung the exhibition. Originally they had wanted to include western film as a component, but they settled on framed photographs; photographic albums by Gardner, Jackson, and O'Sullivan; and "actual stereoscope viewing machines" that were "fastened securely to the shelf."[51] Allowing for the culture of the historical material, Adams still was able to subtly recast the earlier traditions of photography according to his (1940s) modern sensibilities.

Despite his strident aesthetic and interpretive aims, Adams identified with the Northern California region much in the same way as resident photographers had before him. Unlike the itinerants, Adams learned his craft in a particular place, and he invested in visual explication of the place for those of the region and those who visited. Eventually, Adams's sense of location and his place in it expanded, and he became known as a "western" photographer instead of just a "Northern California" photographer. For example, Adams's New Mexican photography continues to take precedence in his oeuvre. *Moonrise, Hernandez, New Mexico*, for instance, represents Adams as a westerner, not just a Yosemite or Bay Area resident. The earlier *Sierra Nevada* images, on the other hand, link him to his specific locale—one that he considered home.

Perhaps because of Adams's midcentury career, his landscapes and images of Native Americans have not been discussed with the same scrutinizing methodologies that have been applied to his nineteenth-century counterparts. The discourse on Native Americans in the West had changed dramatically from the turn of the century and earlier to the 1930s, certainly, but lack of interest in Adams's photographs of Native Americans and their landscapes is made up for in discussions of the roughly contemporary but somewhat older photographs by Edward Sheriff Curtis and others with a more overt interest in the subject. Adams did photograph the Native American landscapes, however, as did the settler photographers before him. Sometimes his efforts were direct, as in his portraits of Native Americans and his photographic contribution to Mary Austin's 1930 book *Taos Pueblo*.[52] At other times, his pure landscape photographs remain disconnected from the cultural history of western places. Adams was busy creating his own western vision, which was distinct enough from that of his earlier American counterparts that his relationship with the "native landscape" was like a cousin twice removed. Adams, like earlier western photographers, carried the traditions and tropes of western visual culture with him, and he applied these conditions to western places laden with discrete cultural history and meanings. Adams, however, also carried the by then thick heritage of his photographic predecessors.

Adams began his career with an intuitive grasp of the importance of western landscape photography to the development of the region. Both the subject matter and formal qualities of his work demonstrate his understanding of western photographic traditions, but he was aware that the discussion surrounding both photography and the West had changed. In the arena of art, especially, ideals concerning photography as art were greatly transformed in the twentieth century. About the 1979 Museum of Modern Art exhibition "Ansel Adams and the West," a perceptive critic noted:

There is, of course, as one might expect at the Modern, where curators like to pretend that nothing matters except the artist's intention, no recognition of the technological changes, the increases in speed and sensitivity to color, that enabled a 20th-century photographer to capture ephemeral effects that were quite beyond the reach of his 19th-century predecessors. Nor is there any attempt to place the quite extensive and interesting selection of early works in its historical context.[53]

Clearly, Adams was not the only one shaping public understanding of his work. "Despite the modernity," the critic continued, "they are fundamentally old fashioned, composed in the grand style of the 19th-century landscape photography . . . speaking with the kind of public voice that everyone can understand and that has almost entirely disappeared from modern art."[54] Despite this criticism, John Szarkowski, curator of the exhibition and influential director of photography at the Museum of Modern Art, also saw the forward-and-backward–looking sensibilities of Adams's work. He acknowledged that Adams was "the last of that line of 19th-century romantic landscape artist who glorified the heroic wilderness, and—simultaneously—one of the sources of a new landscape tradition."[55] By the 1970s, it was easy to recognize Adams as the last of an older type of photographer, despite his insistent modernism. In explanation of the 1977 publication of various portfolios from the 1940s through the 1970s, Szarkowski wrote that Adams's photographs were by then "anachronisms," intuiting that they were "perhaps the last confident and deeply felt pictures of their tradition."[56] Hindsight clearly distinguishes Adams's approach from the avant-garde of the 1970s, but Adams's reputation continued as an early modernist instead of a late landscape photographer in the old style—certainly he was rarely understood as both.

Sensitive to the pulse of his own era, Adams emerged as a visual spokesman for the new twentieth-century West, adapting the past to the new era but also ensuring the importance of the iconic western landscape in the modern imagination. Adams is often criticized for his conformity to what had become landscape clichés in the mid- to late twentieth century. Paradoxically, his conscious and consistent effort to ideologically disconnect himself from western photographic traditions is exactly why he became so successful. His success was ultimately also connected to both his written and visual rhetoric, which demonstrated his deep belief and insistence that his vision—his version of the West—was brand new.

Afterword

THE EXPERIENCES OF EASTERLY, WHITNEY, Britt, Butcher, the Kolbs, and Adams as western photographers extensively affected their communities and audiences in the nineteenth and early twentieth centuries and continue to do so today. In a much larger sense, all the photographers of their era cumulatively influenced conceptions of the West for those both in and out of the region. Through a fundamental connection to the development of their locale, landscape photographs expose as much about the people who bought and looked at them as they do about the photographers who fashioned them.

The widespread practice of picturing the setting of a burgeoning western community is an apt framework with which to explore the work of these photographers, because their landscape images give a sense of what those communities wanted and what the photographers thought they would (or should) want. Their images, however, are neither solely documents nor pure invention. The photohistorian and theorist John Tagg asserted in his influential *The Burden of Representation* that

> we have to see that *every* photograph is the result of specific and, in every sense, significant distortions which render its relation to any prior reality deeply problematic and raise the question of the determining level of the material apparatus and of the social practices within which photography takes place.[1]

Further, he wrote that "the indexical nature of the photograph . . . is therefore highly complex, irreversible, and can guarantee nothing at the level of meaning."[2] Like a painting or a print, settler photographs represent settlers' conceptual understanding of their western places at the same time that they reflect many other related and complex themes. The photographs reflect the hopefulness and optimism of settlers and new communities, often at the same time as they seem to document fortitude in the face of adversity. The dual function of the photographers represented in these chapters was at once to capture the promise of the future that led many settlers west in the first place and to capture a significant era as it rapidly passed into history. Moreover, the landscape photographs were both forward and backward looking: they were simultaneous projections of desire and objects for

161

posterity.[3] For these photographers and their audiences, landscape images were important artifacts that represented important ideas.

Western photographers' ability to interpret their communities was not simply due to the unique characteristics of their respective locations; it was also the result of their desire to construct or capture the prevailing narrative of western settlement. The medium's veracity often obscured the narrative thrust of these works for their nineteenth-century audiences, who chose instead to believe that the European aesthetic of picture making was natural and transparent. As well, consistent use of artistic tropes in landscape views seems to have matched the manner in which immigrants to the West looked at the actual landscapes. Although a community's interest in its local photographer relates to an abiding interest in a sense of place, the explication of the photographs is not so simple.

The parallel trajectories of growth and development in the West as a region and in photography as a medium suggest that these issues are intimately interrelated. Indeed, how quickly and how well a western photographer could produce a desired view depended on his equipment, the complexity of the photographic process he used, and his distribution methods, and these virtually always determined his commercial success. So rapid and distinct were the changes in photographic technology during the era that the average photographer must have possessed remarkable skills, such as extreme technical adaptability and the ability to switch marketing techniques based on the fickle whims of the American people. Time and again, the surge of a particular genre of photography was related to a new format. Beyond the initial excitement of the daguerreotype, the stereoscope augmented landscape sales and the carte de visite format increased portraiture. They both significantly encouraged collection and represent a leisure-time activity that occurred in both the East and the West.

As stated at the outset of this book, the photographers herein are representative of a huge number of western photographers who chose to settle and serve western communities. Their landscape images had a distinct function in their towns and regions, and although some of these images found their way outside of the places they represented, they nonetheless held meaning for residents in a substantially different manner than they did for outsiders. For locals, landscape images may have represented national ideals, but in an immediate sense, they embodied concepts more directly related to locals' own experiences. Local landscape photographs gave residents visual affirmation of hopes and expectations and supported the grassroots struggle for civic distinctiveness that was taking place all over the growing West.

For the photographers, the variation of photographic experience in the West was heavily contingent on the site-specific characteristics of place. Distinct landforms, elevation, and available natural resources inevitably influenced western photographers, as they did all settlers. Environmental factors, such as weather patterns and regional climates, not only influenced the public's desire for landscape views but shaped the photographer's ability to create and then satisfy local demand. Despite the ubiquity of photographers in western communities large and small, regional and local characteristics explain the differences between Easterly, Whitney,

Britt, Butcher, and the Kolbs. The first two worked in urban centers; Britt, Butcher, and the Kolbs performed their endeavors in extremely remote locations. Three of these photographers isolated key monuments in their respective locations. Although Minnehaha Falls, the Big Mound, and Crater Lake were by no means the only local foci of Whitney's, Easterly's, and Britt's landscape endeavors, they represent an important portion of the their respective photographers' productions of views. Conversely, the Kolb brothers' landscape images may at first appear to be a more cohesive and focused effort, but they actually represent many different locations and monuments within the larger place of the Grand Canyon. For instance, Easterly's visually distinct representations of Chouteau's pond and the Big Mound within the city of St. Louis are in sharp contrast to the visual cohesiveness of the diverse places in the vast region of the Grand Canyon. And Butcher, in the absence of the type of natural forms that strike a chord in the mind's eye of the Euro-American, creatively highlighted transformation and utilized the local plains as a stage for human activity. Despite the public's perception of the place, however, the unique microenvironments of the Great Plains landscape, with its overwhelming biodiversity, are no less varied than those of the Grand Canyon. Instead, perception resided in the photographers and their clients and, to a large degree, still resides in the modern viewer of these photographs.

Preconceptions of western places and the desire to fit their landscape images into the aesthetic sensibilities of culture in the eastern states and in the western European visual heritage more generally is apparent in the manner in which photographers depended heavily on culturally accepted aesthetic tropes. An ability to present a prospect or picturesque view, for example, through these tropes allowed photographers to match residents' visual expectations of actual landscapes—of what to look at and how to look at it. Western photographers and the viewing public possessed an automatic ability to produce and understand such views. Because formal elements and principles of design are evident in virtually all western photographs during the frontier era, the western photographers' and their clientele's adherence to European visual culture does not appear largely self-aware—but sometimes it was.

Although their respective audiences generally regarded Whitney and Easterly as photographic artists—that is, as masters of their craft—Britt actually was an artist. His paintings of the same subjects he photographed provide a clear and fascinating link between these two media and their influences on Britt's approach in both. As community purveyors of visual taste, these three photographers sold original and reproductive images in all manner of media along with their own photographs. Butcher and the Kolbs, however, became adept at their trade through their almost involuntary knowledge of how to see landscape in the accepted cultural paradigm. That both photographic outfits worked in the late nineteenth and early twentieth centuries is not a coincidence. Although all photographers had the ability to recognize and even reproduce picturesque landscapes based on the visual culture of their era, Butcher and the Kolbs benefited from forty to seventy years of photographic visual legacy. The plethora of photographic landscapes available by

the turn of the century, especially, gave nonartistic practitioners a substantial body of work after which to model their own.

Throughout their shared history of the American West, Euro-Americans have demonstrated an abiding interest in Native Americans via photography. In fact, the important connection between western landscapes and efforts to photograph them with local native tribes—both historically and often as a formidable contemporary presence—further throws assumed and standardized visual tropes into question. The actual landscape evoked these indigenous populations in myriad complex ways, and thus traces of that awareness exist in the photographs as well. Roland Barthes's seminal book *Camera Lucida* explores the relationship between the photographic image and time past; the author marvels at the discrepancies between "just an image," and "a just image."[4]

As we continue to learn about Native American tribes' relationships to their landscapes, we can reassess how those places were represented in the work of settler photographers. Whether the view is a half plate daguerreotype, a carte de visite, a stereograph, or a large-format print and whether the photographer and audience embraced, rejected, or ignored the existing cultural landscape reveal much about the photographer and his or her clientele. Native Americans in western landscape photographs were regarded during the nineteenth century as desirable commodities for the assumed Euro-American viewing audience. Furthermore, that landscape views were neither made for nor by Native Americans suggests that their tribal methods for understanding and depicting geographic space were not and perhaps could not be embodied by photographs. But as modern viewers continue to scrutinize these photographs, they seem to represent not only a strong narrative about the construction of place and community; they are also extremely redolent of the missing tribal narrative that Euro-American photographers could not capture. Victor Masayesva echoed Barthes when he wrote that "photography reveals to me how it is that life and death can be so indissolubly one; it reveals the falseness of maintaining these opposites as separate."[5] His words underscore the presence and absence of the different cultural narratives in western landscape photographs. Similarly, new approaches to history and photography converge to reveal the falseness of maintaining Euro-American and tribal landscape narratives as separate.

Finally, western photographers enjoyed various levels of community support and success, and they continue to do so. Whitney's attention to Minnehaha Falls in the 1850s and 1860s, for example, remained relevant throughout his career and was taken up by his colleague Charles Zimmerman. Because the site remained important in the Twin Cities, Whitney was retrospectively and posthumously celebrated as a settler photographer. Conversely, Thomas Easterly's career was devalued by the late 1860s because his antiquated brand of picture making was no longer desirable to the St. Louis community, which was looking ever forward to more industrialism, more growth, and more progress. The photographers whose work matured late in the century—Britt and Butcher, for example—lived long enough to see their careers and lives celebrated by their community and by an even larger market, which found a nostalgic value in the passing of what it identified as the frontier era. Britt and

Butcher and others became relics of bygone days during their careers, transforming their studios and galleries into "pioneer studios and galleries."

The Kolbs' brand of localism in the first decades after the turn of the century is different still. Instead of interpreting and constructing local identities through local places, the Kolbs were local "narrators," interpreting place for the steady and ever-increasing stream of outsider tourists. With the pioneer days firmly located in the past and the technology of the photographic medium both a hindrance and a blessing, the Kolbs embraced more deliberately the cultural interpretation of the landscape that came so reflexively to their predecessors. Additionally, the brothers' attempts to explore the Grand Canyon primarily as resident photographers lend credence to the primacy of western photographers' role in western communities.

The diversity of regional characteristics and technological approaches makes an exploration of the phenomenon of locally oriented photographers in the West challenging. Despite the diverging details of their stories, the commonality of settler photographers is that they were vital figures in their western communities and that the important position western photographers sought and held was a passing phenomenon as the nineteenth century progressed. Although largely overlooked as a formidable group, those like Easterly, Whitney, Britt, Butcher, and the Kolbs have not been forgotten individually in their communities, as evidenced by the continuing attention to them by local historians and archivists across the West. Despite their successes and failures, all western photographers were arbiters of their community's visual culture. Local landscapes, as a sharply important genre of the medium, shaped conceptions of the American West from the inside out, and the photographers who pictured them are still valued by modern audiences in their regions in much the same way as they were originally—as witnesses.

Local photographers from the nineteenth and early twentieth century are still revered in the West, and they, like their photographs, have become symbols of a shared past. Their efforts, as much as their images, effectively represent the settler era. At the beginning of this new millennium, with the rapid exchange of information in the digital age, the grassroots efforts of western photographers are revealed as never before and hold promise for more discovery of the region's visual past. The history of western photography requires more attention to reveal the importance of local photographers as a whole. As a counterpoint, the history of settled resident photographers adds depth to the concept of "western views for eastern audiences," and together, these two paths of visual culture, the national and the local, can better elucidate the western past.

THE LEGACY OF NINETEENTH-CENTURY SETTLER PHOTOGRAPHY TODAY

"It seems to me," wrote photography historian Robert Taft in 1938, "that local historians would find a fertile field of research [in state and local historical societies] not only in locating . . . material, but in preparing brief photographic histories of

their localities."[6] His recognition of the richness of state archives for regional and local research seems even more prescient today, as these collections and those of corporations, individuals, and museums are being digitized for Internet accessibility and massive websites devoted exclusively to integrating smaller collections. These efforts have created a staggering level of unprecedented access to what used to be either inaccessible or viewable only with great effort. Thousands, if not millions, of little-known images are now only a click away. In short, what we are witnessing is a surge in convenience and the resultant renewed interest concerning nineteenth-century regional photography—both at a local level, for "brief photographic histories of their localities," as Taft implied, but also in the greater arena of visual-culture scholarship. This newfound access not only prompts interest in nineteenth-century photographs but also requires that we recognize that these images are far more complex creations than has typically been understood. A commensurate reevaluation has begun of how westerners used them and how we, in the twenty-first century, understand them.

Beyond a scholarly reevaluation of nineteenth-century photography, the art photography that emerged in 1920s and 1930s America drew on the settler photographer paradigm. Ansel Adams, especially, embodied that manifestation of the resident landscape photographer. Adams's particular modernist approach via his Group f/64 efforts has often led scholars to consider his work as an important straight photographic beginning in the fine arts, but his position at the end of an era of rooted, residential western landscapes goes mostly unnoticed. His position as a late image maker of a by then very well-known subject matter has, however, largely been intuited by all those who still admire his grandiose imagery.

In the end, all purported "western photographers" must acknowledge the strength of the western landscape paradigm set by those earlier practitioners who ultimately defined not only a genre of photography but an enduring and complex understanding of place. Aided by the likes of Jackson, Watkins, O'Sullivan, and others, the larger group of photographic workers, represented by those discussed herein, still exercise profound influence on local notions of community and heritage—even if they lie, for the time being, chiefly outside the discourse of the history of place making in the American West.

Notes

Introduction

1. William Henry Jackson, *Time Exposure*, 173.
2. Wood, *The Scenic Daguerreotype*, 2. For example, the daguerreotype scholar John Wood has written that "most American scenic daguerreotypes are boring documents of middle-class egotism which again and again do no more than record their owners' painfully ordinary stores, houses, and barns." William Welling, as well, in his suggestion that "America was still without an accomplished landscape photography school in the 1860s," supposes a lack of cultural or aesthetic complexity in the photographs that were produced (*Photography in America*, 171).
3. See, for example, Hales, *William Henry Jackson*; Sandweiss, *Print the Legend*; and Trachtenberg, *Reading American Photographs*. Additionally, much of my own point of view is deeply informed by postmodern photographic theory, most notably Crimp, "Photographic Activity of Postmodernism"; Krauss, "Note on Photography"; Rosler, "In, Around, and Afterthoughts"; Sekula, "On the Invention of Photographic Meaning"; and Solomon-Godeau, "Photography After Art Photography."
4. Armitage, "From the Inside Out," 33, and Worster, "New West, True West," 149. Worster's essay was reprinted in *The American West: Interactions, Intersections, and Injunctions*, which brought together a number of useful essays concerning regional interpretations, including Martin Ridge's essay "The American West: From Frontier to Region." See also Limerick, "Region and Reason."
5. DeBow, *Statistical View of the United States*, 126.
6. Greeley et al., *Great Industries*.
7. Ibid., 881.
8. Ibid., 874–81.
9. Ibid., 880.
10. Mautz, *Biographies of Western Photographers* and Palmquist and Kailbourn, *Pioneer Photographers*. Carl Mautz's encyclopedic effort in *Biographies of Western Photographers*, although it overlaps with Palmquist and Kailbourn's "biographical dictionary," focuses on the historical West and includes states such as Iowa and Missouri that are now popularly considered to lie outside the region. Palmquist and Kailbourn's work focuses on the Far West and excludes midwestern states.
11. The Peter Palmquist collection of more than fifty thousand images is located at the Beinecke Library, Yale University, as part of the Western Americana Collection. Concerned mostly with the history of women in nineteenth-century photography and images from Humboldt County, the Palmquist collection also includes his extensive research materials.

12. John Johnson, *Eureka*, 7–8, as quoted in Welling, *Photography in America*, 10.

13. "America in the Stereoscope," 221.

14. Masteller, "Western Views in Eastern Parlors"; Ostroff, *Western Views and Eastern Vision*; and Bradley Bennett Williams, "Image of the American West."

15. "America in the Stereoscope," 221.

16. Glover, *Philadelphia Photographer*, 239, 339, 367, 371. Written in August, Glover's last correspondence appeared in the same October issue as his obituary. See also Fleming, "Ridgeway Glover, Photographer."

17. Glover, *Philadelphia Photographer*, 371. Taft recounts Glover's story in *Photography and the American Scene*, 275–76.

18. William Henry Jackson, *Time Exposure*, 245.

19. Ibid., 145–246.

20. Roche, *Anthony's Photographic Bulletin*, 268–69. Reprinted in Welling, *Photography in America*, 211.

21. Roche, *Anthony's Photographic Bulletin*, 211.

22. See, for example, Schlissel, *Women's Diaries*; Schlissel, *Far from Home*; and Kolodny, *The Land Before Her*.

23. See, for instance, Roberts, *Longinus on the Sublime*. For later contributions on landscape aesthetics, see Burke, *Philosophical Enquiry*; Gilpin, *Three Essays*; Price, *Essay on the Picturesque*; and Knight, *Analytical Inquiry*.

24. See Kinsey, *Plain Pictures*.

25. "Outdoor Photographs," 129.

26. Ibid.

27. Ibid.

28. Snelling, preface to *Dictionary of the Photographic Art*, v.

29. Edward Anthony to H. H. Snelling, letter, February 1, 1849. Reprinted in Snelling, preface to *History and Practice*. Snelling wrote for and edited *The Photographic Art Journal* in New York from 1851 to 1853 and the *Photographic and Fine Art Journal* from 1854 to 1860.

30. Although a list of influential studies on the topic of Euro-Americans and the western landscape is large, a few notable works include Henry Nash Smith, *Virgin Land*; Nash, *Wilderness and the American Mind*; Goetzmann and Goetzmann, *West of the Imagination*; Marx, *Machine in the Garden*; and John Brinkerhoff Jackson, *Discovering the Vernacular Landscape*, 8, where he wrote, "a landscape is not a natural feature of the environment but a synthetic space, a man-made system of spaces superimposed on the fact of the land."

Chapter 1

1. Goddard, *Where to Emigrate and Why*, 278.

2. The most current scholarship on Easterly includes Kilgo, *Likeness and Landscape*, and Sandweiss, "Picturing Change."

3. *New York Herald*, May 21, 1849. See also Henry M. Whelpley, "The Group of Mounds That Gave St. Louis the Name of Mound City," paper presented at the meeting of the American Association of the Advancement of Science, 1925, Whelpley papers, box 1, Missouri History Museum, St. Louis.

4. Conn, *History's Shadow*, 126–27.

5. Kilgo, *Likeness and Landscape*, 201.

6. Boime, *Magisterial Gaze*, 1.

7. See Reps, *John Caspar Wild*, 57.

8. Sandweiss, "Picturing Change," 88.

9. "Landmarks of St. Louis: Antiquarian Gossip and Legendary Lore," *St. Louis Globe-Democrat*, June 6, 1875.

10. Ibid.

11. Scharf, *History of Saint Louis*, 95.

12. Fern, "Documentation, Art," 12–13.

13. Pauketat, *Ancient Cahokia*, 96–97.

14. Ibid., 107.

15. Dunlop, *Sixty Miles from Contentment*, 95.

16. Jefferson, *Notes on the State of Virginia*, 97–100.

17. Dunlop, *Sixty Miles from Contentment*, 82–83.

18. Peale, *Ancient Mounds of St. Louis*, 391. Major Stephen H. Long led the expedition up the Platte River to explore both the Red and Arkansas Rivers.

19. Ibid.

20. Conant, *Switzler's Illustrated History*, 45.

21. Ibid. Alban Jasper Conant (b. 1821) was an American artist who lived most of his life in Vermont. He is best known for his archaeological publications in Missouri as well as for his portraits of Abraham Lincoln, Edward Bates, and Edwin Stanton. His background suggests that his collaboration with Easterly may have been aesthetic as much as archaeological.

22. Baldwin, *Ancient America*; Foster, *Prehistoric Races*; and others.

23. James, *Account of an Expedition*, 59–60.

24. Priest, *American Antiquities*.

25. See Dippie, *The Vanishing American*, and Lyman, *The Vanishing Race*.

26. Atwater, "Description of the Antiquities," 209.

27. Scharf, *History of Saint Louis*, 98.

28. Conant, *Foot-Prints of Vanished Races*, 41, and Scharf, *History of Saint Louis*, 96–97.

29. Cooper, "A Dissolving View," 83.

30. Scharf, *History of Saint Louis*, 95–99.

31. Ibid., 98.

32. Smit, "Old Broadway," 155. Also cited in Kilgo, *Likeness and Landscape*, 226n82.

33. "The Big Mound," *St. Louis Daily Times*, April 16, 1869.

34. Conant, *Switzler's Illustrated History*, 45.

35. Whelpley, "Group of Mounds." Also quoted in Kilgo, *Likeness and Landscape*, 203, 226.

36. Buckingham, *Eastern and Western States*, 143–44.

37. Scharf, *History of Saint Louis*, 95.

38. Kilgo, *Likeness and Landscape*, 208; Sandweiss, *Print the Legend*, 250–51.

39. Hales, *Silver Cities*, 25. Peter Hales called these photographers "canny exploiters."

40. Turner, "Significance of the Frontier," and Slotkin, *Gunfighter Nation*, 11.

41. Vizenor, *Fugitive Poses*.

42. Masayesva and Younger, *Hopi Photographers*, 90.

43. Rickard, "Occupation of Indigenous Space," 57.

44. Sandweiss, "Picturing Change," 90.

45. *Missouri Republican*, August 19, 1847.

46. *Missouri Republican*, March 25, 1848; *Missouri Republican*, October 6, 1866.

47. S. F. B. Morse, letter to the editor, May 18, 1839, *New York Observer*.

48. Kilgo, *Likeness and Landscape*, 14.

49. From a broadside advertising Easterly's daguerreotypes in 1865. Easterly-Dodge Collection, Missouri History Museum. The full broadside is printed in Kilgo, *Likeness and Landscape*, 28.

50. *Philadelphia Photographer* 7 (November 1870): 385.

51. Ibid.

52. Wright, "'This Perpetual Shadow-Taking,'" 23–24; Taft, *Photography and the American Scene*, 255, 489; and Kilgo, *Likeness and Landscape*, 20.

53. Kilgo, *Likeness and Landscape*, 20. Kilgo asserts that Easterly "showed no interest in vying with Fitzgibbon for national recognition."

54. *Practical Photographer* 6 (April 1882): 144.

Chapter 2

1. Alexander Hesler to Russell Blakeley, "An account of the taking of the first picture of Minnehaha Falls in 1852 and its use by Henry Longfellow in writing Hiawatha," letter, 1880s, Minnesota History Center.

2. Ibid.

3. *Anthony's Photographic Bulletin* 26 (August 1895): 259. Also quoted in Welling, *Photography in America*, 83. This recounting claims that Hesler took the daguerreotype in 1851 rather than 1852. Hesler visited St. Paul in 1851, when he took pictures of St. Anthony Falls and Fort Snelling and first met Whitney. The trip to Minnehaha Falls that produced the image that went to Longfellow did not occur until the next year, 1852.

4. *St. Paul Daily Press*, February 7, 1861.

5. "Longfellow's Song of Hiawatha," *Graham's American Monthly Magazine*, December 1855, 535.

6. Deming, *Manabozho*.

7. "Is Hiawatha Borrowed from the Swedish?" 573.

8. Twain, *Life on the Mississippi*, 589.

9. "Falls of the Minnehaha," 173.

10. Keating, *Narrative of an Expedition*, 302.

11. E. Sanford Seymour, quoted in "Upper Mississippi," 484. See also "Falls of the Minnehaha," 173.

12. Seymour, "Upper Mississippi."

13. Schoolcraft, *Narrative Journal of Travels*, and Eastman, *Dahcotah*.

14. Some early guidebooks include Smith, *Western Tourist and Emigrants' Guide*; Curtiss, *Western Portraiture and Emigrants' Guide*; Andrews, *Minnesota and Dacotah*; and Oliphant, *Minnesota and the Far West*.

15. "Upper Mississippi," 481.

16. Owen, *Report of a Geological Survey*, and Seymour, *Sketches of Minnesota*. Owen was an artist and pioneer geologist in the Midwest and led many federal and state geological surveys in the region.

17. "Upper Mississippi," 483.

18. Ibid.

19. Ibid.

20. Holbrook, "Letter from Minneapolis," 232.

21. Ibid.

22. Ibid.

23. Wilson, "Working the Light."

24. Ibid. For a full list of Minnesota photographers, see Mautz, *Biographies of Western Photographers*, 265–77.

25. Reps, *Cities of the Mississippi*, 4–5.

26. Hales, *Silver Cities*.

27. Ibid., 25.

28. "Whitney's Picture Gallery," 336.

29. *American Journal of Photography* 3 (February 1861): 272; also reprinted in Welling, *Photography in America*, 150.

30. Newhall, *The History of Photography*, 64.

31. Wilson, "Joel Emmons," 2.

32. The Minnehaha Falls area was privately owned until the Minneapolis Park and Recreation Board bought the property and turned it into a city park in 1889. Nonetheless, it was a popular site, and it was eventually augmented by service from "Milwaukee Road" trains in 1875 as one of the stops on the Chicago, Milwaukee, St. Paul and Pacific Railroad.

33. "Whitney's Picture Gallery," 375.

34. Wilson, "Working the Light," 47.

35. "Whitney's Art Depot," *St. Paul Pioneer Press*, November 29, 1866.

36. See *Daily Pioneer and Democrat*, December 23, 1859; "Whitney's Picture Gallery," 376; and, *St. Paul Pioneer Press*, January 12, 1865.

37. *Daily Pioneer and Democrat*, August 2, 1860.

38. *Frank Leslie's Illustrated Newspaper*, December 25, 1869, 253, and Wilson, "Working the Light," 50.

39. Cole, "Essay on American Scenery," 8.

40. Rainey, *Creating Picturesque America*, 206.

41. Magoon, "Scenery and Mind," 3. E. L. Magoon was a Baptist minister who collected landscape drawings and paintings.

42. Smith, "American Emotional and Imaginative Attitudes," 141. See also Smith's published work, *Virgin Land*.

43. Runte, *National Parks*, 228. Here I am suggesting Runte's work as a model for determining the value of certain lands and natural monuments as parks. Specifically, he suggests that monumentality and uselessness are common prerequisites for a national park, although urban recreation areas developed in response to, among other things, the needs of local communities.

44. Holbrook, "Letter from Minneapolis," 232.

45. "Falls of Minnehaha," 173.

46. Bryant, *Picturesque America*, 2:350–52.

47. Rainey, *Creating Picturesque America*, 206–14.

48. "Falls of Minnehaha," 173.

49. Cox, "Upper Mississippi and Northern Lakes," 1. Volume one of this weekly publication carried the subheading, "Representing our Native Land and its Splendid Natural Scenery, Rivers, Lakes, Waterfalls, Geysers, Glaciers, Mountains, Cañons, and Entrancing Landscapes, Reproduced in a Series of Nearly Five Hundred Superb Original Photographs, with Graphic Historical Descriptions and Character Sketches, Constituting a Complete Historical and Geographical Picturesque America."

50. Kinsey, *Thomas Moran*, 22–23, and King, *Mountaineering in the Sierra Nevada*, 43.

51. Trachtenberg, *Shades of Hiawatha*, 16.

52. Seymour, *Sketches in Minnesota*.

53. Eastman, *Dahcotah*, ii. See also Eastman, *American Annual*.

54. Stewart, *American Place-Names*, 297.

55. Monkhouse, "Henry Wadsworth Longfellow." Representations that focused more on the narrative of Hiawatha were also not bound by any specific geography. Thomas Moran's image *The Spirit of the Indian, or, Hiawatha* (1869), for instance, although demonstrating the same type of romantic zeal as could be found in Longfellow's poem, more appropriately situates Hiawatha and other characters in a fictitious setting. See also Nickerson, "Artistic Interpretations."

56. See Gidley, "Figure of the Indian."
57. Nickerson, "Artistic Interpretations," 75.
58. The Anurag Art Foundry claims there is no specific correlation between Noisecat's subject matter and the site. Anurag Art Foundry, e-mail, November 2006.

Chapter 3

1. Miller, *Photographer of a Frontier*, 3.
2. Goddard, *Where to Emigrate and Why*, 70. Goddard reported a population of 2,955 for Jackson County in 1869.
3. The Britt archive, located in the Southern Oregon Historical Society's Research Library and Archives in Medford, Oregon, has a large and impressive collection of materials relating to Britt's life in the region. The Jacksonville Museum also has significant material; most notable is a collection of his paintings, but it also has useful cultural artifacts from the second half of the nineteenth century.
4. Goddard, *Where to Emigrate and Why*, 51.
5. Ibid.
6. Ibid., 63.
7. Harmon, *Crater Lake National Park*, 26–28, and the Crater Lake National Park website, http://www.nps.gov/crla/index.htm.
8. *Oregon Sentinel*, November 8, 1862.
9. Trachtenberg, *Reading American Photographs*, 125.
10. Barbara Alatorre, a Klamath tribal member, describes the lake as a central character in her people's emergence mythology. See "How Giiwas (Crater Lake) Came to Be," http://www.klamathtribes.org/background/giiwaas.html.
11. Jacobs, "Our Knowledge," quoted in Harmon, *Crater Lake National Park*, 17.
12. "Klamath Land," 553.
13. Kern, "Off Beaten Paths," 25.
14. The name "Crater Lake" came into existence in 1869 after a group of locals from Jacksonville, including the editor of the *Oregon Sentinel*, a local attorney, and several "young ladies," took an excursion to the site. Britt was prepared to take pictures, but was unable to secure them due to "smoke [from forest fires] in the atmosphere." *Oregon Sentinel*, September 12, 1868, quoted in Miller, *Photographer of a Frontier*, 62.
15. Victor, "Mountaineering in Oregon," 299–300.
16. "Klamath Land," 153.
17. Dutton, "Crater Lake, Oregon," 179.
18. Ibid., 152.
19. Kern, "Off Beaten Paths," 23.
20. "Crater Lake, Oregon," 1886, 192.
21. "Klamath Land," 548–54.
22. Victor, "Mountaineering in Oregon," 299–300.
23. Edward L. Wilson, "Views in the Yosemite Valley," 106–7.
24. Linn, *Lookout Landscape Photography*, 13. Linn's book was part of Britt's library in his studio in Jacksonville, the contents of which are now at the Southern Oregon Historical Society's Research Library and Archives in Medford.
25. Trachtenberg, *Reading American Photographs*, 125. The same sentiment was expressed by Susan Sontag in her seminal work *On Photography*, 65.
26. Miller, *Photographer of a Frontier*, 25.

27. Britt's diary entry from that day says only, "Photographed the Lake. Very cold and windy. Emil had a cough." Peter Britt Collection, Southern Oregon Historical Society Research Library and Archives, MS 170, box 2, folder 2.

28. Woodbury, "Cloud Negatives and Their Use," 388–89. Woodbury wrote, "Many are the ways and means of making up for their (clouds) want; smoke, cotton-wool, and other materials being brought to play, as well as the production by means of brush and color, which latter, however, require some artistic skill."

29. Welling, *Photography in America*, 91.

30. Palmquist, "Notes about the Plates," 46.

31. Vogel, *Photographic Times*, 403–4, reprinted in Welling, *Photography in America*, 289.

32. Holmes, "Stereoscope and the Stereograph," 744.

33. Despite the stunning success of the stereoscope midcentury, the binocular nature of vision and the monocular aspect of two-dimensional representation were natural observances understood well before the development of photography. In fact, early photohistorians Oliver Wendell Holmes and Henry Hunt Snelling both attributed the first stereoscopic development to Prof. Wheatstone of England as early as 1838. See Wheatstone, "Contributions to the Physiology of Vision," 371–94, and also Holmes, "Stereoscope and the Stereograph," and Snelling, *Dictionary of the Photographic Art*, 214–22. All three men point out the comparative monocular quality of standard photography and painting, an observation that Wheatstone himself attributed to Leonardo da Vinci when he wrote that "after looking over the works of many authors who might be expected to have made some remarks relating to this subject, I have been able to find but one, which is in the Trattato della Pittura of LEONARDO DA VINCI. This great artist and ingenious philosopher observes, 'that a painting, though conducted with the greatest art and finished to the last perfection, both with regard to its contours, its lights, its shadows and its colours, can never show a relief equal to that of the natural objects, unless these be viewed at a distance and with a single eye.'"

34. *St. Louis Practical Photographer* 3 (November 1879): 130–33.

35. Ibid.

36. Miller, *Photographer of a Frontier*, 27. Miller reports that Britt used his own variation of the dry plate process. Rather than buying presensitized plates, Britt was able to create his own with the help of tannic acid.

37. Dutton, "Crater Lake, Oregon," 179.

38. Szarkowski, *Photography Until Now*, 117.

39. Whitney, *The Yosemite Book*. The photographer W. Harris also contributed four photographs to the publication. The less luxuriously illustrated version was distributed as *The Yosemite Guide-Book*.

40. Ibid.

41. For a good discussion of western lands' relationship to the future, see Dunlop's chapter "Yesterday's Future" in *Sixty Miles From Contentment*, 175–96.

42. Lyman, "The Switzerland of the Northwest," 300.

43. Murphy, "Ramblings in Oregon," 129–30. For more commentary about Oregon, see Murphy, *Oregon Hand-book and Emigrant's Guide*; *Sporting Adventures of the Far West*; and *Rambles in North-western America*.

44. Murphy, "Ramblings in Oregon," 7.

45. Peter Britt Collection, Southern Oregon Historical Society Research Library and Archives, MS 170, box 9.

46. Miller, *Photographer of a Frontier*, 22.

47. "Crater Lake, Oregon," 1888, 45–47.
48. Kern, "Off Beaten Paths," 23.
49. Wilbur, "Crater Lake, Oregon," 405.
50. Ibid.
51. See Muir, *Our National Parks*, 79. Muir states directly that "while this glorious park embraces big, generous samples of the very best of the Sierra treasures, it is, fortunately, at the same time, the most accessible portion."
52. Clarence Dutton also promoted the idea. See Dutton, "Crater Lake, Oregon," 179–82.
53. See W. G. Steel to Peter Britt, letter, October 9, 1885, Peter Britt Collection, Southern Oregon Historical Society Research Library and Archives, MS 170, box 1, folder 3.
54. Harmon, *Crater Lake National Park*, 81.
55. Ibid.

Chapter 4

1. For a monographic account of his life and ventures, see Carter, *Solomon D. Butcher*.
2. Butcher, *Pioneer History*, 153.
3. See Mautz, *Biographies of Western Photographers*, 293–317.
4. Frederick Jackson Turner considered the settlement of the Great Plains to be a response to the needs of the West as a whole in terms of transportation and agriculture. His paper "The Significance of the Frontier in American History" was presented at the meeting of the American Historical Association in Chicago, July 12, 1893.
5. Carter, *Solomon D. Butcher*, 5.
6. Butcher, *Pioneer History*, 153.
7. Solomon D. Butcher Papers, State Archives, Nebraska State Historical Society, Lincoln.
8. Trachtenberg, *Reading American Photographs*, 89.
9. Butcher, *Pioneer History*, 3.
10. Wolfe, "'Proving Up' on a Claim," 212.
11. Henry Nash Smith discusses the emotional response to the plains in his chapters "Emotional and Imaginative Responses to the Plains Regarded as a Desert" and "Landscape of the Plains" in his dissertation, "American Emotional and Imaginative Attitudes," 75–176. Although he does not discuss the homestead era, his work provides the foundations for understanding the mindset of Americans who eventually moved into the region.
12. Anne Whiston Spirn wrote that "nested landscape structure, one part enclosed by another, may also convey a sense of refuge as one moves progressively inward," in Spirn, *Language of Landscape*, 107.
13. Kinsey, *Plain Pictures*, 3–6.
14. James, *Account of an Expedition*, 361. Long and James's descriptions and their 1822 map are the source for the phrase "Great American Desert."
15. "American Desert," 83. This short article refers to Major Long's "Expedition to the Rocky Mountains," written by Edwin James.
16. *Nebraska*, 15.
17. Kinsey, *Plain Pictures*, 11.
18. Wray, "Sod House Photographs."
19. Carter, *Solomon D. Butcher*, 44.
20. Kinsey, *Plain Pictures*, 104.
21. Butcher, *Sod Houses*.
22. Carter, *Solomon D. Butcher*, 86.

23. Ibid., 43.

24. M. M. Wolfe describes the muddy yards, visible fire guards, and unceasing winds as the presence of the environment as meaningful and influential entity in Butcher's photographs. Wolfe, "'Proving Up' on a Claim," 198–202.

25. The Nebraska State Historical Society has done an immense amount of work on Butcher's photographs, and they now offer clarified, digitally enhanced images that reveal, for instance, the details of the inside of a sod house as seen through an open window or doorway. Nebraska State Historical Society, Official Nebraska Government Website, last modified June 27, 2006, http://www.nebraskahistory.org/lib-arch/research/photos /digital/newlook.htm. See also Koelling, "Revealing History."

26. Calloway, *One Vast Winter Count*, 8.

27. Richard White, "Cultural Landscape of the Pawnees," 33; see also Richard White, "Indian Peoples and the Natural World."

28. Many firsthand accounts have been published that attest to the extreme isolation that homesteaders experienced. See, for instance, Ise, *Sod and Stubble*, and Elinore Stewart, *Letters of a Woman Homesteader*. The novels of Willa Cather and others also speak of this phenomenon.

29. John I. White, "Pages from a Nebraska Album," 30–31. See also Current and Current, *Photography and the Old West*, 176.

30. Scrapbook of newspaper clippings, Solomon D. Butcher Papers, State Archives, Nebraska State Historical Society, Lincoln.

31. Butcher, *Pioneer History*, 154.

32. Ibid., 3.

33. Butcher advertised for homestead stories in the *Custer County Chief*, according to Harry Chrisman. See his introduction to the third edition of *Pioneer History of Custer County*, vi.

34. Butcher, *Pioneer History*, 3.

35. Ibid., 4.

36. Ibid, 31–43.

37. Solomon D. Butcher Papers, State Archives, Nebraska State Historical Society, Lincoln, RG 2608, box 1, folder 1.

38. Ibid.

39. Butcher, *Pioneer History*, 3–4.

40. These articles are pasted into one of Butcher's books, located in RG 2608, box 2, folder 3 at the Nebraska State Historical Society.

41. Solomon D. Butcher Papers, State Archives, Nebraska State Historical Society, Lincoln, RG 2608, box 2, folder 1. This quotation is from a subscription receipt for the enlarged edition of *Pioneer History of Custer County*.

42. Scrapbook of newspaper clippings, Solomon D. Butcher Papers, State Archives, Nebraska State Historical Society, Lincoln.

43. Solomon D. Butcher Papers, State Archives, Nebraska State Historical Society, Lincoln, RG 2608, box 1, folder 1.

44. Ibid. Butcher was in the process of borrowing some of his prints for fair displays around the state.

45. Butcher, *Sod Houses*.

46. Sandweiss, "Undecisive Moments," 99.

47. Carter, *Solomon D. Butcher*, 8–9. The sum of six hundred dollars was a great disappointment to Butcher, who seems to have fallen victim to the interoffice politicking between Addison Sheldon and Clarence Paine, both of the Nebraska State Historical Society.

Chapter 5

1. Strong, "Ralph H. Cameron and the Grand Canyon."
2. For the most detailed account of the Kolb brothers' history, see Suran, *Kolb Brothers of Grand Canyon*; *Brave Ones*; and *With the Wings of an Angel*.
3. Nye, "Visualizing Eternity," 83. Nye points out that "images of the inner gorge failed to represent a view that any tourist could expect to see, even if they did serve to authenticate the heroism of explorers such as Powell, by depicting the spectacular hardships they endured."
4. This Charles Russell was neither the western artist nor the muckraking newspaperman of the same name.
5. Emery Kolb Collection, Cline Library Special Collections and Archives Department, NAU.MS. 197, series 1, box 1, folder 21.
6. Ibid.
7. Kolb, *Through the Grand Canyon*.
8. Ibid., 4.
9. Ibid., 11.
10. Ibid., 9.
11. Ibid., 7–8. The flat-bottomed design had been "furnished" by Julius Stone. See Stone, *Canyon Country*, 25.
12. Edison Manufacturing Company to E. Kolb, letter in response to inquiry about purchasing a motion-picture camera, 1910, Emery Kolb Collection, Cline Library Special Collections and Archives Department, NAU.MS. 197, series 1, box 1, folder 45a. The Motion Pictures Patent Company lasted until antitrust laws brought about its dissolution in 1915.
13. There was information to be had, however. The Fireproof Film Company suggested of the *Moving Picture News* that "in this publication you can find all the information you desire, and it gives the addresses of all the independent makers of films." Fireproof Film Company to E. Kolb, letter, June 25, 1910, Emery Kolb Collection, Cline Library Special Collections and Archives Department, NAU.MS. 197, series 1, box 1, folder 62.
14. Ibid., folder 110.
15. Ibid. In the end, the Kolbs contacted the Eastman Company to develop their film for them.
16. Patterson, *Saturday Evening Post*, November 23, 1907, 10.
17. Gray and Mygatt, "Rulers of the Movies," 56.
18. Kolb, *Through the Grand Canyon*, 145.
19. Ibid., 231–34.
20. Emery Kolb, radio interview, March 16, 1976, Kolb Collection, Cline Library Special Collections and Archives Department, KMCR, box 18, folder 1816. Transcribed by Brett Poirier. Emery also claimed in this interview that Cecil B. DeMille "made one of the first prints for us to show of our movies."
21. In the realm of narrative, however, photographic trickery was widely understood. See Clarke's "Moving Picture Tricks," 63, for a popular article that exposes the film industry's use of "gears," mirrors, and techniques such as running the film backward and the "stop system" for achieving unusual and unexplainable effects.
22. Although the show is not screened consistently at the canyon anymore, it can be viewed online at Northern Arizona University's Cline Library Special Collections and Archives website: http://library.nau.edu/speccoll/exhibits/kolb/. The Northern Arizona University Cline Library Special Collections and Archives also houses many versions of the written lecture, illustrating how Emery changed it over the course of many years to accommodate

new imagery, new adventures, and new clientele. Emery Kolb Collection, Cline Library Special Collections and Archives Department, NAU.MS. 197, series 3, box 18, folders 1905–8.

23. Emery Kolb Collection, Cline Library Special Collections and Archives Department, NAU.MS. 197, series 3, box 18, folders 1911, 1912.

24. Ibid.

25. Barber, "Roots of Travel Cinema," 68.

26. *Cosmopolitan*, April 1901, 714.

27. Barber, "Roots of Travel Cinema," 69.

28. Dickinson, "Letters from America," 387.

29. "Holiday Publications," 456.

30. Tassin, "Magic Carpet," 418.

31. Wister, introduction, xi.

32. Ibid., ix.

33. Wister, *The Virginian*.

34. Wister, *Roosevelt*.

35. Coffin, "American Illustration of To-day," 348.

36. Remington, *Men with the Bark on*.

37. Kolb, *Through the Grand Canyon*, 4.

38. Wister, introduction, xi–xii.

39. Tassin, "Magic Carpet," 419.

40. "Holiday Publications," 456.

41. See Lavender, *River Runners of the Grand Canyon*, for an account of early Colorado river runners. See also Birdseye and Moore, "Boat Voyage Through the Grand Canyon." According to these sources, the Kolbs' river trip was more likely the ninth such adventure after those of Powell (who ran the river twice, in 1869 and 1871–1872), Frank Brown (1889–1890), Robert B. Stanton (1889–1890), Nathan Galloway (1893–1894 and 1896–1897), George Flavell (1896–1897), William Richmond (1896–1897), Charles Russell, and Julius Stone (1909).

42. Dellenbaugh, *Canyon Voyage*.

43. Kolb, *Through the Grand Canyon*, xiii.

44. "Holiday Publications," 456.

45. Ibid.

46. Kolb and Kolb, "Experiences in the Grand Canyon."

47. Ibid., 99.

48. For example, see Sears, *Sacred Places*, 4, and Shaffer, *See America First*. See also Schulten, "How to See Colorado," 53.

49. Outright animosity sometimes colored the Kolbs' recollections of the monopolizing policies of El Tovar. See Pace, "Emery Kolb and the Fred Harvey Company."

50. "The Kodak," 793.

51. Kolb, *Through the Grand Canyon*, 220.

52. Ibid.

53. See especially the advertisements in *Youth's Companion Magazine* from the 1910s.

54. See *McClure's Magazine*, September 1913, 196.

55. Jackson, *Time Exposure*, 243. See also his *Descriptive Catalogue* for the captions made to accompany the photographs of Native Americans.

56. Monsen, "Picturing Indians with the Camera," 165.

57. Ibid.

58. Dilworth, "Tourists and Indians in Fred Harvey's Southwest," 144.

59. Stone, *Canyon Country*, 21.

60. Ibid., 29.
61. Wister, introduction, x.
62. Emery Kolb Collection, Cline Library Special Collections and Archives Department, NAU.MS. 197, series 2, box 16, folder 1884. See also Stone, *Canyon Country*, 21.
63. Pyne, *How the Canyon Became Grand*, xiii.
64. Babbitt, "Kolbs and Their Photographs," xii–xv. Babbitt was Arizona governor from 1978 to 1987.
65. Ibid., xiv.

Chapter 6

1. Adams, *Sierra Nevada*.
2. Although Eve Weber convincingly tracked the thematic and unbroken link between nineteenth-century western photographic subject matter and the twentieth-century production of Adams, Curtis, and Gilpin in *Ansel Adams and the Photographers of the American West*, her text lacks analysis of the cultural implications of western photographs and the complexity of the changing public perception of the medium.
3. Adams, *Autobiography*, 5–8. Adams discusses the earthquake in his autobiography and emphasizes the event as a critical early memory of his childhood.
4. Adams, "Problems of Interpretation," 47.
5. Adams, "Photography," ca. 1933, Ansel Adams Archive, Center for Creative Photography, University of Arizona, Tucson.
6. Adams, *Autobiography*, 5.
7. Hutchings, *In the Heart of the Sierras*.
8. Adams, *Autobiography*, 40.
9. Fiske's negatives were bought by the Yosemite Park Company and were destroyed by fire in 1943.
10. Newhall, preface to Hickman and Pitts, *George Fiske*.
11. According to Adams, he spent a large part of a year at the exposition as a learning experience that was intended to replace the traditional schooling that he disliked passionately. Adams, *Autobiography*, 15.
12. Ansel Adams is listed as a participant in many outings of the Sierra Club. A sample of his participation can be found in the 1937 "Mountain Records of the Sierra Nevada," Ansel Adams Archive, Center for Creative Photography.
13. Adams, drafts and final version of statement for De Young Exhibition, 1932, Ansel Adams Archive, Center for Creative Photography. Also quoted in Newhall, *Eloquent Light*, 95–96.
14. Adams, "A Warning to Easterners," nd, Ansel Adams Archive, Center for Creative Photography.
15. Ibid.
16. Like artists such as Georgia O'Keeffe and those in Taos and Santa Fe Schools who took leave of the eastern climes in their search for true and deep American subject matter in the physicality of western spaces, Adams struggled in the late 1920s and 1930s in a sort of reverse hybridization of the two traditions. Steeped in what was perceived as a deeply American place, Adams slowly drew on eastern art trends to move his photography out of the nineteenth-century mode for picturing place in the West.
17. Ansel Adams to Alfred Stieglitz, letter, June 22, 1933, Ansel Adams Archive, Center for Creative Photography. Reprinted in Alinder and Stillman, *Letters and Images*, 50.
18. Ansel Adams, "Photography."

19. Ansel Adams to Nancy Newhall, letter, July 17, 1946, Ansel Adams Archive, Center for Creative Photography. Reprinted in Alinder and Stillman, *Letters and Images*, 177.

20. Andrea Gray, *Ansel Adams: An American Place, 1936*, exhibition catalog, 1982, Center for Creative Photography, University of Arizona. See also announcement, with checklist and photocopies of clippings, Ansel Adams Archive, Center for Creative Photography.

21. His early exhibitions in the East also included the Albright Art Gallery in Buffalo, NY, the Gallery of Fine Art at Yale University, and elsewhere.

22. Advertisements for Ansel Adams Photography and Ansel Adams Gallery, Ansel Adams Archive, Center for Creative Photography.

23. Ansel Adams to Alfred Stieglitz, letter, June 22, 1933, Ansel Adams Archive, Center for Creative Photography. Reprinted in Alinder and Stillman, *Letters and Images*, 50.

24. Alinder and Stillman, *Letters and Images*, 60.

25. Ibid., 69.

26. Senf, "Ansel Adams's 'Practical Modernism.'"

27. The exhibition was at the Arts and Industries Building, U.S. National Museum, Smithsonian Institute, Washington, D.C.

28. Adams, *Autobiography*, 81.

29. Adams, drafts and final version of statement.

30. Adams, preface to *Portfolios of Ansel Adams*, v.

31. Adams, "Note on the Photographs," 119.

32. Peeler, "Group f/64," 107–10.

33. Adams, introduction to *Sierra Nevada*. See also Adams, *Autobiography*, 122.

34. Starr, *Guide to the John Muir Trail*.

35. Jackson, "Ansel Adams Scratches a Granite Surface," 16.

36. Alsup, *Missing in the Minarets*.

37. Adams, "Problems of Interpretation," 47.

38. Adams, "Mountain Photography," 2625.

39. Ibid.

40. Adams, "Photography," about 1933, Ansel Adams Archive, Center for Creative Photography. This was written for the *Sierra Club Bulletin* but never published.

41. Ibid.

42. Farquhar, review of *Sierra Nevada*, 141.

43. Adams, "Some Notes on Photography."

44. Adams, "Photography as an Instrument of Social Progress," Ansel Adams Archive, Center for Creative Photography.

45. Adams, "Some Notes on Photography."

46. Ansel Adams, "Introduction," *A Pageant of Photography*, exhibition catalog, 1940. Ansel Adams Archive, Center for Creative Photography, AG31:2:4:15.

47. Ibid.

48. Ibid.

49. Ansel Adams to the director of the Museum of Modern Art, letter, September 5, 1942, Beaumont Newhall Papers, Museum of Modern Art Archives, New York, II.3.

50. Ibid.

51. Beaumont Newhall to Ansel Adams, letter, February 17, 1942, Beaumont Newhall Papers.

52. Austin, *Taos Pueblo*.

53. Thornton, "Ephemeral in Nature," 31, 41.

54. Ibid.

55. Wolmer, "Ansel Adams and the West," 1.

56. Szarkoski, introduction to *Portfolios of Ansel Adams*, xii.

Afterword

1. Tagg, *The Burden of Representation*, 2.
2. Ibid., 3.
3. Wrobel, *Promised Lands*, 1. Western historian David Wrobel referred to this phenomenon in settlers' written memories when he observed that "the hope for a postfrontier future in the West, followed later by a longing for the frontier past, have played an important part in the formation of western identities."
4. Barthes, *Camera Lucida*, 70.
5. Masayesva and Younger, *Hopi Photographers*, 90.
6. Taft, *Photography and the American Scene*, 259.

Bibliography

Archival Sources

Ansel Adams Archive. Center for Creative Photography. University of Arizona Libraries, Tucson.

Bancroft Library. University of California, Berkeley.

Beinecke Rare Book and Manuscript Library. Yale University, New Haven, CT.

Cline Library Special Collections and Archives Department. Northern Arizona University, Flagstaff.

Custer County Historical Society. Broken Bow, NE.

Grand Canyon National Park Museum. National Park Service. Grand Canyon, AZ.

Hennepin County Historical Society. Minneapolis, MN.

Jacksonville Museum. Jacksonville, OR.

J. Paul Getty Museum. Los Angeles.

Library and Archives Canada. http://www.collectionscanada.gc.ca/index-e.html.

Longfellow National Historic Site. Cambridge, MA.

Mercantile Library. St. Louis, MO.

Minnesota History Center. St. Paul, MN.

Missouri History Museum. St. Louis, MO.

Museum of Modern Art Archives. New York.

Nebraska State Historical Society. Lincoln.

Oregon Historical Society. Portland.

Southern Oregon Historical Society. Medford.

University of Iowa Special Collections Department. Iowa City.

Whelpley Papers. Missouri Historical Society. St. Louis.

Primary Sources

Adams, Ansel. *Ansel Adams: An Autobiography.* New York: Little, Brown, and Company, 1985.

——. "An Exposition of My Photographic Technique." *Camera Craft* 41 (April 1934): 173–83.

——. "Landscape." *Camera Craft* 41 (February 1934): 72–74.

——. "Letter Outlining the Objectives and Motives of Group f/64." *Camera Craft* 41 (June 1934): 297–98.

——. *Making a Photograph: An Introduction to Photography.* New York: Studio Publications Inc., 1935.

——. "Mountain Photography." In *The Complete Photographer: An Encyclopedia of Photography*, 2625–41. New York: National Education Alliance, 1942.

——. *The New Photography.* New York: Studio Publications, 1935.

———. "A Note on the Photographs." In *Yosemite and the Sierra Nevada*. By John Muir, 119–20. Boston, MA: Houghton Mifflin, 1948.

———. "A Personal Credo." *Camera Craft* 42 (January 1935): 110–11.

———. *The Portfolios of Ansel Adams*. Little, Brown and Company, 1977.

———. "Problems of Interpretation of the Natural Scene." *Sierra Club Bulletin* (1945): 47–50.

———. *Sierra Nevada: The John Muir Trail*. Berkeley, CA: Archetype Press, 1938.

Adams, Virginia, and Ansel Adams. *Illustrated Guide to Yosemite Valley*. San Francisco, CA: H. S. Crocker Co., 1940.

Alatorre, Barbara. "How Giiwas (Crater Lake) Came to Be." *The Klamath Tribes: Klamath-Modoc–Yahooskin*. Last modified 2012. http://www.klamathtribes.org/background/giiwaas.html.

"America in the Stereoscope." *The Art-Journal*, July 1, 1860, 221.

"American Desert." *Christian Register* 3, no. 21 (January 2, 1824): 83.

Andrews, C. C. *Minnesota and Dacotah*. Washington, D.C.: Robert Farnham, 1857.

Atwater, Caleb. "Description of the Antiquities Discovered in the State of Ohio and Other Western States." *Archaeologia Americana* 1 (1820): 105–267.

Austin, Mary. *Taos Pueblo*. San Francisco, CA: Grabhorn Press, 1930.

Baldwin, J. D. *Ancient America in Notes on American Archaeology*. New York: Harper, 1872.

"The Big Mound." *St. Louis Daily Times*, April 16, 1869.

Birdseye, Claude H., and Raymond C. Moore. "A Boat Voyage Through the Grand Canyon of the Colorado." *Geographical Review* 14 (April 1924): 177–96.

Brewster, David. *The Stereoscope: Its History, Theory, and Construction*. London: Murray, 1856.

Bryant, William Cullen, ed. *Picturesque America*. 2 vols. New York: D. Appleton, 1872–1874.

Buckingham, J. S. *The Eastern and Western States of America*. London: Fisher, Sons, 1842.

Burke, Edmund. *A Philosophical Enquiry into the Origin of Our Ideas of the Sublime and Beautiful*. London, 1757.

Butcher, Solomon D. *Pioneer History of Custer County, and Short Sketches of Early Days in Nebraska*. Broken Bow, NE: Solomon D. Butcher and Ephraim S. Finch, 1901.

———. *Sod Houses or the Development of the Great American Plains: A Pictorial History of the Men and Means that Have Conquered this Wonderful Country*. Kearney, NE: Western Plains Publishing Co., 1904.

Clarke, Frederic Colburn. "Moving Picture Tricks: Some of the Clever and Often Hair-Raising Deceptions of the Camera-man Mercilessly Exposed." *Vanity Fair*, September 1914, 63.

Coffin, William. "American Illustration of To-day." *Scribner's* 11 (March 1892): 333–49.

Cole, Thomas. "Essay on American Scenery." *American Monthly Magazine* 1 (January 1836): 1–12.

Cooper, Miss. "A Dissolving View." *Home Book of the Picturesque: or, American Scenery, Art and Literature*. Edited by Motley F. Deakin, 79–94. Gainesville, FL: Scholars' Facsimiles and Reprints: 1967. Originally published in 1851 by G. P. Putnam.

Conant, A. J. *Foot-Prints of Vanished Races in the Mississippi Valley*. St. Louis, MO: C. R. Barns, 1879.

———. *Switzler's Illustrated History of Missouri, from 1541 to 1877*. Edited by C. R. Barns. St. Louis: C. R. Barns, 1879.

Cox, James. "The Upper Mississippi and the Northern Lakes." *Our Own Country: A Weekly Magazine of Fine Art* 1 (1894): 1–16.

"Crater Lake, Oregon." *Frank Leslie's Popular Monthly* 25 (January 1888): 45–47.

"Crater Lake, Oregon." *Scientific American*, September 25, 1886, 192.

Curtiss, Daniel S. *Western Portraiture and Emigrants' Guide*. New York: J. H. Colton, 1852.

Deakin, Motley F., ed. *Home Book of the Picturesque: or, American Scenery, Art and Literature*. Gainesville, FL: Scholars' Facsimiles and Reprints, 1967. Originally published in 1851 by G. P. Putnam.

DeBow, J. D. B. *Statistical View of the United States.* Washington, D.C.: Beverly Tucker, 1854.

Dellenbaugh, Frederick S. *A Canyon Voyage: A Narrative of the Second Powell Expedition down the Green-Colorado River from Wyoming, and the Explorations on Land, in the Years 1871–1872.* New York: G. P. Putnam's Sons, 1908.

———. *The Romance of the Colorado River.* New York: G. P. Putnam's Sons, 1902.

Dickinson, G. Lowes. "Letters from America." *Living Age* 2 (February 1910): 387–96.

Dutton, Clarence. "Crater Lake, Oregon: A Proposed National Reservation." *Science* 7 (26 February 1886): 179–82.

Eastman, Mary. *The American Annual: Illustrative of the Early History of North America.* Philadelphia, PA: Lippincott, 1855.

———. *Dahcotah; or, Life and Legends of the Sioux Around Fort Snelling.* Minneapolis, MN: Ross and Haines, 1849.

"The Falls of the Minnehaha." *Merry's Museum and Parley's Magazine,* July 1, 1856, 172–74.

Farquhar, Francis P. "Mountain Studies in the Sierra." *Touring Topics* (February 1931).

———. Review of *Sierra Nevada: The John Muir Trail,* by Ansel Adams. *Sierra Club Bulletin* (1939): 141.

Foster, J. W. *Prehistoric Races of the United States of America.* Chicago: S. C. Griggs, 1874.

Gilpin, William. *Three Essays: On Picturesque Beauty; on Picturesque Travel; and on Sketching Landscape.* London, 1792.

Glover, Ridgeway. *The Philadelphia Photographer* 3 (1866): 239, 339, 367, 371.

Goddard, Frederick. *Where to Emigrate and Why.* New York: Frederick B. Goddard, 1869.

Gray, Robert, and Gerald Mygatt. "The Rulers of the Movies." *Vanity Fair,* February 1915, 56.

Greeley, Horace, Leon Case, Edward Howland, John B. Gough, Phillip Ripley, F. B. Perkins, J. B. Lyman, Albert Brisbane, and E. E. Hall. *The Great Industries of the United States: Being an Historical Summary of the Origin, Growth, and Perfection of the Chief Industrial Arts of this Country.* Hartford, CT: Burr & Hyde, ca. 1872.

Holbrook, J. C. "Letter from Minneapolis." *Christian Union,* September 8, 1887, 232.

"Holiday Publications." *Dial,* December 1, 1914, 456–59.

Holmes, Oliver Wendell. "The Stereoscope and the Stereograph." *Atlantic Monthly,* June 1859, 738–49.

Hutchings, J. M. *In the Heart of the Sierras.* Oakland, CA: Pacific Press Publishing House, 1888.

"Is Hiawatha Borrowed from the Swedish?" *Albion* 57 (December 1855): 573.

Jackson, Joseph Henry. "Ansel Adams Scratches a Granite Surface." *San Francisco Chronicle,* January 5, 1939, 16.

Jackson, William Henry. *Descriptive Catalogue of Photographs of North American Indians.* Washington, D.C.: Government Printing Office, 1877.

———. *Time Exposure: The Autobiography of William Henry Jackson.* New York: G. P. Putnam's Sons, 1940.

James, Edwin. *Account of an Expedition from Pittsburgh to the Rocky Mountains.* London: Longman, Hurst, Rees, Orme, and Brown, 1823.

Jefferson, Thomas. *Notes on the State of Virginia.* Edited by William Peden. Chapel Hill: University of North Carolina Press, 1955.

Johnson, John. *Eureka* 1 (September 1846): 7–8.

Kern, Martin A. "Off Beaten Paths." *Overland Monthly* 18 (July 1891): 19–26.

Keating, William. *Narrative of an Expedition to the Source of the St. Peter's River: Lake Winnepeek, Lake of the Woods, Performed in the Year 1823.* Philadelphia, PA: Carey and Lea, 1824.

King, Clarence. *Mountaineering in the Sierra Nevada.* Boston, MA: Osgood, 1872.

"Klamath Land," *Overland Monthly* 11 (December 1873): 548–54.

Knight, Richard Payne. *An Analytical Inquiry into the Principles of Taste*. London: T. Payne, 1805.

"The Kodak." *American Architect and Building News*, March 7, 1891, 2.

Kolb, Ellsworth L. *Through the Grand Canyon from Wyoming to Mexico*. New York: Macmillan Company, 1914.

Kolb, Ellsworth, and Emery Kolb. "Experiences in the Grand Canyon." *National Geographic Magazine* 2 (August 1914): 99–184.

Le Conte, J. N. Review of *Parmelian Prints of the High Sierra*, by Ansel Adams. *Sierra Club Bulletin* 13, no. 1 (February 1928): 96.

Linn, R. M. *Landscape Photography: A Practical Manual*. Philadelphia, PA: Benerman & Wilson, 1872.

Long, Stephen H. *Voyage in a Six-Oared Skiff to the Falls of Saint Anthony in 1817*. Philadelphia, PA: Henry B. Ashmead, 1860.

"Longfellow's Song of Hiawatha." *Graham's American Monthly Magazine*, December 1855, 535–40.

Lyman, W. D. "The Switzerland of the Northwest. Part 1: The Mountains." *Overland Monthly and Outwest Magazine* 2 (September 1883): 300–313.

Magoon, E. L. "Scenery and Mind." In *Home Book of the Picturesque: or, American Scenery, Art and Literature*. Edited by Motley F. Deakin, 1–48. Gainesville, FL: Scholars' Facsimiles and Reprints: 1967. Originally published in 1851 by G. P. Putnam.

Monsen, Frederick I. "Picturing Indians with the Camera." *Photo-Era: The American Journal of Photography* 25 (October 1910): 165.

Morse, Samuel F. B. *New York Observer*, May 18, 1839.

Muir, John. *Our National Parks*. Boston, MA: Houghton Mifflin, 1901.

———. *Yosemite and the Sierra Nevada*. Boston, MA: Houghton Mifflin Co., 1948.

Murphy, John Mortimer. *The Oregon Hand-book and Emigrant's Guide*. Portland, OR: S. J. McCormick, 1873.

———. *Rambles in North-western America, from the Pacific Ocean to the Rocky Mountains*. London: Chapman and Hall, 1879.

———. "Ramblings in Oregon," *Forest and Stream*, October 7, 1875, 129–30.

———. *Sporting Adventures of the Far West*. London: S. Low, Marston, Searle & Rivington, 1879.

Nebraska: Its Resources and Attractions. Omaha, NE: Union Pacific Railroad, 1902.

Oliphant, Laurence. *Minnesota and the Far West*. London: William Blackwood and Sons, 1855.

"Outdoor Photographs Taken Indoors." *Philadelphia Photographer* 3 (1866): 129–31.

Owen, David Dale. *Report of a Geological Survey of Wisconsin, Iowa, and Minnesota: and incidentally of a Portion of Nebraska Territory*. Philadelphia, PA: Lippincott, Grambo, 1852.

Patterson, J. M. *The Saturday Evening Post*, November 23, 1907, 10.

Peale, Titian Ramsey. *Ancient Mounds of St. Louis, in 1819*. Annual report to the Board of Regents of the Smithsonian Institution. Washington, D.C.: U.S. Government Printing Office, 1862.

The Picturesque Pocket Companion: and Visitor's Guide, Through Mount Auburn. Boston, MA: Otis, Broaders, 1839.

Pidgeon, William. *Traditions of De-Coo-Dah and Antiquarian Researches*. New York: Thayer, Bridgman & Fanning, 1853.

Powell, John Wesley. *The Cañons of the Colorado*. Meadville, PA: 1895. Reprinted in 1981 by Outbooks.

Price, Uvedale. *An Essay on the Picturesque, as Compared with the Sublime and Beautiful; and on the Use of Studying Pictures, for the Purpose of Improving Real Landscape.* London, 1796.

Priest, Josiah. *American Antiquities, and Discoveries in the West: Being an Exhibition of the Evidence that an Ancient Population of Partially Civilized Nations, Differing Entirely from those of the Present Indians, Peopled America, Many Centuries Before Its Discovery by Columbus.* Albany, NY: Hoffman and White, 1833.

Remington, Frederic. *Men with the Bark on.* New York: Harper and Brothers, 1900.

Roche, Thomas C. *Anthony's Photographic Bulletin* 2 (1871): 268–69.

Scharf, Thomas J. *History of Saint Louis City and County.* Philadelphia, PA: L. H. Everts, 1883.

Schoolcraft, Henry. *The Myth of Hiawatha, and Other Oral Legends, Mythologic and Allegoric.* Philadelphia, PA: Lippincott, 1856.

——. *Narrative Journal of Travels Through the Northwestern Regions of the United States, Extending from Detroit Through the Great Chain of American Lakes to the Sources of the Mississippi River, in the Year 1820.* Albany, NY: E. & E. Hosford, 1821.

Seymour, E. Sanford. *Sketches of Minnesota: The New England of the West: With Incidents of Travel in that Territory During the Summer of 1849.* 2 vols. New York: Harper & Bros., 1850.

Smit, William. "Old Broadway, a Forgotten Street, and Its Park of Mounts." *Bulletin of the Missouri Historical Society* 4 (April 1948): 4.

Smith, Calvin J. *The Western Tourist and Emigrants' Guide.* New York: J. H. Colton, 1840.

Snelling, Henry Hunt. *A Dictionary of the Photographic Art and a Comprehensive and Systematic Catalogue of Photographic Apparatus and Material, Manufactured, Imported and Sold by E. Anthony.* New York: H. H. Snelling, 1854.

——. *The History and Practice of the Art of Photography.* New York: G. P. Putnam, 1849.

Spencer, Robert F. "Native Myth and Modern Religion Among the Klamath Indians." *Journal of American Folklore* 65 (1952): 217–26.

Squire, E. G., and E. H. Davis. *Ancient Monuments of the Mississippi Valley: Comprising the Results of Extensive Original Surveys and Explorations.* Washington, D.C.: Smithsonian Institution, 1947.

Stanton, Robert B. "Engineering with a Camera in the Cañons of the Colorado." *Cosmopolitan Magazine,* July 1893, 292–303.

Starr, Walter Augustus. *Guide to the John Muir Trail and the High Sierra Region.* San Francisco, CA: Sierra Club, 1934.

Steel, William. *The Mountains of Oregon.* Portland, OR: David Steel, 1890.

Stone, Julius. *Canyon Country: The Romance of a Drop of Water and a Grain of Sand.* New York: G. P. Putnam's Sons, 1932.

Switzler, William F. *Switzler's Illustrated History of Missouri, from 1541 to 1881.* St. Louis, MO: C. R. Barns, 1881.

Tassin, Algernon. "The Magic Carpet." *Bookman* 40 (December 1914): 418–36.

Taylor, H. J. *Yosemite Indians and Other Sketches.* San Francisco, CA: Johnck & Seeger, 1936.

Thornton, Gene. "Ansel Adams: The Ephemeral in Nature." *New York Times,* September 16, 1979, 31, 41.

Turner, Frederick Jackson. "The Significance of the Frontier in American History." In *Proceedings of the Forty-First Annual Meeting of the State Historical Society of Wisconsin,* 79–112. Madison, WI, 1894.

Twain, Mark. *Life on the Mississippi.* Boston, MA: J. R. Osgood, 1883.

"The Upper Mississippi." *National Magazine: Devoted to Literature, Art, and Religion* 9 (December 1856): 481–87.

Van Dyke, Henry. *The Grand Canyon and Other Poems.* New York: Charles Scribner's Sons, 1914.

Victor, F. F. "Mountaineering in Oregon." *Overland Monthly* 1 (March 1883): 299–300.

Vogel, Hermann. *Photographic Times* 13 (August 1883): 403–4.

Wheatstone, Charles. "Contributions to the Physiology of Vision. Part 2. On Some Remarkable, and Hitherto Unobserved, Phaenomena of Binocular Vision." *Philosophical Transactions of the Royal Society of London* 128 (1850): 371–94.

"Whitney's Picture Gallery." *Minnesota Farmer and Gardener* 12 (December 1861): 375.

Whitney, J. D. *The Yosemite Book: A Description of the Yosemite Valley and the Adjacent Region of the Sierra Nevada, and of the Big Trees of California.* New York: Julius Bien, 1868.

Wilbur, Earl Morse. "Crater Lake, Oregon." *Scientific American* 5 (December 1896): 405.

Wilson, Edward L., ed. "Art Writings for Photographers." *Philadelphia Photographer* 8 (April 1871): 102–4.

———. "Views in the Yosemite Valley." *Philadelphia Photographer* 3 (April 1866): 106–7.

Wister, Owen. Introduction to *Through the Grand Canyon from Wyoming to Mexico*, by Ellsworth Kolb, vii–xi. New York: Macmillan Company, 1938.

———. *Roosevelt: The Story of a Friendship.* New York: MacMillan, 1930.

———. *The Virginian: A Horseman of the Plains.* New York: Macmillan, 1902.

Woodbury, Walter. "Cloud Negatives and Their Use." *Philadelphia Photographer* 5 (October 1868): 388–89.

Secondary Sources

Alinder, Mary Street. *Ansel Adams: A Biography.* New York: Henry Holt and Company, 1996.

Alinder, Mary Street, and Andrea Gray Stillman. *Ansel Adams: Letters and Images, 1916–1984.* New York City: Bulfinch Press, 1988.

Alison, Jane, ed. *Native Nations: Journeys in American Photography.* London: Barbican Art Gallery, 1998.

Alsup, William. *Missing in the Minarets: The Search for Walter A. Starr, Jr.* San Francisco, CA: Yosemite Conservancy, 2001.

Anderson, Michael F. *Living at the Edge: Explorers, Exploiters, and Settlers of the Grand Canyon Region.* Grand Canyon, AZ: Grand Canyon Association, 1998.

Anderson, Nancy. "Curious Historical Artistic Data: Art History and Western American Art." In *Discovered Lands, Invented Pasts.* Edited by Jules Prown, 1–35. New Haven, CT: Yale University Press, 1992.

———. "'The Kiss of Enterprise': The Western Landscape as Symbol and Resource." In *The West as America: Reinterpreting Images of the Frontier, 1820–1920.* Edited by William Truettner, 237–84. Washington, D.C.: Smithsonian Institution Press, 1991.

Andrews, Ralph. *Photographers of the Frontier West: Their Lives and Works, 1875–1915.* Seattle, WA: Superior, 1965.

———. *Picture Gallery Pioneers, 1850–1875.* Seattle, WA: Superior, 1964.

Armitage, Susan. "From the Inside Out: Rewriting Regional History." *Frontiers* 22, no. 3 (2001): 32–47.

Armitage, Susan, and Elizabeth Jameson. *The Women's West.* Norman: University of Oklahoma Press, 1987.

Axtell, James. "The Ethnohistory of Native America." In *Rethinking American Indian History*. Edited by Donald Fixico, 11–28. Albuquerque: University of New Mexico Press, 1997.

Babbitt, Bruce. *Grand Canyon: An Anthology*. Flagstaff, AZ: Northland Press, 1976.

———. "The Kolbs and Their Photographs." In *Grand Canyon: An Anthology*, xii–xv. Flagstaff, AZ: Northland Press, 1978.

Bacon, Charles R. "Eruptive History of Mount Mazama and Crater Lake Caldera, Cascade Range, U.S.A." *Journal of Volcanology and Geothermal Research* 18 (1983): 57–115.

Balio, Tino, ed. *The American Film Industry*. Madison: University of Wisconsin Press, 1985.

Ballantyne, Andrew. *Architecture, Landscape, and Liberty: Richard Payne Knight and the Picturesque*. Cambridge: Cambridge University Press, 1997.

Banta, Melissa, and Curtis M. Hinsley. *From Site to Sight: Anthropology, Photography, and the Power of Imagery*. Cambridge, MA: Peabody Museum Press, 1986.

Barber, X. Theodore. "The Roots of Travel Cinema: John L. Stoddard, E. Burton Holmes and the Nineteenth-Century Illustrated Travel Lecture." *Film History* 5 (1993): 68–84.

Barger, Susan M. *The Daguerreotype: Nineteenth-Century Technology and Modern Science*. Washington, D.C.: Smithsonian Institution Press, 1991.

Barthes, Roland. *Camera Lucida: Reflections on Photography*. New York: Hill and Wang, 1981.

Bartley, Paula, and Cathy Loxton. *Plains Women: Women in the American West*. Cambridge: Cambridge University Press, 1991.

Basso, Keith H. *Wisdom Sits in Places: Landscape and Language Among the Western Apache*. Albuquerque: University of New Mexico Press, 1996.

Batchen, Geoffrey. *Burning with Desire: The Conception of Photography*. Cambridge, MA: MIT Press, 1997.

———. *Each Wild Idea: Writing, Photography, History*. Cambridge, MA: MIT Press, 2001.

Beezley, William H. "Homesteading in Nebraska, 1862–1872." *Nebraska History* 53 (1972): 59–75.

Bellin, Joshua David. "The 'Squaw's' Tale: Sympathy and Storytelling in Mary Eastman's *Dahcotah*." *Legacy: A Journal of American Women Writers* 17 (2000): 18–32.

Bernardin, Susan, and Melody Graulich. *Trading Gazes: Euro-American Women Photographers and Native Americans, 1880–1940*. New Brunswick, NJ: Rutgers University Press, 2003.

Betsky, Aaron, Eldridge M. Moores, Sandra S. Phillips, and Richard Rodriquez. *Crossing the Frontier: Photographs of the Developing West*. San Francisco, CA: San Francisco Museum of Modern Art, 1997.

Berkhofer, Robert F. *The White Man's Indian: Images of the American Indian, from Columbus to the Present*. New York: Vintage Books, 1979.

Birrell, Andrew. "Classic Survey Photos of the Early West." *Canadian Geographic Journal* 91, no. 4 (1975): 12–19.

Blackhawk, Ned. *Violence over the Land: Indians and Empires in the Early American West*. Cambridge, MA: Harvard University Press, 2006.

Boime, Albert. *The Magisterial Gaze: Manifest Destiny and the American Landscape Painting*. Washington, D.C.: Smithsonian Institution, 1991.

Bolton, Richard, ed. *The Contest of Meaning: Critical Histories of Photography*. Cambridge, MA: MIT Press, 1989.

Bordewich, Fergus M. *Killing the White Man's Indian: Reinventing Native Americans at the End of the Twentieth Century*. New York: Doubleday, 1996.

Botham, Fay, and Sara M. Patterson. *Race, Religion, Region: Landscapes of Encounter in the American West*. Tucson: University of Arizona Press, 2006.

Brew, J. O. "Hopi Prehistory and History to 1850." In *Handbook of American Indians*. Vol. 9, *Southwest*. Edited by A. Ortiz, 514–23. Washington, D.C.: Smithsonian Institution Press, 1979.

Broehl, Wayne G. "The Plow that Broke the Prairies." *American History Illustrated* 19 (1985): 16–19.

Brown, Julie K. *Contesting Images: Photography and the World's Columbian Exposition*. Tucson: University of Arizona Press, 1994.

Bush, Alfred L., and Lee Clark Mitchell. *The Photograph and the American Indian*. Princeton, NJ: Princeton University Press, 1994.

Bush, Clive. "'Gilded Backgrounds': Reflections on the Perception of Space and Landscape in America." In *Views of American Landscapes*. Edited by Mick Gidley and Robert Lawson-Peebles, 13–30. Cambridge: Cambridge University Press, 1989.

Calloway, Colin G. *One Vast Winter Count: The Native American West Before Lewis and Clark*. Lincoln: University of Nebraska Press, 2003.

Carter, John E. *Solomon D. Butcher: Photographing the American Dream*. Lincoln: University of Nebraska Press, 1985.

Castleberry, May, Martha Sandweiss, and John Chávez. *Perpetual Mirage: Photographic Narratives of the Desert West*. New York: Whitney Museum of American Art, 1996.

Chiarenza, Carl. "Notes on Aesthetic Relationships Between Seventeenth-Century Dutch Painting and Nineteenth-Century Photography." In *One Hundred Years of Photographic History: Essays in Honor of Beaumont Newhall*. Edited by Van Deren Coke, 20–34. Albuquerque: University of New Mexico Press, 1975.

Christian, Shirley. *Before Lewis and Clark: The Story of the Chouteaus, the French Dynasty that Ruled America's Frontier*. New York: Farrar, Straus and Giroux, 2004.

City Art Museum of St. Louis. *Mississippi Panorama: The Life and Landscape of the Father of Waters and Its Great Tributary, the Missouri*. Exhibition catalog. St. Louis, MO: Caledonia Press, 1950.

Clark, Neil McCullough. *John Deere: He Gave to the World the Steel Plow*. Moline, IL: Desaulniers et Company, 1937.

Collins, Douglas. *The Story of Kodak*. New York: Abrams, 1990.

Conn, Steven. *History's Shadow: Native Americans and Historical Consciousness in the Nineteenth Century*. Chicago: University of Chicago Press, 2004.

Conron, John. *American Picturesque*. Philadelphia: Pennsylvania State Press, 2000.

Coulter, Edith, and Jeanne Van Nostrand. *A Camera in the Gold Rush*. San Francisco, CA: Taylor and Taylor, 1946.

Crary, Jonathan. *Techniques of the Observer: On Vision and Modernity in the Nineteenth Century*. Cambridge, MA: MIT Press, 1993.

Crimp, Douglas. "The Photographic Activity of Postmodernism." *October*, no. 15 (Winter 1980): 91–102.

Cronon, William. "Revisiting the Vanishing Frontier: The Legacy of Frederick Jackson Turner." *Western Historical Quarterly* 18 (1987): 156–76.

Current, Karen, and William Current. *Photography and the Old West*. New York: Harry N. Abrams, 1978.

Dalan, Rinita A., George R. Holley, William I. Woods, Harold W. Watters, Jr., and John A. Koepke. *Envisioning Cahokia: A Landscape Perspective*. DeKalb: Northern Illinois University Press, 2003.

Darrah, William. "Stereographs: A Neglected Source of History of Photography." In *One Hundred Years of Photographic History: Essays in Honor of Beaumont Newhall*. Edited by Van Deren Coke, 43–46. Albuquerque: University of New Mexico Press, 1975.

———. *The World of Stereographs*. Gettysburg, PA: W. C. Darrah, 1977.

Davis, Keith. *An American Century of Photography*. New York: Abrams, 1995.

Davis, Robert Murray, ed. *Owen Wister's West: Selected Articles*. Albuquerque: University of New Mexico Press, 1987.

Davis, Rose. "How Indian is Hiawatha?" *Midwest Folklore* 7 (Spring 1957): 5–25.

Debord, Guy. *Society of the Spectacle*. Detroit, MI: Black and Red, 1983.

Deming, Alden O. *Manabozho: The Indian's Story of Hiawatha*. Edited by Milo B. Hillegas. Philadelphia: F. A. Davis, 1938.

Dick, Everett Newfon. *The Sod-House Frontier, 1854–1890: A Social History of the Northern Plains from the Creation of Kansas and Nebraska to the Admission of the Dakotas*. New York: D. Appleton-Century, 1937.

Dicken, Samuel N., and Emily F. Dicken. *The Making of Oregon: A Study in Historical Geography*. Portland: Oregon Historical Society, 1979.

Dilworth, Leah. *Imagining Indians in the Southwest: Persistent Visions of a Primitive Past*. Washington, D.C.: Smithsonian Institution Press, 1996.

———. "Tourists and Indians in Fred Harvey's Southwest." In *Seeing and Being Seen: Tourism in the American West*. Edited by David M. Wrobel and Patrick T. Long, 142–64. Lawrence: University of Kansas Press, 2001.

Dippie, Brian. "Government Patronage: Catlin, Stanley, and Eastman." *Montana* 44 (1994): 40–53.

———. *The Vanishing American: White Attitudes and U.S. Indian Policy*. Middleton, CT: Wesleyan University Press, 1982.

Driebe, Tom, and Dave Palmiter. *In Search of the Wild Indian: Photographs and Life Works by Carl and Grace Moon*. Moscow, PA: Maurose Publishing, 1996.

Dumych, Daniel M. *Niagara Falls: Images of America*. Dover, NH: Arcadia, 1996.

Dunlop, M. H. *Sixty Miles from Contentment: Traveling the Nineteenth-Century American Interior*. New York: Basic Books, 1995.

Earle, Edward, ed. *Points of View, the Stereograph in America: A Cultural History*. Rochester, NY: Visual Studies Workshop Press, 1979.

Edwards, Elizabeth, ed. *Photography and Anthropology: 1860–1920*. London: Royal Anthropological Institute, 1992.

Elsaesser, Thomas, ed. *Early Cinema: Space, Frame, Narrative*. London: British Film Institute, 1990.

Eskind, Andrew, and Greg Drake. *Index to American Photographic Collections*. Boston, MA: G. K. Hall, 1995.

Faris, James. *Navajo and Photography: A Critical History of the Representation of an American People*. Albuquerque: University of New Mexico Press, 1996.

Fern, Alan. "Documentation, Art, and the Nineteenth-Century Photography." In *The Documentary Photograph as a Work of Art: American Photographs, 1860–1876*, 11–16. Chicago: David and Alfred Smart Museum, University of Chicago, 1976.

Fisher, Linda. "A Summer of Terror: Cholera in St. Louis, 1849." *Missouri Historical Review* 99 (2005): 189–211.

Fixico, Donald. "Methodologies in Reconstructing Native American History." In *Rethinking American Indian History*. Edited by Donald Fixico, 117–30. Albuquerque: University of New Mexico Press, 1997.

Fleming, Paula Richardson. *Native American Photography at the Smithsonian: The Schindler Catalogue*. Washington, D.C.: Smithsonian Institution Press, 2003.

———. "Ridgeway Glover, Photographer." *Annals of Wyoming* 74, no. 2 (2002): 17–27.

Fleming, Paula Richardson, and Judith Luskey. *Grand Endeavors of American Indian Photography*. Washington, D.C.: Smithsonian Institution Press, 1993.

———. *The North American Indians in Early Photographs*. London: Calmann and King, 1986.

Foley, William E. *The First Chouteaus, River Barons of Early St. Louis.* Urbana: University of Illinois Press, 1983.

Foresta, Merry A., and John Wood. *Secrets of the Dark Chamber: The Art of the American Daguerreotype.* Washington, D.C.: Smithsonian Institution Press, 1995.

Freund, Gisele. *Photography and Society.* Boston, MA: David R. Godine, 1980.

Garrison, Lon. "A Camera and a Dream: The Story of the Kolb Brothers." *Arizona Highways,* January 1953, 30–35.

Gernsheim, Helmut. *The Rise of Photography: 1850–1880: The Age of Collodion.* New York: Thames and Hudson, 1988.

Gidley, Mick. "A Hundred Years in the Life of American Indian Photographs." In *Native Nations: Journeys in American Photography.* Edited by Jane Alison, 153–67. London: Barbican Art Gallery, 1998.

——. "The Figure of the Indian in Photographic Landscapes." In *Views of American Landscapes.* Edited by Mick Gidley and Robert Lawson-Peebles, 199–220. Cambridge: Cambridge University Press, 1989.

Glanz, Dawn. *How the West Was Drawn.* Ann Arbor, MI: UMI Research Press, 1978.

Glassberg, David. *American Historical Pageantry: The Uses of Tradition in the Early Twentieth Century.* Chapel Hill: University of North Carolina Press, 1990.

Goetzmann, William H. *Exploration and Empire: The Explorer and the Scientist in the Winning of the American West.* New York: History Book Club, 1993.

Goetzmann, William H., and William N. Goetzmann. *The West of the Imagination.* New York and London: Norton, 1986.

Goetzmann, William H., and Joseph C. Porter. *The West as a Romantic Horizon.* Omaha, NE: Joslyn Art Museum, 1981.

Graulich, Melody, and Stephen Tatum, eds. *Reading* The Virginian *in the New West.* Lincoln: University of Nebraska Press, 2003.

Gray, Alice. *Ansel Adams: The National Park Service Photographs.* New York: Artabras, 1995.

Gray, John S. "Itinerant Frontier Photographers and Images Lost, Strayed or Stolen." *Montana: The Magazine of History* 28 (April 1978): 2–15.

Griffiths, Alison. *Wondrous Difference: Cinema, Anthropology, and Turn-of-the-Century Visual Culture.* New York: Columbia University Press, 2002.

Grover, Kathryn, ed. *Hard at Play: Leisure in America, 1840–1940.* Amherst: University of Massachusetts Press, 1992.

Guidi, Benedetta Cestelli. "The Pen and the Gaze: Narratives of the Southwest at the Turn of the 19th Century." In *Native Nations: Journeys in American Photography.* Edited by Jane Alison, 223–28. London: Barbican Art Gallery, 1998.

Guidry, Gail. "Long, Fitzgibbon, Easterly, and Outley: St. Louis Daguerreans." *St. Louis Literary Supplement* 1 (November–December 1977): 6–8.

Hagan, William. "The New Indian History." In *Rethinking American Indian History.* Edited by Donald Fixico, 29–42. Albuquerque: University of New Mexico Press, 1997.

Hales, Peter Bacon. "American Views and the Romance of Modernization." In *Photography in Nineteenth-Century America.* Edited by Martha Sandweiss, 204–57. New York: Abrams, 1991.

——. *Silver Cities: The Photography of American Urbanization, 1839–1915.* 2nd ed. Philadelphia, PA: Temple University Press, 1984.

——. *William Henry Jackson and the Transformation of the American Landscape.* Philadelphia: Temple University Press, 1988.

Hammond, Anne. "Ansel Adams and Fiat Lux." *History of Photography* 16 (Winter 1992): 388–91.

———. "Ansel Adams and Mary Austin: Taos Pueblo (1930)." *History of Photography* 23, no. 4 (Winter 1999): 383–90.

———. "Ansel Adams and Objectivism: Making a Photograph with Group f/64." *History of Photography* 22, no. 2 (Summer 1998): 169–78.

———. "Ansel Adams and the High Mountain Experience." *History of Photography* 23, no. 1 (Spring 1999): 88–100.

———. *Ansel Adams: Divine Performance.* New Haven, CT: Yale University Press, 2002.

Hanson, Olaf. "The Impermanent Sublime: Nature, Photography and the Petrarchan Tradition." In *Views of American Landscapes.* Edited by Mick Gidley and Robert Lawson-Peebles, 31–50. Cambridge: Cambridge University Press, 1989.

Harlan, Theresa. "Indigenous Photographies: A Space for Indigenous Realities." In *Native Nations: Journeys in American Photography.* Edited by Jane Alison, 233–45. London: Barbican Art Gallery, 1998.

Harmon, Rick. *Crater Lake National Park: A History.* Corvallis: Oregon State University Press, 2002.

Harrell, Thomas. *William Henry Jackson: An Annotated Bibliography (1862–1995).* Nevada City, CA: Carl Mautz, 1995.

Hegeman, Susan. "Landscapes, Indians, and Photography in the Age of Scientific Exploration." In *The Big Empty: Essays on Western Landscapes as Narrative.* Edited by Leonard Engel, 49–74. Albuquerque: University of New Mexico Press, 1994.

Hickman, Paul, and Terence Pitts. *George Fiske, Yosemite Photographer.* Flagstaff, AZ: Northland Press, 1980.

Hight, Eleanor M., and Gary Sampson. *Colonialist Photography: Imagining Race and Place.* London: Routledge, 2002.

Hills, Patricia. "Picturing Progress in the Era of Westward Expansion." In *The West as America: Reinterpreting Images of the Frontier, 1820–1920.* Edited by William Truettner, 97–148. Washington, D.C.: Smithsonian Institution, 1991.

Hoobler, Dorothy, and Thomas Hoobler. *Photographing the Frontier.* New York: G. P. Putnam's Sons, 1980.

Horse Capture, George. "Myth and Reality: The Art of the Great Plains." *Heritage: The Yorker Scene* 22 (2007): 20–25.

Howard, Rhonda Lane. *Shifting Ground: Transformed Views of the American Landscape.* Seattle, WA: Henry Art Gallery, 2000.

Hughes, Donald J. *In the House of Stone and Light: A Human History of the Grand Canyon.* Grand Canyon, AZ: Grand Canyon Natural History Association, 1978.

Huhndorf, Shari M. *Going Native: Indians in the American Cultural Imagination.* Ithaca, NY: Cornell University Press, 2001.

Huyda, Richard J. *Camera in the Interior: 1858, H. L. Hime, Photographer.* Toronto, ON: Coach House Press, 1975.

Hyde, Anne Farrar. *An American Vision: Far Western Landscape and National Culture, 1820–1920.* New York: New York University Press, 1990.

Ise, John. *Sod and Stubble: The Story of a Kansas Homestead.* New York: Wilson-Erickson, 1936.

Jackson, John Brinkerhoff. *Discovering the Vernacular Landscape.* New Haven, CT: Yale University Press, 1984.

Jackson, Virginia. "Longfellow's Tradition; or, Picture-Writing a Nation." *Modern Language Quarterly* 59 (December 1998): 471–96.

Jacobs, Melville. "Our Knowledge of Pacific Northwest Indian Folklore." *Northwest Folklore* 2 (1967): 14–21.

Jensen, Richard. "On Modernizing Frederick Jackson Turner: The Historiography of Regionalism." *Western Historical Quarterly* 11, no. 3 (1980): 307–22.

Johns, Elizabeth. "Cities, Excursions into Nature, and Late-Century Landscapes." In *American Victorians and Virgin Nature*. Edited by T. J. Jackson Lears, 64–78. Cambridge, MA: Isabella Stewart Gardner Museum, 2002.

———. "Settlement and Development." In *The West as America: Reinterpreting Images of the Frontier, 1820–1920*. Edited by William Truettner, 149–90. Washington, D.C.: Smithsonian Institution Press, 1991.

Johnson, Tim, ed. *Spirit Capture: Photographs from the National Museum of the American Indian*. Washington, D.C.: Smithsonian Institution Press in association with the National Museum of the American Indian, 1998.

Jussim, Estelle, and Elizabeth Lindquist-Cock. *Landscape as Photograph*. New Haven, CT: Yale University Press, 1985.

Keil, Charlie. *Early American Cinema in Transition: Story, Style and Filmmaking, 1907–1913*. Madison: University of Wisconsin Press, 2001.

Kelsey, Robin. *Archive Style: Photographs and Illustrations for U.S. Surveys, 1850–1890*. Los Angeles: University of California Press, 2007.

Ketner, Joseph D. II, and Michael J. Tammenga. *The Beautiful, the Sublime, and the Picturesque: British Influences on American Landscape Painting*. St. Louis, MO: The Gallery, 1984.

Kilgo, Dolores A. *Likeness and Landscape: Thomas M. Easterly and the Art of the Daguerreotype*. St. Louis: Missouri Historical Society Press, 1994.

Kinsey, Joni. *Thomas Moran and the Surveying of the American West*. Washington, D.C.: Smithsonian Institution Press, 1992.

———. *Plain Pictures: Images of the American Prairie*. Washington, D.C.: Smithsonian Institution Press for the University of Iowa Museum of Art, 1996.

Klein, Kerwin. *Frontiers of Historical Imagination: Narrating the European Conquest of Native America, 1890–1990*. Berkeley: University of California Press, 1997.

Koelling, Jill. "Revealing History: Another Look at the Solomon D. Butcher Photographs." *Nebraska History* 81, no. 2 (2000): 50–55.

Kolodny, Annette. *The Land Before Her: Fantasy and Experience of the American Frontiers, 1630–1860*. Chapel Hill: University of North Carolina Press, 1984.

Krauss, Rosalind. "A Note on Photography and the Simulacral." *October*, no. 31 (Winter 1984): 49–68.

Lamar, Howard. "Image and Counterimage: The Regional Artist and the Great Plains Landscape." In *The Big Empty: Essays on Western Landscapes as Narrative*. Edited by Leonard Engel, 75–92. Albuquerque: University of New Mexico Press, 1994.

Lavender, David. *River Runners of the Grand Canyon*. Tucson: University of Arizona Press, 1985.

Lear, T. J. Jackson. *No Place of Grace: Antimodernism and the Transformation of American Culture, 1880–1920*. New York: Pantheon Books, 1981.

Levine, Barbara, and Stephanie Snyder. *Snapshot Chronicles: Inventing the American Photo Album*. New York: Princeton Architectural Press, 2006.

Limerick, Patricia Nelson. *The Legacy of Conquest: The Unbroken Past of the America West*. New York: W. W. Norton, 1987.

———. "Region and Reason." In *All Over the Map: Rethinking American Regions*. Edited by Edward L. Ayers. Baltimore, MD: Johns Hopkins University Press, 1996.

———. *Something in the Soil: Legacies and Reckonings in the New West*. New York: W. W. Norton, 2000.

Limerick, Patricia Nelson, Clyde Milner, and Charles Rankin. *Trails: Toward a New Western History*. Lawrence: University Press of Kansas, 1991.

Lindquist-Cock, Elizabeth. *The Influence of Photography on American Landscape Painting, 1839–1880*. New York: Garland, 1977.

Lippard, Lucy, ed. *Partial Recall: Photographs of Native North Americans*. New York: New Press, 1992.

Lockard, Joe. "The Universal Hiawatha." *American Indian Quarterly* 24 (2000): 110–25.

Lowenthal, David. "The Pioneer Landscape: An American Dream." *Great Plains Quarterly* 2 (Winter 1982): 5–19.

Lucas, Decoursey Clayton. "African American Homesteading on the Central Plains." *Magazine of History* 19, no. 6 (2005): 34–38.

Lueck, Beth Lynne. *American Writers and the Picturesque Tour: The Search for National Identity, 1790–1860*. New York: Garland, 1997.

Lyman, Christopher. *The Vanishing Race and Other Illusions: Photographs of Indians by Edward S. Curtis*. Washington, D.C.: Smithsonian Institution Press, 1983.

Maillet, Arnaud. *The Claude Glass: Use and Meaning of the Black Mirror in Western Art*. New York: Zone Books, 2004.

Mairs, John, Kathryn R. Winthrop, and Robert H. Winthrop. *Archaeological and Ethnological Studies of Southwest Oregon and Crater Lake National Park: An Overview and Assessment*. Ashland, OR: Winthrop Associates Cultural Research, 1994.

Margolis, David. *To Delight the Eye: Original Photographic Book Illustrations of the American West*. Dallas, TX: DeGolyer Library, Southern Methodist University, 1994.

Martin, Charles E. "The Pioneer Photographs of Solomon Butcher." *Family Heritage* 2 (1979): 4–11.

Marx, Leo. *The Machine in the Garden: Technology and the Pastoral Ideal in America*. New York: Oxford University Press, 1964.

Masayesva, Victor, Jr., and Erin Younger. *Hopi Photographers, Hopi Images*. Tucson: Sun Tracks and University of Arizona Press, 1983.

Masteller, Richard N. "Western Views in Eastern Parlors: The Contribution of the Stereograph Photographer to the Conquest of the West." *Prospects: The Annual of American Cultural Studies* 6 (1981): 55–72.

Maurer, Evan M. *Visions of the People: A Pictorial History of Plains Indian Life*. Minneapolis, MN: Minneapolis Institute of Arts, 1993.

Mautz, Carl. *Biographies of Western Photographers: A Reference Guide to Photographers Working in the 19th Century American West*. Nevada City, CA: Carl Mautz, 1997.

McAsh, Heather. "Remnants of Power: Tracing Cultural Influences in the Photography of Solomon D. Butcher." *American Studies* 32 (1991): 29–39.

Miles, George. "To Hear an Old Voice: Rediscovering Native Americans in American History." In *Under an Open Sky: Rethinking America's Western Past*. Edited by William Cronon, George Miles, and Jay Gitlin, 52–70. New York: W. W. Norton, 1992.

Miller, Alan Clark. *Photographer of a Frontier: The Photographs of Peter Britt*. Eureka: Interface California Corporation, 1976.

Miller, Nina Hull. *Shutters West*. Denver, CO: Sage Books, 1962.

Miller, Robert. *Native America, Discovered and Conquered: Thomas Jefferson, Lewis and Clark, and Manifest Destiny*. Westport, CT: Praeger, 2006.

Milner, Clyde. "The View from Wisdom: Four Layers of History and Regional Identity." In *Under an Open Sky: Rethinking America's Western Past*. Edited by William Cronon, George Miles, and Jay Gitlin, 203–22. New York: W. W. Norton, 1992.

Mintz, Lannon W. *The Trail: A Bibliography of the Travelers on the Overland Trail to California, Oregon, Salt Lake City, and Montana During the Years 1841–1864*. Albuquerque: University of New Mexico Press, 1987.

Mitchell, Lee Clark. *Witness to a Vanishing America: The Nineteenth-Century Response*. Princeton, NJ: Princeton University Press, 1981.

Mitchell, Lynn Marie. "Photographer on the Nebraska-South Dakota Frontier." *South Dakota History* 20, no. 2 (1990): 81–95.

Mitchell, William J. "Wunderkammer to World Wide Web: Picturing Place in the Post-Photographic Era." In *Picturing Place: Photography and the Geographical Imagination.* Edited by Joan M. Schwartz and James R. Ryan, 283–304. New York: I. B. Taurus, 2003.

Mitchell, W. J. T. *Picture Theory: Essays on Verbal and Visual Representation.* Chicago: University of Chicago Press, 1994.

Momaday, N. Scott. *With Eagle Glance: American Indian Photographic Images, 1868–1931.* New York: Museum of the American Indians, 1982.

Monkhouse, Christopher. "Henry Wadsworth Longfellow and the Mississippi River: Forging a National Identity through the Arts." In *Currents of Change: Art and Life Along the Mississippi River, 1850–1861.* Edited by Jason T. Busch, Christopher Monkhouse, and Janet L. Whitmore, 140–78. Minneapolis, MN: Minneapolis Institute of the Arts, 2004.

Morehouse, Barbara J. *A Place Called Grand Canyon: Contested Geographies.* Tucson: The University of Arizona Press, 1996.

Musser, Charles. "At the Beginning: Motion Picture Production, Representation and Ideology at the Edison and Lumière Companies." In *The Silent Cinema Reader.* Edited by Lee Grieveson and Peter Krämer, 15–30. New York: Routledge, 2004.

———. *The Emergence of Cinema: The American Screen to 1907.* Vol. 1 of *History of American Cinema.* Edited by Charles Harpole. New York: Scribner, 1990.

Nadeau, Luis. *Encyclopedia of Printing, Photographic and Photomechanical Processes.* 2 vols. Fredericton, NB: Atelier Luis Nadeau, 1989.

Naef, Weston. *Era of Exploration: The Rise of Landscape Photography in the American West, 1860–1885.* Buffalo: Albright-Knox Art Gallery and New York Metropolitan Museum of Art, 1975.

Nash, Roderick. *Wilderness and the American Mind.* New Haven, CT: Yale University Press, 1967.

Neel, David. *Our Chiefs and Elders: Words and Photographs of Native Elders.* Vancouver: University of British Columbia Press, 1992.

Nemerov, Alex. "Doing the 'Old America': The Image of the American West, 1880–1920." In *The West as America: Reinterpreting Images of the Frontier, 1820–1920.* Edited by William Truettner, 285–344. Washington, D.C.: Smithsonian Institution Press, 1991.

Newhall, Beaumont. *The Daguerreotype in America.* New York: Dover, 1976.

———. *The History of Photography.* New York: Little, Brown and Co., 1982.

———. "Minnesota Daguerreotypes." *Minnesota History* 34 (Spring 1954): 28–33.

Newhall, Nancy. *Ansel Adams: The Eloquent Light: His Photographs and the Classic Biography.* Millerton, NY: Aperture, 1980.

Nickel, Douglas. *Carleton Watkins: The Art of Perception.* San Francisco, CA: San Francisco Museum of Modern Art, 1999.

Nickerson, Cynthia. "Artistic Interpretations of Henry Wadsworth Longfellow's 'The Song of Hiawatha,' 1855–1900." *American Art Journal* 16 (Summer 1984): 49–77.

Norris, Scott, ed. *Discovered Country: Tourism and Survival in the American West.* Albuquerque, NM: Stone Ladder Press, 1994.

Nye, David E. "Constructing Nature: Niagara Falls and the Grand Canyon." In *Narratives and Spaces: Technology and the Construction of American Culture*, 13–24. New York: Columbia University Press, 1998.

———. "Visualizing Eternity: Photographic Constructions of the Grand Canyon." In *Picturing Place: Photography and the Geographical Imagination.* Edited by Joan M. Schwartz and James R. Ryan, 74–65. New York: I. B. Tauris, 2003.

Nyerges, Alexander Lee. *In Praise of Nature: Ansel Adams and Photographers of the American West.* Dayton, OH: Dayton Art Institute, 1999.

Orvell, Miles. *The Real Thing: Imitation and Authenticity in American Culture, 1880–1940.* Chapel Hill: University of North Carolina Press, 1989.

Ostroff, Eugene. *Photographing the Frontier.* Washington, D.C.: Smithsonian Institution Press, 1976.

———. *Western Views and Eastern Vision.* Washington, D.C.: Smithsonian Institution Press, 1981.

Pace, Michael. "Emery Kolb and the Fred Harvey Company." *Journal of Arizona History* 24 (1983): 339–64.

Palmquist, Peter E. *Carleton E. Watkins, Photographer of the American West.* Albuquerque: University of New Mexico Press, 1983.

———. "Notes about the Plates." In *Photographer of a Frontier: The Photographs of Peter Britt.* By Alan Clark Miller, 37–47. Eureka: Interface California Corp., 1976.

Palmquist, Peter E., and Thomas R. Kailbourn. *Pioneer Photographers of the Far West: A Biographical Dictionary, 1840–1865.* Stanford, CA: Stanford University Press, 2000.

Panzer, Mary. "How the West Was Won: Reinventing the Myth of William Henry Jackson." *Afterimage* 16 (March 1989): 17–19.

Pauketat, Timothy R. *Ancient Cahokia and the Mississippians.* Cambridge: Cambridge University Press, 2004

Payne, Darwin. *Owen Wister: Chronicler of the West, Gentleman of the East.* Dallas, TX: Southern Methodist University Press, 1985.

Peeler, David. "Group f/64." In *Original Sources: Art and Archives at the Center for Creative Photography.* Edited by Amy Rule, 107–10. Tucson, AZ: Center for Creative Photography, 2002.

———. *The Illuminating Mind in American Photography: Stieglitz, Strand, Weston, Adams.* Rochester, NY: University of Rochester Press, 2001.

Plain, Nancy. *Light on the Prairie: Solomon D. Butcher, Photographer of Nebraska's Pioneer Days.* Lincoln: University of Nebraska Press, 2012.

Pomeroy, Earl. *In Search of the Golden West: The Tourist in Western America.* New York: Knopf, 1957.

Pronechen, Joseph S. "The Making of Hiawatha." *New York Folklore Quarterly* 2 (June 1972): 151–57.

Prown, Jules. *Discovered Lands, Invented Pasts: Transforming Visions of the American West.* New Haven, CT: Yale University Press, 1992.

Pyne, Stephen J. *How the Canyon Became Grand.* New York: Viking, 1998.

Quinn, Karen E. *Ansel Adams: The Early Years.* Boston, MA: Museum of Fine Arts, Boston, 1991.

Rainey, Sue. *Creating Picturesque America: Monument to the Natural and Cultural Landscape.* Nashville, TN: Vanderbilt University Press, 1994.

Read, Michael, ed. *Ansel Adams, New Light: Essays on His Legacy and Legend.* San Francisco, CA: Friends of Photography, 1993.

Reps, John. *Cities of the Mississippi: Nineteenth-Century Images of Urban Development.* Columbia: University of Missouri Press, 1994.

———. *Cities on Stone: Nineteenth-Century Lithographic Images of the Urban West.* Fort Worth, TX: Amon Carter Museum, 1976.

———. *John Caspar Wild: Painter and Printmaker of Nineteenth-Century Urban America.* St. Louis: Missouri Historical Society Press, 2006.

Rickard, Jolene. "The Occupation of Indigenous Space as 'Photograph.'" In *Native Nations: Journeys in American Photography*. Edited by Jane Alison, 57–71. London: Barbican Art Gallery, 1998.

Ridge, Martin. "The American West: From Frontier to Region." In *The American West: Interactions, Intersection, and Injunctions*. Edited by Gordon Morris Bakken and Brenda Farrington, 123–39. New York: Garland, 2000.

Riley, Glenda. "Writing, Teaching, and Recreating Western History Through Intersections and Viewpoints." In *The American West: Interactions, Intersections, and Injunctions*. Edited by Gordon Morris Bakken and Brenda Farrington, 103–21. New York: Garland, 2000.

Rinhart, Floyd, and Marion Rinhart. *The American Daguerreotype*. Athens: University of Georgia Press, 1981.

Robbins, William. "Laying Siege to Western History: The Emergence of New Paradigms." *Reviews in American History* 19 (September 1991): 313–31.

Roberts, W. Rhys, ed. *Longinus on the Sublime*. New York: Garland, 1987.

Roosa, Alma Carlson. "Homesteading in the 1880s: The Anderson-Carlson Families of Cherry County." *Nebraska History* 58, no. 3 (1972): 371–94.

Rosler, Martha. "In, Around, and Afterthoughts (on Documentary Photography)." In *The Contest of Meaning: Critical Histories of Photography*. Edited by Richard Bolton, 303–41. Cambridge, MA: MIT Press, 1989.

Rothman, Hal. *Devil's Bargains: Tourism in the Twentieth-Century American West*. Lawrence: University Press of Kansas, 1998.

Rudisill, Richard. *Mirror Image: The Influence of the Daguerreotype on American Society*. Albuquerque: University of New Mexico Press, 1971.

Rule, Amy, ed. *Carleton Watkins: Selected Texts and Bibliography*. Boston, MA: G. K. Hall, 1993.

Runte, Alfred. *National Parks: The American Experience*. Lincoln: University of Nebraska Press, 1987.

Sandweiss, Eric. *St. Louis: The Evolution of an American Urban Landscape*. Philadelphia, PA: Temple University Press, 2001.

Sandweiss, Martha. "Picturing Change: Early St. Louis Photography." In *St. Louis and The Art of the Frontier*. Edited by John Neal Hoover, 83–91. St. Louis, MO: St. Louis Mercantile Library, 2000.

———. *Print the Legend: Photography and the American West*. New Haven, CT: Yale University Press, 2002.

———. "Undecisive Moments: The Narrative Tradition in Western Photography." In *Photography in Nineteenth-Century America*. Edited by Martha Sandweiss, 98–129. New York: Abrams, 1991.

———. "Views and Reviews: Western Art and Western History." In *Under an Open Sky: Rethinking America's Western Past*. Edited by William Cronon, George Miles, and Jay Gitlin, 185–202. New York: W. W. Norton, 1992.

Schimmel, Julie. "Inventing 'the Indian.'" In *The West as America: Reinterpreting Images of the Frontier, 1820–1920*. Edited by William Truettner, 149–90. Washington, D.C.: Smithsonian Institution Press, 1991.

Schlissel, Lillian. *Far from Home: Their Land, Their Lives*. Albuquerque: University of New Mexico Press, 1988.

———. *Women's Diaries of the Westward Journey*. New York: Schocken Books, 1992.

Schulten, Susan. "How to See Colorado: The Federal Writers' Project, American Regionalism, and the 'Old New Western History.'" *Western History Quarterly* 36 (Spring 2005): 49–70.

Sears, John F. *Sacred Places: American Tourist Attractions in the Nineteenth Century.* Oxford: Oxford University Press, 1989.

Sekula, Allan. "On the Invention of Photographic Meaning." *Artforum* 8 (January 1975): 37–45. Reprinted in *Thinking Photography.* Edited by Victor Burgin, 84–109. London: Macmillan, 1982.

Sennett, Robert S. *The Nineteenth-Century Photographic Press: A Study Guide.* New York: Garland Publishing, 1987.

Shaffer, Marguerite S. *See America First: Tourism and National Identity, 1880–1940.* Washington, D.C.: Smithsonian Institution Press, 2001.

———. "Seeing America First: The Search for Identity in the Tourist Landscape." In *Seeing and Being Seen: Tourism in the American West.* Edited by David M. Wrobel and Patrick T. Long, 165–93. Lawrence: University of Kansas Press, 2001.

Sichel, Kim. *Mapping the West: Nineteenth-Century American Landscape Photographs from the Boston Public Library.* Boston, MA: Boston University Art Gallery, 1992.

Silverberg, R. *Mound Builders of Ancient America: The Archaeology of a Myth.* New York: F. W. Dodge, 1961.

Slotkin, Richard. *Gunfighter Nation: The Myth of the Frontier in Twentieth-Century America.* New York: Atheneum, 1992.

———. "Visual Narrative and American Myth from Thomas Cole to John Ford." In *American Victorians and Virgin Nature.* Edited by T. J. Jackson Lears, 91–112. Boston, MA: Isabella Stewart Gardner Museum, 2002.

Smith, Dean. *Brothers Five: The Babbitts of Arizona.* Tempe: Arizona Historical Foundation, 1989.

Smith, Dwight L., ed. *The Photographer and the River, 1889–90: The Colorado Cañon Diary of Franklin A. Nims with the Brown-Stanton Railroad Survey Expedition.* Santa Fe, NM: Stagecoach Press, 1967.

Smith, Henry Nash. *Virgin Land: The American West as Symbol and Myth.* Cambridge, MA: Harvard University Press, 1950.

Sobieszek, Robert A. *The Daguerreotype Process: Three Treatises, 1840–1849.* New York: Arno Press, 1973.

Solomon-Godeau, Abigail. "Photography After Art Photography." In *Art After Modernism: Rethinking Representation.* Edited by Brian Wallis, 75–86. Boston, MA: Godine, 1984.

Sontag, Susan. *On Photography.* New York: Picador, 1979.

Spaulding, Jonathan. *Ansel Adams and the American Landscape: A Biography.* Berkeley: University of California Press, 1995.

Spirn, Anne Whiston. *The Language of Landscape.* New Haven, CT: Yale University Press, 1998.

Sternberger, Paul Spencer. *Between Amateur and Aesthete: The Legitimization of Photography as Art in America, 1880–1900.* Albuquerque: University of New Mexico Press, 2001.

Stevenson, Louise L. *The Victorian Homefront: American Thought and Culture, 1860–1880.* New York: Twayne, 1991.

Stewart, Elinore. *Letters of a Woman Homesteader.* Boston, MA: Houghton Mifflin, 1914.

Stewart, George R. *American Place-Names: A Concise and Selective Dictionary for the Continental United States of America.* New York: Oxford University Press, 1970.

Stilgoe, John R. *Common Landscape of America, 1380–1845.* New Haven, CT: Yale University Press, 1982.

Stillman, Andrea Gray. *Ansel Adams: An American Place, 1936.* Tucson: Center for Creative Photography, University of Arizona, 1982.

Stillman Andrea G., and William A. Turnage, eds. *Ansel Adams: Our National Parks.* Boston, MA: Little, Brown, and Company, 1992.

Strangis, Joel. *Ansel Adams: American Artist with a Camera*. Berkeley Heights, NJ: Enslow Publishers, Inc., 2002.

Strong, Douglas H. "Ralph H. Cameron and the Grand Canyon." *Arizona and the West* 20 (1978): 41–64.

Suran, William. *The Brave Ones: The Journals and Letters of the 1911–1912 Expedition Down the Green and Colorado Rivers by Ellsworth L. Kolb and Emery C. Kolb, Including the Journal of Hubert R. Lauzon*. Flagstaff, AZ: Fretwater Press, 2003.

———. *The Kolb Brothers of the Grand Canyon*. Grand Canyon, AZ: Grand Canyon Natural History Association, 1991.

———. *With the Wings of an Angel: A Biography of Emery and Ellsworth Kolb, Photographers of Grand Canyon*. 1991. Grand Canyon Explorer. http://www.kaibab.org/kaibab.org/kolb/kolb.htm.

Szarkowski, John. *Ansel Adams at 100*. Boston, MA: Little, Brown, 2001.

———. Introduction to *The Portfolios of Ansel Adams*, by Ansel Adams. Boston, MA: Little, Brown and Company, 1977.

———. *Photography Until Now*. New York: Museum of Modern Art, 1989.

Taft, Robert. *Photography and the American Scene*. New York: Dover, 1938.

Tagg, John. *The Burden of Representation: Essays on Photographies and Histories*. London: Macmillan, 1988.

Thacker, Robert. "The Plains Landscape and Descriptive Technique." *Great Plains Quarterly* 2 (Summer 1982): 146–56.

Trachtenberg, Alan. *Reading American Photographs: Images as History, Mathew Brady to Walker Evans*. New York: Hill and Wang, 1989.

———. *Shades of Hiawatha: Staging Indians, Making Americans, 1880–1930*. New York: Hill and Wang, 2004.

Truettner, William. "Ideology and Image: Justifying Westward Expansion." In *The West as America: Reinterpreting Images of the Frontier*. Edited by William Truettner, 27–54. Washington, D.C.: Smithsonian Institution Press, 1991.

———. "Prelude to Expansion: Repainting the Past." In *The West as America: Reinterpreting Images of the Frontier*. Edited by William Truettner, 55–96. Washington, D.C.: Smithsonian Institution Press, 1991.

Tsinhnahjinnie, Hulleah. "When Is a Photograph Worth a Thousand Words?" In *Native Nations: Journeys in American Photography*. Edited by Jane Alison, 41–56. London: Barbican Art Gallery, 1998.

Tuan, Yi-Fu. *Space and Place: The Perspective of Experience*. Minneapolis: University of Minnesota Press, 1977.

———. *Topophilia: A Study of Environmental Perception, Attitudes, and Values*. Englewood Cliffs, NJ: Prentice-Hall, 1974.

Underwood, Brett. "Chouteau's Pond." *Gateway Heritage* 22 (2001): 4–15.

Van Ravenswaay, Charles. "The Pioneer Photographers of St. Louis." *Bulletin of the Missouri Historical Society* 10 (October 1953): 48–71.

Vickers, Scott B. *Native American Identities: From Stereotype to Archetype in Art and Literature*. Albuquerque: University of New Mexico Press, 1998.

Vizenor, Gerald. *Fugitive Poses: Native American Indian Scenes of Absence and Presence*. Lincoln: University of Nebraska Press, 1998.

Volpe, Andrea L. "Cartes de Visite Portrait Photographs and the Culture of Class Formation." In *Looking for America: The Visual Production of Nation and People*. Edited by Ardis Cameron, 42–57. Malden, MA: Blackwell, 2005.

Vorpahl, Ben Merchant. *My Dear Wister: The Frederic Remington–Owen Wister Letters*. Palo Alto, CA: American West, 1972.

Wajda, Shirley. "A Room with a Viewer: The Parlor Stereoscope, Comic Stereographs, and the Psychic Role of Play in Victorian America." In *Hard at Play: Leisure in America, 1840–1940*. Edited by Kathryn Grover, 112–38. Amherst: University of Massachusetts Press, 1992.

Watkins to Weston: 101 Years of California Photography 1849–1950. Exhibition catalog. Santa Barbara, CA: Santa Barbara Museum of Art and Roberts Rinehart, 1992.

Weber, Eva. *Ansel Adams and the Photographers of the American West*. San Diego, CA: Thunder Bay Press, 2002.

Weigle, Marta. "Exposition and Mediation: Mary Colter, Erna Fergusson, and the Santa Fe/Harvey Popularization of the Native Southwest, 1902–1940." *Frontiers* 12 (1992): 116–50.

Welling, William. *Photography in America: the Formative Years, 1839–1900*. New York: Thomas Y. Crowell, 1978.

White, John I. "Pages from a Nebraska Album: The Sod House Photographs of Solomon D. Butcher." *American West* 12 (March 1975): 30–31.

White, Richard. "The Cultural Landscape of the Pawnees." *Great Plains Quarterly* 2 (Winter 1982): 31–40.

———. "Indian Peoples and the Natural World: Asking the Right Questions." In *Rethinking American Indian History*. Edited by Donald Fixico, 87–100. Albuquerque: University of New Mexico Press, 1997.

———. *"It's Your Misfortune and None of My Own": A New History of the American West*. Norman: University of Oklahoma Press, 1991.

———. *The Organic Machine*. New York: Hill and Wang, 1995.

———. "Transcendental Landscapes." In *American Victorians and Virgin Nature*. Edited by T. J. Jackson Lears, 1–16. Boston, MA: Isabella Stewart Gardner Museum, 2002.

Whitmore, Janet L. "A Panorama of Unequaled Yet Ever-Varying Beauty." In *Currents of Change: Art and Life Along the Mississippi River, 1850–1861*. Edited by Jason T. Busch, Christopher Monkhouse, and Janet L. Whitmore, 12–61. Minneapolis, MN: Minneapolis Institute of Arts, 2004.

Williams, Carol. *Framing the West: Race, Gender, and the Photographic Frontier in the Pacific Northwest*. New York: Oxford University Press, 2003.

Williams, Howell. *Crater Lake: The Story of Its Origins*. Berkeley: University of California Press, 1941.

Wills, Jocelyn. *Boosters, Hustlers, and Speculators: Entrepreneurial Culture and the Rise of Minneapolis and St. Paul, 1849–1883*. St. Paul: Minnesota Historical Press, 2005.

Wilson, Bonnie. "Joel Emmons: Minnesota's Leading Pioneer Photographer." In *Joel Emmons Whitney: Minnesota's Leading Pioneer Photographer, Catalog of Cartes De Visite Native American and Landscape Views*. Edited by Minnesota Historical Photo Collectors Group, 1–3. St. Paul: Minnesota Historical Photo Collectors Group, 2001.

———. "St. Anthony's Falls on Silver: A Daguerreotype Collection." *The Daguerreian Annual* (1992): 129–44.

———. "Working the Light: Nineteenth-Century Professional Photographers in Minnesota." *Minnesota History* 52 (Summer 1990): 42–60.

Wilson, Chris. *The Myth of Santa Fe: Creating a Modern Regional Tradition*. Albuquerque: University of New Mexico Press, 1997.

Wingerd, Mary Lethert. *Claiming the City: Politics, Faith, and the Power of Place in St. Paul*. Ithaca, NY: Cornell University Press, 2001.

Wolf, Daniel. *The American Space: Meaning in Nineteenth Century Landscape Photography*. Middletown, CT: Wesleyan University Press, 1983.

Wolmer, Bruce. "Ansel Adams and the West." *MoMA Quarterly*, Summer 1979, 1–2.

Wood, John. *The Scenic Daguerreotype: Romanticism and Early Photography.* Iowa City: University of Iowa Press, 1995.

———. ed. *America and the Daguerreotype.* Iowa City: University of Iowa Press, 1991.

Worster, Donald. "New West, True West: Interpreting the Region's History." *Western Historical Quarterly* 18, no. 2 (1987): 141–56.

Wright, Bonnie. "'This Perpetual Shadow-Taking': The Lively Art of John Fitzgibbon." *Missouri Historical Review* 76 (October 1981): 23–24.

Wrigley, Richard. *Ansel Adams: Images of the American West.* New York: Smithmark Publishing, 1995.

Wrobel, David. *Promised Lands: Promotion, Memory, and the Creation of the American West.* Lawrence: University Press of Kansas, 2002.

Wyatt, Victoria. "Interpreting the Balance of Power: A Case Study of Photographer and Subject in Images of Native Americans." *Exposure* 28, no. 3 (1991): 23–33.

Dissertations and Theses

Avery, Kevin Joseph. "The Panorama and Its Manifestation in American Landscape Painting, 1795–1870." PhD diss., Columbia University, 1995.

Everett, Christopher. "A Historical Study of the Emery Kolb Grand Canyon Camera Collection." Master's thesis, Northern Arizona University, 1981.

Goodyear, Frank. "Constructing a National Landscape: Photography and Tourism in Nineteenth-Century America." PhD diss., University of Texas at Austin, 1998.

Lindquist-Cock, Elizabeth. "The Influence of Photography on American Landscape Painting." PhD diss., New York University, 1967.

Miller, Alan Clark. "Peter Britt: Pioneer Photographer of the Siskiyous." Master's thesis, Trinity College, 1972.

Mitchell, Lynn Marie. "Shadow Catchers on the Great Plains: Four Frontier Photographers of American Indians." Master's thesis, University of Oklahoma, 1987.

Seefeldt, Douglas. "Constructing Western Pasts: Place and Public Memory in the Twentieth-Century American West." PhD diss., Arizona State University, 2001.

Senf, Rebecca. "Ansel Adams's 'Practical Modernism': The Development of a Commercial Photographer, 1916–1936." PhD diss., Boston University, 2008.

Siegel, Elizabeth Ellen. "Galleries of Friendship and Fame: the History of Nineteenth-Century American Photograph Albums." PhD diss., University of Chicago, 2003.

Smith, Henry Nash. "American Emotional and Imaginative Attitudes Toward the Great Plains and the Rocky Mountains, 1803–1850." PhD diss., Harvard University, 1940.

Williams, Bradley Bennett. "The Image of the American West in Photography, 1839–1890." PhD diss., University of Iowa, 1984.

Wolfe, Mary Melissa. "'Proving Up' on a Claim in Custer County, Nebraska: Identity, Power, and History in the Solomon D. Butcher Photographic Archive (1886–1892)." PhD diss., Ohio State University, 2005.

Wray, Kenton. "The Sod House Photographs of Solomon D. Butcher." PhD diss., University of Northern Colorado, 1986.

Index

Page numbers in italic text indicate illustrations.